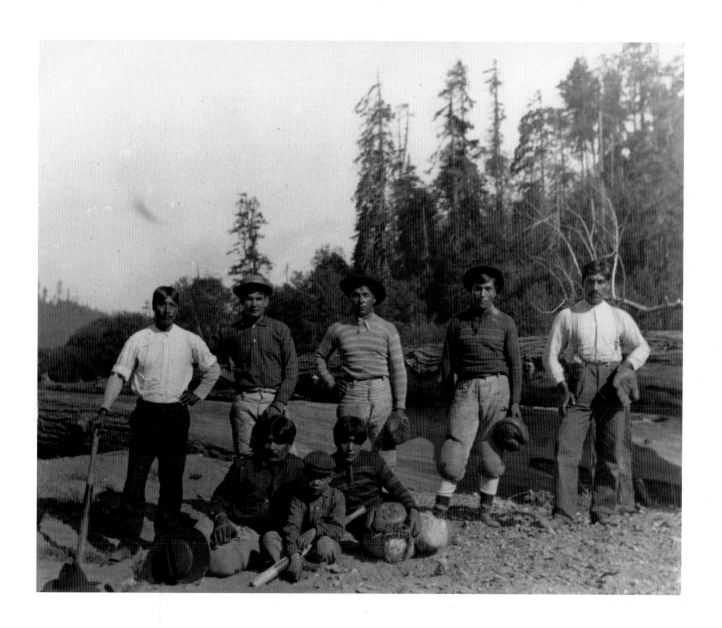

First Families

A Photographic History
of California Indians

First Families

A Photographic History of California Indians

L. Frank and Kim Hogeland

HEYDAY BOOKS, BERKELEY, CALIFORNIA

Library of Congress Cataloging-in-Publication Data

L. Frank
 First families : a photographic history of
California Indians / L. Frank, Kim Hogeland.
 p. cm.
 Includes bibliographical references and
index.
 ISBN 978-1-59714-013-3 (pbk. : alk. paper)
 1. Indians of North America--California-
-History. 2. Indians of North America--
California--Portraits. 3. Indians of North
America--California--Pictorial works. I.
Hogeland, Kim. II. Title.
 E78.C15L46 2007
 979.4004'9700222--dc22
 2006039389

Front Cover: *Sage LaPena (left) with her uncle Isgrig
Towendolly (Wintu), Salt Creek, c. 1970 (courtesy of
Sage LaPena).*

Back cover: *top left, Tom Jimenez (in uniform), Ajach-
mem, returning from World War I, surrounded by family and
friends, San Juan Capistrano, 1917 (courtesy of Marguerite
Lobo); top right, Bill Tupper (Modoc), Beatty Creek,
1956 (courtesy of Bill Tupper); bottom left, Bertha Norton
(Wintun), 1999 (photo by and courtesy of Dugan Aguilar);
bottom right, members of the Chumash Maritime Associa-
tion, 2001 (photo by and courtesy of Frank Magallanes and
Althea Edwards)*

Cover Design: Toki Design
Interior Design/Typesetting: Toki Design
Printed in Singapore by Imago

Orders, inquiries, and correspondence should
be addressed to:
 Heyday Books
 P. O. Box 9145, Berkeley, CA 94709
 (510) 549-3564
 Fax (510) 549-1889
 www.heydaybooks.com

10 9 8 7 6 5 4 3 2 1

Contents

ACKNOWLEDGMENTS ix

PREFACE xi
L. Frank

FOREWORD xiii
Marina Drummer

One CENTRAL VALLEY AND WESTERN SIERRA NEVADA 3
History and Culture 5
Not by Bread Alone 15
Vessels of Culture 21
Song, Dance, and Ceremony 31
Indian Cowboys 36
Golden Opportunity 42
At the Valley's End 48

Two CENTRAL COASTAL CALIFORNIA 51
History and Culture 55
A Culture of Abundance 65
Keeping Culture in Its Place 71
The Pomo Indian Women's Club 77
Valley of the Bears 82
Words to the Wise 85
The Round Valley 88

Three COASTAL SOUTHERN CALIFORNIA 91
History and Culture 93
Indian Gaming, the Old-Fashioned Way 103
Seagoing Vessels 108
Resisting the Invasion 119
The Exiles of Cupa 127
The Border 132
Culture Heroes 134

Four INLAND SOUTHERN CALIFORNIA 143
History and Culture 145
Bird Songs 148
Advocates and Organizers 153
Sherman Institute 157
Indian Gaming 165
A Desert Uprising 167

Five GREAT BASIN 179

 History and Culture 181

 Ancient Art History 186

 Foods of the East 191

 Datsolalee—Louisa Keyser 197

 Nüümü Yadoha 202

Six NORTHEASTERN CALIFORNIA 207

 History and Culture 209

 Indian Doctors 217

 The Ghost Dance 222

 Preserving the Sacred 226

 Ishi, a Man 234

Seven NORTHWESTERN CALIFORNIA 239

 History and Culture 241

 A Matter of Value 247

 Traditional Tattoos 252

 Fish for Life 255

 Seagoing Redwoods 259

 A Traditional Yurok Village 262

NOTES 277

BIBLIOGRAPHY 279

Acknowledgments

IT TAKES MANY PEOPLE TO PROPEL A PROJECT OF THIS SIZE AND SCOPE TO completion. Marina Drummer was instrumental in the early collecting phases of the project, accompanying L. Frank to native communities from the Smith River to the Mojave Desert. Marion Green and the LEF Foundation provided crucial funding, as did the California State Library. At that institution, Kevin Starr, Carole Talan, Charlene Simmons, and Susan Hildreth were particularly helpful and encouraging. Further institutional support came from Advocates for Indigenous California Language Survival, the California Indian Basketweavers Assocation, and the California Indian Storytellers Association. As always, Bev Ortiz went above and beyond in providing photos, information, and community contacts. Melissa Nelson at the Cultural Conservancy, Laura Grant of the Owens Valley Career Development Center's Nüümü Yadoha program, the Hargrave family, and Henry Koerper also generously shared resources and contacts.

At Heyday, Lillian Fleer, Jeannine Gendar, Sarah-Larus Tolley, and Malcolm Margolin all contributed their knowledge, experience, and skill to *First Families*. Interns Sarah Barkin and Abel Patterson contributed generous amounts of their time as well.

Special thanks go out to Cheryl Hogeland for her patience.

Most of all, we are immeasurably grateful to the families who have so graciously shared their memories and their photographs.

PREFACE BY L. FRANK

AT THE BEGINNING OF THIS WONDERFUL IMMERSION IN OUR CALIFORNIA NATIVE lives, we asked if we could enter Indian homes and meeting places to look at people's personal family photo albums and record them talking about the pictures. My job was to simply look and listen. My friend Marina Drummer went with me and helped beyond measure. People opened their lives to us. Many times they thanked us for listening instead of telling them what was important. Most of the people we listened to were elders. The images were chosen by the interviewees with no direction from me other than "Choose what is important to you and your family for whatever reason. Define yourself for yourself." What emerged was no less than incredible.

While we California Natives were being pushed and shoved off and around our homelands, we were taking photographs. Photos of ourselves dancing in our front yards with our pants legs rolled up while the women participated from the front porch; walking to the nationals camp with your best girl laughing at all you say; our mothers and fathers just after they met and married at boarding school; and hundreds of pictures of our children.

The artist in me was interested to see that many people had at least one and quite often two cameras, usually Brownies. And from a modern photographic perspective, the composition, perspective, and subject matter are stunningly luscious.

What I saw and recorded explains how our families not only survived but went on against all odds with a tremendous sense of humor and beauty. And yes, there were many photographs of us working in the fields for others, photos of Indian girls learning how to vacuum from an Anglo teacher at boarding school. And then there is the prison photo of a young Indian woman, Modesta Avila, who just wanted to hang a clothesline where her mother had always done so and ended up the first convicted felon of Orange County, sentenced to three years' hard labor in San Quentin. Our clothes may be tattered and frayed, but we ourselves are not.

I've talked about my journey into the real California to my friends and a few strangers, and I have tried to write about it, but only drawings came out until now. And even now, the shared emotions of more than one hundred elders' voices are really to be absorbed and pondered more than written about. Marina said to me one day something about how exhausted we were after interviewing only two families in one day (we would spend about three hours with each person). When I heard her say this, I realized I was exhausted not because three hours is a long time, but because these generous people took us down a very long path, paved deeply with timeless emotions connected to some creator or some act of magic or one particular spot on this earth.

I've called this preface "sovereignty defined" because this is what the individual voices collectively said. The peoples' sovereignty is expressed in their journey from then to now to the future.

Tillie Lobo and Walter Arrow, San Juan Capistrano, 1940s.
COURTESY OF RUTH LOBO.

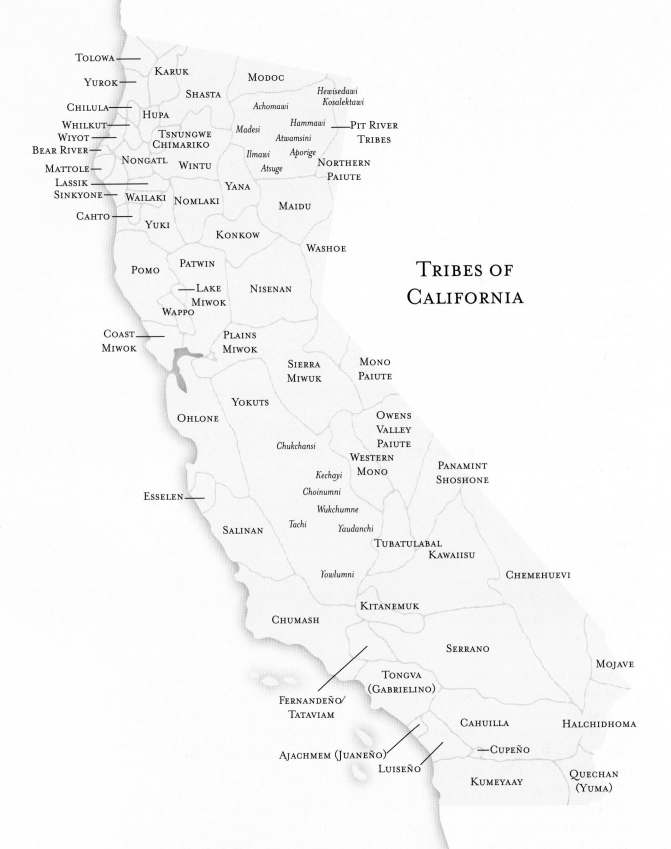

TRIBES OF
CALIFORNIA

TOLOWA
YUROK
CHILULA
WHILKUT
WIYOT
BEAR RIVER
MATTOLE
LASSIK
SINKYONE
CAHTO
COAST MIWOK
ESSELEN

KARUK
SHASTA
HUPA
TSNUNGWE
CHIMARIKO
NONGATL
WINTU
WAILAKI
NOMLAKI
YUKI
KONKOW
PATWIN
POMO
LAKE MIWOK
WAPPO
PLAINS MIWOK
NISENAN
SIERRA MIWUK
YOKUTS
OHLONE
SALINAN

MODOC
Hewisedawi
Kosalektawi
Achomawi
Madesi
Hammawi
PIT RIVER TRIBES
Atwamsini
Ilmawi
Aporige
Atsuge
NORTHERN PAIUTE
YANA
MAIDU
WASHOE

MONO PAIUTE
Chukchansi
Kechayi
Choinumni
Wukchumne
Tachi
Yaudanchi
Yowlumni

OWENS VALLEY PAIUTE
WESTERN MONO
PANAMINT SHOSHONE
TUBATULABAL
KAWAIISU
CHEMEHUEVI
KITANEMUK
CHUMASH
FERNANDEÑO/ TATAVIAM
TONGVA (GABRIELINO)
SERRANO
MOJAVE
AJACHMEM (JUANEÑO)
CAHUILLA
HALCHIDHOMA
LUISEÑO
CUPEÑO
KUMEYAAY
QUECHAN (YUMA)

As most important things in life do, this adventure began in a kitchen—Janeen Antoine's kitchen, to be exact. On a quiet fall evening in 2002, L. Frank Manriquez's stop by Janeen's home turned into the journey of a lifetime. Janeen shared a letter she'd received from publisher Malcolm Margolin: he was looking for someone who could take the time to travel the state, meet with individuals from different tribes, scan in personal photos they were willing to share, and do brief interviews. The goal of the project was to create a book that would reveal the richness and diversity of California's indigenous people.

The letter suggested that whoever applied should have a good working knowledge of California Indians and an even better sense of humor. L. and Janeen agreed that undertaking a project like this would be an incredible opportunity. L.'s familiarity with individuals from many different tribes statewide—acquired over many years of serving on boards and traveling as an artist and cultural activist—certainly qualified her, and she'd always dreamed of using her knowledge of California Indians for a project of this magnitude. (In fact, L. dreamt this job when she was a small child.) As for the sense of humor, anyone who knows L. would agree that there is no shortage of comedic skill in her approach to life. It not only seemed like a match made in heaven, it was. The next morning she called Malcolm, formally applied for the job, and got it.

November and December were consumed with planning for the journey. A notebook computer, a scanner, a digital camera, and a trustworthy tape recorder were part of the package, along with expenses for motels and meals. Never one to do things by halves, L. assembled a list of the equipment she would *really* need to make the work possible and the final product first-class. Assembling the existing and additional equipment, installing the necessary software, and getting the various computers, cameras, and scanners functioning was a project in and of itself. Fortunately, Marion Greene of the LEF Foundation, long a supporter of Native American projects, supplied additional funding. And perhaps more important, the funds Marion granted also made it possible to burn extra CDs of all the photos that were scanned. The CDs were sent them to people who had participated, giving them a record of their contribution to the project that could be shared with their family, community, and friends.

(And did we mention Betty? One of our most crucial pieces of equipment, Betty is a Global Positioning System that plugs into a car lighter, sits on the dashboard, and when properly programmed can find a trailer on a dirt road in a remote rancheria! Betty became the most indispensable of all traveling companions, relied upon daily to guide the expedition and keep it on track. Without Betty, there would have been fewer interviews and lots more frustration.)

One of the first challenges was figuring out whom to interview. We availed ourselves of every mailing list we could find and took advantage of contacts from the California Indian Basketweavers Association, Advocates for Indigenous California Language Survival, *News from Native California*, and L.'s extended network of contacts.

The pages of names, addresses, and numbers became the source for calls we placed daily to set up appointments to visit as many people as possible. As we worked our way through the pages, one thing became abundantly clear: California Indians are probably the busiest people on the planet. Finding convenient times to meet with even the oldest and best of friends was a challenge.

As it turned out, the journey was as much about the landscapes in between our stops as it was about the people. The hills and valleys, the mountains and forests, the deserts and plains, the entire panorama that is California unfolded before us. The beauty of the state and the magnificent strength and dignity of the people kept us in a prolonged state of wonder. Each visit became a journey through not only an individual's personal history, but his or her tribal history as well. At the end of the day, even if we had only visited two people, we were emotionally and factually overloaded, unable to process more information.

We did our best to drop into places and lives and really feel and hear and see, so that we could accurately channel the momentous events shared with us through each consultant's daily life and celebrations. The picnics at the beach, confirmations, and graduations frequently took on the feel of Indian rituals, while the most traditional of tribal ceremonies were tinged with Western modernity. Things remain the same, things change. The people went from living off the wealth of the land to picking fruit and vegetables to working in shopping malls. Through it all, the voices we kept hearing said, "We are the first people of this land, we are Indians, and we are still here."

Through all the interviews and oral histories, bits and pieces of stories and legends streamed to the surface. Singers swallowed crickets to heighten their skills. Girls baked in shallow earthen ovens to prevent menstrual problems in later life. A good wife was one that could carry two railroad ties at the same time. Tribal chiefs who went to Washington to advocate for their communities had to wear Plains Indian headdresses to get recognition. And while these stories stand out for their uniqueness, other elements stand out for their universality, including family ties, fires, relocations, magic, and cradleboards.

Another common theme was sports. In pictures from the turn of the twentieth century through the turn of the twenty-first century, California Indians of both sexes frequently appear in baseball uniforms. There are numerous photos of early boxing teams and young men who had professional or semiprofessional boxing careers. Traditional games like shinny were played right alongside American imports like football. San Juan Capistrano had an interesting twist on the sports scene—in the 1940s and 1950s, it looks like the whole tribe, women included, took to motorcycles! One of our consultants told us that her mother had traded her land for a motorcycle during those wild days.

Motorcycles weren't the only things people were riding. Photographers traveled the state with prop ponies, and all children—native or not—had their pictures taken on the back of one. It doesn't seem possible that the same rented pony appears in

each of these shots, and yet they're all nearly identical—as are the cowboy outfits the children are wearing. The irony of dressing Indian children as cowboys isn't so great as it may seem. Indeed, the Luiseños claim that they were the first real cowboys in America, predating Texas cowboys by some thirty or forty years.

Some of the most amazing stories were about Indian doctors. Not that long ago, people traveled long distances to visit healers. In almost every community, there were remembrances of getting packed up in a horse-drawn wagon and sent to an adjacent reservation or rancheria to see a healer. Some healers had idiosyncratic styles—one always wore the same clothes and made his own prosthetic for a missing leg. He is remembered as a real human being who knew what to do and how and when to do it. He'd get drunk once a month and never acted holier-than-thou. He had a sense of humor and when one of his patients died, he'd say they were going to give him a bad name.

WHAT WE LEARNED FROM ALL THIS IS THE HISTORY THAT IS RARELY TAUGHT IN schools. There were the early times, when Natives were the only people in what we now call California. Land was carefully managed, game was plentiful in most areas, and life was lived in accordance with ritual and order. Then the Spanish came, establishing the coastal missions and forever changing the fabric of Native life. Despite the missions' official closure in the 1830s, they still dominate Indian community life in some areas. At some missions, contemporary Natives still participate in ceremonies. When asked about this, they say it is for the ancestors, not the tourists.

The impact of the gold rush was equally extensive and destructive. In 1849, hundreds of thousands of people from around the world—but mainly from the eastern United States—flooded into California. In areas where Natives had little if any contact with outsiders, there were suddenly Europeans and Americans everywhere. Competition for resources was fierce. Many Natives were chased off their land. Militia forces, reimbursed by the state, carried out violent massacres. Indentured servitude and the kidnapping of children were considered legal, and Governor Peter Burnett called for a war of extermination against the Native population, claiming that "the inevitable destiny of the race is beyond the power or wisdom of man to avert."[1] Population levels sank to historic lows.

Around the turn of the twentieth century, the U.S. government began to establish rancherias. Although they were supposedly being assured land, Native people were rarely consulted about where this land would be. Many communities were relocated, sometimes hundreds of miles away. Parents warned children not to eat the food when they arrived at their government-chosen destinations, because they thought it might be poisoned. As one of our consultants stated, "They pushed us back so far, into land that was so barren and dry, that even the rattlesnakes had to pack water sacks to survive." Despite this, Native people remember their original homelands and many travel back to them when possible for cultural and medicinal purposes.

The reservations and rancherias to which Native people were consigned were frequently miles from anywhere and on the worst land to be found. Combined with the poverty of many Native communities, this remoteness led to a number of serious problems. One that we were surprised to encounter was that of frequent destructive fires. At first it seemed impossible that so many people we called on were unable to participate because their photos had been burned. However, a stop at Tule River Reservation during fire season made it clear that fire was a constant concern in many areas. We could see the flames from where we sat visiting. Before casinos and development, even a small fire could become destructive by the time firefighters made it to remote tribal areas.

Another common predicament that California Indians face throughout the state is a legal problem: California Indians have been marginalized by a system that emphasizes bureaucracy and written records. Those born at home generally lack birth certificates, making it impossible to receive official recognition. When tribal lands were "generously given" to members, they weren't told about property tax and all too frequently lost their land for failure to pay it. Tribes who are now trying to gather the documents needed to establish federal recognition and gain some kind of support for their members are finding this lack of records and land to be a major stumbling block.

The federal recognition process has created a whole host of problems. "They said that some of us were Indians and some of us weren't. It hurt real bad." What an ingenious way to divide a people. Our travels brought us into contact with groups who had found a way to unite in order to obtain federal recognition and others who seemed to fragment into ever smaller factions while trying to control a tribe's search for sovereignty. Families were split, as siblings with the same mother and father were alternately accepted or rejected as "real" Indians. Tribes that achieved federal recognition were disenrolling tribal members. As one consultant asked, shaking his head over recent news of more disenrolled members, "What makes us Indian?" Another consultant pointed out that the previous unifying and identifying factor had been poverty.

TRAVELING OVER FIFTY THOUSAND MILES AND CRISSCROSSING THE STATE, WE TRIED to reach California Indians from as many areas as possible. L. kept saying that the project would have been much easier if we'd been covering Rhode Island Indians! For every bad thing we saw on our journey, there was also a good thing. There are people in every community doing real cultural work. These are the keepers of the tribal memory. Through their efforts, cultures are maintained and revitalized on many fronts. Several tribes have built ocean-going vessels and made historic journeys utilizing ancient skills. Others work to bring back ceremonies and dances. Some concentrate on retaining their languages. Every tribe has its own way of moving forward, but tribes also work with each other. Statewide groups share the good news and programs that communities have developed, spreading the cultural wealth.

Throughout the journey people asked how L. could possibly represent all the tribes in California in a six-month journey. Obviously, getting representation from every location was impossible, but with a few notable exceptions, most of the state's tribes were indeed represented. The second comment people made was that there was no way of adequately representing any tribe by visiting just a few people. Certainly there are nuances that could not be captured in such a short period. Ethnographers and historians can spend whole lifetimes on just one area. The object of this book, however, was not an in-depth historical and cultural survey, but rather an overview of the diversity of cultures and lifestyles within the state.

The journey went all too quickly, and yet toward the end it was clear that it would be impossible to absorb much more. A couple of years later, the memories and images still seep to the surface regularly. For six months we visited with California Indians from all walks of life: from people who lived traditional lifestyles and were deeply involved in their cultures to people who lived very contemporary lives and were only remotely involved in the old ways; old people and young people; security guards and shamans, teachers and students; people working in tribal government and people totally removed from tribal politics; casino workers, basketweavers, bronco riders, and poets. Now, reviewing the photos and listening to the tapes, it is clear that this journey was nothing short of epic and that the resulting book will serve as a testimony to this particular time and place in history where five hundred years of colonization and genocidal policies intersected with the rise of gaming, technological advances, and cultural revival. It is a poignant record of what was and what is, and a promise of what is yet to come.

First Families

A Photographic History
of California Indians

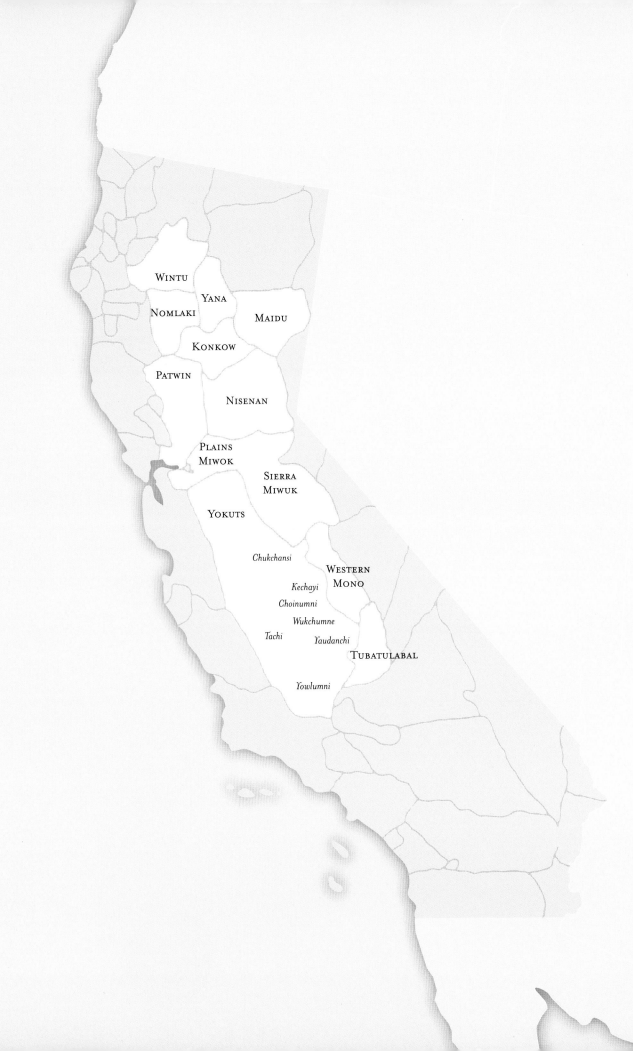

One

Central Valley and Western Sierra Nevada

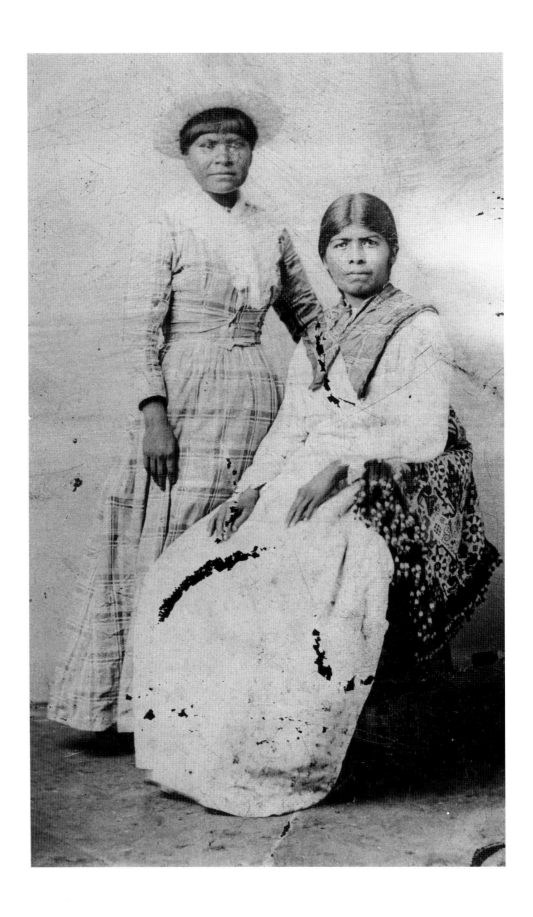

Running nearly the length of California, two rivers give life to the great, open flatlands that lie between the Sierra Nevada and the Coast Range. The Sacramento

River, drawing waters from the rugged, snowy peaks of the southern Cascades, flows southward from the Mount Shasta area to the Delta. Here it meets the San Joaquin River flowing north. These two river valleys, the Sacramento and the San Joaquin, together form California's Great Central Valley, four hundred and fifty miles long from Redding to Bakersfield and between forty and sixty miles wide.

A network of creeks and rivers, mostly flowing westward from the Sierra, feeds into the Sacramento and the San Joaquin. Within the dozens of valley and foothill microenvironments carved by these waterways, seventy-four thousand native people found food, shelter, and an eminently sustainable way of life. Throughout the Sierra foothills, where the Maidu, Konkow, Nisenan, Miwuk, and Mono people lived; in the Sacramento Valley, home of the Wintu, Nomlaki, and Patwin people; and in the San Joaquin Valley of the Yokuts and Tubatulabal, the native peoples adapted to and prospered in unique environments. While a warm and watertight house built with layers of cedar slabs around a central fire was home to many foothill people, those in the Central Valley—where cedar was unknown and in fact all wood was at a premium—might live in brush shelters during the hot summers, in capacious earthen-roofed underground houses during the rainy winters. A Konkow woman might use willow or big-leaf maple shoots for a basket, whereas a Yokuts weaver might use deer grass. People differed greatly from one valley to the next, and they rejoiced in their distinctiveness.

A typical political group in California was not a huge tribe managed by a few leaders, as in the eastern part of the continent or on the Plains, but a small, autonomous unit, often no larger than a village made up of a few extended families who shared a language dialect. The various groups just mentioned—Maidu, Miwuk, etc.—were not cohesive political entities but rather language groups. The people we are calling Yokuts, for example, had approximately sixty defined political units, each speaking a distinct dialect of a common language. Territory was often defined by a single watershed. Within each of these watersheds could be found a cultural universe of stories, ceremonies, beliefs, customs, and ways of living.

It is commonly assumed that California was a Garden of Eden and that life was easy. Yet while nature offered many and varied opportunities, wresting sustenance out of such small landholdings took knowledge, hard work, flexibility, and savvy. The many inhabitants of the Central Valley and Sierra foothill environments were tenacious people who learned to leech the bitterness out of acorns and make them a nutritional

OPPOSITE: *The legendary Yoimut (Tachi Yokuts, standing) with an unidentified companion near Lemoore in the late 1800s. Yoimut spoke several languages, including French, Spanish, Portuguese, and at least eleven native dialects.*
COURTESY OF DOREAN BAGA.

mainstay; industrious people who found a use for every part of the deer, from the heart to the hooves; accommodating people who knew how to survive in flood and in drought, who learned to trade and fight, and who, when necessary, could change and adapt. As Europeans began to arrive, first in small numbers and then, after 1848, in an onslaught, native people would recognize the bittersweet value of this adaptability.

Those who lived in the Sierra foothills and in the northern part of the Central Valley had little significant contact with Europeans until the late 1830s. But as the Spanish missions spread from southern California—Mission San Diego, the first California mission, was founded in 1769—Central Valley people living nearer the coast came to know something of European ways, especially when soldiers pursued escapees into their homelands, and when these runaway "neophytes" (recent converts to Christianity) sought refuge among them. Despite reprisals for giving shelter to escapees, many villages continued to do so, thereby receiving valuable tools for the forthcoming struggle: knowledge of how to handle horses and an understanding of European ways and especially European military tactics.*

In 1834 the Mexican government formally abandoned the mission system, and some of the Mission Indians moved inland to join relatives. The populations of Californios (Mexican Californians) and Anglos continued to grow, pushing out from the coastal areas, and for the next decade there was intermittent violence in the southern part of the Central Valley as Indians waged guerrilla warfare to discourage further encroachment. The Yokuts, along with the neophytes who had fled the missions and had taken refuge with them, sometimes raided settlements for horses and cattle, and ranchers organized campaigns to recover livestock and punish the natives.

It was during this chaotic era that one of the strangest and most controversial characters in California history appeared on the landscape. In 1839, Johann August Sutter arrived in California from Switzerland by way of Hawai'i. He built a fort in what would later become the city of Sacramento and employed Konkow, Nisenan, and Miwuk people. He brought with him several Native Hawai'ians; they intermarried with the local people, and many members of the Indian community today claim Native Hawai'ian as well as California Indian ancestry.

Sutter had a reputation, at first, for treating his Indian laborers well; many went to the fort willingly. But when he came up short on workers to bring in his harvests, he would simply round up local natives and force them to work in the fields. He also trained armies of Indians to guard his fort and subdue nearby hostile villages. Edwin Bryant visited Sutter's fort in August 1846, writing that Sutter had "succeeded by degrees in reducing the Indians to obedience, and by means of their labor erected the spacious fortification which now belongs to him."[1] Indeed, it was largely native labor that built Sutter's fort into the seat of his short-lived empire. Pioneers stopped there on their way into California, and it became a fort in truth during the Mexican-American War. And it was on another of Sutter's properties, a sawmill on the American River, that James Marshall first discovered gold in January of 1848.

*See chapter 2 (Central Coastal California) and chapter 3 (Southern Coastal California) for a more in-depth treatment of the mission system.

The gold rush was a major turning point in the history of California—for Euro-Americans, of course, but especially for the native population. After the influx of miners and settlers that began in 1849, nothing would ever be the same again for the people of the foothills and the Central Valley. Violence, formerly erratic, now became a constant, and it was brutal. One of Tehama and Butte Counties' vigilantes, Sim Moak, described a fellow Indian fighter with "a string of scalps from his belt to his ankle."[2] The Indians of the area were not subject to conquest or warfare, rather to massacre and attempted genocide.

Although often attributed to individual acts of unruly miners, the horrific brutalization and slaughter that happened during the gold rush and in the years that followed had widespread political and legal sanction. Under an 1850 law entitled "An Act for the Government and Protection of Indians," any white citizen could indenture the labor of an Indian child if he could prove to a judge that the child was an orphan, taken in in good conscience. The worst that could happen to someone who failed to feed, clothe, and treat the child humanely was a ten-dollar fine and the reassignment of the child to a new master. The law thus condoned the kidnapping and sale of children and young women for use as house servants and sexual slaves. This statute was not repealed until 1863, four years after Lincoln's emancipation proclamation. Anthropologist and historian Robert F. Heizer estimated that as many as ten thousand California Indians were indentured under the law's tenure.[3]

Even the state's highest official, California governor John McDougall, called for the extermination of Indians. In his annual message of 1852, he stated that Indians were a "source of much annoyance" in California and that they would continue to be so as long as they were still present in the state.[4] Vigilante groups, often formed in fits of revenge, idleness, or drunkenness, pursued native people even to their villages, and after shameless massacres they would present a bill for "services" to the state government, confident that their costs would be reimbursed.

On top of this, the natural environment was changing. Hydraulic mining ravaged rivers and streams and destroyed wildlife habitat. Cattle and other livestock ate and trampled the native seeds and grasses, while annual grasses and other invasive plants from Europe took over wide swaths of the landscape, virtually eliminating important sources of food. As years passed and more settlers arrived, private land ownership increased, limiting traditional hunting, fishing, and gathering. Homeless and starving, native people were now outcasts in the lands that had once supported them so well.

In 1850, Thomas Jefferson Mayfield, a six-year-old boy from Texas, crossed over the Pacheco Pass into the Central Valley with his family. He later recalled:

> Suddenly my daddy pointed over the tops of the bare hills ahead of us
> and exclaimed, "Look there!" And there in the distance, until then
> lost to us in the haze, was our valley. A shining thread of light marked
> El Rio de San Joaquin flowing, as my mother said, "through a crazy

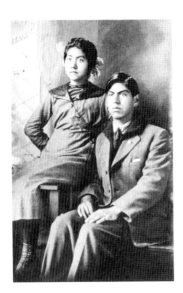

*Eva Wilson Pierce and Edward Wilson
(Mechoopda Maidu), date unknown.*

*The family (Konkow/Wailaki) of
Vera Clark McKeen at a Fourth of July
celebration, Yankee Hill, 1915. Left
to right: Vera's father, her mother's
brother Tom Crabtree, Vera's mother and
older sister. In front are Vera and her
siblings, including Katie, Helen, Arlie,
and Bernice.*

quilt of color." How excited we all were. Everyone wanted to talk at once. Then someone noticed, still farther to the east, that what we had at first taken for clouds was a high range of snow-covered peaks, their bases lost in the purple haze.[5]

After the family settled in the Valley, Mayfield's mother died and he was adopted by a prosperous Yokuts group, the Choinumne of the San Joaquin Valley and Kings River area. In a finely detailed memoir, he recounts the intimacies of traditional daily life, then the dwindling of population and the tragic loss. He felt that he was a witness to the end of a way of life. But while a way of life did indeed come to an end, it was not the end of the Choinumne people. Like the other peoples of the region, they adapted, as they had always done, to changes in their environment. Along with other native people of the Central Valley and foothills, they worked as cowboys, farmhands, maids, and miners. Today, from Grindstone to Tule River, Greenville to Big Sandy, the many tribes are as rooted in the Valley and foothills as ever. Their presence may be as subtle as an elderly woman clipping redbud by the side of the road or as obvious as a casino marquee; their memories go back to the beginning of time.

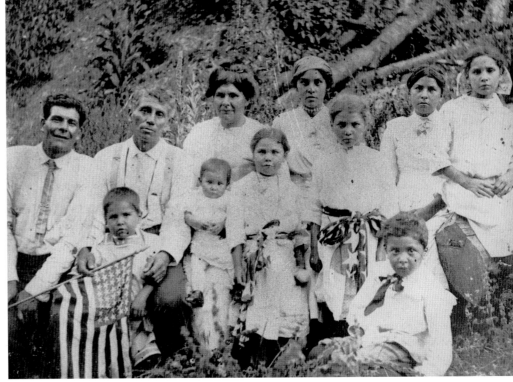

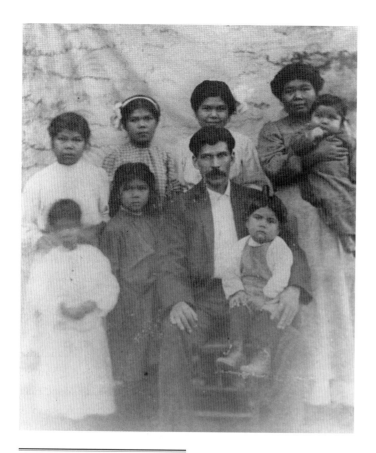

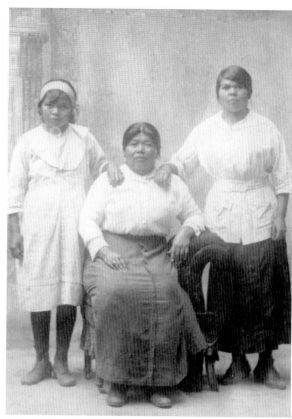

ABOVE LEFT *The Carsoner family (Northern Sierra Miwuk), 1910: patriarch Tom with Dan on his lap, mother Rose holding Mary, and the sisters (left to right), Louella, Nettie, Bessie, Alice, and Jenny.*
COURTESY OF ZANDRA BIETZ.

ABOVE RIGHT *Three generations of Miwuk women. Left to right: Alice Carsoner Pruitt, Mattie Jim, and Rose George, Tuolumne, early 1900s.*
COURTESY OF JENNIFER BATES.

Jennifer Bates: That's my grandmother, my great-grandmother, and my great-great-grandmother. And Mattie George and Rose were both weavers. Mattie's the great-great.

BOTTOM *Reverend Thayer baptizing Margaret Marvin Baty at Big Sandy, early 1900s.*
COURTESY OF MELBA BEECHER.

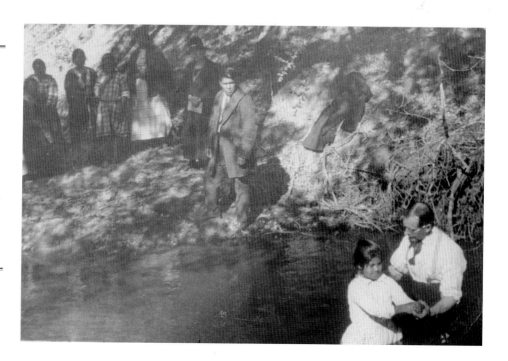

A long time ago there was a young girl and she wanted to go pick blackberries, and she was too young, so her brother went with her. And they traveled along the American River picking blackberries, and all of a sudden someone came up behind them and kidnapped them. For days they carried them on horseback south. They arrived in a makeshift village of Spanish. And they were kept there for approximately four years.

The older brother, who was sent to care for his sister and protect her because there was always a chance of a bear being around where they were picking blackberries, stayed with his sister as much as possible, but they were separated once they came to this Spanish encampment. And over the years he developed different songs to tell his sister things...He knew the bird language, and so he could communicate with her, but he wasn't allowed to see her. And at a time when his sister was in a sort of makeshift corral, he was able to dig a hole in to her and they were able to escape.

The first day out they hid in a very cold, wet place...and each day they could travel further and further, making their way north...He could see a curve in the river and it looked familiar, but he couldn't really tell exactly tell where he was at and if it was the American River...So they moved forward very stealthily, crossing the river and moving toward what appeared to be a familiar village. And as soon as they stepped out, all the elders started crying and yelling in jubilation for these two members that had been lost.

The young man's name was Mike and the little sister Pamela. Mike became very involved in the medicine of that area. He traveled quite a bit with different medicine doctors and he became quite well known in the area for different ceremonies. My dad would say that Uncle Mike would climb onto his horse in his full regalia and he would travel to whoever had passed away. And he asked him one time how he knew that this person had passed away. And so my dad was able to observe the feather that spun around in the house and...would tell my Uncle Mike who had passed away.

—Rick Adams, Nisenan

OPPOSITE: *Pamela Adams (Nisenan),
the matriarch of Shingle Springs
Rancheria, Folsom, 1880s.*
COURTESY OF RICK ADAMS.

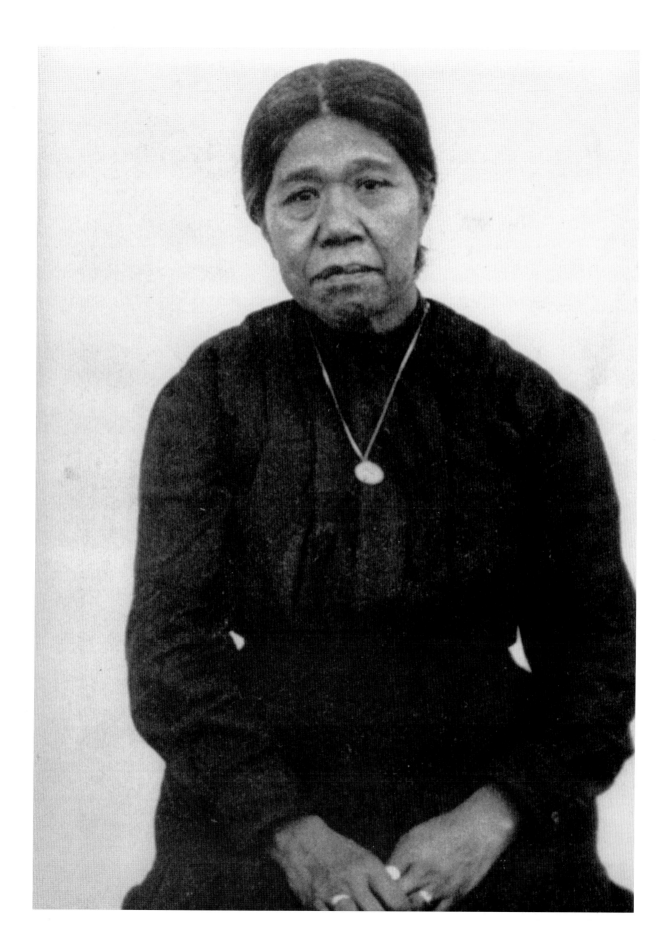

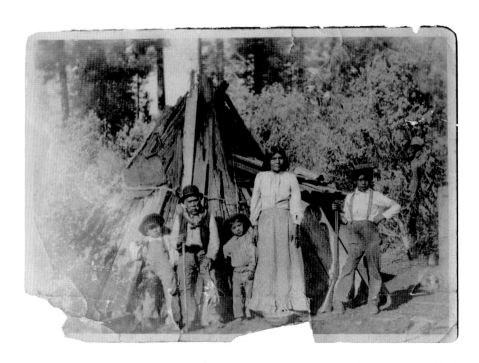

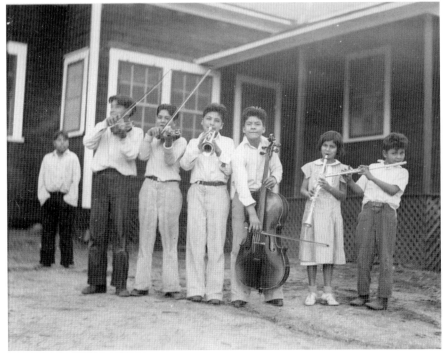

The Temple family (Mono) in front of
their home, a traditional cedar-bark
structure, North Fork, 1920s.
COURTESY OF MAE BERRY.

The Auberry church orchestra (Mono),
mid-1920s. Left to right: unidentified,
Albert Moore, Walter Anderson,
Lawrence Marvin, Illene Cape, and
Clarence Marvin.
PHOTO BY GEORGE HOLT. COURTESY OF THE JESSE
PETER MUSEUM, SANTA ROSA JUNIOR COLLEGE.

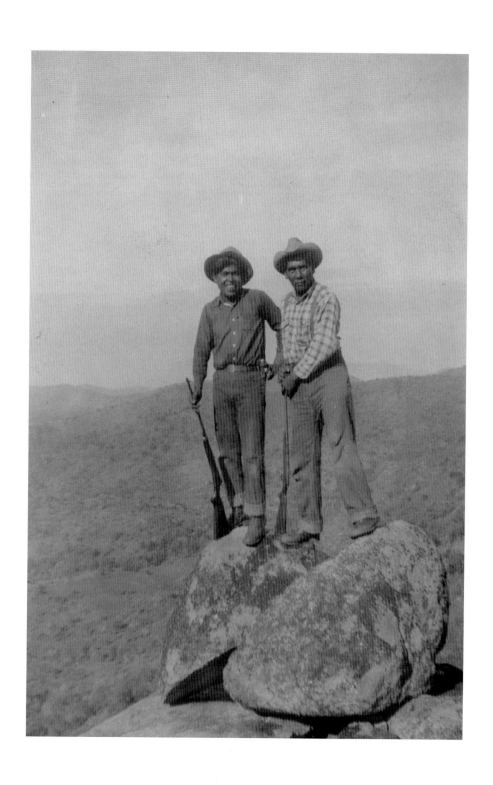

*Two men with rifles at the Tule River
Reservation, 1930s.*
COURTESY OF DOREAN BAGA.

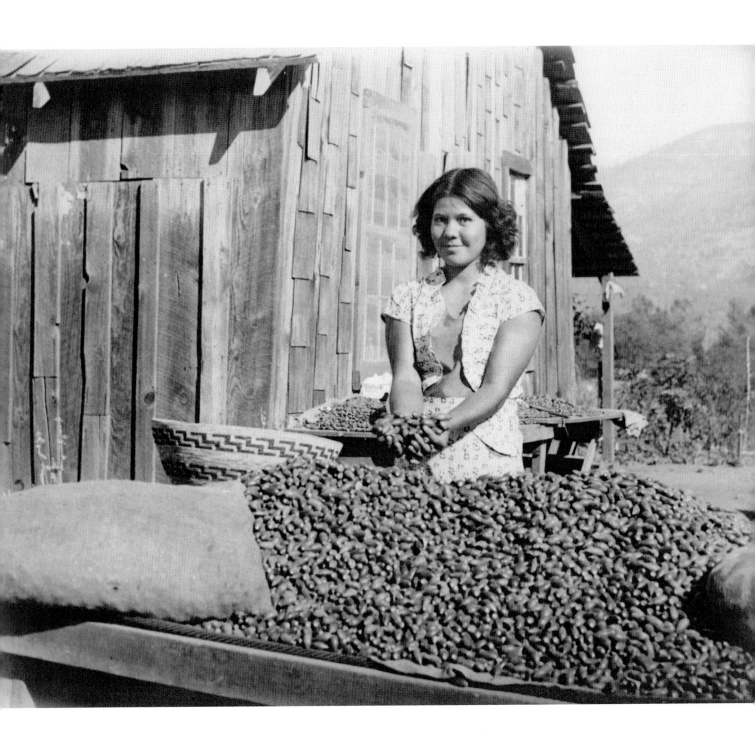

WHY ARE OAKS SCATTERED THROUGHOUT THE SIERRA FOOTHILLS? BIOLOGISTS and old Nisenan accounts agree: Scrub Jay is responsible. In early times, according to Nisenan legend, a ceremony was held in the roundhouse to celebrate the gift of fire. Scrub Jay (Chayit) was pounding the floor drum, and in his fervor he kicked the drum so hard that acorns burst from the depths of the earth, cut a hole through the roundhouse roof, and dispersed throughout the foothills. Even today, Chayit can be seen burying acorns, thereby creating the oak forests that have for so many centuries sustained abundant life—animal as well as human—in the foothills.[6]

As this ancient story and others like it suggest, acorns were an essential food for most of California's native people. But while essential and in most years plentiful, acorns are hardly a "convenience food"; highly refined skills and special equipment are necessary to render them edible. Acorns contain tannic acid and are too bitter to be eaten directly from the tree. While the details of preparing acorns vary from tribe to tribe, even person to person, nearly everyone follows the same basic steps.

After collecting acorns, people spread them out in the sun, turning them to ensure that they dry evenly. Modern methods include drying them on homemade racks, spreading them out on the dining room floor, or keeping them under the woodstove or in the oven.

Once dried, nuts were traditionally stored in granaries. Construction varied, but a typical granary would be made of brush or tule, look something like a small hut, and be placed on a platform elevated a few feet off the ground to prevent animals from pillaging the nuts. These days, people usually store acorns in burlap sacks in a place with good air circulation to prevent rotting.

When ready to make acorn mush, soup, or bread, the cook cracks the acorns, removes the shells, cleans the nuts of their paper-thin husks, and pounds them into a fine, silky flour—sometimes in a stone mortar with a heavy stone pestle, or often, these days, in a blender or some other type of electric grinder. The flour is then tossed in a flattish basket to separate out the coarse pieces, which are returned to the mortar or blender.

When at last pounded into a uniformly fine powder, the flour is put into something that drains—a sand basin, a basket, a leaf filter, or a piece of cheesecloth—and copious water is poured through the flour to leach the acid out. Finally the flour is mixed with fresh water and boiled into a soup. While a pot and a stove often do the job today, in the old days the cooking was accomplished in a watertight basket; red-hot stones were dropped into the basket and stirred until the mix came to a boil.

From the gathering right through to the final steps of preparation, the making of acorn involved mortars and pestles, several different kinds of baskets, looped sticks for handling the red-hot cooking stones, and soaproot brushes for cleaning the sifting baskets. The whole process was highly evolved and elaborate, demanding special skills and full of nuance and grace.[7]

OPPOSITE: *Margaret Marvin Baty (Mono) posing with acorns at Big Sandy, 1920s.*

PHOTO BY GEORGE HOLT. COURTESY OF THE JESSE PETER MUSEUM, SANTA ROSA JUNIOR COLLEGE

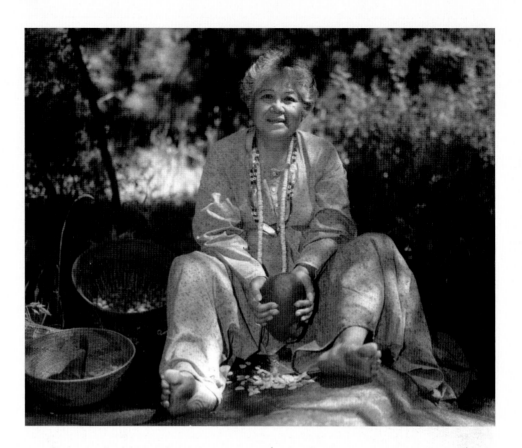

Dorothy Stanley (Northern Sierra Miwuk) pounding acorns at the Tuolumne Me-wuk Rancheria, 1985.

PHOTO BY JANET CARON. COURTESY OF ZANDRA BIETZ.

Kimberly Stevenot: She's pounding acorns. If truth be known, she's BS-ing [laughs].

Allison Stevenot: She's got an abalone necklace with clamshell-disk beads.

Kimberly Stevenot: Clamshells, abalone shells, all those things are symbols of God. The more you have, the harder you've worked to attain. The hardworking person is most happy—which is true with most tribes. She's got on a dress she made when she worked over in Yosemite as an interpreter in the Indian garden...[It's] taken from a pattern that they found from 1849, a pattern of that dress period.

Composed of up to 6 percent protein (depending on the variety of acorn), up to 18 percent fat, and up to 68 percent carbohydrates, this traditional food, not surprisingly, was once a staple throughout most of California. (In comparison, modern varieties of corn and wheat have 10 percent protein, 2 percent fat, and 75 percent carbohydrates.) Acorn is also a good source of vitamins A and C and many of the essential amino acids.[8] Although all oaks bear edible acorns, in the foothill area black oak acorns (*Quercus kelloggii*), with rich, oily kernels, have always been the favorites.

Like everything else in the Indian world, the collecting, preparing, and eating of acorns are not isolated events. Sometimes one goes out to collect acorns and comes back with more. Zandra Bietz, of Tuolumne Rancheria, recalls a time when her mother, the renowned Dorothy Stanley, used to borrow Zandra's van for acorn collecting:

> My mother—they found a dead bear on the highway...I had a van, and she kept using the van at that time. Oh yeah, they picked up that bear. I don't know who she was with, but that bear for years stunk up that van. I mean dead bear! It's that sweet, pungent smell. Man, I can still smell it right now. I mean, what can you say to your mother, you know?[9]

While not the mainstay they once were, acorns are still used, valued, beloved, and widely connected to many other aspects of Indian life. Go to any native event in California and you're still likely to see someone making acorn soup. If it is new to you, try some. When made properly it is sweet and nutty. The food that for so many centuries nourished the body today nourishes the soul.

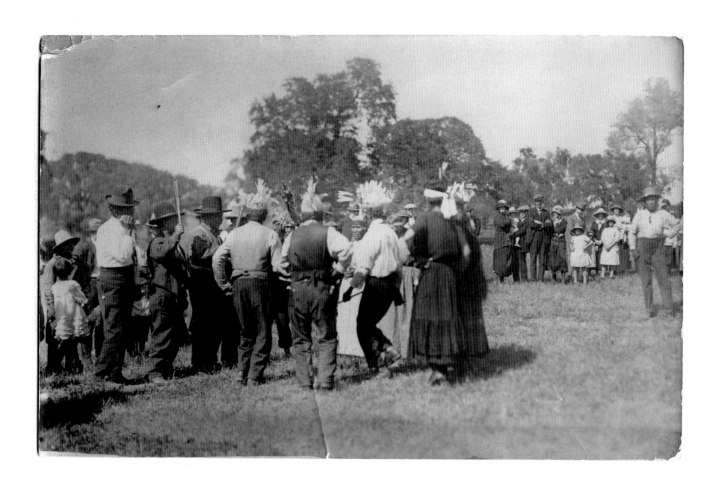

Indians at a symbolic burning of the "digger Indian," Calaveras County, 1930s.
Courtesy of Zandra Bietz.

Kimberly Stevenot: "Digger" was a derogatory term used to refer to California Indians. And Indians were making a statement: they made an effigy of an Indian, and they lit it on fire, in a way saying, "We are no longer to be referred to as diggers, we are the people, we are Indians. Not diggers."

Beatrice Wilcox (Yowlumni Yokuts) near Porterville in the 1930s.
Courtesy of Nicola Larsen.

Nicola Larsen: Aunt Beatrice used to always look like a fashion plate—dresses and heels, meticulous hair—even while she was out in the fields picking oranges and prunes.

*Margaret Rodilez (Yowlumni Yokuts) and
Jose Maximo Valdez on their wedding day,
St. Anne's Church, Porterville, c. 1954.*
Courtesy of Margaret Valdez.

Clinton Towendolly (Wintu), 1940s.
Courtesy of Sage LaPena.

Niece Sage LaPena explains that
family members were living and
working in the cities because
that's where the jobs were—and
if you were there, you might as
well be hip and dress well.

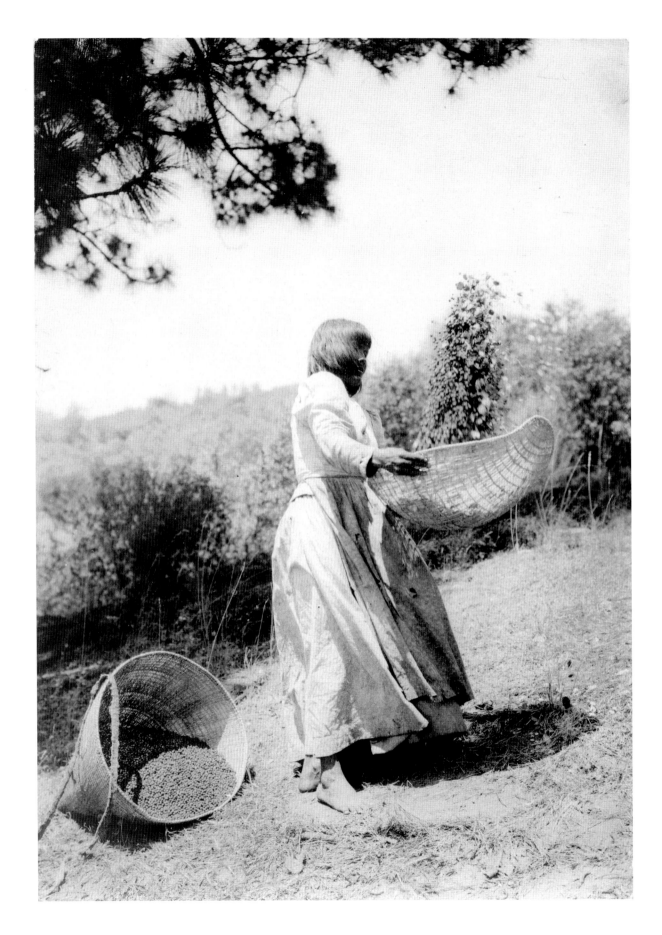

THE BASKETS OF NATIVE CALIFORNIA ARE AN ELEGANT COMBINATION OF FORM AND function, meticulously constructed of native sticks, shoots, roots, and grasses that have been gathered, stripped, split, and cured with love, skill, hope, and patience. Baskets were integral to native life, and the weavers who produced them—often women, though men had their specialties—were understandably proud of their art. Baskets were used to gather, process, cook, and serve food; to carry water; as cradles; as hats; as fish traps; as gifts; as storage containers; for ceremonial functions; and much more. Each creation is a marvelous mix of function, tribal aesthetics, and individual devotion to craft and beauty.

By the late nineteenth century, the land-based life ways of California Indians and the traditional arts that supported them were severely damaged. While other native arts and skills, evolved over millennia, fell into neglect, something unusual happened to the art of basketry: wealthy collectors of fine, native-made baskets created a new market. In the new society of California, basketry became the one traditional activity from which an Indian could gain respect and economic reward. Weavers still made a few utilitarian baskets, baby cradles, and gift baskets for family and friends; it was, however, income from collectors as much as anything that kept California-style basket weaving alive.

After World War II, the market became less active, and though many young women had learned how to collect and prepare basket materials and how to weave from their older relatives, fewer and fewer chose to pursue the art. Those who did have been a godsend in recent years as more native people have reawakened to the challenges and joys of traditional basket weaving.

As basketry declined in the last decades of the twentieth century, weavers and would-be weavers often felt isolated and adrift as they tried to find teachers and gather materials in a changing landscape. Master weaver Elsie Allen (Pomo, 1899–1990) talked about how she was run off one of her traditional family gathering sites by an irate, gun-wielding property owner, and how she felt so frightened and discouraged that she nearly gave up weaving. In another story she told about what she had to do to dig sedge roots at an old gathering site which had become a state park. She and a friend set up a card table and put out a tablecloth and picnic basket, and then they took turns pretending to enjoy a leisurely afternoon picnic while the other crawled into the undergrowth to dig her roots. Elsie Allen laughed at the recollection, but for some this story of how an elderly master weaver had to sneak around to gather materials in a place where her people had dug roots for centuries came to symbolize the sad state of basketry.[10]

In 1991 Sara Greensfelder, a cultural activist from Nevada City, convened a gathering of weavers from all over California. It was planned as a one-time forum for sharing traditions, stories, techniques, hopes, and fears. Out of this gathering grew the California Indian Basketweavers Association (CIBA), a nonprofit organization dedicated to preserving and promoting traditional California Indian basketry.

OPPOSITE: *A Mono woman winnowing manzanita berries near Auberry, early 1900s.*

COURTESY OF THE GRACE HUDSON MUSEUM.

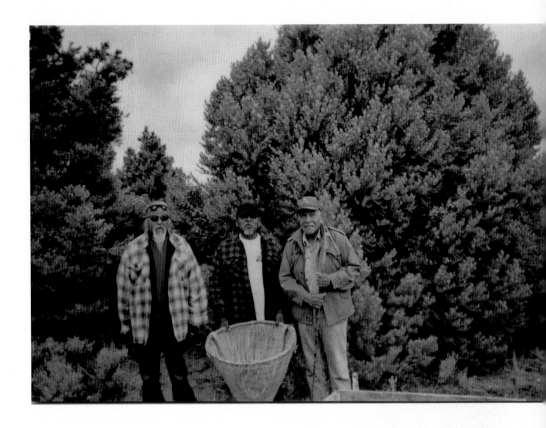

Having been established to further an art that depends on an intimate acquaintance with nature, CIBA finds itself much involved with environmental issues; the organization has opened discussions with government agencies regarding safe access to areas where basketry plants grow, limiting the use of herbicides, using controlled burns and other land management techniques to keep plants healthy, and protecting native species.[11]

CIBA has also helped to reinvigorate the practice of basketry and has encouraged a thriving community of weavers, skilled and novice alike. Jennifer Bates (Miwuk, Tuolumne Rancheria), longtime chair of CIBA, talks about CIBA's role in "helping weavers find support and understanding; not being alone in what you do; finding out that you don't have to feel isolated, there are others like yourself out there weaving and keeping the traditions alive."[12]

The CIBA gatherings, held each year in the late spring in different locations throughout California, are filled with the muffled hum of gentle conversation; the tinkling, clacking sounds of jewelry made from shells, beads, and pine nuts; and the nimble fingers of dozens of weavers creating exquisite baskets one strand at a time. Youngsters show off their first attempts, elders mentor and encourage. These annual gatherings serve as a quiet but effective reminder of the value, fulfillment, dazzling beauty, and outright fun that have so long been part of the tradition of basket weaving.

Mono elders Floyd Joe, Wilford William, and Albert Moore gathering pine nuts near Carson City, 2002.
COURTESY OF MELBA BEECHER.

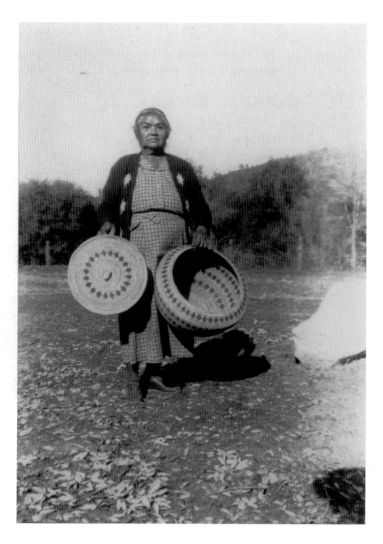

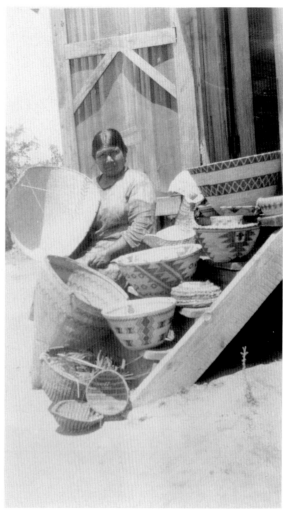

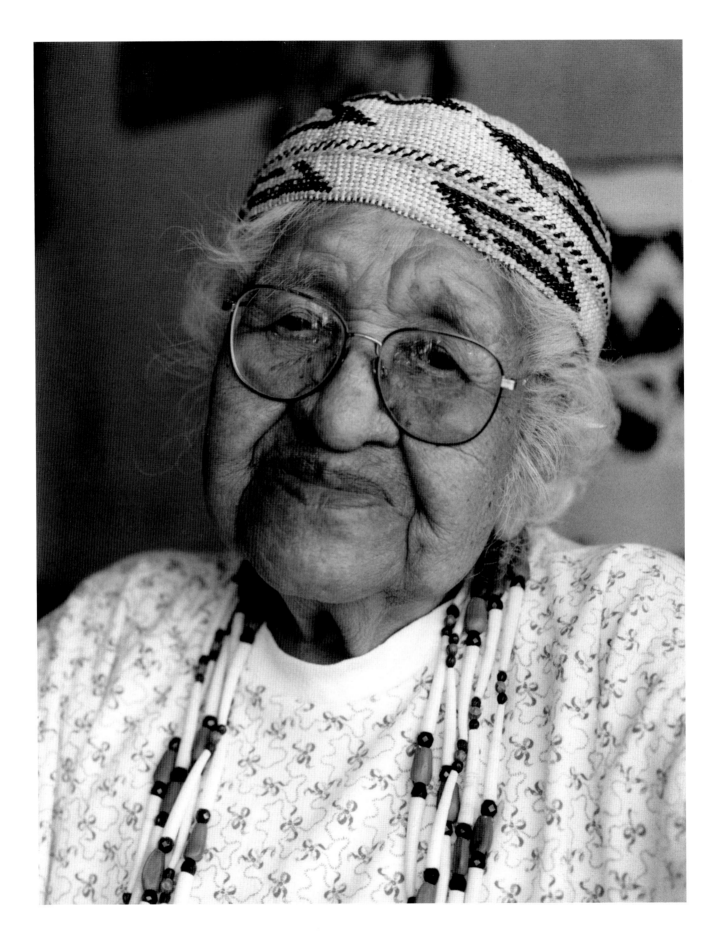

[About the first statewide basketweavers' gathering]: It was really moving. There were a lot of differ-ent feelings that moved around in there. But they were all really good...

That first gathering brought together a lot of people...It was a really good time in my life, and I hate to use the word "empowerment," but it really did give me a lot of empowerment...And to hear weavers there who had the same concerns and fears that I had was amazing...

At that first gathering I guess I came off as kind of like a militant maybe? [Laughs] People really recognized me then, and the following year we...started to form the association, and because of my "militancy," I guess, the way I talked about stuff, they wanted me to be the chairperson. They voted me in as chairperson, and I've been there ever since. But I'm not a militant!

—Jennifer Bates (Miwuk)

OPPOSITE *Bertha Norton (Wintun), 1999.*
PHOTO BY DUGAN AGUILAR. COURTESY OF DUGAN AGUILAR.

BELOW LEFT *Margaret Baty (North Fork Mono) holding one of her baskets, 1988.*
PHOTO BY BEVERLY R. ORTIZ. COURTESY OF BEVERLY R. ORTIZ.

BELOW RIGHT *Lois Conner (North Fork Mono) holding one of her baskets.*
PHOTO BY BEVERLY R. ORTIZ. COURTESY OF BEVERLY R. ORTIZ.

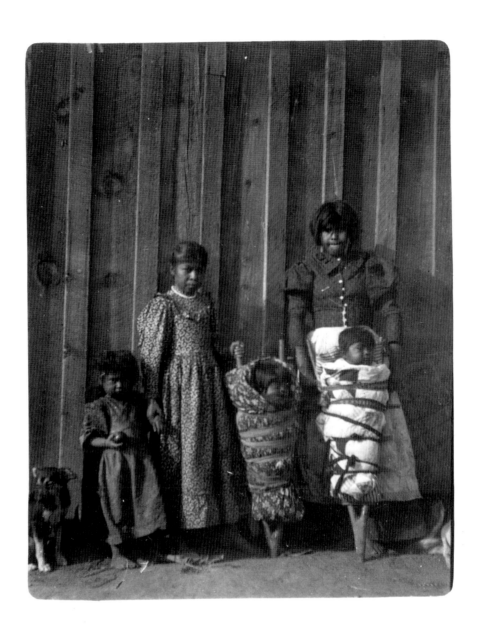

*An unidentified family with cradle-
boards near Tulare, early 1900s.*

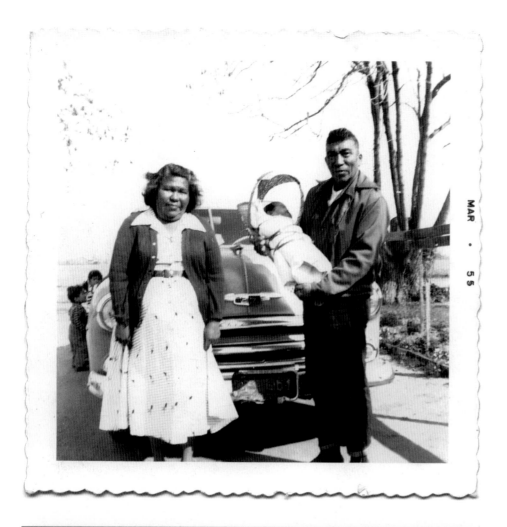

Jennifer Bates: Yeah, it's a Paiute
cradleboard. All of our kids
have been raised in Paiute
cradleboards. They just seem
to be, to me, warmer and…just
a better make and model.
[laughs] You know the Miwuk
ones are okay, but they don't
have the buckskin around
them, and that seems to do
the trick better. I'd recommend
a Paiute one over just about
any of them.

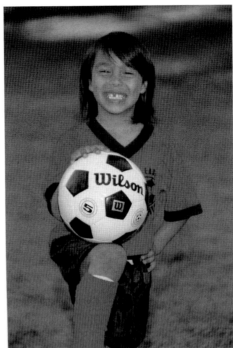

CENTER *Raven LaPena (Wintu),
2002.*
COURTESY OF SAGE LAPENA.

Sage LaPena: Raven Brings the
Dawn, first year playing
soccer. Definitely a soccer
guy, always right where the
ball is, a natural.

RIGHT *Kai LaPena (Wintu) attending
a healing circle at George Gillette's place
near Lakehead, 1999.*
COURTESY OF SAGE LAPENA.

*I put him [her son] right on the wall on a big nail so he could see what was going on, [like] in the old
style, hanging on trees. The basket has that hood, it's not only for shade. If the basket falls it comes in
handy; it breaks the fall so the baby doesn't touch…*

*In the past, it was always a safe place, so you could be hung somewhere so you didn't get the
spiders and snakes, all the things that are crawling around…And also it's your portable bed, it's your
safety zone, and even as all the kids have grown out of their baskets, they can still go back to them as a
place to be…When you're in the womb, of course, it's a really small space. So when you come out, the
cradleboard helps you to retain that comfort.*

*Raven—until he was probably about five—he would drag his basket out, and even when he wasn't
in it anymore he would put his stuffed animals in it and tie them in. And for cartoons, he would always
set them up to watch with him or he would put a pillow in the bottom part and drape his legs over the
sides of the cradleboard. And even when he slept on a big bed, he would put this thing up on his bed
and sleep in it, but on his bed.*

—*Sage LaPena (Wintu)*

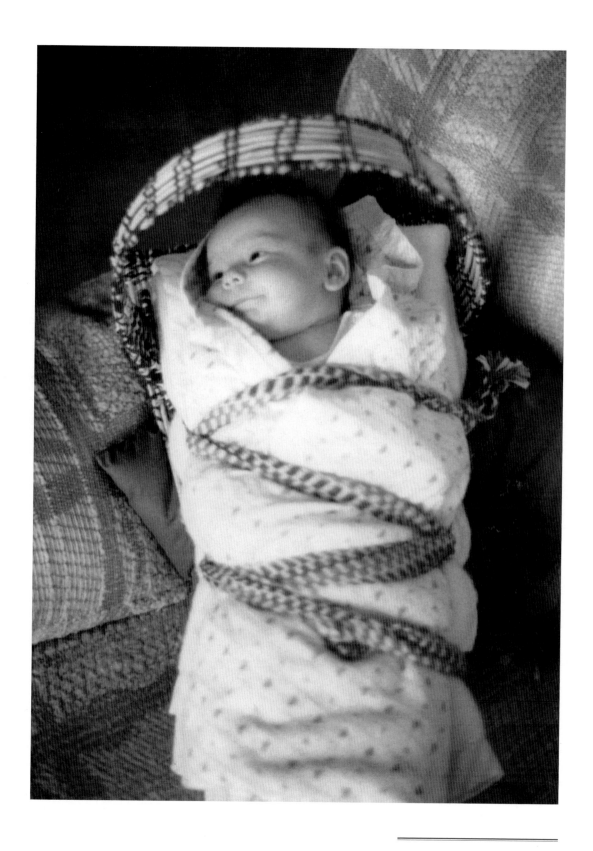

Theresa Berry (Mono) in a cradleboard made by Melba Beecher, Big Sandy, 2002.

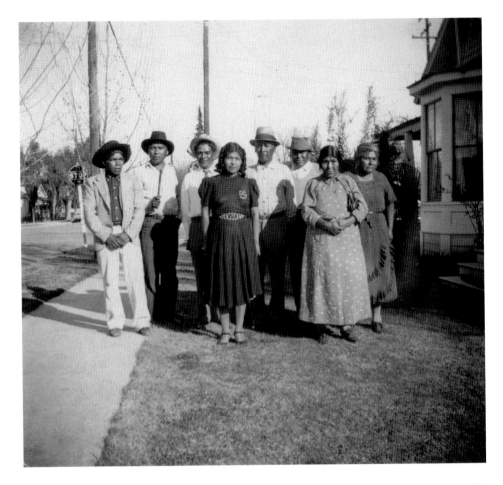

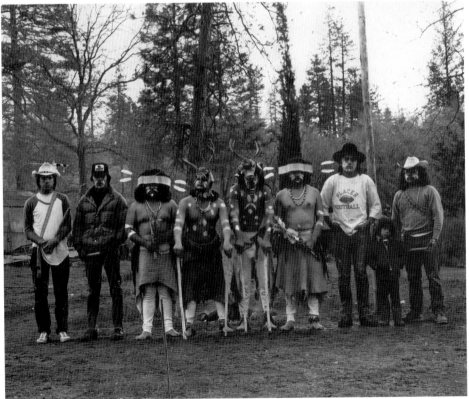

When I am dancing, it is for the people on the side watching, especially the old ones, and for those I am praying for, as well as myself. If the fire is hot, the sweat is cleansing and sometimes burns the eyes…When my body is weary, I try to relax and let the goodness fill me with energy and love for the movement of dance; I wish peace and love for all things on this earth and pray that it will last forever.

—Frank LaPena[13]

DISMISSED AS A "FINE ART" OR AS ENTERTAINMENT FOR THE RAMBUNCTIOUS YOUNG, dance is marginal and not highly regarded in mainstream culture. In Indian cultures, however, both traditional and modern, it has always been central. There are dances done simply for the fun of it, dances that bring people together in social events, and religious dances that renew the world and put people in contact with the divine.

"Praying with the body" is how the religious dances are described, and they are an essential component of Indian spiritual life. In preparation for these dances, ample and special foods must be gathered and prepared, regalia painstakingly manufactured or renewed, and the site sanctified. The dancers often have to fast or in some other way purify themselves. Dance is a serious activity, demanding of time and resources, and dancers and dance leaders are greatly respected in their communities. In the wide embrace of the Indian world, "serious" and "fun" are not mutually exclusive, and the dances are also great fun.

The Valley and Sierra foothills have produced several of California's most long-lived native dance groups. The Grindstone Dancers, from the Nomlaki/Patwin community of Grindstone Rancheria in Glenn County, are part of a long legacy: it is said that the roundhouse (ceremonial house) at Grindstone, at over one hundred years old, is the oldest in continuous use in California. Much of this success is owed to Wallace Burrows (1887–1988), remembered as a teacher devoted to keeping tradition alive. Living past the age of one hundred, he was one of the last remaining speakers of the Nomlaki language, and he knew many of the old songs—both the Nomlaki and Patwin songs of his own people and the Maidu songs from the neighboring groups around Chico.

In Burrows' youth, many of the old ways were still much alive. One day when he was out and about with his cousin Orson, just minding his own business, he was grabbed by tribal elders. He told the story to Brian Bibby:

> They took Orson first. Rolling up his pant legs, one of the old men gave Orson a whack on the back of the legs with a branch of chamise, naming him "hunter" as he struck. He did this ten times, naming it each time. "And he was a good hunter too," Wallace said. "He'd go anywhere and get deer, rabbits. He always had good luck hunting." Next they grabbed Wallace. "I gave 'em a pretty good fight. They got in two, maybe three licks and I got away from them." Wallace had

OPPOSITE TOP *The Santa Rosa Rancheria (Yokuts) dance group in Lemoore, 1940s.*
COURTESY OF DOREAN BAGA.

OPPOSITE BOTTOM *The Maidu Dancers and Traditionalists after a deer dance near Clipper Gap, 1974.*
COURTESY OF FRANK LaPENA.

31

been named "runner," Chetlep ph'naina', traditionally an official and highly respected position among the Nomlaki.[14]

Wallace Burrows was destined to be not only a runner but a tremendous cultural force. He served as a mentor not just to the Grindstone Dancers but to another group, the Maidu Dancers and Traditionalists, founded in 1973 by Konkow Maidu artist and teacher Frank Day. The group, which over time has had Maidu, Miwuk, Wintu, Washoe, and Pomo members, became the focus for an unparalleled community of tradition keepers that met at Herb and Peggy Puffer's Pacific Western Traders in Folsom during the 1970s and 1980s. As their skill and reputation grew, the group began traveling around California to perform, demonstrate, instruct, and inspire. Today they are often seen at the gatherings and ceremonies that mark the change of seasons and celebrate the abiding presence of native belief in California.

As the Grindstone Dancers learned from Wallace Burrows and the Maidu Dancers learned from Frank Day, so did the Miwok Dancers learn from Bill Franklin. Having participated in his youth in ceremonies at the Ione and Buena Vista roundhouses, Bill Franklin was passionate about traditional dance and refused to see it disappear. As he said in a 1993 interview:

> In the early forties…it had been dormant for many years. You see, when the war started, everybody was gone. The old captain died and they abandoned the roundhouse. That was the custom, either burn it up or just let it go. So I began to think, gee whiz, I wanted to keep it up, I wanted to be a dancer, and keep this thing alive. What can I do?[15]

Heartsick, Franklin organized a small group beginning in the early 1950s, long before Californians developed an appreciation for things Indian. He enlisted the help of Albert Clifford, who remembered the old songs, and together they started dancing and singing, all the while recording the songs. After Clifford's death, Franklin listened to the recordings for two years, until he felt he had learned them well enough to pass them on. His group would grow from a small collection of dedicated individuals into the California Indian Dance and Culture Group, which he formed with Marie Potts (Maidu) in the late 1950s.

Bill Franklin's efforts weren't restricted to dance alone. He was instrumental in the construction of roundhouses in the traditional style at Chaw'se (Indian Grinding Rock State Park), in Amador County, and at West Point, a nearby community in Calaveras County. He also pursued legislation to protect native burial sites, and he served as one of the first members of the state's Native American Heritage Commission. When he passed away in 2000 at the age of eighty-seven, he left behind a cultural world invigorated with song, dance, and a strong sense of political entitlement.

Men like Wallace Burrows, Frank Day, and Bill Franklin acted with integrity and spirit. It is because of their devotion and hard work that to this day at ceremonies throughout the Sierra foothills and on the Valley floor one can hear the singing of ancient songs, the rustling of flicker-feather headdresses, the pounding of floor drums and the stomping of bare feet, as humanity continues to fulfill its ancient role—to re-energize the world through dance.

Wintu healer and spiritual leader Florence Jones blessing the water at Salt Creek, c. 1989.
PHOTO BY REGINA RAMIREZ. COURTESY OF FRANK LAPENA.

Henry Asbill (Konkow) at a workshop on desegregation at D-Q University, 1972.
COURTESY OF FRANK LAPENA.

Frank LaPena: Henry was the one that was interested in tradition and carrying on…preserving the traditional ways of making things. And he could talk about history and myths.

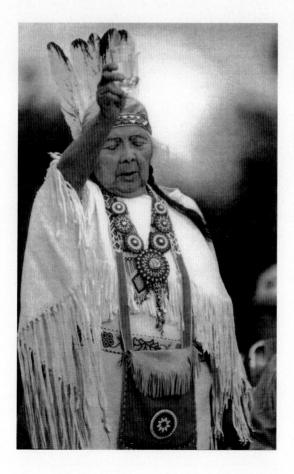

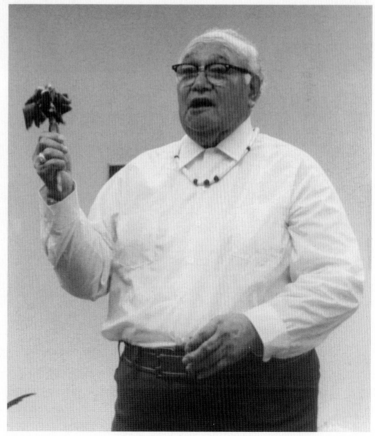

Maidu dancer Vincent "Craiger" LaPena (Wintu) with his trike and his dog at Salt Creek, 1970.

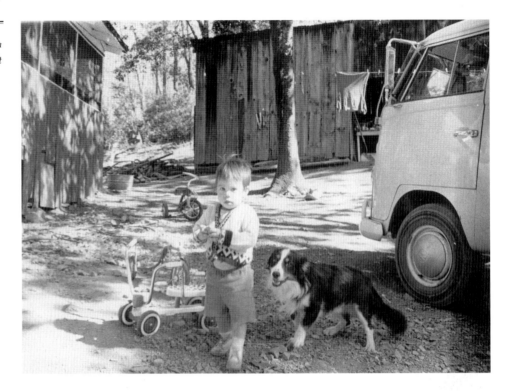

Jennifer Bates, reminiscing about her son, Carson: He was only six or so. Brian and Emma said, "Carson, whatever you do, just follow Kevin"—my nephew Kevin was there. And...they were closing the dance, and Kevin decided to get fancy, and I don't know if you guys know about the roundhouse in Chaw'se, but the fire pit must be about three or four feet across...And Kevin, you know, decided—him being the adult—to jump the fire...to show what a good dancer he was. So he just jumped across, and he did a good job because he was a big strong guy. Well, Carson was told to follow Kevin. So, I'm over to the side dancing, and I'm real proud because Carson's dancing, and all of a sudden I look over, and there's my little boy, and I could tell that he was getting ready to try to jump that fire. And there was no way he was going to be able to jump that fire and clear it. And...I'm looking at Brian, looking at Frank...someone's going to save my kid, because I'm not supposed to, because I'm in there dancing. But if it comes down to my kid, I'm gonna go in there and I'm gonna get him. And finally my uncle Brian pulled him back, and I was going, "Oh my God!" And you could hear it in the audience...because they knew what this little boy was going to do.

The Maidu Dancers and Traditionalists in 1982, after deciding to go down to Old Sacramento and get an old-fashioned portrait made. Back row, left to right: Vince "Craiger" LaPena, Joe Marine, Kenny Fred, Frank LaPena. Middle row, left to right: Wanda Enos, Brian Bibby, Rose Enos. Front: Sage LaPena.

The California vaquero, whether Indian or Mexican, was a superb horseman—perhaps the most skill-ful the world has ever seen—and had no superior in the use of the lasso or reata.

—*Robert Glass Cleland*

ONE OF THE GREAT SYMBOLS OF CHANGE WROUGHT ON NATIVE AMERICAN culture by encounters with Europeans is the horse, and many of the most popular and enduring images of Native Americans revolve around the horse culture of the Great Plains. While less celebrated in American popular mythology, the role of the horse in California cultures was also pronounced.

It would not take long after the 1769 arrival in California of Spanish mission-aries—and their livestock—for the hard-working Indian vaquero to become a pre-dictable sight on the cultural landscape. When ethnologist and historian Frank Latta interviewed the pioneer stockmen of the San Joaquin Valley early in the twentieth century, he reported that they all sang the praises of Indian horsemanship, giving "uniform statements to the effect that the native Indians made the best stock hands ever employed in the Valley." These Indian cowboys, noted Latta, spread far and wide; they "ran stock from the Sacramento Valley across the Tehachapi Range of mountains into the Mojave Desert."[16]

Although Spanish officials decreed that Indians outside the missions were not allowed horses, the spread of this remarkable, gorgeous, and useful animal could not be stopped. The missionaries had trained newly converted Indians to work with horses, and those who fled the missions to seek refuge with the interior tribes took their knowledge with them. Also, loosely restrained herds spread across the landscape and became easy pickings for Indians outside the missions. In addition to riding them (and sometimes eating them), native raiders honed their horse skills by rounding up and taming wild mustangs, selling and trading them to the east. In the years before the gold rush, native people along the frontier of the mission zone and in the Central Valley had already instituted a campaign of continual harassment and horse raiding against Spanish and Mexican settlements on the coast, rapidly developing a horse culture of their own.

As the missions were secularized and the land passed into the hands of Mexican rancheros and later into the hands of Anglos, native people were forced to adapt to a cash economy. Many became vaqueros, either working on ranches or running their own herds of horses and cattle. Horse handling became a core skill, a means of liveli-hood, and a source of recreation throughout California. Bill Tupper (Modoc) from the northeastern corner of the state, recalls his childhood in the area around Beatty and Whiskey Creek:

OPPOSITE *Lloyd George (Wintu) with a saddle and lariat, date unknown.*
COURTESY OF ROBERT BURNS.

I rodeoed a lot in Beatty. They rode mostly bucking horses back then. A lot of Indian people had a lot of horses. My grandmother had thirty or forty. Some other people had hundreds of them. That

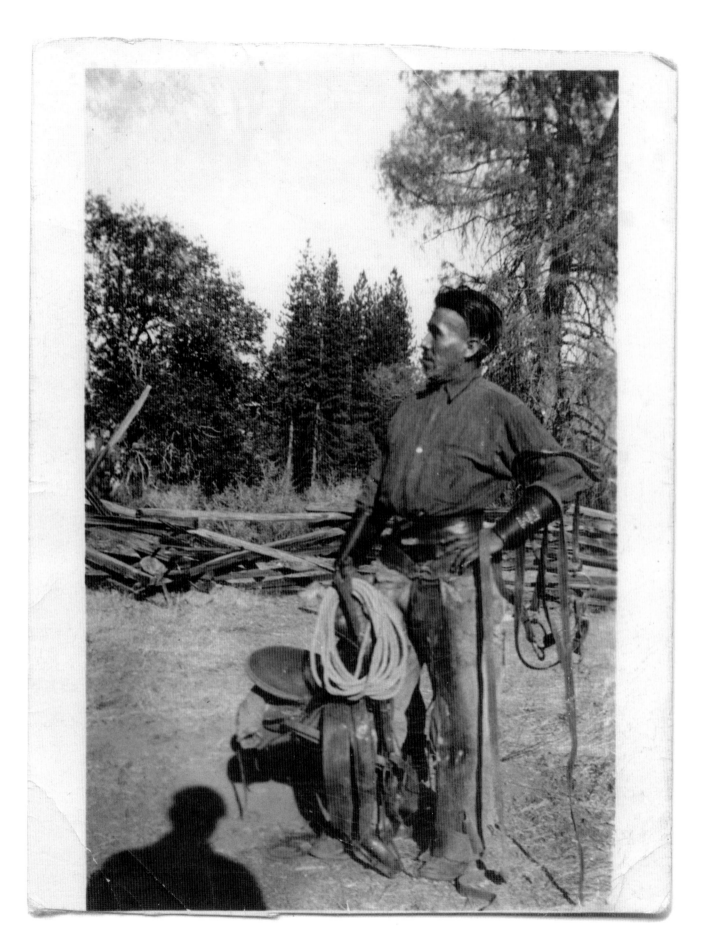

Nicola (Chico) Larsen recalled that all her brothers were, at some point, cowboys. Steve, Leroy, and Guy all used to rodeo. They started riding as children and do a lot of roping now, ride the professional circuit. Their mother was very proud of them. Leroy, the youngest brother, ended up working on a big ranch up in Oregon. One of the brothers went to Oklahoma one year for the Professional Rodeo Cowboys Association (PRCA).

was the pastime, to run those horses in, and I was one of the main ones that liked to do that, even when I was young. Later on…by the time I was ten, twelve years old, I could do anything with a horse, and he [Tupper's grandfather] let me do anything with 'em. I'd practice roping them. I'd front-foot them and tie 'em to the fence and drag 'em in the barn and…just whatever I wanted to do, he let me do it. But most of all I wanted to ride buckin' horses. And as the Lord would have it, I got pretty good at it.

As ranching spread to the rest of the country, the skills of the California Indian vaquero spread well beyond California, and the word "vaquero" eventually became Anglicized as the more familiar "buckeroo." To this day horsemanship looms large in California Indian culture, and generations after the mission period, Indian vaqueros are still renowned for their skill in working cattle, training horses, and competing at rodeos.

Albert Raines and Tom Tye (Wintu)
in Redding, mid-1900s.
COURTESY OF ROBERT BURNS.

OPPOSITE *Wintu cowboys Jim Tye,*
Tom Tye, and Sam Dock near Redding,
early 1900s.
COURTESY OF ROBERT BURNS.

Robert Burns: All three of these
men worked cattle all their lives.

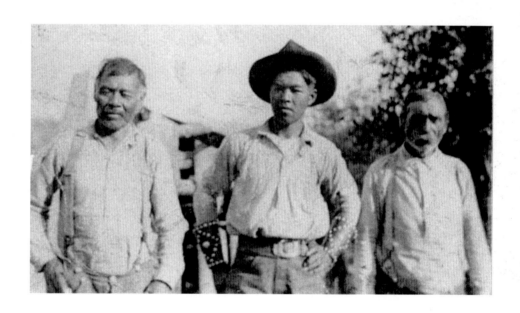

There are Indian cowboys all over California. Julie Tumamait-Stensley (Chumash) recalls: "[Great-great-aunt] Antonia—we have some horse reins—she and [grandfather] Cecilio used to make reins out of leather and horse hair and sell them around the valleys around Ventura and Ojai, to all the cowboys around here and vaqueros and stuff. They learned that trade. Both of them spoke the Chumash Ventureño dialect.

My mother used to tell me about this Indian lady that had [a] gold cracking rock, big round one... White man come there and give that old lady fifty cents for it and take it away. But she don't care. That old lady had lotta those regular cracking rocks and fifty cents besides. Old-time Indian never seem to care about gold like white people.

—*Lizzie Enos*[17]

WHEN ONE THINKS ABOUT MINING AND CALIFORNIA, THE IMAGE THAT COMES to mind is of a bearded Anglo immigrant panning for gold along a Sierra river. Left out of most popular histories, however, is the fact that native people have participated in the mining industry ever since the earliest days.

In January 1848, Martin Murphy, for whom the Calaveras County town of Murphys is named, moved an entire village of native people from the Sacramento Valley to the upper Stanislaus River to mine for gold. That same year, Isaac Humphrey took some of John Sutter's Indian laborers to Coloma and was successful enough to inspire others to do the same: laborers working for another of Sutter's neighbors reportedly retrieved sixteen thousand dollars in gold in just five weeks. With the rapid environmental and social changes being wrought by gold rush immigrants, native people were forced into the new cash economy. As early as June 1848, California's military governor, Richard Barnes Mason, visited the goldfields and estimated that half of the four thousand miners there were Indians.

As the white population rose and competition increased, the racist attitudes of the day prevailed, along with unbridled greed, and many of the Indian miners were driven out. Still, their presence was only decreased, not eradicated, and native labor remained an essential part of early mining operations.

After the uproar of the early gold rush years died down, many Nisenan and Miwuk people who had been driven from their villages returned and went to work in nearby mines. Mining for gold, copper, and other minerals continued to be a viable but dangerous economic option for native people throughout the twentieth century. Miwuk elder Bill Franklin's recollections offer a vivid picture of what life in a cash economy meant early in the twentieth century:

> We'd get dizzy, and outside the doorway they had a safety post wrapped with cloth, and when you got so dizzy you couldn't hardly see, you'd walk around and head for that post, and hang onto it, outside—hang onto that post till you got your head back together. Then go back and stir some more...fumes a-bubbling, the cyanide. All we had was a handkerchief over our face. There was no respirators or nothin' like that. This was back in the 1930s, and there was no safety precautions. You done this 'cause you had to have a job.[18]

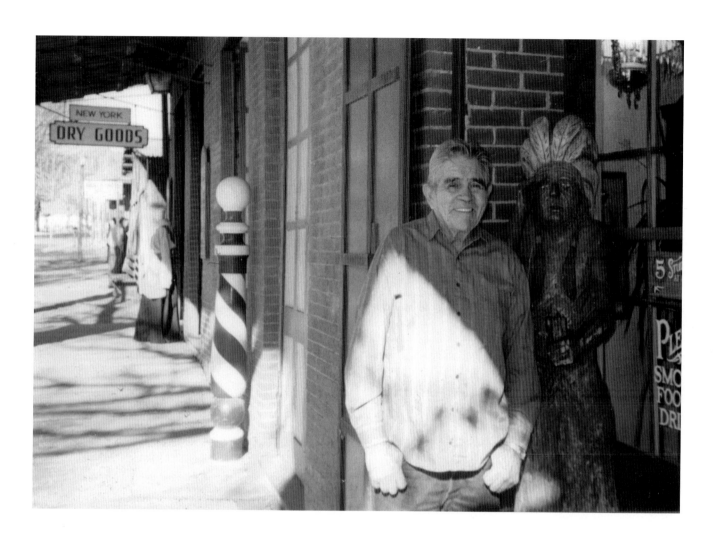

Elmer Stanley (Sierra Miwuk) standing
beside a cigar-store Indian in the Sierra
"Gold Country," Columbia, 1990.

ABOVE *Dan Carsoner (Miwuk) near Tuolumne, 1937.*
COURTESY OF ANDREW CARSONER.

BELOW LEFT *Elmer Stanley (Northern Sierra Miwuk), at one time the best choke setter in California's logging industry, Tuolumne, 1996.*
COURTESY OF ZANDRA BIETZ.

Zandra Bietz: Women would go, "Oh, Elmer is so wonderful, he's so fabulous," and my mom would say, "Yeah, you go ahead and bring him home for three days, and I guarantee you'll bring him back."

BELOW RIGHT *Jose Valdez (Yowlumni Yokuts) in Delano, 2001.*
COURTESY OF MARGARET VALDEZ.

Jose is a fire captain with the Kern County Fire Department.

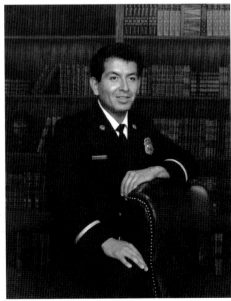

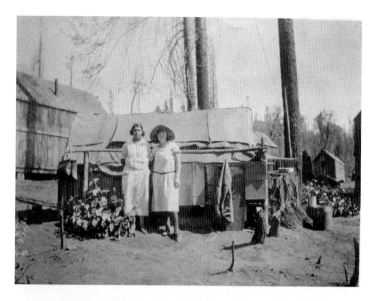

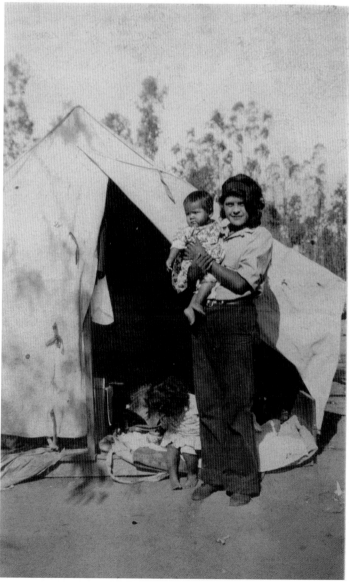

Etta Fuller (Northern Sierra Miwuk, left) and an unidentified woman working as cooks at Basin Creek logging camp, 1940s.
COURTESY OF ZANDRA BIETZ.

Zandra Bietz: I remember in the summer going up there, and she had this one room always full of boxes of fruit and stuff, and she was forever canning. She had cows, and she'd get milk every morning, and she was always churning butter fresh in the morning...All this is in my cookbook. And she'd make biscuits, and I remember going in the pitcher...for some reason I was the only kid in there who loved to drink the milk while it was still warm. [Laughs] Those were the good old days, the posse, the calories posse.

Rose Baga (Yokuts) holding her son Richard at a work camp near Hollister, 1938.
COURTESY OF DOREAN BAGA.

Dorean Baga recalled that they used to follow the crops— Hollister was one of the places they went—and they sheared sheep along the coast, in the San Miguel area.

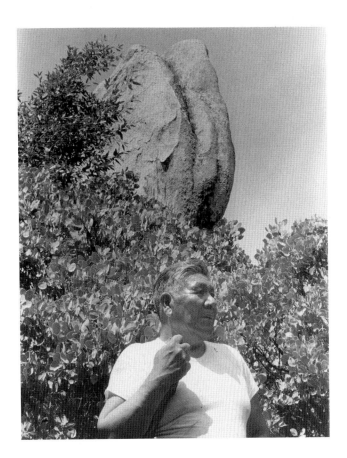

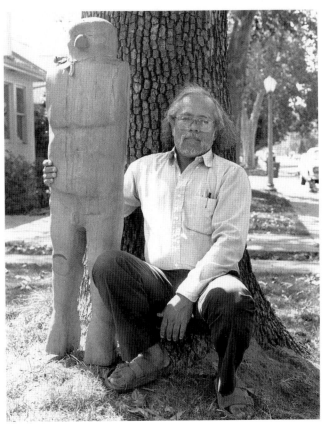

LaPena explains that,
like Coyote, Wuk'wuk
accompanied the creator
and made suggestions, but
he was perhaps more dependable
and more powerful. Wuk'wuk
is a healer as well as a helper,
and he is still present in some
places in the Wintu homeland.
This piece was carved from oak
from the family's allotted trust
land. Most of Frank LaPena's
art is somehow related to the
reality of being Wintu.

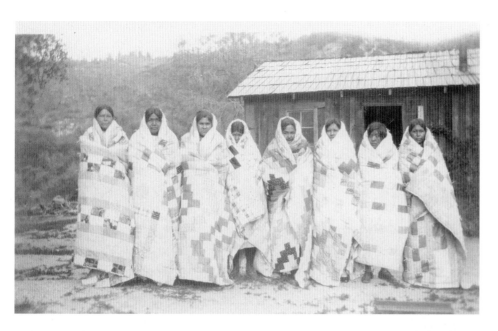

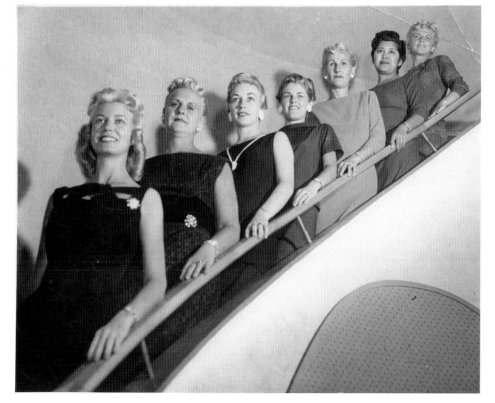

Mono women wrapped in their handmade quilts, Auberry, 1934. Left to right: Emma Major, Ellen Murphy, Annie Anderson, Topsy Strombeck, Frona Grisby, Caroline Turner, Lena Moore, and Ida Hutchins.

Photo by George Holt. Courtesy of the Jesse Peter Museum, Santa Rosa Junior College.

Dorothy Stanley (Northern Sierra Miwuk, second from right) at an AT&T recognition dinner in San Francisco in the 1950s.

Courtesy of Zandra Bietz.

Kimberly Stevenot: She worked for the phone company for thirty years, in Hayward, San Francisco, Ukiah, and in Sonora. She talked to a lot of celebrities over the phone—yeah, back in those days you'd talk to the people…She worked as an operator and as a floor supervisor.

ANYONE WHO HAS EVER DRIVEN ON INTERSTATE 5 TO OR FROM LOS ANGELES HAS passed over the Grapevine—Tejón Pass. The history of this road—the main access point between the Central Valley and southern California—goes back to the earliest days of Spanish settlement, when rancheros driving their cattle to market, and Paiutes from the eastern Sierra making stock raids, passed over it. To the north lies the great Central Valley, to the west the Coast Ranges, to the northeast the southern end of the Sierra Nevada, to the southeast the desert. A regional confluence, the area was familiar to Yokuts, Kawaiisu, Kitanemuk, Chumash, Tubatulabal, and Tataviam peoples. Today Fort Tejon State Park, near the summit of the pass, provides a pleasant stop on the busy interstate.

The history of Fort Tejon is rooted in a failed attempt to establish a more equitable legal relationship between California Indians and the federal government. In 1851, the United States sent three federal agents to negotiate treaties with the Indians of California, to set them up on reservations, and to keep them from "harassing" the white population. The next year, eighteen California Indian treaties were drawn up and signed by the negotiators and native leaders throughout much of the state. The treaties were then submitted to Congress for ratification, only to meet with fierce opposition from the California delegation. To quote from the majority report of the California committee assigned to examine the treaties:

> As to the wild Indians now located within this State, your committee must protest against locating them within our limits... It is indispensable that this State should be wholly occupied by a homogeneous population, all contributing, by their character and occupation, to its strength and independence. To take any portion of the country west of the Sierra Nevada for the home of the wild and generally hostile Indians would be manifestly unwise and impolitic.[19]

Edward Beale, who had recently been appointed Indian agent for California, defended the treaties, but he and other supporters lost the battle. The U.S. Senate refuse to ratify the treaties, and these materials stayed hidden from public view for some fifty years. As a result tribes that had signed the eighteen treaties in good faith—treaties that promised protected lands and other compensation to repay them for loss of access to their traditional territories—were never sufficiently compensated for their sacrifices and never told of the outcome of the process until fifty hard years had passed.

Beale, from a prominent military family and himself a naval lieutenant, was nonetheless determined to build a reservation system, and he chose to begin in the southern San Joaquin Valley. In 1853 Sebastian Indian Reservation—popularly called the Tejón Indian Reservation—inaugurated the grand experiment. A fort would be

built nearby in 1854 to protect the Indians and the settlers from each other and from eastern raiders. The reservation was modeled in part on the mission system and ruled with military discipline.

At fifty thousand acres (but soon reduced to twenty-five thousand and eventually to nothing), the reservation was comparatively large. Beale brought farming equipment to the reservation and crops were planted; many of those living at Tejón were refugees from the missions and had farming experience.[20]

For all of Beale's planning, things did not go well. Drought, disease, and insects doomed many harvests throughout the reservation's existence. Residents had to rely on their traditional foods for survival, and on food grown at nearby Tule River Farm, an "agricultural reserve" at the base of the Sierra foothills near Porterville established in 1853 by Beale's replacement, Thomas Henley. Settlers encroached on the reservation, and their animals grazed on the Indian crops. It was apparent that the reservation experiment was failing at Tejón, and the reservation was officially closed in June 1864.

Beale, meanwhile, had been buying ranches in the area and eventually purchased the reservation land as well, forming the Tejón Ranch. While many of the Tejón Indians had been sent to Tule River Farm or had drifted north to Bakersfield, there were those who chose to stay closer to their homelands. The Tejón Indians were still recognized as a tribe until the early 1900s, when they were effectively terminated by "administrative negligence." Several federally unrecognized groups still live and work in the area today, including the Tehachapi Tribe, the Kitanemuk Tribe of Tejón Indians, the Kawaiisu Tribe, and the Kern Valley Indian Council.

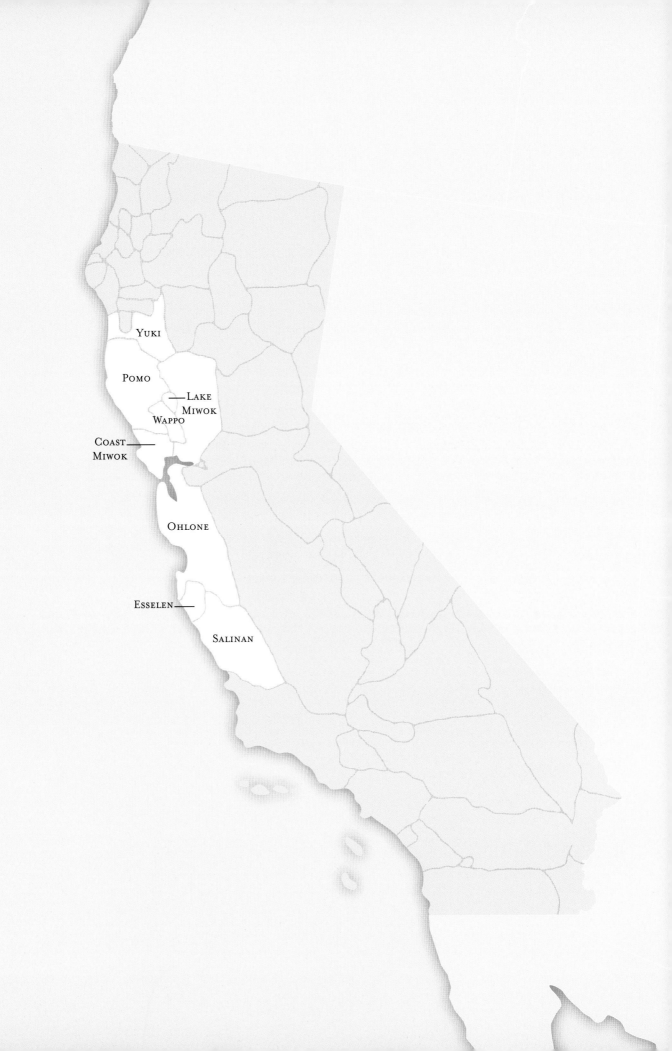

Two

Central Coastal California

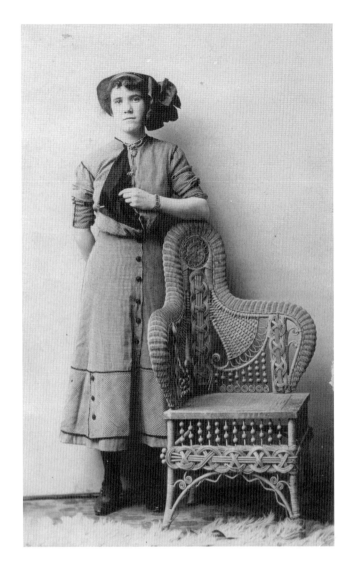

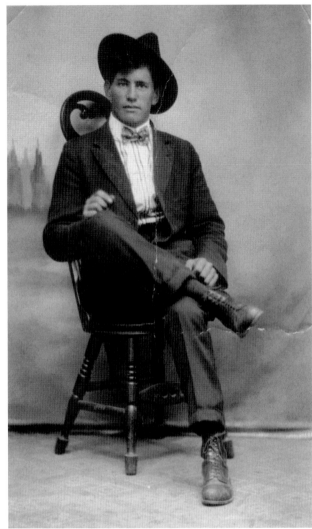

*Annie Bracisco (Salinan), who died at the
hands of a jealous boyfriend.*
COURTESY OF DEBRA UTACIA KROL/JOLON INDIAN
PUBLISHING.

*Frank McCormack (Salinan), who died
young while building the Bitterwater
Road, east of King City.*
COURTESY OF DEBRA UTACIA KROL/JOLON INDIAN
PUBLISHING.

Debra Utacia Krol: Most of the
Bracisco/McCormack generation
passed on before their time.

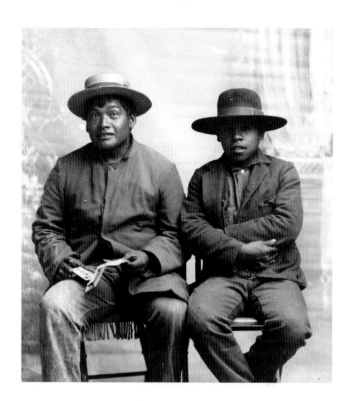

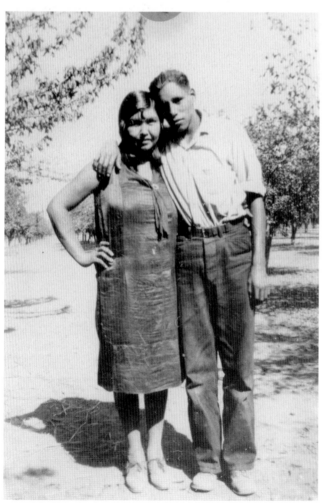

LEFT *Gilbert Salsedo (Mission Indian) and Helen Von Pelt (Wappo) standing in a Sebastopol apple orchard, 1920s.*
Courtesy of Christina Gabaldon.

ABOVE *Dutch John Stevenson and Mike Gomez (Yokia Pomo), early 1900s.*
Courtesy of the Grace Hudson Museum.

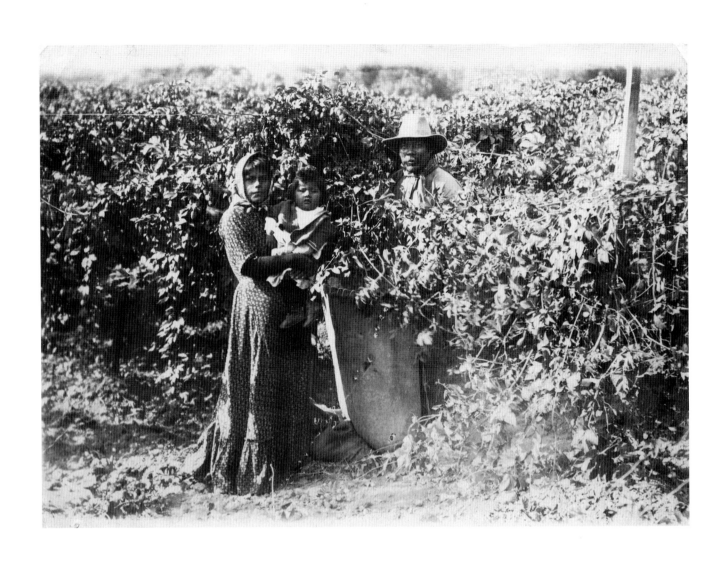

Long before the urban sprawl of the Bay Area,
central coastal California was already a major
population center. The entire area from Mendocino

County to San Luis Obispo County was, in fact, one of the most densely populated
regions in all North America, home to the Pomo, Lake Miwok, Wappo, Coast Miwok,
Ohlone, Esselen, and Salinan peoples. While smaller villages and encampments
were scattered along the ocean shorelines, it was the sheltered, oak-dotted valleys just
inland that provided the most desirable village sites—the Russian River Valley, Ander-
son Valley, Napa Valley, Petaluma Valley, Santa Clara Valley, Salinas Valley, etc. Here
populous and complex societies thrived. The Pomo village of Shanel, for example,
near present-day Ukiah, was home to fifteen hundred people. Governing this rela-
tively large population required a highly sophisticated and well-organized political
structure, which included hereditary chiefs, an elected war chief, twenty "house" and
"speaking" chiefs, and still more officially recognized leaders with specific roles, not
to mention a host of people skilled in specialized crafts for which they were paid.

Although Spanish galleons and survey ships had been plying the coast since the
sixteenth century, Europeans did not attempt to settle Alta California until much
later. In 1769, nearly three hundred years after Columbus's voyages, Gaspar de
Portolá led the first land expedition into Alta California. Marching up the coast from
Mexico, Portolá and his men happened upon a village near Monterey Bay. Miguel de
Costansó, an engineer assigned to the expedition, recorded the event in his journal:

> These Indians had no notice of our coming to their lands, as was
> seen by the consternation and terror our presence caused among
> them: for some, amazed and confounded, scarce knowing what they
> did, ran to their weapons; others shouted and cried out; the women
> dissolved into tears. Our people did all they could to quiet them,
> and the sergeant of Loreto Presidio, who was in charge of the party,
> managed it with great difficulty by getting down from his mount and
> approaching them with signs of peace.[1]

With some variation, this scene would be replayed throughout the region time
and time again.

One year after Portolá's arrival, Mission San Carlos Borromeo was founded in
Monterey.[2] By 1823, twenty-one missions had been established throughout Califor-
nia, eleven of them in the central coastal region, from Mission San Luis Obispo to
Mission San Francisco de Solano in present-day Sonoma.

OPPOSITE *Mark Robinson (Pomo)*
with his wife and child in the hop fields,
Hopland, early 1900s.

Fascinated by the newcomers, their goods, their foods, and their ideas—attracted perhaps by new opportunity, the promise of wealth, the hope of power, or maybe simple novelty—many Indians were drawn to the missions. The practices of the priests in some ways paralleled their own ideas of healing, and the physical wealth of the Spanish indicated that these strangers were in good standing with the spirit world. The native worldview allowed for openness in worship and belief: since these people came from afar with strange technologies, it was natural that they would have different methods of worship, but this was seen as expanding, not contradicting, native options.

Mission life, however, was devastating. Diseases like smallpox, measles, and syphilis swept through native communities, decimating populations and challenging traditional healing practices. Many of the missionaries, more intent on saving souls than bodies, were ruthless and punished even minor infractions with undue severity. Crops regularly failed. Reduced to starvation, forbidden their traditional practices, unaccustomed to the harsh restrictions of mission life, and not understanding that baptism was an unbreakable commitment, many people fled, only to be chased down by soldiers and forced to return to the missions.

In contrast, the Russian traders who came to California from the north had little interest in the souls of their native workers. Fort Ross was established in Kashaya Pomo territory (northern Sonoma County) in 1812 by the Russian-American Company as a trading post for otter pelts. Believing that cordial relations would lead to higher profits, the Russian government ordered soldiers and traders living at the fort to treat the native people well. Although conditions at Fort Ross could indeed be harsh—at times of labor shortage the Russians readily commandeered Indian labor—life among the Russians was preferable to life among the Spanish. And it has been argued convincingly that the Kashaya Pomo, who have held onto more of their language and tradition than groups to the south, owe their cultural survival in part to the fact that their first encounters with Europeans were less crushing than the encounters of others in California.[3]

From the founding of Mission San Carlos Borromeo in 1770 to the decades following the gold rush, successive and overlapping waves of Spanish, Russian, and Anglo-American immigrants eventually overwhelmed the native population throughout coastal California. While individuals survived, many cultural practices and political institutions crumbled. The people, who had lived for generations within the supportive structure of small villages governed by chiefs whose role was to ensure their well-being in the worst as well as the best of times, now had to adapt to a system in which cash was king. Land was now privately owned, and "justice" was meted out by a domineering people who often had little regard for native values, traditions, and legal rights and sometimes held them in deep contempt.

With powerlessness came displacement. A few bands of Ohlones and others lived in communities on the eastern shore of the San Francisco Bay, but by the 1920s they were landless. By 1920 the only lands held in trust by the U.S. government for

Indians in the central coastal region were small reservations—called rancherias—that dotted the landscapes of Sonoma, Mendocino, and Lake Counties. Most of the rancherias had been established early in the twentieth century in response to reformers' observation that the U.S. government had never provided any recompense to California Indians for the loss of their land; unlike the earlier reservations, which were a means of confining and controlling native people, those established in the twentieth century were meant to be homes, not prisons. Over the following decades, the United States would vacillate many times between policies that recognized native sovereignty and policies that advocated assimilation of native people into mainstream culture.

In 1958 the pendulum swung again, and the government decided to "terminate" forty-one California tribes, disbanding their rancherias and, essentially, declaring them nonexistent. As part of the termination pact, the government was to improve roads on trust lands, install water and sanitation systems, and establish vocational education programs for these tribes before the lands were transferred to private ownership. It was yet another empty government promise, and in 1983, a landmark case, *Tillie Hardwick* v. *United States,* was brought against the government to "unterminate" seventeen tribes, charging that since the government had not fulfilled the terms of the agreement, the tribes should never have been terminated. The courts restored the tribes' official status, and although in some cases much of the original land had been lost or sold, to this day unterminated tribes are continuing their efforts to rebuild their rancherias and restructure their governments. Others followed the lead of the *Tillie Hardwick* tribes, yet today twelve of the tribes that were disbanded under the California Rancheria Act are still terminated. And of course many other tribes were never granted land or any form of federal acknowledgment in the first place.

As of this writing, sixty California tribes are petitioning the U.S. for recognition. The Federated Indians of Graton Rancheria (Coast Miwok) were granted recognized, through legislation, in 2000; Ohlone, Salinan, and Esselen peoples continue to struggle for that recognition after being ignored, dropped from federal rolls, and prematurely declared extinct by scholars and census agents.

Part of the burden of achieving federal recognition is the need to prove to the government's satisfaction that one's tribe has had a continuous political existence and

Elizabeth Williams Lair (Ohlone), born c. 1825.

<small>COURTESY OF THE HARGRAVE FAMILY.</small>

Coast Miwok patriarch and healer Tom Smith, born c. 1835.

<small>PHOTO BY EUGENE R. PRINCE. COURTESY OF THE PHOEBE A. HEARST MUSEUM OF ANTHROPOLOGY, UNIVERSITY OF CALIFORNIA, BERKELEY.</small>

de facto recognition from others—others who acknowledge that this or that group has indeed always been Indian. This has been difficult. For decades, many native people had learned to hide their identity from outsiders; indeed, to admit to being Indian in the early part of the century was dangerous. Gregg Castro (Salinan) remembers his father talking about the census agents who came to the Salinas Valley in the 1920s:

> One of the family members owned a little tavern—in fact it's still there, right on the edge of what is now [Fort] Hunter Liggett. It was a common gathering place for people in the area, and a lot of them were Salinan people, a lot of them were relatives...One day somebody came in who obviously wasn't from the area, kind of nicely dressed—new threads, so to speak—and said, "Are there any Indians around here?" Well, they looked at this guy, and the first thing they thought of was "law," or "government." So you know, there wasn't a big rush to tell this guy that probably the whole room was Indian...

> He [Gregg Castro's father] was raised by his grandmother and grandfather, so we're going back into the late 1800s, and he got the impression from them that it wasn't a good idea then to tell people that you're Indian.

One of the ironies of petitioning for federal acknowledgment is that these groups must go to great lengths to prove to outsiders that they exist as "Indian tribes" within definitions provided by the dominant culture—but within native communities, despite the diffusion and disarray of the past two and a half centuries, people know who they are.

The significance of federal recognition goes beyond legal or economic ramifications. Greg Sarris (Coast Miwok), chair of the Federated Indians of Graton Rancheria, recalls the first few meetings of tribal members as they organized around regaining federal status. People showed up with memories and with family albums, spontaneously opening them and sharing their stories, exploring their relationship with one another. Writes Sarris:

> Wasn't what was taking place a doctoring of sorts, a ceremony? For isn't a ceremony, in the best sense of the word, that which reconnects us to one another and the world around us and thus revives well-being and strength? And isn't the recognition of our relation to one another the first, and undoubtedly the most important, prerequisite "to put back into existence" a tribe and all that that means, its health, its courage, its hope once again for a home? Yes, for we were blessed that evening, empowered to journey forth for restoration, to hope.[4]

OPPOSITE *Salinans Joe Freeman, Penny Hurt, and Gregg Castro, Washington D.C., 1996. They were in Washington to research Salinan language and genealogy at the Smithsonian Institution and to meet with BIA officials about tribal recognition.*
COURTESY OF GREGG CASTRO.

The Salinan Nation—we're not recognized by the part of the government that matters, which is the [chuckles] BIA, but we do work with other branches of the government, like the Forest Service, the Department of Defense, and Caltrans...You always are conscious of their being there—not that they present themselves like this, most of the time—out of the goodness of their hearts...Now, a lot of agencies are acting as though you are recognized, and most of the time that's kind of an effective way to work. It hasn't happened to us—maybe "yet"—but I've heard that relationship exists until you hit a roadblock. And if it gets too contentious they pull out the "Well, you're really not a federally recognized tribe."

—Gregg Castro, Salinan

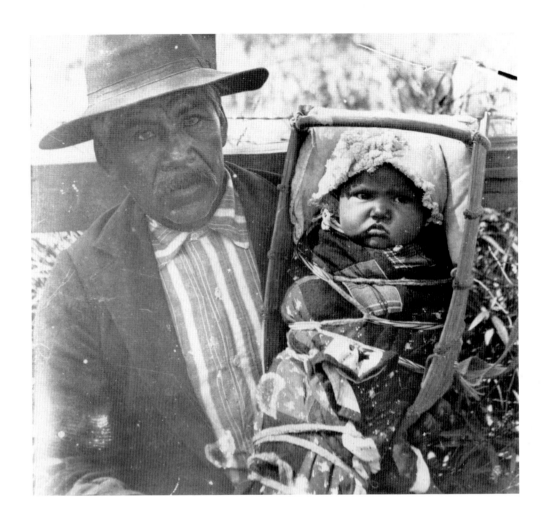

James Shakeley (Pomo) with his niece
Lucy Lozinto Smith (Pomo), Healdsburg
Plaza, 1906.

*Nancy Smith Napolitan (Dry Creek
Pomo/Coast Miwok) hiking with her
daughter Francesca at Point Reyes, 1981.*
Photo by Brian Napolitan. Courtesy of
Nancy Smith Napolitan.

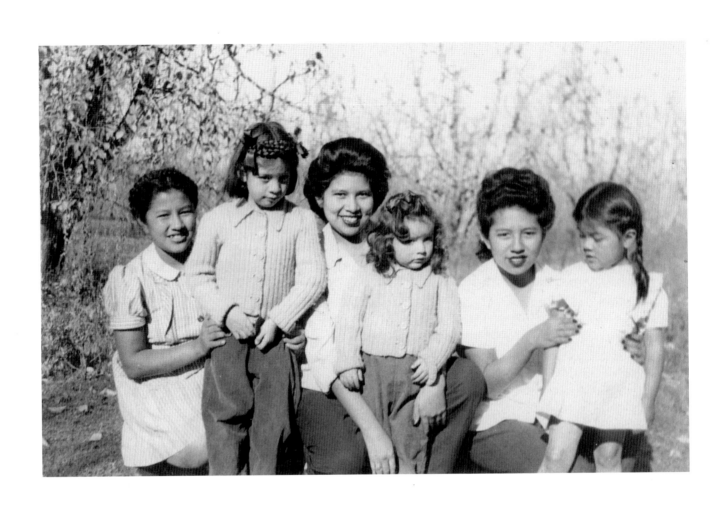

*Left to right: cousins Joanne Ross
Campbell, Patricia Wright, Leona Ross
Newman, Donna Wright Gitchell, Lois
Ross Thorne, and Judy Ross Davidson
(Coast Miwok) at Ross Pear Ranch,
Lake County, c. 1945.*
COURTESY OF KATHLEEN SMITH.

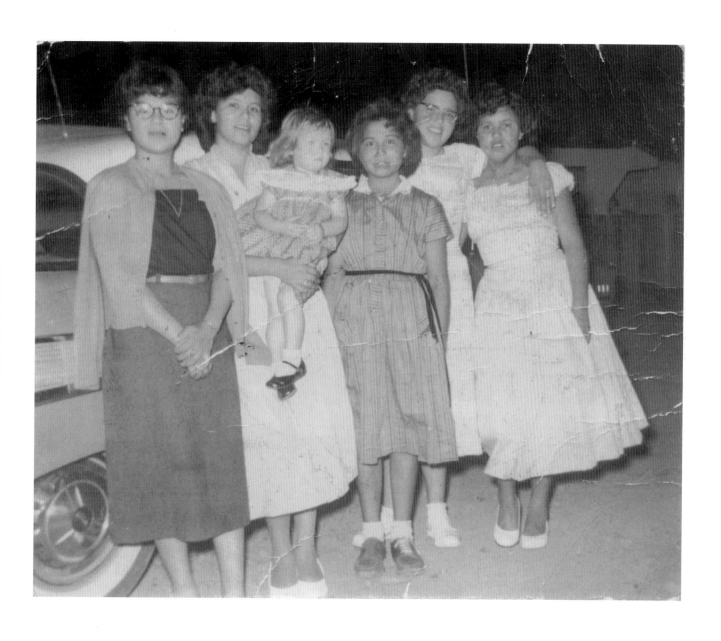

Left to right: Wappo sisters Donna Dipiero, Helen (holding her niece Lynette), Kitty, Lola, and Vera Guillory in Santa Rosa, 1957.

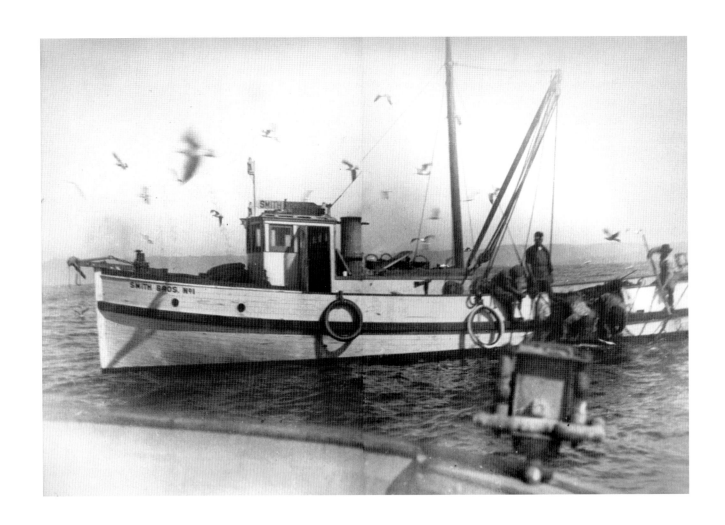

Dorothy Reid (Wailaki): *We always go to the ocean to get seaweed.*

Susie Campbell (Maidu/Pomo): *We dry it. We even have to have a license to pick the seaweed now! And you can only get so much. It just doesn't seem right, but...*

Dorothy: *Kelp—it's that round one with the big, long tail. They dry it and they deep-fry it and it puffs way up. Like popcorn.*

Susie: *It's soooo popcorn!*

WHEN SEBASTIÁN VIZCAÍNO LANDED AT MONTEREY BAY IN 1602, HE CHARACTERIZED the land as "very populated." An "endless number of Indians" came to his camp, he wrote, and they indicated to him that there were many settlements inland.[5]

Indeed, with food from the ocean as well as from land, the central coastal region of California could support human life in great numbers. Game was plentiful; early European explorers often commented on the abundance of elk, deer, rabbit, and other animals. Arriving in Monterey Bay in 1786, the French explorer Jean François Galaup de la Pérouse exclaimed, "There is not any country in the world which more abounds in fish and game of every description."[6] A steady parade of visitors to early California echoed this sentiment.

Though plentiful, game animals were neither taken for granted nor treated disrespectfully. For native people, hunting big game was a skillful, deliberate, ritualized, and sacred means of acquiring food. Before a deer hunt, a man had to prepare himself physically and emotionally through fasting, sexual abstinence, and visits to the sweathouse. There were rules about how to handle bows, arrows, and other equipment, and who could handle them. A favored method of deer hunting was for the hunter to don a deerskin headdress and imitate the movements of a deer, moving closer and closer until—it has been said—he could almost reach out and touch the deer. After the kill, there was a prayer of thanks. Further rules, rituals, and restrictions dictated how the deer would be butchered and how the meat would be divided. It was felt that deer had given themselves to people to relieve them of hunger, and the great gift of a life needed to be properly honored.

Despite the changes that the arrival of Europeans engendered, skills acquired over centuries of careful observation continue to prove useful. Deer hunting is still a valued skill, and venison is eaten and honored at many a festival and family gathering.

For the Coast Miwok people of Bodega Bay, fishing, even more than hunting, was essential to life. Like other maritime societies, they relied on the ocean for food, jewelry, cutlery, toys, and other elements daily life. Crabs, abalone, clams, and other shellfish, as well as fish and seaweed, provided both food and utensils. To this day, despite modern restrictions on what can be harvested and when, families still get together annually to gather seaweed and collect shellfish.

Given this intense relationship with the ocean, it is little wonder that a Coast Miwok man, William Smith, is credited with the birth of the Bodega Bay fishing industry. The son of Tsupu, a Coast Miwok woman, and Steven Smith, a Massachusetts sea captain who had come to California in the gold rush era, William Smith was a larger-than-life character with boundless energy. He started the Smith Brothers commercial fishing business with one small sailboat near the turn of the twentieth century. Kathleen Smith, his great-granddaughter, describes him not just as a successful fisherman but as a "traditional clamshell-disk-bead maker, generous, loved, and respected by all who knew him."[7]

OPPOSITE *Part of the Smith Brothers fleet of fishing boats, Bodega Bay, 1950s.*
COURTESY OF KATHLEEN SMITH.

David Peri (Coast Miwok), Lucy Lozinto Smith (Dry Creek Pomo), Kathleen Smith (Pomo/Coast Miwok), and Laura Somersal (Wappo/Dry Creek Pomo), c. 1979.

COURTESY OF KATHLEEN SMITH.

By the time William Smith's five sons—Steve, Bill, Eli, Ernest, and Edward—took over the family enterprise, the Smith Brothers name was well recognized along the Sonoma coast. Credited with having the first pier at Bodega Bay, the brothers sold crab and fish to businesses and individuals throughout northern California. As one of the brothers, Bill Smith, told the *Santa Rosa Press Democrat* in March 1951, his family has been fishing on Bodega Bay "almost ever since there's been a bay here."[8] When the brothers retired the family business closed, but one merely has to drive to Smith Brothers Lane in Bodega Bay to see that their legacy lives on.

Smith Brothers Lane in Bodega Bay.

Photo by Beverly R. Ortiz. Courtesy of
Kathleen Smith.

*Ira Campbell Jr. and Ira Campbell III
gathering seaweed, Mendocino coast,
1997.*

Courtesy of Susie Campbell.

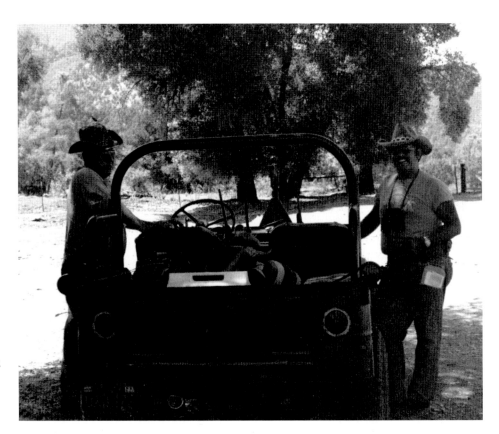

Gregg Castro recalled his father,
Benjamin Castro, and family
friend Manuel Gonzales, shown
here in front of Wagon Caves,
hunting in the Salinan home-
land at a site of great cultural
and archaeological significance
to the Salinan people where
there is an important birthing
rock as well as grinding rocks,
village sites, basketry plants,
and rock art. People used to
be able to camp there, but it's
partially closed and somewhat
protected now.

Benjamin Castro served
in World War II but didn't
talk much about it. A master
sergeant, he was a gunner in the
Army Air Force. Based in India,
he flew in campaigns over Burma
and China and was shot down
over China. He was the last one
out of the plane and landed
behind enemy lines. Both legs
broke when he landed, and he
was found by Chinese guerrillas,
who bound his legs and made
him makeshift crutches. After
six months, when the Army
offered them money for downed
soldiers, they took him in. Army
doctors had to rebreak his legs
and reset them. He was sent back
to India and served there until
the end of the war.

Elders told stories of the brothers
coming to town with mountain
lions stacked on the hood
of their truck.

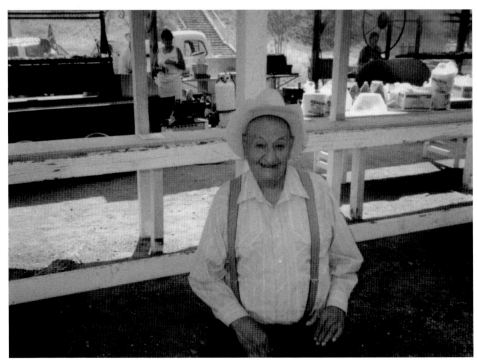

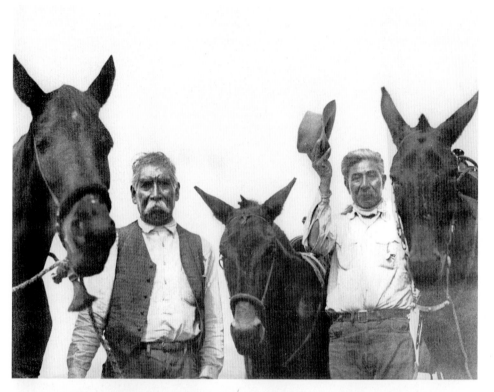

Tito Ensenales and Tony Fontes,
Salinan guides for linguist/ethnographer
J. P. Harrington, near Lucia, 1932.
PHOTO BY J. P. HARRINGTON. COURTESY OF
GREGG CASTRO.

Gregg Castro: A private research
foundation has a nature reserve
over on the coast, and it happens
to have the ranch where my
Grandpa Tony lived—at least the
last place he lived. The first place
he lived, the Hearsts took it!
But that's a whole 'nother story.

When he moved up to this
area, it was not long before...
Harrington got there. And
Harrington went with my
grandfather and another
consultant, Dave Mora, and
they went on a two- or three-
day pack trip where they went
around...he pointed out all the
sites and places and that. And
some friends of mine...got the
Harrington notes about the
trip. And they tried to hike the
same route. And we found a
bunch of spots...Of course it
was all overgrown, because it
was in 1932 or something—so it
was seventy years down the road.

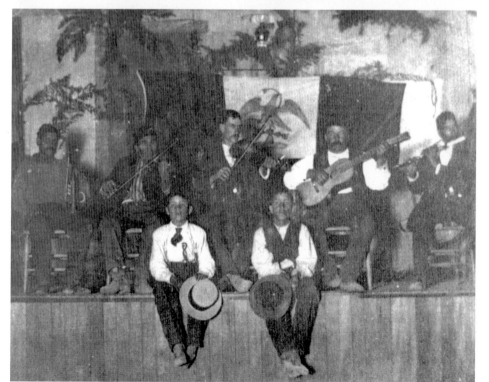

Celestino Garcia's Jolon String Band
playing for Mexican Independence Day
(undated).

COURTESY OF DEBRA UTACIA KROL/JOLON
INDIAN PUBLISHING.

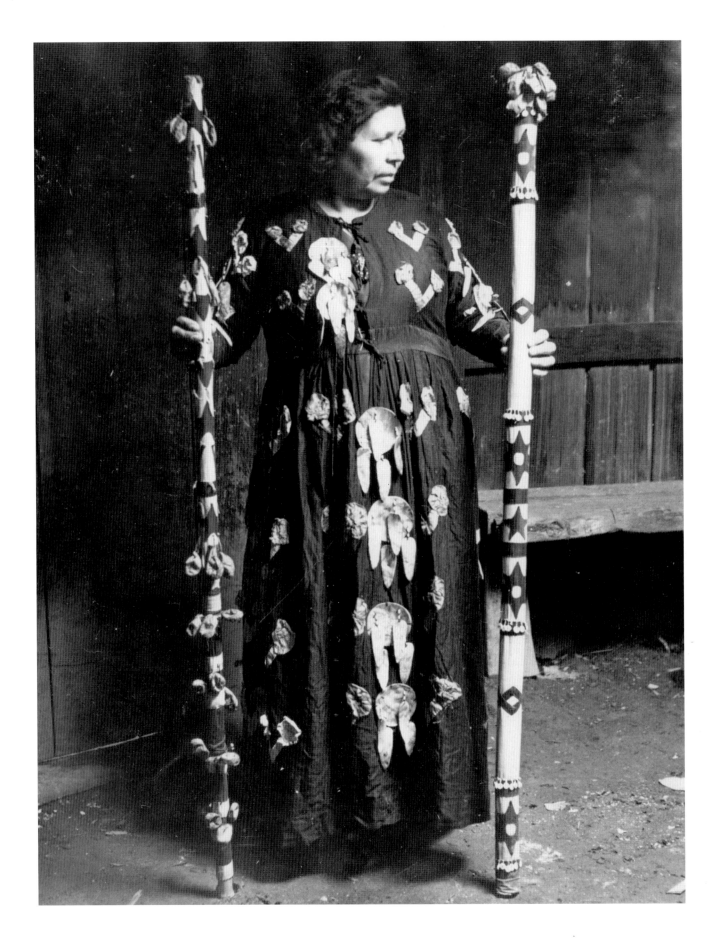

These things we do, they speak of who we are, and the families we're from, and about our relatives too. We are not just one person; we are many. In just one, there is the whole tribe, and our ancestors too. White people call this "history" or "tradition," or something like that. I heard it said in the white church that a man is known by his works. This is true. I was educated about this by the Spirit in my dreams, and it's true.

—*Essie Parrish*[9]

ON THE SECLUDED COAST OF NORTHERN SONOMA COUNTY, WHERE THERE WAS little to attract the attention of Anglo settlers, the Kashaya Pomo were isolated from much of the non-Indian population well into the twentieth century—not only by the nature of the landscape, but by intent. By regulating the behavior of their people, a series of strong isolationist leaders ensured the survival of the Kashaya language and traditions.

From 1912 to 1943, Annie Jarvis forbade gambling, banned interracial marriage, kept children away from government-run and church-run boarding schools, and encouraged the use of the Kashaya language.

Following the death of Annie Jarvis, Essie Parrish became the spiritual leader of the Kashaya community. She had been acknowledged at the young age of six to be a Kashaya *yomta*, a term that can only be translated roughly: dreamer, seer, prophet, revelator, visionary, and healer are just a few of its implications. The Bole-Maru, a religion that developed in the 1870s and gained particular strength among Pomo and Wintu people, relies heavily on the direction provided by a tribe's *maru*, or dreamer.[10] Marus receive instructions in their dreams that they have to follow, and they frequently give orations urging others to follow them as well.

Essie Parrish dreamed many things, including patterns she used in ceremonial clothing, basket weaving, and other aspects of her life. When Kashaya men went off to fight in World War II, each was given a handkerchief embroidered with a special pattern that she had dreamed. These handkerchiefs were intended to protect the men, and there were many who credited them with their safe return from the war.

Essie Parrish taught at the reservation school, educating children in Kashaya language, law, and culture, and worked with linguist Robert Oswalt to compile a Kashaya dictionary. She was a leading member of the group that convinced the U.S. government to turn over a former CIA listening post in Forestville to Pomo people for the creation of Ya Ka Ama Indian Education Center in the early 1970s.

Throughout her life (1903–1979), Essie Parrish kept her community centered and used her influence to ensure the continuity of Kashaya customs, language, belief, and ceremony. When a general cultural revival began to take root among other groups in central California in the 1970s and 1980s, many tribes looked toward Kashaya for knowledge and memory of ways almost forgotten elsewhere.

OPPOSITE *Kashaya Pomo spiritual leader Essie Parrish, c. 1962.*

COURTESY OF THE PHOEBE A. HEARST MUSEUM OF ANTHROPOLOGY, UNIVERSITY OF CALIFORNIA, BERKELEY.

Pomo healer Bernice Torrez, daughter of
Essie Parrish, c. 1995.

Tony Ramos, Clarence Carrillo, and Tom Ramos (Pomo) singing at Santa Rosa's Jesse Peter Museum, 1989.

PHOTO BY LEE BRUMBAUGH. COURTESY OF LEE BRUMBAUGH.

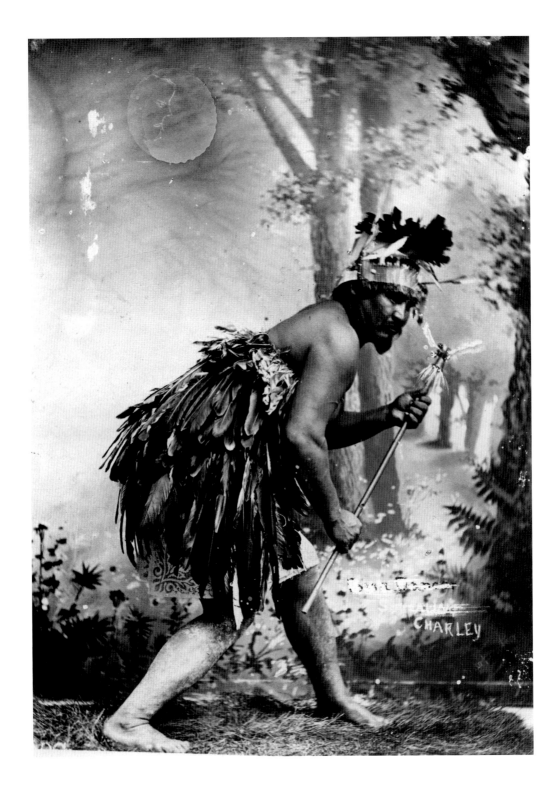

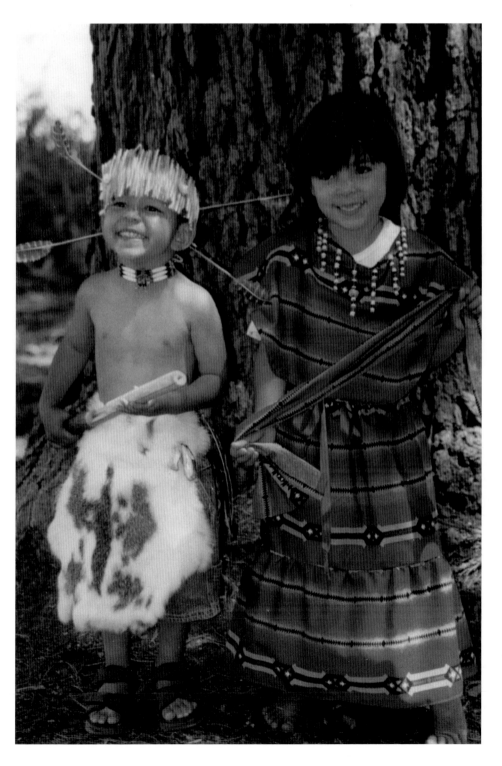

OPPOSITE *"Squealing Charlie" Brown (Pomo), Yokia, early 1900s. Charlie was so named because his throat had been slit, making his voice very high and odd.* COURTESY OF THE GRACE HUDSON MUSEUM.

Dominique and Sedacia (Pomo), Redwood Valley, 2000. They had been dancing at the elders' picnic at Lake Mendocino. COURTESY OF SUSIE CAMPBELL.

IN 1940 A GROUP OF POMO WOMEN LED BY ELSIE ALLEN, ANNIE BURKE, AND EDNA Sloan Guerrero formed the Pomo Mother's Club, later to be renamed the Pomo Indian Women's Club. Their mission was to support their community through education and fundraising. The members organized dances and bazaars, selling items that had been donated or handmade by club members. If someone fell on hard times and needed money for funeral expenses or because of illness, unemployment, or other unexpected hardship, the club stepped in.

At the time the Pomo Indian Women's Club was founded, prejudice against Indians was widespread, especially in the Ukiah area. Edna Guerrero recalled:

> Beauty shops, barber shops, wouldn't allow Indians. The only restaurant that allowed us to come in and eat was owned by the Chinese. We weren't even permitted in the toilets, and in the theaters we sat way up there in the "Heaven" as we called it.[11]

Not long after the founding of the Pomo Indian Women's Club, Yokayo Rancheria leader and activist Steven Knight sued a Ukiah theater for refusing to allow his granddaughter to sit anywhere but in the balcony. The club lent its support to the case, and the theater owner settled out of court. Worried that they would face similar lawsuits, other Ukiah merchants began to desegregate their shops.

The memories of racism are still felt. When interviewed in 2003, Dorothy Reid (Wailaki) recalled, "I graduated from high school and moved to Los Angeles. I just had to get out of Willits, because they didn't like us. Ukiah was the worst place I know, really...They called us 'dirty Indians.'" In the same interview Susie Campbell remembered her grandfather telling her "they used to go and buy their lunch in the store and go out in back and eat because they weren't allowed in there." There was considerable discussion and some laughter about when or if things had changed.

Members of the Pomo Indian Women's Club felt that the best way to fight this racism was to educate surrounding non-Indian communities about Pomo culture, especially by spotlighting basketry. Pomo baskets are world-famous for their skill and artistry, dazzlingly beautiful and a source of deep cultural pride. Founding member Annie Burke, a local weaver of some renown, and her daughter Elsie Allen assembled a large collection of Pomo baskets. Under the auspices of the club, they exhibited the collection and gave weaving demonstrations throughout Sonoma and Mendocino Counties, and occasionally as far away as the San Francisco Bay Area. Elsie's daughter Genevieve Aguilar recalls the ceaseless traveling: "I always said I rode my mother's shirttails, because when Mother was invited wherever...she needed company. It was an education for me accompanying her on exhibit displays."[12] Although the club disbanded in 1957, it is remembered with affection and admiration, and its accomplishments can still be felt.

OPPOSITE *Mabel McKay (Pomo) cleaning sedge at Warm Springs Dam, 1987.*

PHOTO BY BEVERLY R. ORTIZ. COURTESY OF BEVERLY R. ORTIZ.

OPPOSITE *Julia Parker (Pomo/Miwok), renowned basketmaker, demonstrating acorn pounding at Chaw'se (Indian Grinding Rock State Park), 2002. Many people recognize her from her decades of demonstrating traditional skills at Yosemite National Park.*

PHOTO BY NANCY SMITH NAPOLITAN. COURTESY OF NANCY SMITH NAPOLITAN.

Susan Billy (Hopland Pomo) working on a basket, Hopland, 1985.

PHOTOGRAPH BY RALPH COE. COURTESY OF SUSAN BILLY.

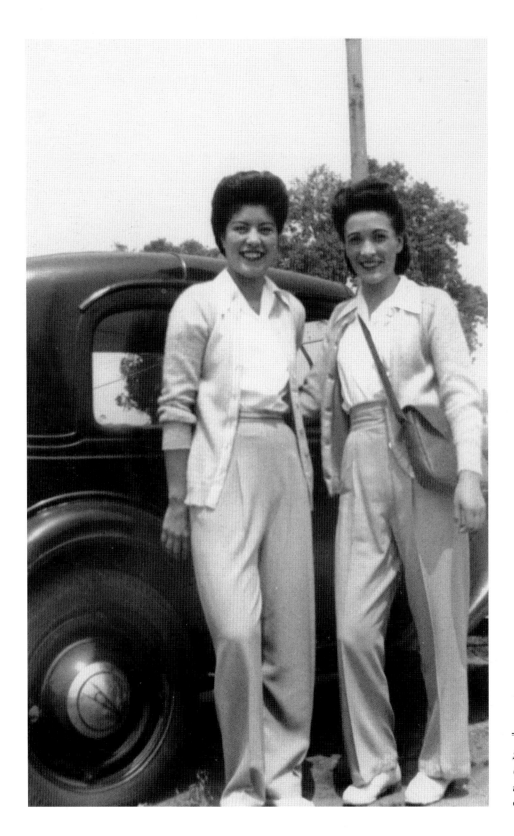

Sisters Dorothy and Gladys Wilburn (Wailaki) in Los Angeles, where they worked as riveters, 1941.

Courtesy of Dorothy Wilburn Reid.

IN THE 1970S A GROUP OF MARIN COUNTY SCHOOLTEACHERS LED BY SYLVIA Thalman and Don Thieler envisioned a traditional Coast Miwok village at the Point Reyes National Seashore and set out to build it. It would be a piece of living history, an outdoor museum that would exhibit the culture of the native people who had once thrived throughout Marin County. After studying ethnographic texts and archaeological reports, the crew embarked on the long and laborious process of recreating a village using only traditional methods and tools. They shoveled with abalone shells, removed the earth in baskets, and shaped the wood with obsidian flakes. Working afternoons and weekends, it took over a year just to clear the space for the ceremonial dance house. Besides the ceremonial house, the crew built a sweathouse, acorn granaries, and several dwellings.

Naming the newly created village Kule Loklo (Valley of the Bears), in 1980 National Park Service rangers and teachers inaugurated a series of public programs to teach schoolchildren about the history and the long-lost traditional skills of the Coast Miwok people. Here, the creators of Kule Loklo felt, children could get a physical feel for what traditional Indian life was like, and on many a warm weekend afternoon adult visitors could watch as schoolteachers and volunteers twisted dogbane into string, used hand drills to make holes in shell beads, chipped obsidian into arrowheads, and summoned ancient spirits by twirling a bull-roarer in the air.

In its earliest days, Kule Loklo was a village seemingly complete in all respects except one: it was an Indian village without Indians. The schoolteachers, like almost everyone else in Marin, had assumed that the local Coast Miwok culture was extinct. But the Coast Miwok had not disappeared, and neither had their traditions and language. Many still lived in the area. Why hadn't anyone asked for their input? Maybe it was because the tribe had no reservation, no official status. Some had intermarried with the Pomos, to the north, and now lived on the Kashaya Reservation. For those still living in Marin County, their Indian lives were all but invisible to the community around them.

Curious and suspicious, Coast Miwok people began to visit Kule Loklo to judge how their past was being presented. There were more than a few uneasy moments, but in the end all parties realized that they had something to learn from each other. The teachers brought to the village technologies long since discarded; the natives could bring a living culture. A few years after being invited into village activities by rangers and interpretive staff, the Coast Miwok people were running the interpretive programs.

One of the most ubiquitous and beloved personalities at Kule Loklo throughout the 1980s and 1990s was Lanny Pinola (Coast Miwok/Kashaya Pomo). He taught at the village and led nature walks in the area, and he was instrumental in Kule Loklo's transition from museum to cultural site, helping to institute and run events such as the Strawberry Festival held each April and the Big Time in July. A traditional dancer and singer, Pinola, along with his mentor, Bun Lucas, also worked with dance groups,

selecting and training local people and encouraging traditional dancers from around the state to participate in the Kule Loklo festivals.

In taking over the interpretive programs, Lanny Pinola, Bun Lucas, and others reinstituted traditional rules and values. Meyo Blue Cloud of Robinson Rancheria recalls her first Strawberry Festival at Kule Loklo in 1994:

> When I get to the main part of the roundhouse, where the circle starts, I turn twice, my hands spread open, presenting myself to the spirits and elders for a closer look so that they will know I am ready to embrace my traditional values and to show my respect for the first of the four ways. Going to the right, not the left, because I am following the path of the sun, I turn twice at the next three corners of the world.[13]

Once a museum built to commemorate an "extinct" people, Kule Loklo has become a living and vibrant center of culture and community. In addition to public programming, a number of private ceremonial events are held in the village each year, imbuing the site with a spiritual and cultural connection that could not have been imagined when it was first built. Through the hard work and cooperation of many people, Kule Loklo is widely known, a model for other such centers across the country.

Lanny Pinola (Coast Miwok/Kashaya Pomo) with his fiancée, Susie Montijo-Moore (Yokuts/Chumash) and her grandson, 2001.

Courtesy of Kathleen Smith.

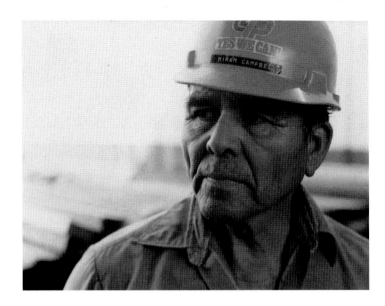

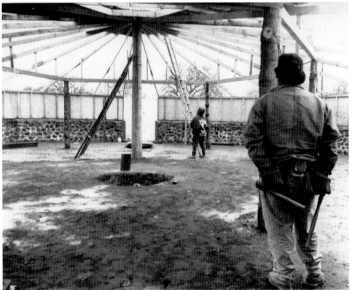

*Hiram Campbell (Pomo), who received
a commendation from Louisiana Pacific
Lumber for thirty-six years of loyal
service.*

<small>Courtesy of Susie Campbell.</small>

*Construction workers at the Elem
Roundhouse, 1991.*

<small>Photo by Judith Wilkinson. Courtesy of the
Lake County Record Bee.</small>

*Larry Myers (Pomo), executive director of
the California Native American Heritage
Commission, speaking at the California
State Library in Sacramento, 1989.*

<small>Photo by Heather Hafleigh. Courtesy of
Heather Hafleigh.</small>

BEFORE THE COMING OF EUROPEANS, MUTSUN, ONE OF THE EIGHT OHLONE languages, was spoken by perhaps twenty-seven hundred people whose homeland covered southern Santa Clara and northern Monterey Counties. Their cultural center was the Pajaro River at present-day Watsonville. With the disruptions of the mission period, the cataclysmic loss of life and land throughout the nineteenth century, and the displacements and scattering of people that followed, fewer and fewer spoke the old language. When Ascención Solorsano de Cervantes, widely thought to be the last fluent speaker of Mutsun, died in 1930, everyone assumed that the language had died with her.

In the early 1990s, a young Mutsun woman, Quirina Luna, discovered a Mutsun phrasebook compiled by Arroyo de la Questa, a Franciscan missionary with a scholarly bent who had served at Mission San Juan Bautista from 1808 to 1833. Quirina Luna had grown up in Madera, traveling with her family to harvest grapes and apricots, and she was then working as a cashier. What she lacked in formal academic training, she more than made up in a deeply felt determination to learn more about her ancestors and their language. Her searching led her to the archives at the University of California, Berkeley, where field notes and publications of linguists and anthropologists who had been studying California Indians for decades were collected. In these notes, she found more than just glossaries and grammars; early researchers, intent on documenting what native life might have been like before its presumed demise, had compulsively jotted down scraps of information about customs, beliefs, and everyday activities. In these field notes and technical publications, Quirina Luna found the culture and recorded memory of the Mutsun people.

In 1999, Luna and fellow tribal member Lisa Carrier founded the nonprofit Mutsun Language Foundation. Devoted to restoring as much language and culture as possible, the foundation has compiled, with the help of trained linguists, a dictionary, textbook, phrasebook, and CD of the Mutsun language. And in a delightful move to bring Mutsun into today's world, the foundation has even translated and adapted the Dr. Seuss classic *Green Eggs and Ham* into "cutsuSmin yuukise yuu urakase," "Green Eggs and Salmon."

Today, foundation members have learned enough Mutsun to put phrases together, and they try to speak the language in their homes as much as possible. They realize that language is not just words, but culture, heritage, and identity. Quirina Luna was especially pleased when her third child, Jonathan, spoke his first word: *ta-tay*. It's the Mutsun word for touch.

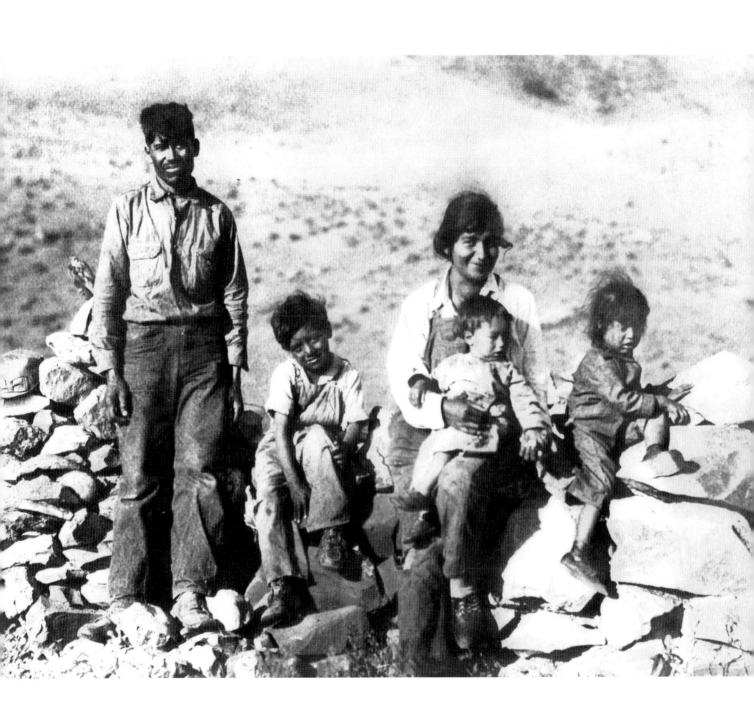

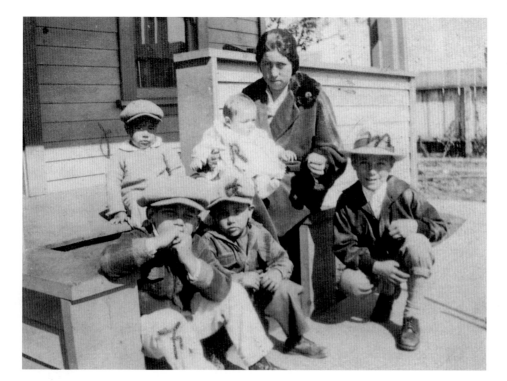

OPPOSITE *Members of the Ensenales family with linguist J. P. Harrington north of Lucia, 1932.*
PHOTO BY J. P. HARRINGTON. COURTESY OF GREGG CASTRO.

Frances Moreno Moniz (Amah Mutsun Ohlone) with five of her seven children, Oakland, 1926. Top, left to right: Joe and Rudy. Bottom, left to right: Frank, Art, and Marion.
COURTESY OF LISA CARRIER.

[Asked why native people go through the difficulty of trying to preserve or revive languages] It's almost like asking, "Why is your arm so important?" And in a sense that is what it is: it's a part of you. Even if you don't understand it. Even if you take it for granted. Like kids...they start running and then they trip over themselves and pick themselves up and keep running. That's the way kids learn how to walk. And...in ten years of wandering over the state doing various things, that's the sense I get: it's like an arm or a leg—or their heart. It's important on a deeply personal, emotional level. And it's almost like you can't help but do it, you can't not do it.

—Greg Castro, Salinan

FOR CENTURIES, THE YUKI, COAST YUKI, AND HUCHNOM PEOPLES HAVE LIVED in their own little part of northern California, from today's Fort Bragg inland to the upper Eel River drainage. In most ways, their culture was similar to those of their neighbors—mainly the Wailaki, Cahto, and Pomo—but their language was quite different. The Yuki language, along with the Wappo language of the Napa Valley, form a unique language family, apparently unrelated to any other existing language on earth.

The Yuki had no significant contact with Europeans until 1854, when Frank Asbill of Missouri established a ranch in Round Valley, about thirty miles inland from the coast in what is now northern Mendocino County. At the time Asbill was setting up his ranch, the United States government was making plans to remove Indians from their homelands throughout California and concentrate them on reservations. There were to be five large-scale reservations across the Golden State. Only one was in northern California, the Nome Lackee Reservation (established in 1856) at the northwestern edge of the Sacramento Valley (in present-day Tehama County). Realizing that Nome Lackee would not provide enough space for all the Indians they wanted to move, the government established the Nome Cult Farm in Round Valley as an extension. Nome Cult would become the Round Valley Reservation in 1858.

From 1855 to 1865, thousands of Indians from all over northern California were forced from their homelands and driven like cattle over miles of trail onto the reservation. In 1862, the government abandoned Nome Lackee and herded the remaining Indians living there over the mountains into Round Valley. In 1863, the largest and most notorious of the roundups occurred when several hundred Indian people were driven from Chico over the Nome Cult Trail to Round Valley. It was a California "Trail of Tears"; many did not survive the journey.

Among those relocated to Round Valley were Cahto people from near Laytonville; Lassik from Alder Point; Wailaki from Island Mountain; various Pomo bands from Willits, Ukiah, Potter Valley, Santa Rosa, and Lake County; Maidu from Chico; Yana from Mt. Lassen; Wintun and Konkow from the upper Sacramento Valley; Achumawi, Atsuguwi, and Modoc from Modoc County; and Nomlaki, who were age-old enemies of the Yuki, from Paskenta. While coming from disparate cultures and regions, they all shared the common bond of being forced to live with unknown peoples and—except for the Yuki—in a new place.

The tribes of Round Valley have weathered much in the past hundred and fifty years: massacres, the loss of their homelands, great deprivation as this remote reservation failed to meet basic human needs, and, later, the loss of reservation lands, as well as family feuds and police oppression. In spite of all of this, they have persevered. The reservation now sports a health clinic and library. A California Indian Days celebration is held every fall, as is a commemoration and reenactment of the Nome Cult Trail. While each tribe that calls the valley home still retains aspects of its unique culture, a blended culture and reservation experience have emerged that adds a new layer to the identities of the peoples of Round Valley.

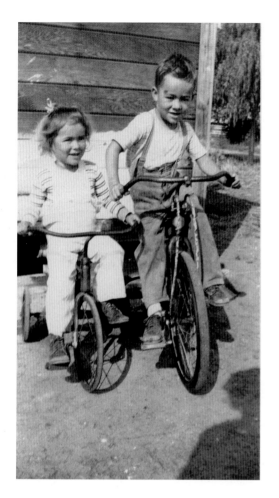

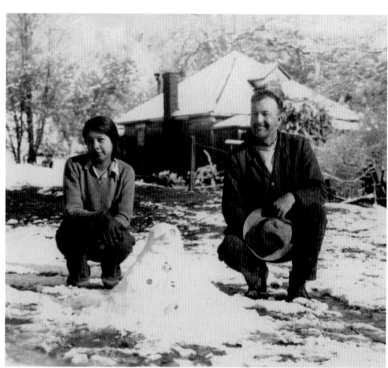

Siblings Maria Elena Moniz Carrier and Frank Moniz (Amah Mutsun) showing off their new bikes, Hayward, 1940s.
Courtesy of Lisa Carrier.

Martha Herrera (Amah Mutsun) and linguist J. P. Harrington admiring her snowman.
Courtesy of Marion Martinez.

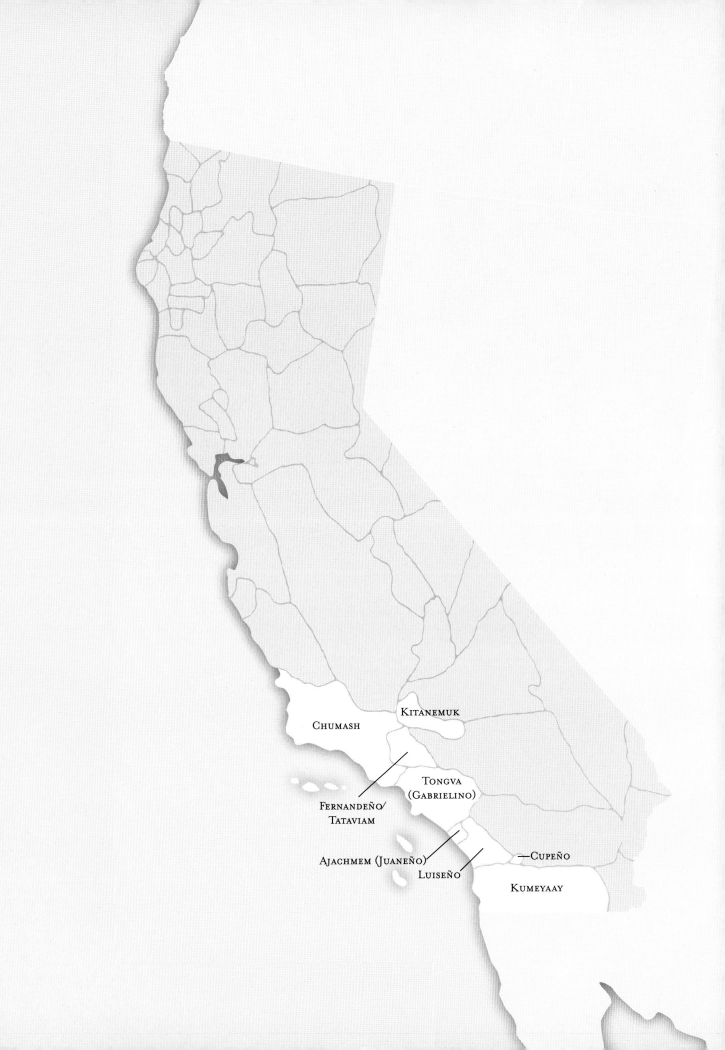

CHUMASH

KITANEMUK

FERNANDEÑO/
TATAVIAM

TONGVA
(GABRIELINO)

AJACHMEM (JUANEÑO)

LUISEÑO

CUPEÑO

KUMEYAAY

Three

COASTAL SOUTHERN CALIFORNIA

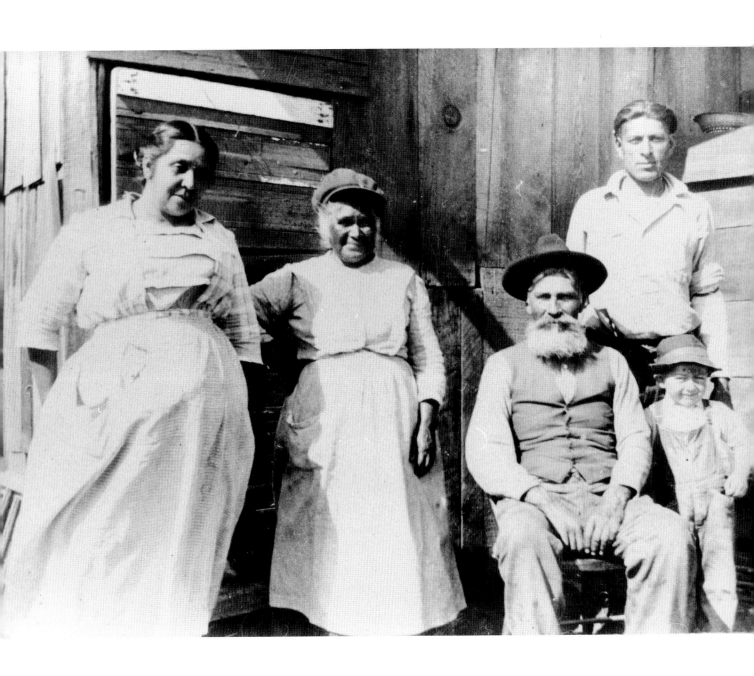

Southern California holds a special place in the American imagination as a land of perfect beaches, palm trees, surfers, and movie stars. In this place where people come

to reinvent themselves and redefine the world around them, people born in California are a rare bunch, and Native Californians, with roots deep in the land, rarer still. But while largely absent from the media, the original inhabitants of southern California are still a strong presence in their ancestral homeland. On reservations and in the cities, recognized by the government or not, thousands of native people are carrying on, often just under the radar of the dominant culture, still caring deeply about the land of their ancestors despite the astounding transformation of the landscape. It is difficult to be an Indian under any circumstances; think what it must be like to see a phenomenon like Los Angeles spreading over your meadows and valleys, diverting your rivers, building parking structures on your holy sites, transforming the land that nurtured your ancestors into something unrecognizable.

As is true throughout California, this coastal region and the lands immediately inland are marked by considerable geographic and cultural variety. The Tongva of what is now the Los Angeles area and the Chumash of present-day Santa Barbara lived in large and prosperous coastal villages. Their splendid plank canoes plied the waters between mainland villages and communities on the offshore islands. Early European explorers were startled and impressed by what they saw here. Father Juan Crespí, a member of the 1769 Portolá expedition, described a Chumash village near present-day Ventura in these words:

> After traveling for about two and a half hours we arrived at the shore, where we saw an acceptable town, the most populous and best laid out of any we had seen on the journey…We counted about thirty large, comfortable, and well-constructed houses. They are shaped like spheres with roofs of grass. According to the people we saw and who came down to the camp, there were close to four hundred souls there. They are a large and healthy people, quick, industrious, and clever. Their skill and ability stand out particularly in the construction of their canoes. They are made from good pine planks which are joined together well to form an elegantly shaped canoe with two bows. They maneuver the canoes as skillfully as they construct them. Three or four men go out to sea in the canoes to fish. The canoes can hold as many as ten men. They use long oars with two blades and row with an indescribable ability and speed.[1]

opposite A Kumeyaay family before their removal from the San Pascual Valley in 1910. Left to right: Eloisa Osuna, Guadalupe Duro Martinez, Jose Juan Martinez, Jose Dolores (JD) Martinez, Eddie Martinez.

Courtesy of Tilda M. Green.

Tilda Green: A lot of them were evicted from the valley in the early days, sometime after 1887. Had something to do with the Treaty of Guadalupe Hidalgo, and the land becoming American instead of Mexican. Indians (as Mexican citizens) were supposed to be able to keep their land, but when the Americans saw how good the land was, they developed tax laws that Indians knew nothing about and didn't understand, and were thus evicted. Great-grandfather was forcibly taken from his home…During the evictions, the people had to take what they could and leave everything else.

Those who lived inland, however—while in contact with the coast—had their lives shaped by the dry, desert-like land and climate. Except at a few oases and in other favored places, this landscape could not support large villages. People tended to live in smaller settlements, traveling widely over their territory in small bands in a yearly circuit to collect the foods and other materials they needed for a good life.

The Spanish established ten missions in the coastal area between San Diego and San Luis Obispo, and from 1769 until the missions were secularized in 1834, the mission experience dominated the southern California natives and transformed their destiny. In early literature these once distinct people were often lumped together as "mission Indians," and to this day many tribes bear the names of missions into which their ancestors were drawn—"Luiseño" for San Luis Rey, "Fernandeño" for San Fernando, and so forth.

From the beginning, the missionaries exhibited a mix of devout passion, self-sacrifice, intolerance, and misplaced idealism. They had little sense that the Indians of California were anything but heathens and savages who needed to be purged of their culture and beliefs for their own material benefit and spiritual salvation. A chilling statement by Fermín Francisco de Lasuén, who succeeded Junípero Serra in 1785 as head of the California missions, instructs others on how to go about transforming "a savage race into a society that is human, Christian, civil, and industrious":

> This can be accomplished only by denaturalizing them. It is easy to
> see what an arduous task this is, for it requires them to act against
> nature. But it is being done successfully by means of patience and
> unrelenting effort.[2]

Once physically established, the missions drew converts with offers of a reliable supply of food, enticing technologies, a nontraditional power structure in which even the low-born could rise to prominence, and protection from disease. In truth, however, these promises were not kept. Fatal diseases such as measles, mumps, smallpox, dysentery, and tuberculosis swept through the overcrowded missions and spread to the surrounding communities. Indeed, no mission in California ever succeeded in maintaining a stable population except by drawing more and more natives from an increasingly wide territory to sustain its numbers.

Nor, despite agriculture and irrigation, did the missions provide ample food. The food was monotonous, inadequate, and badly prepared. Many observers commented on the prevalence of obvious malnutrition, and at times starvation, and this in turn demoralized and lowered resistance to disease.

Ill-trained, frustrated, and confused by the misery around them, some of the missionaries simply broke down and had to be sent back to Mexico or Spain. Others leaned harder on the whip and became simply ruthless. Correspondence within the church and between church and government presents a picture of disarray at best

and—at worst—brutality. The memory of that era lingers well into modern times. In 1987 Maurice Magante wrote from his home on the Pauma Reservation:

> The subject of how the Indians were used as slaves or as a labor force to build California missions is a horror story. These historical events were told to me by my elders and my mother and my great-grandmother, Conception Pachito. My mother was Bessie Valenzuela (her maiden name) and daughter of Santos Valenzuela, and my grandmother Anita (Pachito) Valenzuela.

> They told me how the Indians were tortured and punished, while building those missions. Huge timber logs were cut and carried from Mt. Palomar to the San Diego area, now the San Diego Mission, San Juan Capistrano Mission and San Luis Rey Mission, all within fifty to seventy miles, "as the crow flies"…carried on their shoulders and they couldn't sit or drop the timbers on the ground until they reached the mission grounds. If they did, they were severely whipped and punished. Many of our people died because of punishment, disease, and starvation.

> The Pala Mission still has the "prison cell," with iron flat bars, where our people were punished if they did something considered to be wrong or didn't do what they were told to do. Our people were taken from their villages to the mission compound as slaves. Many of our young were taken from their families and put into slavery.[3]

Contrary to the conventional view that native people passively accepted their situation, they did not in fact capitulate easily. Neophytes found dozens of subtle ways to resist the missionaries, from work slowdowns to secretly held ceremonies to playing on the rivalries between the Spanish clerics and the military. Abortion and infanticide were not unknown, particularly among women who had been raped by Spanish soldiers. People also rebelled openly and violently at times; there are documented cases of abusive priests having been assassinated.

By 1834 Mexico had gained independence from Spain. A liberal ethos prevailed in the Mexican government, and officials—in some cases inspired directly by the democratic revolution in Britain's American colonies and by the ideals of the French Revolution—objected to the missionaries' simultaneously cruel and paternalistic treatment of Indians. The missions had been intended as a temporary means to an end, and now the Mexican government decreed that they would be secularized: land and other assets were to be distributed to the Indians of each mission. In reality, most of the land was appropriated by the secular mission administrators and granted in large tracts to ranchers of Mexican and European descent.

There was little room in the new society for Indians, and conditions got even worse with the arrival of large numbers of Anglo-Americans and, soon thereafter, statehood. Some former mission Indians would find work on the ranchos as laborers and vaqueros. Many found it expedient to identify themselves as Mexican, or to withdraw into the remote hills of southern California. These were the people Helen Hunt Jackson wrote about in her report on the situation of the "Mission Indians" to the U.S. Senate:

> From tract after tract of such lands they have been driven out, year by year, by the white settlers of the country, until they can retreat no farther; some of their villages being literally in the last tillable spot on the desert's edge or in mountain fastnesses. Yet there are in southern California today many fertile valleys, which only thirty years ago were like garden spots with these same Indians' wheat fields, orchards, and vineyards. Now there is left in these valleys no trace of the Indians' occupation, except the ruins of their adobe houses. In some instances these houses, still standing, are occupied by the robber whites who drove them out.[4]

For the native people of coastal southern California, the legacy of the missions and the decades that followed has been invisibility. The harsh reality is that the U.S. government does not even acknowledge the existence of most of the tribes that were heavily affected by the missions. In the popular imagination, these people exist only in the myths of a bygone era. But they haven't disappeared, and their survival tactics range from bitterness to laughter. In the words of L. Frank (Tongva/Ajachmem), "I think the biggest misconception about Natives is that 'stoic thing.' I find most Natives are incredibly humorous. And I think that the key to the failure of genocide has been the failure to take away our sense of laughter."[5]

The native people who inherited the aftermath of the missions have learned to survive by taking advantage of whatever opportunities their local economies offer. They are fighting to regain their stolen sovereignty and their cultural heritage, and they are fighting against desecration of their burial sites. Their weapons are legal, moral, and spiritual.

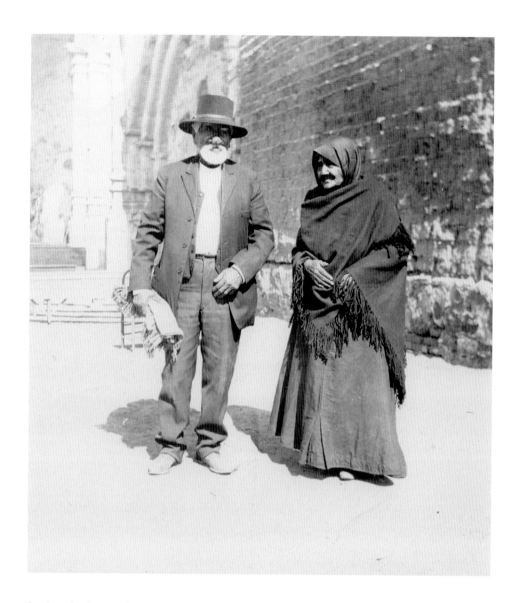

Looking back now, having gone through the same system that every other person goes through in America—going into kindergarten, being trained that you would be American, and that...George Washington is your father, I think it was always obvious to me that—no, no, no! [laughs]... George and I are not related.

So I always had something there, but...maybe in my early teens I was able to actually understand it...feeling ties with the land or the people or anything that was happening around [here]. This was why—because I am from here, this is where not just me, but all of our people before were from...

It's really hard to explain...Just standing on top of Mount Baldy and being able to see the ocean. It's Catalina, just taking that breath of like [sighs], "We are here, this is us!"...When we would go to the reservation—we would go probably once a month, and it would seem like forever to get there—but I remember...we'd get to this certain portion...and I would say, "Ah, those are the rocks that's bringing us, this is where we are, these are the rocks that belong there because we belong here." And I would know...by seeing those rocks that we were almost there to where we were supposed to be, with family and friends that were on the reservation...I think I always had some kind of consciousness at different levels that was always building, building and building.

—*Virginia Carmelo (Tongva)*

Aku, also called Jose de Garcia Cruz (Ajachmem), with his wife at Mission San Juan Capistrano, 1925.

Photo by E. C. Howell. Courtesy of the San Juan Capistrano Historical Society.

When you learn your history, a lot of things begin to make sense…Our people have a soul sickness, we self-destruct, keep everyone at bay…Once you explain that…things begin to happen.

—*Beverly Means (Barona Kumeyaay)*

Jose Candelario Doram (Ajachmem), Santa Ana, 1880s. Born in 1864, he became a tribal elder, sheep shearer, linguist, and historian. He was one of linguist J. P. Harrington's southern California consultants.

<small>COURTESY OF FRAN YORBA.</small>

Carmelita and Pedro LaChappa
(Kumeyaay) at Viejas, 1920s.
COURTESY OF JANE DUMAS.

Cecilio Tumamait (Chumash) and his
wife, Maria, with Margaret, Vernon,
and Vincent Tumamait and Antonia and
Henry Leyva, Santa Ynez, 1924.
COURTESY OF VENTURA COUNTY MUSEUM OF
HISTORY AND ART.

Julie Tumamait-Stensley: Aunt
Margaret told me, "My father
used to take us out to Santa
Ynez...they used to lend us
out." [I said,] "Lend you out?!"
"Yeah, yeah, we'd work for that
ranch and when we were done
working, they'd send us down
the road to work for the other
people." I was stunned, and she
accepted that with such ease.
It was just the way of life back
then—that these people, once
secularization happened during
that mission period, people
were given little homes along
Ventura Avenue—and our old
home on Olive Street is the
on-ramp to the road to come to
Ojai—but they grew up in these
little houses and then they went
to work. They dried apricots
for people. They picked all
kinds of food.

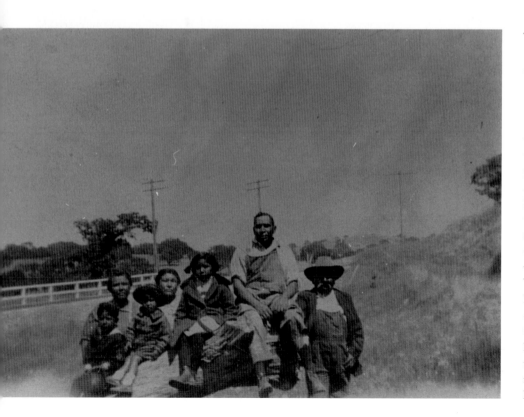

*Salvador Qwilix (Pechanga Luiseño),
Pechanga, 1921.*
Courtesy of Mark Macarro.

Mark Macarro recounted that
Salvador Qwilix was famous
for his beautiful singing voice.
He was said to have been the
best singer of Laaqwish songs—
ancient funeral songs accompa-
nied with a deer-hoof rattle.

*Kumeyaay men with funerary figures
performing a sacred dance, Campo,
1918. Second from left, Jim McCarty;
second from right, Paion Cuypipe.*
Photo by Edward Davis. Courtesy of Harry
Paul Cuero Jr.

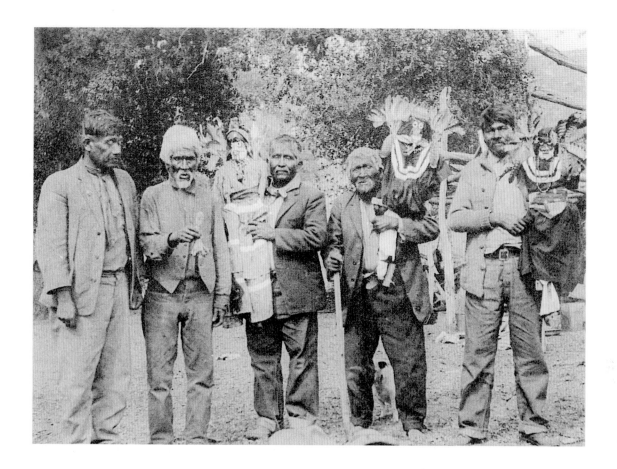

We are faced today with a lot of the burials being disturbed...In the last ten years I think they've uncovered at least three new burial sites each year. Three...

As a young person with not so many elders around, sometimes you know that things are important, and you know that they have meaning, but you don't know exactly the pinpoint of it, what things symbolize and why it's not right to uncover somebody—although you just feel it within you that it's not.

So one time I was monitoring this site in San Pascual...It was in this park that was completely forgotten...and they wanted to put new grass in it. As they were excavating, the excavator hit a skull. A skull. And all these new pipe systems were going to be put in there, and so they called us out and the city is like, "Okay, we need to finish. We hit the skull, let's take it out and rebury it." And so I sat there all week while they were taking out the burial, and there was about four archaeologists on the site, and they were being very careful, trying to be as respectful as possible...This [one] person had four projectile points with him in his hand, I think, and he was also buried in a very strange way, very strange. Face down, with legs up...

I was feeling very uneasy—very—but I couldn't really pinpoint my feelings over a lot of things. So, as they were removing the last bone, all of a sudden I hear [makes a surging, whistling sound in three pulses], and there's one hawk, and then two hawks, and then three hawks, and then four hawks came around...I just, it was the weirdest thing. I just broke down, I started crying—the whole week I held it together—and I cried and I cried, and I had to get away...

I knew how important and how symbolic everything was, but it really grounded it for me. How serious this really is, how sensitive it is for somebody to be taken out of the ground.

—Tonantzin Carmelo (Tongva)

PEON ("PAY-ÓWN,") IS THE SOUTHERN CALIFORNIA VERSION OF A GAME PLAYED throughout Native America. Two teams sit in a line opposite each other—there might be four players on a team—and every player is equipped with a white bone and a dark piece of wood. Each team also has a number of counting sticks for keeping score.

Presiding over the game is an umpire-like person who resolves any disputes that might arise and holds the money that the teams have laid down for bets. Aside from the main bets made between the players, those in the assembled crowd frequently place bets of their own. Lined up behind each team are women, who do not play but sing to encourage their side and intimidate the opposition with the power and confidence of their singing. The players on each side have a blanket stretched across their knees, and they grasp it in their teeth to hide their actions as they shift the playing pieces from hand to hand.

After attaching the pieces to their wrists with short cords to prevent last-minute switches, the players drop the blanket and cross their arms over their chests, tucking their hands into their armpits and joining the singing. The other team must then guess where the pieces are hidden: which hand of each player holds the white bone. If they guess all four correctly, the pieces pass over to them for hiding. If some of their guesses are incorrect, they must repeat the process with the players they guessed wrong until they have caught all four sets of pieces. For each incorrect guess, the hiding side receives a counting stick. Play continues, passing back and forth between the sides, until one team amasses all of the sticks.

More than a simple guessing game, peon is rich with banter and psychological tension. And as Jane Dumas, a Kumeyaay elder from Jamul, implies, the game was far from trivial, carrying with it an undercurrent of ancient beliefs about the nature of luck and power:

> The louder the singing, the happier the players. And the old-timers took it very seriously. It's not just a run-of-the-mill thing, like "We're going to go play tennis," or anything like that. It has to be something that has a lot of meaning to them, to the players.

Peon involves the whole community. One of the most popular gambling games among southern California tribes for centuries, it is still popular, among young and old, at tribal gatherings today.

OPPOSITE *Kumeyaay men playing peon, Jamul or Sycuan, 1961. The man in the white cowboy hat is Ambrosio Thing; Sam Brown is to his left.*
COURTESY OF JANE DUMAS.

Kumeyaay men playing peon.
COURTESY OF HARRY PAUL CUERO JR.

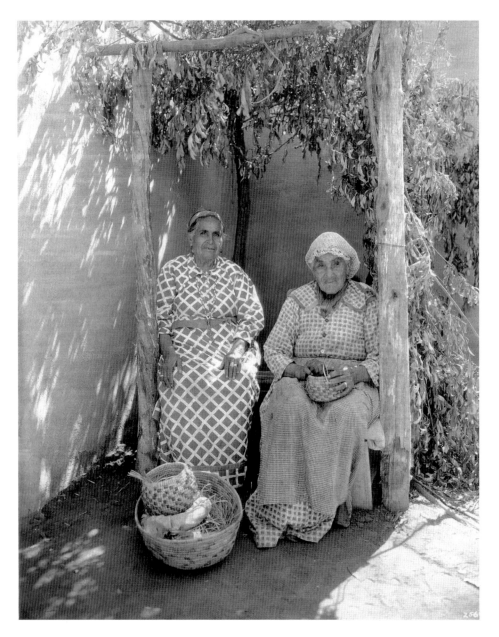

Andrea Cuevas and Maria Ygnacio Nejo Yuachena (Kumeyaay) as part of a living display at the Balboa Park Exposition in San Diego, 1935.
COURTESY OF KAREN VIGNEAULT.

Karen Vigneault recounted that Maria Ygnacio Yuachena was a historian. She lived to be over a hundred years old. A star pattern was her trademark on baskets. Many of the baskets the Kumeyaay women made were given away during their lifetimes or burned when they died.

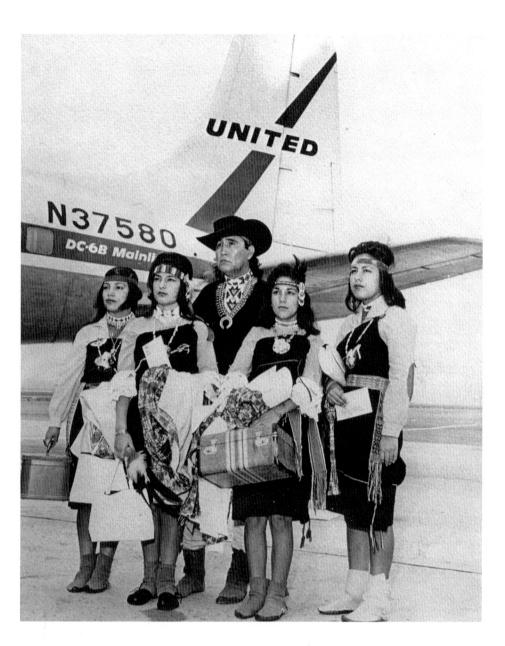

Semu Huaute with daughters Nashun, Samuka, Weewish, and Papuya (Chumash) heading to an international youth leadership conference, 1963.
<small>COURTESY OF NASHUN HUAUTE.</small>

Nashun Huaute: I'd never been on an airplane. We were going to Mackinac Island…representing southern Californian Indian teenagers, and they had all these teenagers from all around, from every tribe and from every nation…All the different teenagers going to this big huge gathering where we were together to pray for peace, and to get to know each other… We just all kind of worked together. We had these competitions of groups, we had relays, and just had fun…We were all kind of shy and quiet, but we enjoyed it.

In my early teens we had a group of buffalo dancers, with some young teenage boys. We got together with some Pueblo people, and they taught us the dancing, and we danced as couples, as pairs, and we would do these benefits for the Boy Scouts, and the different schools, and money was donated…and clothes and food for the Indian people on the reservations—and of course then things were a lot different, and they really needed a lot of help. And so my dad [Semu Huaute] got this together with Mr. Garcia. And that's what we did for about three to five years. On our weekends we would practice, and all summer long we would go to different places and help out—a lot of the different pueblos.

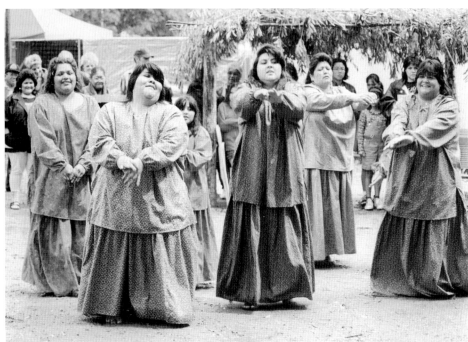

Kumeyaay bird singers at the Barona Cultural Center opening in 2000. Left to right: unidentified, Paul Cuero Jr., John Christman, Steve Banegas, unidentified.

<small>Courtesy of the Barona Cultural Center.</small>

Cupeño dancers in Hawaii, 1997.

<small>Courtesy of the Cupa Cultural Center.</small>

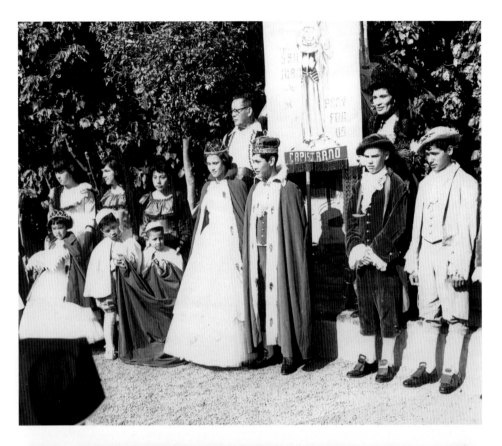

Marcelina Soto and Elias Mesa, Queen and King of Swallow Day at Mission San Juan Capistrano, 1960s.
PHOTO BY PAUL AVISO. COURTESY OF RUTH LOBO.

L. Frank: So did life revolve around the mission?
Ruth Lobo: Oh yeah, it revolved around the cemetery. I remember going to the cemetery a lot as a kid. A young kid. I'm talking about maybe a year old. Lobos have long memories.

Richard Mendez Jr. and Richard Mendez Sr. (Ajachmem) at a ceremony in San Juan Capistrano, 1989.
COURTESY OF RICK MENDEZ.

Rick Mendez Sr.: I came back [from Korea] in '52 and...worked and started a family. And then shortly after that we started coming to the meetings, and reuniting all our people, which was really nice. And you know, it doesn't seem like it was that far back at all.

COASTAL SOUTHERN CALIFORNIA

THE CHUMASH OF THE SANTA BARBARA AREA AND TONGVA OF THE LOS ANGELES area, while linguistically separate, are neighboring groups with similar cultures. Among the things they share is the plank canoe, called *tomol* by the Chumash, *ti'at* by the Tongva. To build them, both tribes used redwood from the north that had washed up on southern beaches. If redwood wasn't available, they used pine. They split the driftwood into long, even planks with whalebone wedges, then shaped the edges of the planks so they would fit tightly together. They drilled holes in the planks and sewed them together with yards of plant-fiber cordage. They caulked the seams with *yop* (Chumash), a sticky gum made from asphaltum (tar from natural seeps) and pine pitch. They sanded with sharkskin, stained the planks with red ochre, and decorated the boats with inlaid abalone shell. These seagoing canoes were large and impressive, often about thirty feet long and able to hold up to four thousand pounds. Crews ranged from six to twelve people.

Tomols were built and crewed by a kinship-based society called the Brotherhood of the Canoe. In about 1912 Fernando Librado, or Kitsepawit, a Ventureño Chumash who in his youth had assiduously collected information from members of the brotherhood, dictated his memories about boat building to the linguist J. P. Harrington.

> The board canoe was the house of the sea. It was more valuable than a land house and was worth much money. Only a rich man owned such a canoe, and sometimes he might own several...The Indians were united in spirit with their tools...The old-time people had good eyes, and they would just look at a thing and see if it was right. No one hurried them. It was not like the whites. The Indians wanted to build good canoes and they did not care how long it would take...An old canoe maker would have his helpers and he would allow no one else around...Palatino made three canoes at Mitsqanaqa'n with the help of Vicente Qoloq, Teodoro, Leandro, Almuastro, myself, and others...When Palatino finished making them, they went to sea. One of his canoes was like a flower on water.[6]

In the days before Spanish missionaries and Russian otter hunters arrived in Alta California, hundreds of tomols and ti'ats plied the coast, connecting the villages of the mainland with those of the Channel Islands. Trade, travel, hunting, and fishing were all accomplished by boat. By 1800 the Tongva ti'ats were out of use, and by 1834 ten Chumash tomols were all that remained of a once vast flotilla.

The marvelous watercraft of the Tongva and Chumash seemed destined for extinction, their memory preserved only in archives and anthropological journals. But in 1976 something amazing happened: a team of anthropologists and Chumash people built a tomol using Harrington's notes and, for a model, a tomol whose construction Librado had supervised for Harrington. The *Helek*, named for Peregrine

OPPOSITE *Ti'at* Mo'omat Ahiko *being paddled by Marcus Lopez, Burt Barlow, Pastor Lopez Jr., Rick Mendez, and John Adargo on its first voyage to Catalina Island, 1995.*
PHOTO BY KATHY CONTI. COURTESY OF CINDI ALVITRE.

Barbara Drake: It was so beautiful when we watched them come around the point, and by then we were all pretty emotional... that this has really come true, that this is who were are, and this is what our people—like we were standing there watching them do this, like two hundred years ago, how they would come to the islands.

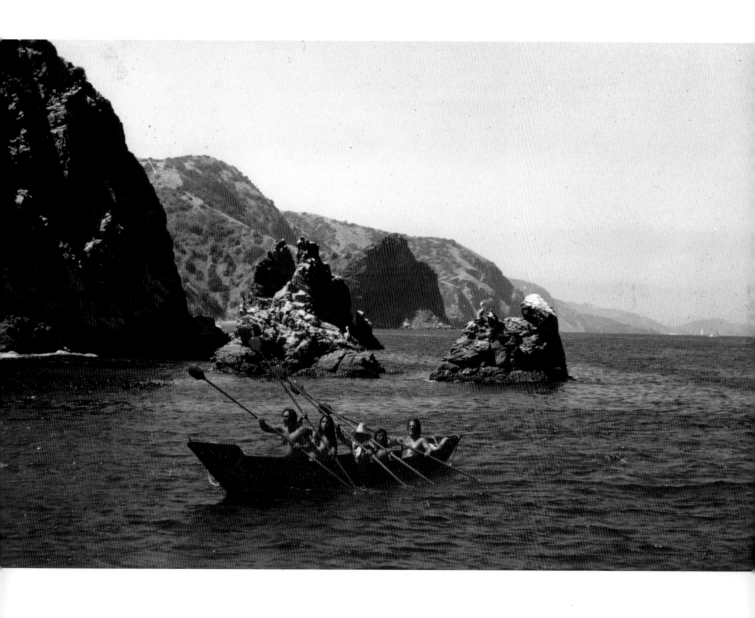

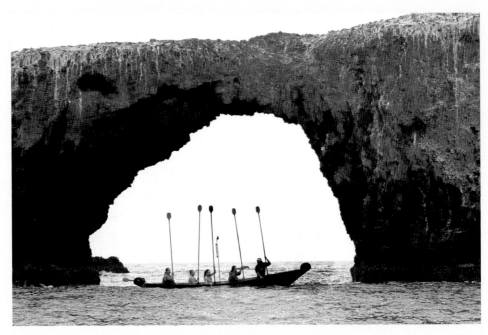

Falcon, was taken out to the Channel Islands by a Chumash crew in a difficult and much-celebrated journey.

Helek is long retired and now hangs on a wall in the Santa Barbara Museum of Natural History, across a courtyard from the boat Librado built. But the revival of southern California maritime tradition did not stop there. What had begun as a sort of anthropological exercise grew into a cultural victory when the Tongva people completed the first ti'at to be built in over two hundred years: *Mo'omat Ahiko* (Breath of the Ocean) was launched in January 1993 and, after years of training and practice, paddled to Catalina Island (Pimu) in 1995. Cindi Alvitre (Tongva) recalls the strength of vision that she and others felt even before they met kayak expert Jim Noyes and others who helped them make *Mo'omat Ahiko* a reality:

> I had this dream that the ti'ats came back to our people through a warrior that emerged out of a mountain behind my house. The mountains opened up and the ocean was there, and the islands, and my people were in ti'ats—turning them all towards the islands—and we were paddling, singing in our language, rowing, going towards the islands as one big family, going back home.[7]

Barbara Drake (Tongva), active in the Ti'at Society, recalled:

> The preparation and the actual thought that we could do something that had not been done…for two hundred years is what motivated us—and that we could all get together and prepare for this event as a big giant family, and how happy we were, making the garlands to put on the beautiful ti'at…
>
> When the paddlers were coming home they weren't tired anymore. They were so happy. We were singing them in, and bringing them back

Members of the Chumash Maritime Association paddle the tomol 'Elye'wun *past the arch of Anacapa Island, 2001.*

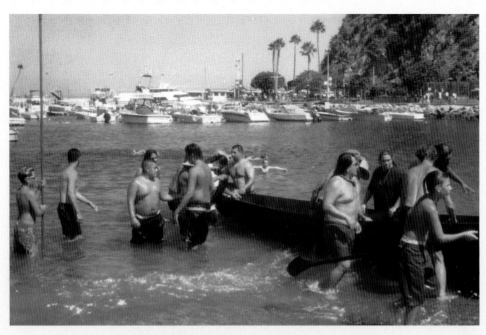

home to the island. And to be part of this, part of our history, was just
the most amazing thing…To see that happen was pretty special.

In Chumash country, the Chumash Maritime Association began building *'Elye'wun*
(Swordfish) in November 1996 with the help of Peter Howorth, a boatbuilder who had
been essential to *Helek*'s construction. *'Elye'wun* was launched in November 1997 and
paddled from the coast to Anyapakh (Anacapa Island) and then to Limuw. Her crew
for the 2004 crossing, which included many longtime Chumash Maritime Associa-
tion members, consisted of Perry Cabugos, Marcus Lopez, Michael Cordero, Roberta
Cordero, Michael Cruz, Tom Lopez, Rick Mendez, Oscar Ortiz, Reggie Pagaling,
Alan Salazar, Jacqueline Scheinert, Steve Villa, and Mati Waiya. The landing crew
was Marcus V. O. Lopez, Tano Cabugos, Diego Cordero, Jimmy Joe Navarro, and
Michael Sanchez.

An article by Julie Cordero explains that *'Elye'wun* is not just an anthropological
novelty or even a cultural triumph:

> A traditionally built Chumash tomol, bound together with two miles
> of respectfully tended, sustainably gathered dogbane cordage, is…
> more than a beautiful, handcrafted wooden boat: she is our balancing
> point, our fulcrum between our world and the world of our ancestors;
> between the earth that gave us the plants to build the canoe so we
> can fish, and the ocean that gives us the fish; between our skilled,
> practical, ecological knowledge of this land and our humility and awe
> in the face of the Pacific Ocean; between our birthright as descendants
> of this land and our obligation to serve the people. The tomol is the
> embodiment of our commitment to this land and the water.[8]

To all who see them, the plank canoes that once again ply the coast of southern
California are indeed, as Fernando Librado said, like flowers on water.

*Members of the Ti'at Society during a
launching at Avalon on Catalina Island,
1995.*
Courtesy of Barbara Drake.

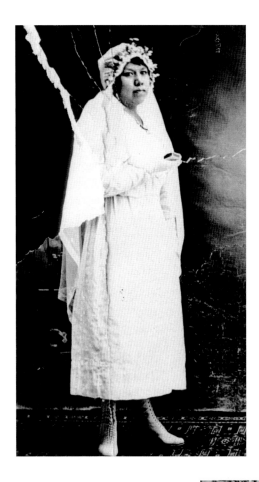

Vera Ortega (Tataviam) at her First Communion, San Fernando, c. 1915.
COURTESY OF BEVERLY SALAZAR FOLKES.

Cecilia Virginia Cruz (Ajachmem), 1916.
COURTESY OF CHRISTOPHER J. CRUZ.

Christopher Cruz recalls that Cecilia Cruz went by her middle name, Virginia. She married Johnny Ramos. They had no children, but she baptized a lot of people and was much loved in San Juan Capistrano.

The Grand family, c. 1905. Bernardine Osuna Grand (Diegueño) is seated in the back row at left. Margaret Grand Farmer is seated in the center of the front row.
COURTESY OF JUSTIN FARMER.

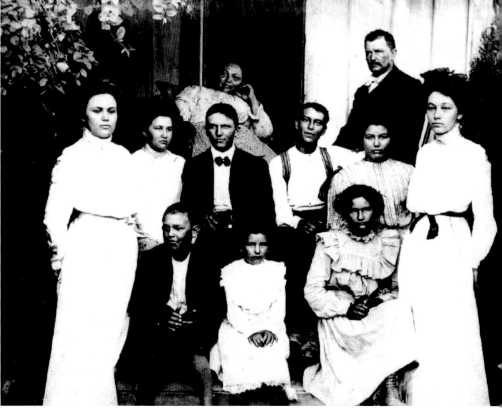

Rose Valenzuela Lassos (Tongva), Santa Monica, 1980s.

Albert Lassos Sr.: This is a photograph of my mother, Rose Lassos. She was born in San Gabriel March 29, 1887. My sister Anita...had a big backyard and used to have these parties for my mother every year or every two years, and we used to have a real good time—plenty of food, plenty to drink, and it was a good time. My mother used to enjoy things like that when she got all her kids together.

My mother spoke Spanish also, and she spoke a few Indian words but nothing like a whole lot...She raised us all on English...She wanted us all to get an education and to grow up to be somebody. She didn't want us to be a bum or anyone going...in that direction, or she'd change your mind real quick! When I got out of high school, I got three or four scholarships to go to four different colleges or something and go play football.

My mother used to tell us all kinds of little stories about the Indians coming from the hills to go wash in the gully or in the ocean.

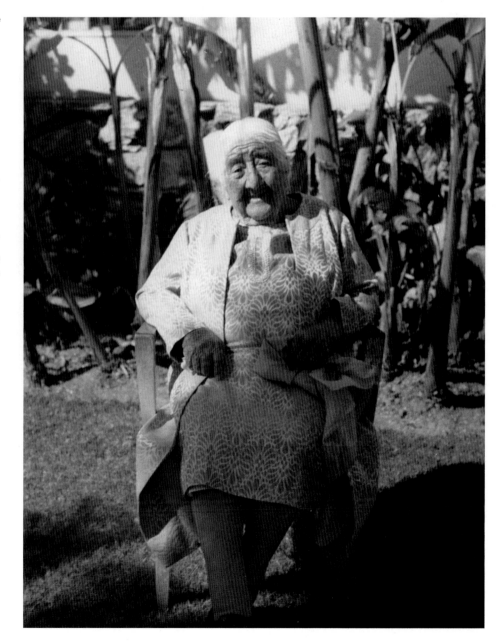

Alfonso Lobo (Ajachmem) at the age of twenty-two, Santa Ana, 1910.
COURTESY OF FRANK LOBO.

Frank Lobo (Alfonso's son): He was the son of a fairly wealthy landowner, Felipe Lobo—owned a ranch north of town…It was a very large, busy ranch at that time, according to what he told me. It was sold by Felipe Lobo. [He] was an extravagant fellow. He liked to gamble, and I think he gambled away the ranch.

[About San Juan Capistrano] They—the "native element" and mainstream culture—were pretty well mixed. You didn't know where one began and the other one left off. There was both, together…We had a special feast day on December twenty-first, twenty-second, because that was the winter solstice. So…Christmas and the winter solstice were combined together into one big feast.

There was no distinction, too much, between Mexicans and Indians—except everyone knew that the older families were all Indians, and younger families were newcomers—*nuevos*, recent ones.

Esperanza Robles Lobo (Ajachmem), Santa Ana, 1910.
COURTESY OF MARGUERITE RAMONA LOBO.

Marguerite Lobo explains that this was a studio shot of her mother at about sixteen. Her given name was Esperanza and she went by Hope. She played guitar and mandolin and loved the music of the Twenties— Charleston tunes—and played them all the time. She had a little band and her father played guitar in it. She wore the highest heels and the shortest dresses, with her hair "up in ruffles." Marguerite's father played the violin and would play with Hope's band occasionally. Hope died young of tuberculosis.

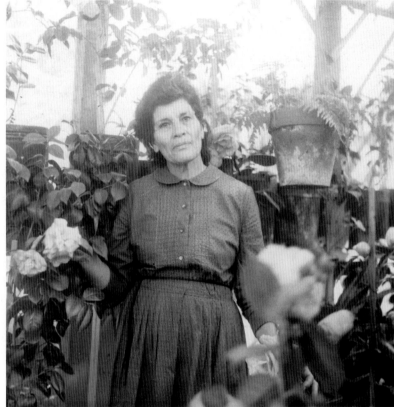

Rita Lobo (Ajachmem) in her nursery,
San Juan Capistrano, 1970. Photo by
Frank Lobo with a Brownie twin lens.
<small>Courtesy of Frank Lobo.</small>

Philip Saturnino Miranda (Ajachmem),
a member of the Lobo family, before
leaving Santa Ana for World War I.
<small>Courtesy of Christopher J. Cruz.</small>

Frank Lobo (Rita Lobo's son):
She had all the plants from
the area…she did a lot of
carnations of various colors…
and she raised the roses and
fruit trees, like guava trees…
She would gather a lot of wild
plants, medicinal plants as
well, she knew them well…
I'll always remember being
doctored by her.

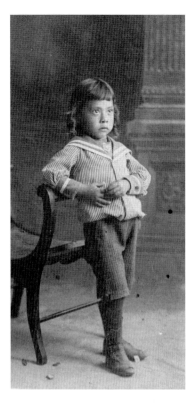

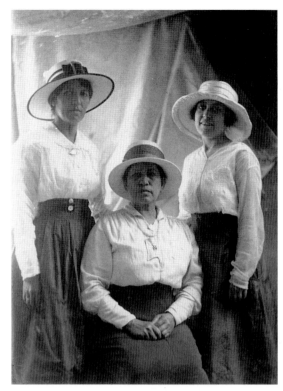

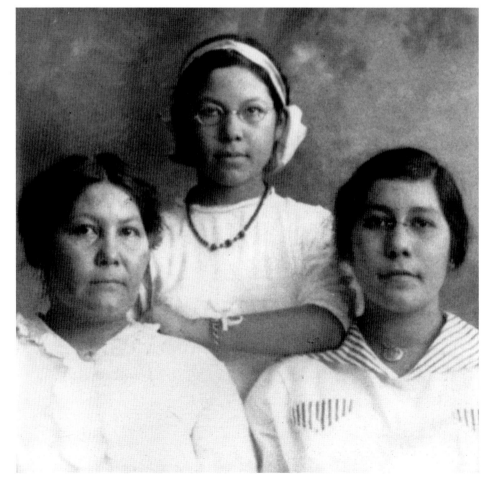

Nick Bermudez (Chumash), Santa Barbara, late 1800s.

Catherine Bermudez (seated), with daughters Maggie Arabus (left), and Rosa Padilla (Chumash), Santa Barbara, 1920.

Diane Garcia Napoleone (Rosa's daughter) recalls that her mother's fifth husband bought her the Rose Café on Haley Street in Santa Barbara so she'd have something to do—the family operated it until the late 1950s.

Mabel Mendez, Nefa Valenzuela, and Ricardas Gaitten (Ajachmem), San Juan Capistrano, 1920s.

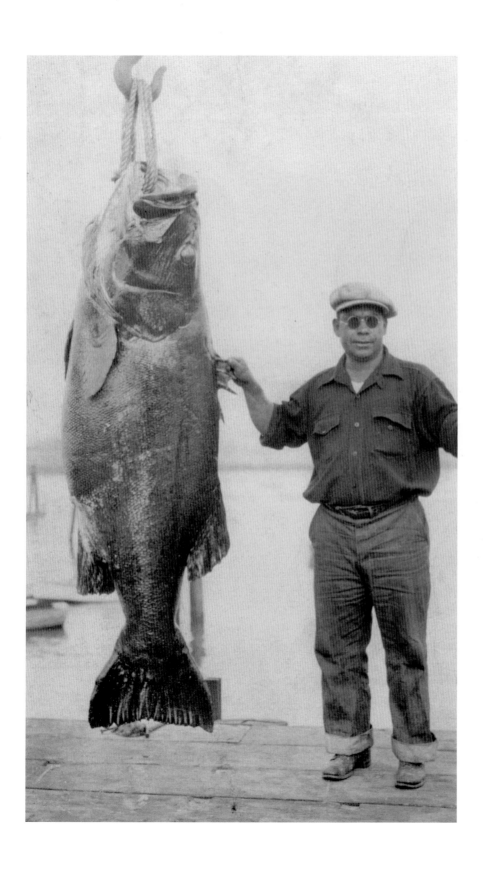

Nick Bermudez (Chumash) with a giant sea bass, Santa Barbara, early 1930s.
COURTESY OF DIANE GARCIA NAPOLEONE.

Diane Garcia Napoleone: What can I tell you? He liked to fish!

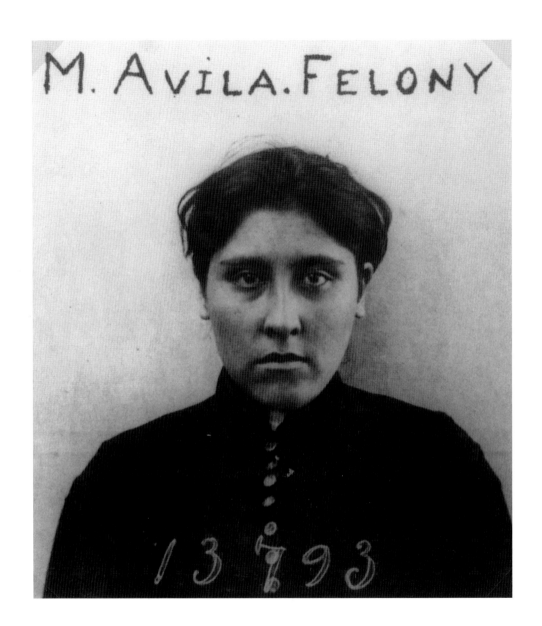

CONTRARY TO POPULAR ILLUSION, THE INDIANS OF CALIFORNIA DID NOT SUBMIT docilely to the Spanish missionaries. From the earliest days, there were rebellions and confrontations. In fact, the first of the southern California uprisings against the Spanish occurred in August 1769, only two months after the founding of Mission San Diego. Here the Kumeyaay engaged the Spaniards while raiding the mission for Spanish goods. If nothing else, they slowed down the missionaries' progress: no converts were made for an entire year afterward.

Six years later, in the fall of 1775, violence again broke out at San Diego. Local leaders and shamans mobilized a huge group of warriors from fifteen villages, attacking the mission and burning it to the ground. During the battle several people were killed, including Father Luis Jayme.

In 1785, Toypurina, a shaman who refused to convert to Christianity, attempted to lead her people in an uprising at Mission San Gabriel. Her co-conspirator, neophyte Nicolás José, was to rally the Indians within the mission while Toypurina convinced free Indians from outlying villages to join their cause. The Spanish discovered the plot and were lying in wait when the Indians invaded. During the trial that followed, Toypurina was questioned about why she had assembled forces to invade the mission. Her testimony was simple and to the point: she was angry with the priests because they were living on her ancestral land.[10]

Although she failed to drive the Spanish from the area, Toypurina's uprising is significant for other reasons. The collaboration of a traditional religious leader with a missionized Indian points to a new direction in the leadership of tribal peoples in California, a blending of the new and old ways.

Traditionally, people had been divided into small towns and villages, each with its own territory and leadership. In the missions, people found themselves having to get along with others who spoke different languages and who were in some cases traditional enemies. Divisiveness and dispersion of power hampered revolt and enabled missionaries and soldiers, though outnumbered, to control the native population.

By the 1820s, however, this began to change. The so-called Chumash uprising was a widespread, highly planned, coordinated attack by many people on three missions at once, La Purísima, Santa Inez, and Santa Barbara. Hundreds of people were involved and caused significant destruction at Santa Barbara and Santa Inez. The rebels managed to hold La Purísima for a month against Mexican troops. In the end a large group of neophytes fled to the interior and established a colony in the "Tulares," the southern part of the San Joaquin Valley, refusing to leave until, under a flag of truce, they negotiated with the Mexicans the terms of their surrender. Four leaders were sentenced to ten years of chain-gang labor, but two of them managed to escape.

OPPOSITE *Modesta Avila (Ajachmem), prison photo, 1889.*
COURTESY OF SAN JUAN CAPISTRANO HISTORICAL SOCIETY.

Angered by the noise and filth of the Santa Fe railroad running through her mother's land and that they had never paid for the right of way, Modesta Avila protested: locals said she hung her laundry on a clothesline across the tracks; Santa Fe said she placed a railroad tie across the tracks. Either way, a railroad agent removed it before the train came. Four months later Modesta Avila was arrested and charged with attempting to obstruct a train. She was sentenced to three years in San Quentin. She died, at the age of twenty-two, after serving two years of her sentence.

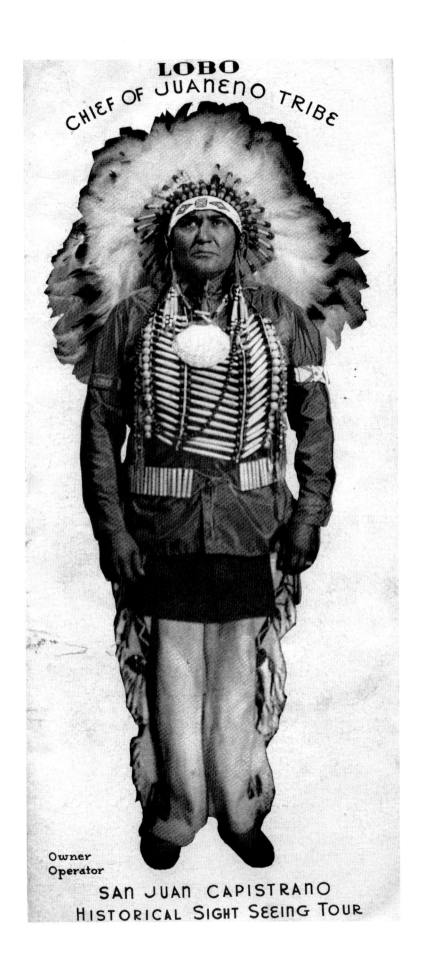

Image of Chief Clarence Lobo (Ajachmem) from a brochure, 1940s.
COURTESY OF BERTHA STANFIELD CARTER (BOLA) AND JOYCE STANFIELD PERRY.

Bola Carter: He was our chief in the fifties, forties, and even further back. It was Clarence that fought for our land rights. [In the seventies] we were all protesting. We all walked down the street dressed like Indians. Then we just, wherever we thought the property was nice to build a home, we just put our stick down. Then we mailed a money order to the president [of the United States] for twelve dollars and fifty cents. And he rejected it. They sent us back all the money orders saying, "This is not your land. This land belongs to the govern-ment and that's it." After that, when we went to Washington, he [Clarence Lobo] went in to start talking. He said, "If we can't have our property, our land, then you pay the Indians the money that you owe them." But they only gave us some-thing like six hundred and sixty some-odd dollars. Big deal.

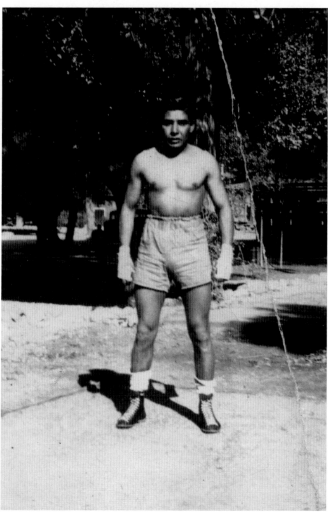

LEFT *Vincent Tumamait (Chumash) as a middleweight boxer in Ventura, 1930s.*
COURTESY OF JULIE TUMAMAIT-STENSLEY.

Julie Tumamait-Stensley recalls that her father, Vincent Tumamait, sometimes changed his name to Lopez, particularly during his boxing days—no one would hire Indians.

Later in life, he started doing school programs about Chumash culture and began learning older songs and stories. He traveled with the "Painted Cave Choir" and sang at the Hollywood Bowl.

ABOVE *Frank Lobo (Ajachmem), San Juan Capistrano High School, c. 1947.*
COURTESY OF FRANK LOBO.

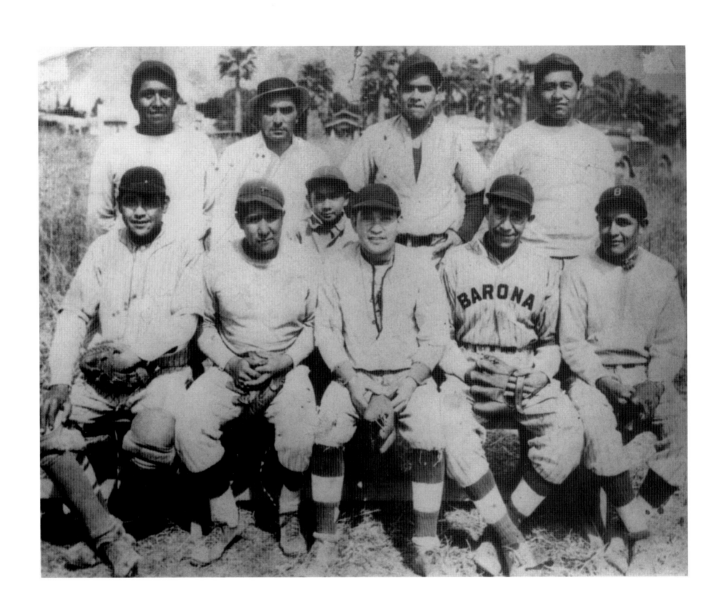

The Barona baseball team, Oceanside,
1935. Back row, left to right: Cay Curo,
Alfred Magginni, Gene Curo, Victor
Rodriguez. Front row, left to right: Bill
Banegas, Martin Prieto, batboy, Frank
(Hack) LaChappa, John Banegas,
Vincent Mesa.

Aunts Lisa (TiTi) and Grace (Ajachmem),
San Juan Capistrano, 1930s.

Justin Farmer (Diegueño), front and
center, Julian Elementary School,
c. 1931.

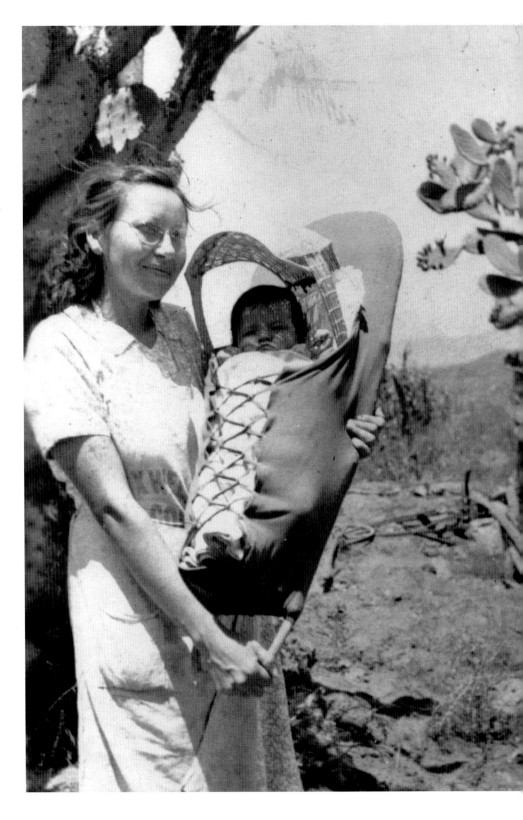

Pauline Pratt Freeman (Hunkpapa Sioux) holding her son Robert (Hunkpapa/Luiseño), Rincon, 1940.
<small>COURTESY OF ROBERT FREEMAN.</small>

Robert Freeman: We would travel—I was raised in Vallejo... so we would go over across to Reno, to Elko, and through Wyoming to South Dakota...In fact, as a child, I was taken to South Dakota in the summertime and we would stay with my grandmother while my mother worked...To me it was very, very Indian—because living in Vallejo we had buses and radios, electricity, and going back to South Dakota, they had no electricity, no running water. They ate off the land, literally. They raised a little corn. They ate beaver, deer, we went to the Indian agency on a buckboard every weekend. We'd go to the Indian Agency to get vaccinated, to buy supplies. It was a social kind of thing, and all the Indian people spoke Sioux. And being a California kid, I didn't know the language at all and kind of felt a little bit alienated, but at the same time, I played with all my cousins, and my aunts and uncles, so I was part of that family.

The Martinez family (Tongva), Buena
Park, 1940s: Viola, Angie, Lucy, Henry,
Stella, Henry Jr., and Fred.
Courtesy of Craig L. Torres.

Dolores Lassos (Tongva) in Los Angeles,
1940s.
Courtesy of Barbara Drake.

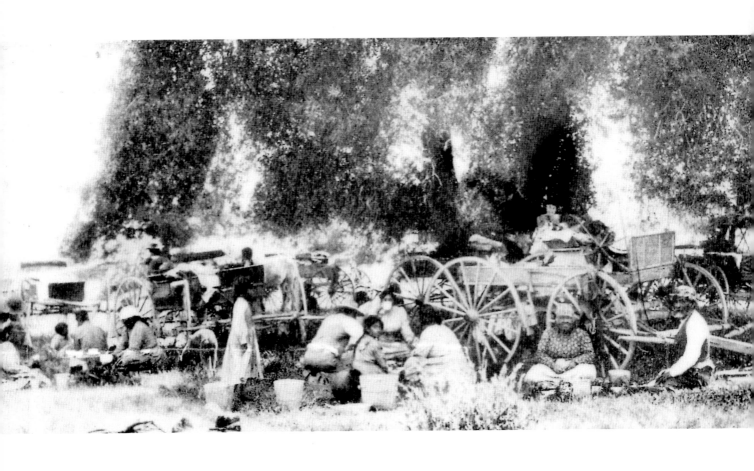

IN A SMALL AREA AT THE HEAD OF THE SAN LUIS REY RIVER LIES THE HOMELAND of the Kuupangaxwichem, called Cupeño by the Spanish and Americans. One of the smallest tribes in California, their population probably numbered about six hundred at the time of contact. They were organized into moieties, a kinship system in which half the people are in one descent group and half in the other—a straightforward approach to organizing family and sacred affairs as well as trade. From ancient times, the Cupeño occupied two permanent villages, Kupa (at what was later called Warner Springs because of its hot springs) and Wilákulpa.

In 1844, John Warner, a native of Connecticut who had come west in 1830 with a trading expedition led by the famed mountain man Jedediah Smith, became a naturalized Mexican citizen and was granted fifty thousand acres of Cupeño land by the Mexican government. He named the region Warner's Ranch and officially changed his own name to Juan José Warner. The people living at Kupa worked his ranch, and Warner encouraged them to build permanent houses and plant crops. Over the years a substantial village of adobe homes, gardens, orchards, a chapel, and a schoolhouse grew and even prospered.

In 1880, John Downey, an ex-governor of California, purchased the property from Warner. By 1892, the hot springs had become a popular tourist destination, and Downey filed a complaint in Superior Court against the Cupeños. He claimed they were "trespassing" and demanded their eviction. The tribe rebutted, noting that under Mexican law they had been citizens, and that the Treaty of Guadalupe Hidalgo had guaranteed that Mexican citizens would retain full rights of citizenship under the American regime. Thus, they argued, the tribe retained title to their ancestral homelands. Downey died in 1892, but in 1901, after much legal maneuvering, his heir was given authority by the courts to remove the Cupeño people from their homes. About two hundred Indians were living at Kupa at that time.

President Theodore Roosevelt appointed a commission to find a new home for the Cupeño people. Asked where he would like to go, Cupeño headman Cecilio Blacktooth replied:

> You ask us to think what place we like next best to this place where we always live. You see that graveyard out there? There are our fathers and our grandfathers. You see that Eagle-nest mountain and that Rabbit-hole mountain? When God made them, he gave us this place. We have always been here. We do not care for any other place. It may be good, but it is not ours. There is no other place for us. We do not want you to buy us any other place. If you do not buy this place we will go into the mountains like quail and die there, the old people and the women and the children.[11]

OPPOSITE *The last photo taken at Warner Springs before the Cupeño removal to Pala, May 1903.*
COURTESY OF THE CUPA CULTURAL CENTER.

Eventually the commission recommended that the Cupeños be evicted and relo-
cated with the Luiseños on Pala Reservation, near Palomar Mountain. On May 12,
1903, Indian Bureau agent James Jenkins arranged for forty-two wagons to begin the
removal. They rounded up ninety-eight people—including a pregnant woman who was
about to deliver—and threw their belongings into carts, and the procession started out
for Pala, about sixty unimaginably distant miles away. Cupeños consented to the move
only after the attorney they had hired to speak for them said that it would be useless to
resist further. Diana Lavato Duro remembers the lifelong effect the journey had on
her grandmother, Rosinda Nolasquez, who was about eleven years old at the time:

> They were scared. They didn't know what people were talking about
> because they didn't know English. These men would be telling
> them...to eat bread or drink, and they wouldn't take it because they
> were afraid they were going to poison them. They were really scared,
> being kids—you can imagine how you'd be afraid. It was so drastic that
> we had to learn her heartache. She didn't ask for that heartache. It
> happened...It happened in a way that she would never forget and she
> would never let us forget. Wherever she went, she told. She wouldn't
> be quiet about it.

When the caravan arrived at Pala on the morning of May 14, there were almost
as many reporters present as there were Cupeños. About a hundred more Cupeños
came on their own a few days later. Jenkins is said to have been tactful and firm in
managing the caravan, given that there was great tension among the teamsters as well
as the Cupeños. In fact, the baby born on the march was named after Jenkins.

While today Cupeños and Luiseños are united into a single political tribe, the
Pala Band of Mission Indians, Cupeño descendants have not forgotten their unique
history. There is a Cupeño Cultural Center at Pala, and Cupa Days, an event held
each May at Pala, commemorates Cupeño history and culture. In May 2003, the
centennial of the removal, Cupa Days were held at Warners Springs resort, in the
traditional village of Kupa. Using casino earnings, the Pala Band rented a large block
at the resort that included the seventeen adobe cottages that Cupeño people occupied
until 1903. Pala Vice Chairman Leroy Miranda, director of the Cupa Cultural Cen-
ter and great-grandson of Rosinda Nolasquez, explained: "The reason we did it is so
our people can remember where they came from. We want this to be an awakening and
a curing of a tragic time in our history."

Diana Lavato Duro: They wanted to
make sure that the people never
forgot they had a language and
a culture...Rosinda loved it
when the kids would beg to be
told more, they'd stay with her
for days...[She] would speak to
her kids and grandkids mainly
in Cupeño. All her friends
would be very impressed that
her grandkids were fluent.
Robert always told the kids to
listen to Rosinda, that one day
she wouldn't be there and they
would miss her.

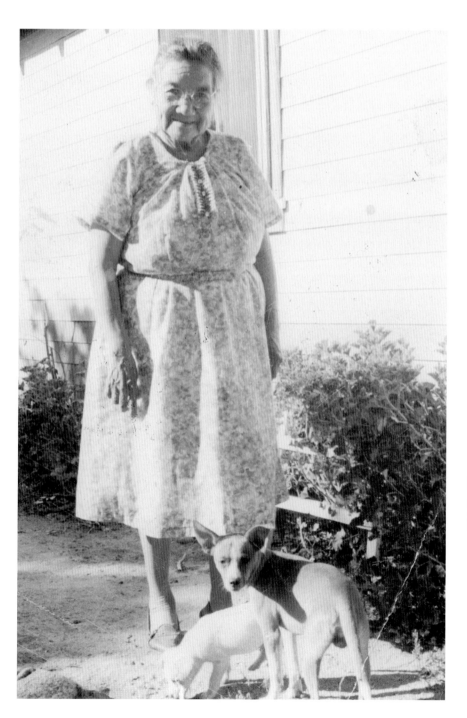

Marguerite Lobo: There was a big race in Elsinore and my brother wasn't going because he had to work…So he was on the ground there, working on his motorcycle, and he stuck his hand in his pocket and threw the keys at me: "Go." "Alone?" And he said, "But don't let anybody touch my motorcycle, and when you go down the grade in Elsinore"— you know how it goes around and around—he said, "Let your gas out, shut off your spark, then you'll get the pretty noise." 'Cause you know how it goes *rrrrr—rrrrr*—it makes that funny noise. I didn't dare say no, because he never let me ride it. So I went. "But don't go alone, take a couple of guys along in case something happens."

So we rode two, three miles out of town…And just before we got to the grade, I heard a group of motorcycles, from another town, I guess. They were looking at me…I had a stocking cap on, so maybe my hair was showing in the back. Because when they passed me, I heard the other fellow go, "It's a *girrrrlll!*" [laughter] And I had this hopped-up motor going *rrrrr.* Anyway, I did what he told me to, I shot up the gas and shut off the spark and it made a truck noise…it goes *brrrrr*, you know, like a growling noise. I did that going down the grade. That was a lot of fun.

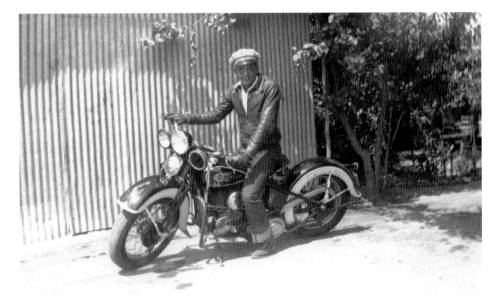

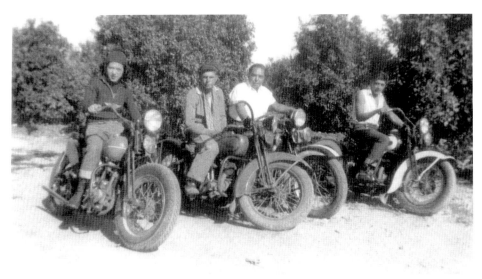

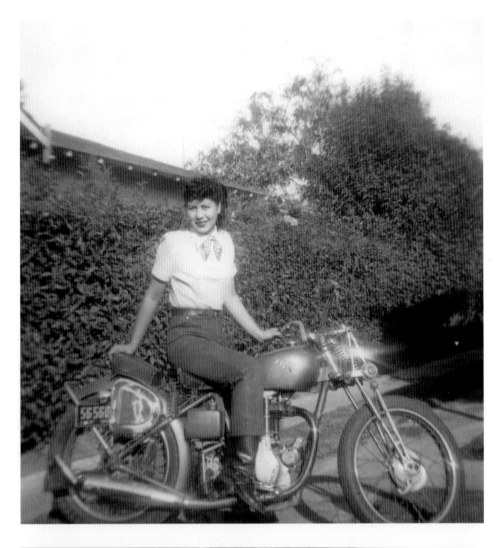

OPPOSITE TOP *Motorcyclists, including Henry Gaitten (Ajachmem), readying for an uphill race outside of San Juan Capistrano, 1920s.*
COURTESY OF RICK MENDEZ.

OPPOSITE MIDDLE *Richard Lobo (Ajachmem), on his brother Clarence's Harley 80, San Juan Capistrano, 1938.*
COURTESY OF MARGUERITE RAMONA LOBO.

OPPOSITE BOTTOM *Marguerite Lobo, Joe Lopez, Dave Velasquez, and Richard Lobo (Ajachmem), San Juan Capistrano, 1940s.*
COURTESY OF THE SAN JUAN CAPISTRANO HISTORICAL SOCIETY.

ABOVE *Barbara Gaitten Lorenzen (Ajachmem), Raitt Street, Santa Ana, late 1940s.*
COURTESY OF RICK MENDEZ.

BOTTOM *Rick Mendez (Ajachmem) with his partner Claudia, San Juan Capistrano, early 1990s.*
COURTESY OF RICK MENDEZ.

COASTAL SOUTHERN CALIFORNIA

As A GLANCE AT ALMOST ANY ATLAS WILL TELL YOU, THE WORLD IS FULL OF arbitrary boundaries that divide ecologically unified lands and culturally unified peoples. Among those affected by this phenomenon are the Kumeyaay of southern California and Mexico: their homeland stretches across what is now San Diego County and northern Baja California. Until the Treaty of Guadalupe Hidalgo (1848) drew a relatively senseless but all-important line through the middle of their territory, people traveled feely north and south as part of their seasonal rounds, trading, worshipping, celebrating, and intermarrying in that wider and yet unfragmented world.

Through the mid-twentieth century, indigenous people of Mexico and the United States could still travel easily across the border. With the tightened immigration laws and increasingly strict border policies of the last half-century, communication became increasingly more difficult, and the histories of the two groups began to diverge.

In Mexico, the Kumiai (as the tribal name is spelled in Spanish) were ignored, unrecognized by the government, and largely marginalized by Mexican society. Their villages are remote and economically poor. Ironically, the poverty and isolation have kept much of their traditional culture alive. Many still hunt, gather, weave, and otherwise pursue the traditions and activities of their ancestors. Many speak the Kumiai language fluently—in fact, there are some who don't speak Spanish.

Meanwhile, on the U.S. side of the border, government policies and the runaway economic development and population growth of San Diego County have led to loss of language and other aspects of culture for the Kumeyaay.

A few decades ago total cultural assimilation seemed inevitable, but this is hardly the case today. Led by cultural activists such as Jane Dumas, Richard Bugbee, Stan Rodriguez, Paul (Junior) Cuero, Mike Connolly, and others, a younger generation has reinfused tradition with energy, belief, and practice. While young men sing bird songs, artists skillfully weave baskets, and families head out to collect chia seeds, spring greens, and medicinals, the Kumeyaay are also garnering economic strength from their participation in mainstream culture. Casino income in particular has brought a measure of stability to the reservations of the Kumeyaay, as well as funding for cultural education.

The increasing wealth of many Kumeyaay communities north of the border has triggered a hunger for the cultural heritage still kept alive in remote villages to the south. But the Kumiai from these isolated communities often have trouble producing the kinds of documents that would allow them to cross the border to visit their relatives in the United States. Some were even born U.S. citizens, but they have no proof.

Since the 1990s, various individuals and organizations have been working to bring the Kumiai and the Kumeyaay into closer contact. At the forefront is the Native Cultures Institute of Baja California (CUNA), which has been organizing trips north for the Kumiai since 1992. (See http://www.nativa.netfirms.com/nativai/ncunai.html for more information) At such gatherings, food is shared, stories are told (often in the Kumeyaay language), baskets are woven. As people share the strengths they have developed since their histories diverged, the two cultures are slowly coming back together.

OPPOSITE *Bill, Margaret, Catherine, and Joseph Banegas (Kumeyaay) at the old Capitan Grande Reservation, 1919.* COURTESY OF BEVERLY MEANS.

Jane Dumas (Kumeyaay) with her children Daleane and Dale, San Diego, 1946. COURTESY OF JANE DUMAS.

Sisters Danica and Carmelita Cuero (Kumeyaay), Campo, 1996. COURTESY OF HARRY PAUL CUERO JR.

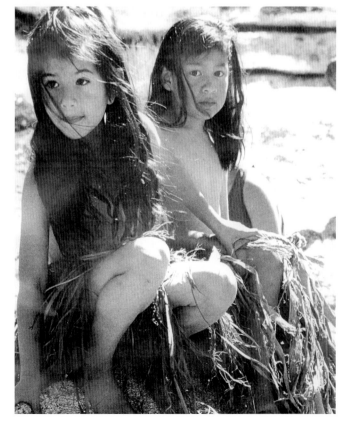

Born in Massachusetts in 1884, raised in Santa Barbara, and educated at Stanford, the brilliant and eccentric John Peabody Harrington devoted his life to recording endangered Indian languages. Although he traveled the country in the employ of the Smithsonian Institution, working on at least ninety different languages, he is best remembered for his work in California.

Everywhere in the state, it seemed, native people—many born before the gold rush—were rapidly fading away, and with them all memory of customs and fluency of language. Harrington worked day and night to salvage everything he could. His ex-wife, Carobeth Laird, once reminisced, "The vessel of the old culture had broken, and its precious contents were spilling out and evaporating before our very eyes. Harrington, like a man dying of thirst, lapped at every random trickle."

Obsessed with recording, Harrington published little. Instead, he accumulated hundred of thousands of pages of field notes, many written in several languages at once, sometimes in secret codes meant to discourage academic theft. He further obscured things by hiding his notes in caches throughout the state.

Chaotic, wildly inconsistent, and notoriously difficult to navigate, Harrington's records have nonetheless proven invaluable to contemporary native people, especially those whose languages are no longer spoken fluently and whose customs have been long forgotten. Linda Yamane, a Rumsien Ohlone from the Monterey Bay Area, described working with Harrington's notes:

> There are stories, or so-called myths, there—but...it's not like you just go to the story category and then copy down the stories in a row. You look through frame after frame after frame [of microfilm], and you get headaches, and you feel like your eyes are burning in their sockets, and your back hurts...and you spend maybe a year or so to learn how to read Harrington's handwriting, and you look through everything and find all the pieces, and eventually you hope that you can put it all together right. But there is *so* much there...It's not just words on a piece of paper, but it's saving something from the past that connects with people now.[12]

Equally heroic and perhaps equally brilliant were the native speakers with whom Harrington worked. While he was passionate about all endangered languages, Harrington was particularly interested in Chumash language and culture. Throughout his life, he had Chumash friends and collaborators. One of the first was Fernando Librado (Kitsepawit). Librado was born in the village of Swaxil on Santa Cruz Island, not long before the island's inhabitants were taken to Mission San Buenaventura in 1839. Growing up in Ventura, he was fluent in both the island dialect (Cruzeño) and the Ventureño dialect. During his long life, he worked as a vaquero on ranches throughout Chumash territory—Ventura, Santa Barbara, Lompoc, Gaviota Pass. He

spent considerable time collecting cultural data from the elders of his community, asking them detailed questions about every aspect of native life. He was an ethnographer of tremendous talent.

When Harrington and Librado found each other, only a few years before Librado's death, they seemed equally delighted—Harrington to have such a deeply knowledgeable "informant," Librado to have at last the vehicle for recording and disseminating the tremendous knowledge he had collected over his lifetime. It was an astounding and fruitful partnership. When, for example, the linguist expressed an interest in traditional Chumash canoes, Librado could not only tell him in detail how they used to be made, but agreed to direct the building of one. The canoe was completed in time for the Panama-Pacific Exposition in 1915. Later that year, Fernando Librado died, but his legacy lives on in Harrington's notes and recordings, and in the lives of those who have been nourished and informed by them.

Two years before Librado's death, Harrington had been introduced to a woman who, along with her family, would have a profound impact on his life and his work. In 1913 he had begun to work with Luisa Ygnacio on the Barbareño Chumash dialect. Ygnacio had been born at Mission Santa Barbara, probably in 1830. She died in 1922. Harrington passed long hours at her home in Santa Barbara, working first with her, then with her daughters Lucrecia and Juliana, and finally with her granddaughter Mary Yee, the last fluent speaker of Barbareño. It would certainly be fair to say that Harrington, in the end, became part of the family and its history. Mary Yee spent many long hours talking, working, and arguing with Harrington, particularly after his retirement to Santa Barbara in the mid-1950s. "Retirement" simply meant he was no longer traveling or officially working for the Smithsonian; Harrington rented a room at the Rivers Hotel and continued to passionately pursue the recording of the Chumash language and culture. When his health began to deteriorate, Mary Yee cared for him until his death in 1961. To this day, Harrington's constant presence in Mary Yee's kitchen is recalled with fondness and humor by Ygnacio-Yee family members. Yee's daughter, Ernestine Ygnacio De Soto, had this to say about Harrington:

> He would bring things, he would send gifts, he would give my mother
> gifts towards the end. And so it was kind of nice to see him. I always
> knew I might get a couple of dollars or something to get lost...
> My mother would always call him a cuckoo and draw a caricature of
> him [in her journal], because they would fight over various words,
> and they sometimes didn't agree. But they respected one another.[13]

Quirky, driven, and brilliant, Harrington made a contribution to our knowledge of the past that is tremendous and irreplaceable. His heroic efforts are remembered with gratitude throughout California by members of native communities who have found in his notes treasured records of their languages and customs.

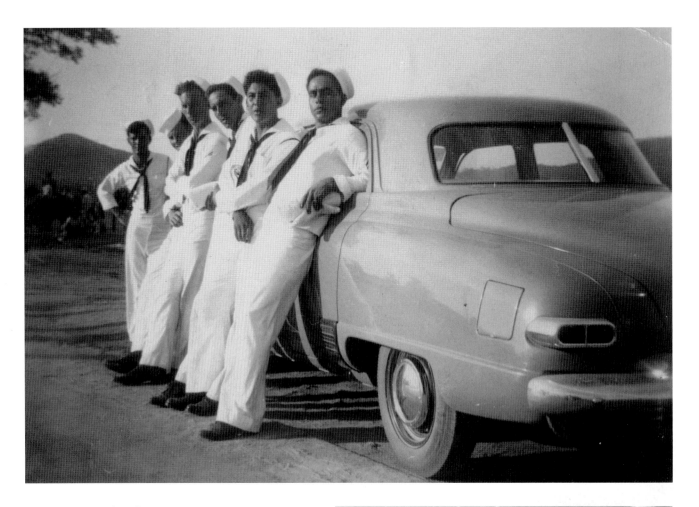

Bertha Stanfield (Bola) Carter: *The oranges would fall off the boxes [and] we'd gather the oranges in paper bags and run home, and here comes the four o'clock train, and at that time we'd throw the oranges to the sailors, the marines, and they'd throw us money. Nickels and dimes. Heck, we made some money off those oranges.*

Sailors—including Albert Lassos Sr. (Tongva)—leaning against a car while on furlough in Korea, 1946.
<small>Courtesy of Albert Lassos Sr. and Dolores Lassos.</small>

Albert Lassos Sr.: When I was in Korea I said, "If I ever get back to Culver City I am never going to leave again!"

Ray Ruis (Fernandeño/Tataviam), Pacoima, 1940s.
<small>Courtesy of Rudy Ortega Jr.</small>

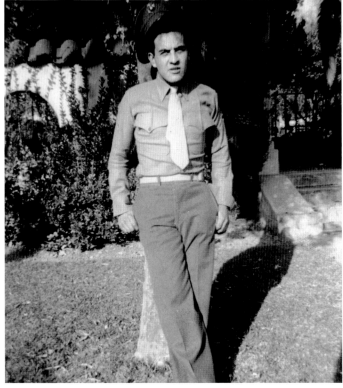

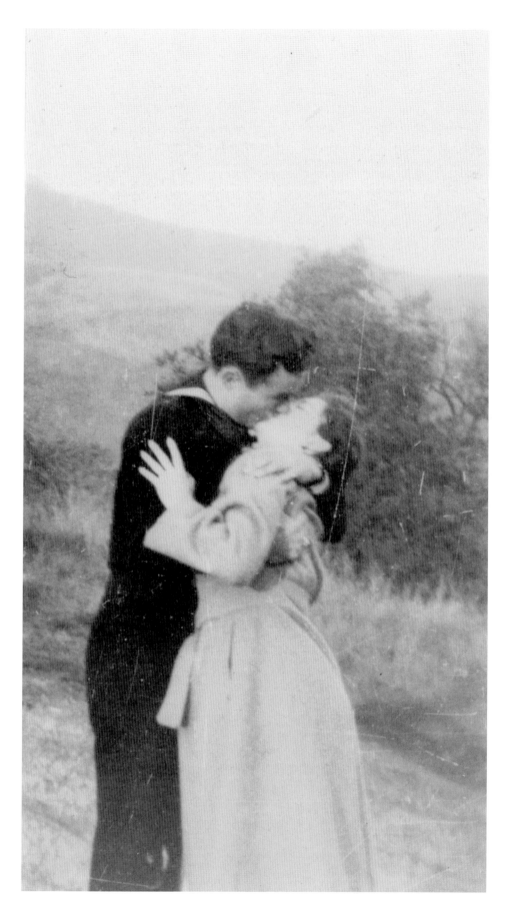

Arthur Phillips (Chumash) bidding his wife, Zora, good-bye before leaving for World War II, San Jose, 1942.
Courtesy of Michael Phillips.

Michael Phillips: This is my father, Arthur Phillips, and he grew up around the San Luis Obispo Mission...He was an altar boy there...and the church caught fire—the nunnery did. And while they were evacuating he went in and saved the chalice and the sacraments. And when the building burned down, he was able to present them back to the missions. And for his reward, the head nuns gave him the mission school bell. So I have it at home now.

He had a lot of stories— our mistake was not taping a lot of them. He was one of the boys that...you weren't educated unless one of the Spanish families took you in and educated you, which they did to him. And he had stories where he used to work on the ranch and they'd send him into town to get cream, and he was coming back on an old horse and someone came by in an old Model A and honked the horn and spooked the horse and it took off running, so by the time he got back home all the cream was butter! [laughs]...

He used to be this big hunter...and as kids, they used to hunt on this one ranch. And he'd always tell us these stories of how they'd go out and get these beautiful elk and bring them home, but they had to hide in poison oak all the time because these riders would come in and chase them out, because they were trespassing, apparently. And then later on we found out it was Hearst Castle! [laughs]

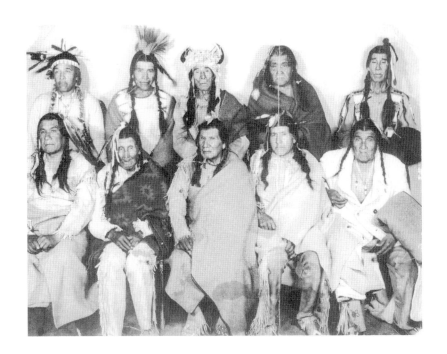

L. Frank: *He was in over two hundred movies, my grandfather.*

Martin Alcala: *Did he do stunt work or what?*

L. Frank: *Yeah, he was a stunt-man actor.*

Anita Alcala: *So he played cowboys and Indians?*

L. Frank: *Exactly...My grandmother and her five sisters said [they] never had to work. [They] were always extras in the movies...*

Anita Alcala: *They got paid pretty good money back then, fifteen or twenty dollars a day— [enough] to spend on groceries for a week or so at least!*

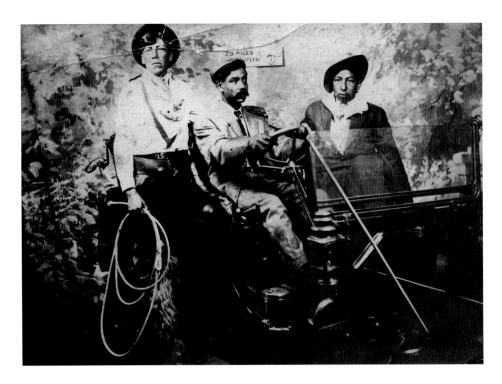

TOP *Cupeño Indians from Pala dressed as Plains Indians for a film shoot on Catalina Island, 1940s.*
COURTESY OF ANDREW GOODWIN.

Andrew Goodwin: They (movie people) used to take them away. They'd come and take them on a trip. They'd never been away from here. Put shoes on them [laughs]. They used to like it. They had a lot of fun. They'd do it every year.

LEFT *Tony Valenzuela (Tongva, left), San Gabriel, 1951. Tony Valenzuela took care of horses for Hollywood movie studios.*
COURTESY OF ALBERT LASSOS SR. AND DOLORES LASSOS.

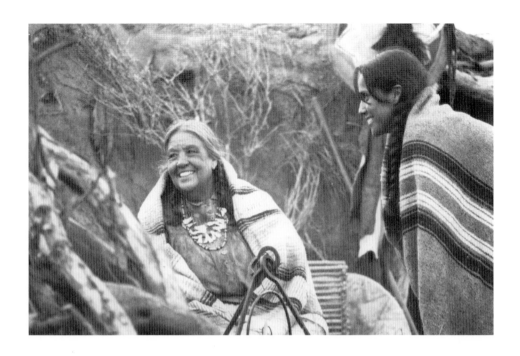

Karen Vigneault (far left) recalled that Miramax was making a film about California Indians, but this footage was cut—although she did see it on the Travel Channel once. Karen's skirt, made by her grandmother, was from the 1930s. The others were made recently.

Michael Sanchez (Tongva), Los Altos
High School, 1996.
Courtesy of Albert Lassos Sr. and Dolores
Lassos.

Virginia Arvizu (Tongva) with her son
Peter at a cultural demonstration in
San Leandro, 2002.
Courtesy of Virginia Carmelo.

Virginia Carmelo: This is a picture
of my daughter, who is named
after me and I was named after
my great-grandmother, who
was a Gabrielino. So we're all
Virginias. And this is her child,
my grandson, who is first of
the next generation. His name
is Peter, and you can see that
we dressed him up and he has
on his little rabbit skin. He has
on his little beaded bracelet,
and he has his shells on, and
he's holding a shell rattle which
belongs to my other daughter.
He just naturally loves music
and to keep beats, so anything
that makes noise, for him, is
really good. I think he was
eight months, seven or eight
months here.

Leroy Miranda (Cupeño), San Diego, 1960s. Leroy Miranda is now the director of the Cupa Cultural Center.
Courtesy of Diana Lavato Duro.

Diana Lavato Duro: We went to a lot of schools to dance and sing. We'd go to San Diego, we'd get a lot of dancing done in San Diego, in the elementary schools...to let them know that there were Indians out here and that we weren't the TV Indians—that we lived in houses and that we had running water, that we weren't ashamed of who we were. We wanted them to know that Pala had Indians here.

A grindcore band with two Tongva members setting up for a House of Blues performance, Hollywood, 2000. Left to right: Fred, Dana Alcala (Tongva), Sam, Evan Alcala (Tongva).
Courtesy of Martin Alcala.

L. Frank: What kind of music is grindcore?
Dana Alcala: Rock.
Martin Alcala (Dana's father): Teenage angst music.

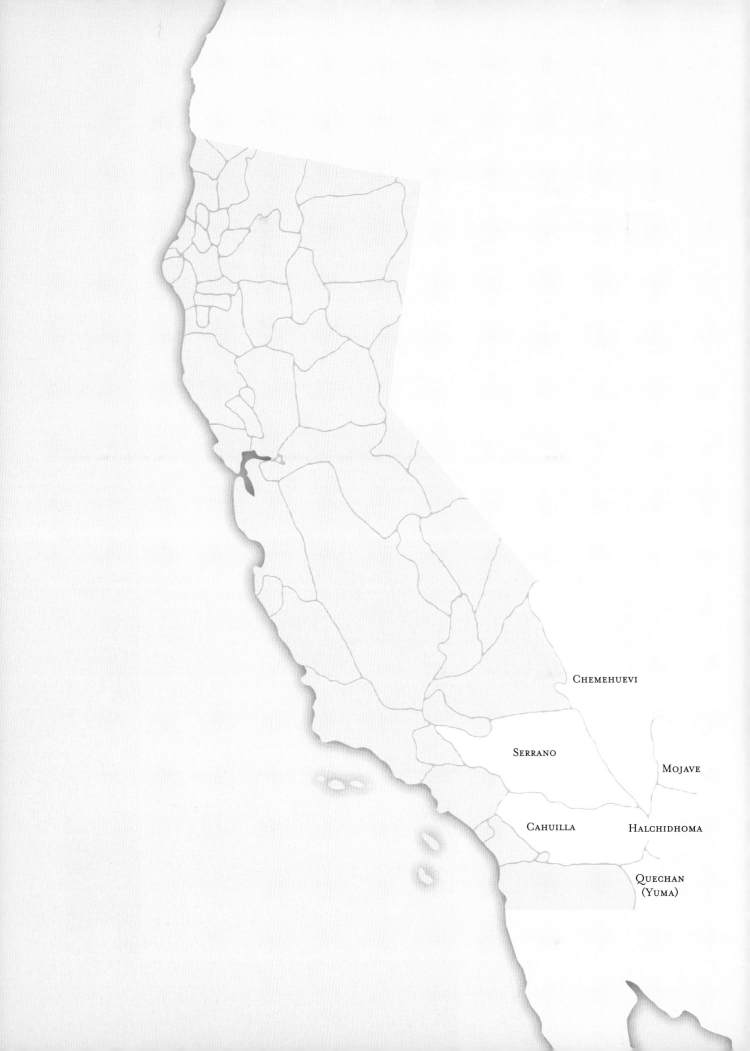

CHEMEHUEVI

SERRANO

MOJAVE

CAHUILLA

HALCHIDHOMA

QUECHAN
(YUMA)

Four

Inland Southern California

" *The land was important. Mainly because it gave every-thing that you needed to live on. Well, we came from the land, from the earth itself. And it was created especially*

for you, and so you had a place within that, and you were going back to it."[1]

Many people see the Mojave and Colorado Deserts of California as inhospitable environments, vast expanses of seemingly barren flats and boulder-strewn mountains. Yet today in the interior of San Diego County there are a dozen reservations and rancherias, mostly Kumeyaay. Riverside County supports another nine reservations, mostly Cahuilla. In San Bernardino County there are four reservations: two Chemehuevi, one Serrano, and one Mojave. The Fort Yuma Indian Reservation in Imperial County is Quechan. And straddling the border with Arizona is the Colorado River Indian Tribes Reservation of native Mojave and Chemehuevi people, along with Navajo and Hopi who were relocated here in relatively modern times.

It is no surprise that when most of these reservations were created early in the twentieth century, those in power selected locales that they considered wastelands. Yet for some native people, these are lands of plenty. The desert served as the source of life, and when they were able to hunt and gather freely in those vast lands, a good and sustainable life was possible. To those who know this land intimately, it provides food and medicine. Says Katherine Saubel, Cahuilla elder of the Morongo Reservation near Banning:

> The Cahuillas used plants for food, for medicine, for housing, for clothing—for everything they used the plants, especially the medicine. A lot of the medicine that grows now, grows on the high hills. The ones that come from the mountains are the best medicine that can be used. That is why I fight so much to preserve all this, so we can continue to use these things. I still get my medicine plants from the mountains where I was born. That is why I would like to have it protected.[2]

While modern political boundaries have placed these tribes in a state now called California, culturally they have more in common with the people of the Colorado River, the Southwest, and northern Mexico than they do with, say, the people of the Central Valley or the coast. While the salmon-laden rivers of northwestern California and the oak-rich valleys of central California supported larger villages and denser communities, the carrying capacity of the desert called for smaller units. These were often extended families and clans with wide territories. Among their traditional foods

OPPOSITE *Katherine Siva Saubel (Cahuilla), Agua Caliente tribal office, Palm Springs, 1991.*

Courtesy of the Agua Caliente Cultural Museum.

were six varieties of acorn, mesquite beans, piñon nuts, and the fleshy parts of several cactuses. Desert peoples made yucca-fiber cordage for nets and used mescal fibers for sandals. Music from elderberry flutes and rattles made of turtle shells, deer hooves, and gourds, and most importantly, the human voice accompanied much of daily life. Houses were typically made of brush. Petroglyph sites—their meanings mysterious and certainly spiritual—abound in the region; in these sun-baked areas of the world, of the spirit seems close. Testament to this, perhaps, is the way that the Mojave went to war not only with warriors and war chiefs, but also with soothsayers and dreamers.

Like native people everywhere in California, those who dwelled in the desert were skilled basketweavers, using a surprisingly wide range of native materials—deer grass, juncus, devil's claw, flicker quill, willow, porcupine quill, bulrush, and yucca root, for instance—to weave fine, useful, decorative baskets.

In addition to baskets, the people of the desert made pottery, often excised and painted, by coiling the clay and paddling the coils against a smooth stone. The beauty of this style of ceramics is in its functionality: construction methods are practical; the pots are often thin-walled but durable; and their forms are ideal for storing food and water. Potters knew where to get just the right kind of clay and how to fire it to make pots that are sturdy but lightweight. Because California pottery is not as decorative as the pottery of the Hopi, the Tewa, and others of the Southwest, it never attracted the attention of collectors, and the practice fell into disuse. Traditional techniques were lost for many years, until Cahuilla potter David Largo and others revived the art in relatively recent times.

While all Californian peoples cultivated and managed their land through conservation, burning, pruning, digging, and other techniques, only along the Colorado River can we find anything that looks like European-style agriculture. The Colorado River—which is similar to the Nile in its yearly floods—deposits thick, fertile silt as it shrinks from its high-water stage during the summer; and several tribes planted fields of corn, squash, beans, and melons here. So central was this agriculture that when the Spanish appropriated the best Quechan fields in the late eighteenth century, it led to a full-scale uprising. Mojave elder Elda Butler affectionately remembers the remnants of traditional farming and the presence of the as yet undammed river (which today is more like a lake) in her childhood:

> All they had to do was plant. And that was it, and then just wait for
> [the crops] to ripen. But that river was something else. Just small kids,
> just grammar school, you know, and we'd swim across the river, whole
> bunches of us. And we'd have to start way up here, and by the time we
> crossed we were way down there because the water was so swift...And
> then we'd get melons and then we'd swim back. All that work, and
> then we'd swim back with the melons, and then when we got to this
> side we'd sit and eat them...We were down at the river all the time.

For a while, the allegedly undesirable nature of this land paradoxically protected the desert tribes from some of the atrocities suffered elsewhere in the state by way of gold mining, grazing, logging, corporate farming, and runaway residential development. When Europeans and Americans finally gained a strong foothold in the region late in the nineteenth century, they claimed the best land. Native people were unable to move freely in their traditional hunting, fishing, and gathering places. Like many of the peoples from other parts of the state, they were forced to live on small, isolated, poverty-stricken reservations.

Life has gotten somewhat easier in recent times—at least for tribes with casino income—but land-use issues continue. Still embedded in the minds of the dominant culture is the sense that this is a "wasteland," and by the end of the twentieth century "wasteland" suddenly had value: a nuclear waste dump was proposed for Ward Valley, twenty-one miles west of Needles, a site long sacred to the Mojave and Chemehuevi. The dump—alarmingly close to an aquifer and the Colorado River—might well have had disastrous effects on both tribal and nontribal residents of California, Arizona, and Mexico. Following an occupation of the site by members of five tribes and various environmental activists, the Department of Interior officially cancelled their plans in 1999.

David Largo (Cahuilla) holding one of his hand-built pots.

Photo by Beverly R. Ortiz. Courtesy of Beverly R. Ortiz.

The Ward Valley fight was only one of many. For years the tribes have been defending their land rights, water rights, and sovereignty rights. The Quechan are currently battling a proposed open-pit gold mining operation, nearly nine hundred feet deep and a mile wide, which would destroy sacred sites and petroglyphs near Indian Pass and despoil land for miles around it.

The Colorado River tribes, unlike most others in California, have always been known for their warrior traditions. For the Mojave and Quechan, specialized weapons such as a "potato masher" club of strong mesquite wood and fire-hardened wooden spears were common. From a very young age, boys trained in dodging arrows and shooting at targets—even practicing for war by throwing mudballs at hornet nests, in formation. War leaders organized and trained men around hand-to-hand combat. From earliest days they successfully defended their homelands against the Spanish and early Anglo intruders. Generations later, though methods differ, they have not stopped.

INLAND SOUTHERN CALIFORNIA

STANDING SIDE BY SIDE OUTDOORS, USUALLY ON A HOT, DUSTY DAY, ACCOMPANYING themselves with gourd rattles, the singers of bird songs sound faint at first. Despite their contemporary clothing—jeans, cowboy boots or running shoes, Southwest-style ribbon shirts, tribal t-shirts—with their faces lined by the southern California heat, they look as if they've been there forever. As one draws closer, the reverberant rumble of men's voices begins to sound strong and ancient.

For the Cahuilla people, the bird songs tell the story of their ancestors' migrations in the early days after the death of their Creator. In the Cahuilla creation story, the brothers Mukat and Temayawet had made the world together. They both built clay humans, but Temayawet worked in haste and did a poor job of it: his "people" had webbed digits and double-sided faces and stomachs. Mukat, on the other hand, worked slowly and carefully, and the people he made were beautiful and efficient. Mukat looked dubiously at Temayawet's faulty creations. With webbed fingers how could they pick things up? With faces and stomachs on both sides, how could they sling carrying baskets over their shoulders to transport heavy loads? In shame and anger, Temayawet withdrew underground, taking his creatures with him and leaving the world to Mukat and the humans he created.

Over time Mukat changed, and instead of helping people he turned against them, introducing death, giving poison to rattlesnake, inventing the bow and arrow and tricking people into shooting at each other. The people decided to kill Mukat. And, as Katherine Saubel (Cahuilla) explains:

> The people burn Mukat's body. From Mukat's ashes, all the food
> plants grow—acorns, squash, chia, sage, all the food of the Cahuilla.
> In his death, Mukat has given his people their way of life, their laws,
> customs and ceremonies, and their food.[3]

The Cahuilla bird songs deal with the time immediately following Mukat's death. Having killed their Creator, the people were sorrowful, and they scattered in many different directions. Time passed, and the few Cahuillas who remained in the original homeland decided to bring the others back, and they set off on a great journey to find them. Some say they circled the continent, others say they journeyed only through southern California and northern Mexico. The people who were living away realized that their original homeland was the best place after all. The bird songs, in hundreds of short stanzas, recount incidents and stories of these travels as the people separated and then came together again, moving and migrating in the way that birds do.

Bird songs are also a feature of Kumeyaay, Mojave, and Quechan culture, as well as indigenous cultures in northern Mexico. In traditional times, the linked stanzas of the song were sung for several nights in a row from dusk to dawn—beginning songs started the event, at midnight the returning songs began, and everything was timed to end with mornings songs when the sun rose. The songs are usually in a

OPPOSITE *Andreas family bird singers (Cahuilla), Agua Caliente, 1950s.*
COURTESY OF THE AGUA CALIENTE CULTURAL MUSEUM.

language understood by the singers, but often embedded in the songs are fragments of other languages thought to be ancient and mysterious. Although they deal with spiritual issues, the bird songs are not sacred, nor are they restricted; there is no special requirement for being a bird singer other than an honest interest in the songs. Bird singers sometimes stay up all night, singing and dancing, stopping only occasionally for short breaks. At other times samples of song provide welcome entertainment for a fiesta or celebration.

By the last decades of the twentieth century, the singing of bird songs had declined, no longer practiced, reduced to a memory borne by fewer and fewer. Alvino Siva, realizing what it would mean to lose the tradition, began singing again in 1975. He, Robert Levi of Torres-Martinez, Tony Andreas of Agua Caliente, and others began to revive the tradition, pulling out of their collective memories the songs, their sequence, and the stories relating to them. And they trained younger apprentices such as Mark Macarro, Luke Madrigal, and Leroy Miranda, who in turn trained others. Tony Andreas describes some of the story:

> As I got to be about thirty, I started to sing with Joe Patencio and also Bert Levi. They used to say, "Come on. Sit down and sing with us," so I'd start singing with them...I knew some of the songs, but I didn't know them right. And Joe Patencio and Burt Levi taught me how to sing them the right way. I still don't know, but at least they gave me a path to follow. It's all synchronized. The songs have their own pattern and their own order.
>
> I have nobody to go back and ask questions—to say, "Am I doing it right, or is this the way?" They used to tell me, "Well you'll figure it out." Figure out what?! I didn't know what to figure out. But now I think I know what they meant...And I hope I've figured it out right.[4]

In December 2005, the Agua Caliente Reservation in Palm Springs sponsored a day-long Bird Song Festival. Singers from all over came and sang for an audience of many hundreds. The performers, men mostly in their thirties and forties, were skilled and proud, their singing robust and confident. Here and throughout the area bird singing is once again connecting California's desert people, their land, and their past.

OPPOSITE LEFT *Tony Andreas (Cahuilla) with a gourd rattle, 1990s.*
PHOTO BY BEVERLY R. ORTIZ. COURTESY OF BEVERLY R. ORTIZ.

RIGHT *Alvino Siva (Cahuilla) with a handmade gourd rattle, 1990s.*
PHOTO BY BEVERLY R. ORTIZ. COURTESY OF BEVERLY R. ORTIZ.

BOTTOM *Francisco Patencio (Cahuilla) in front of a ceremonial house at Agua Caliente, early 1900s.*
COURTESY OF THE AGUA CALIENTE CULTURAL MUSEUM.

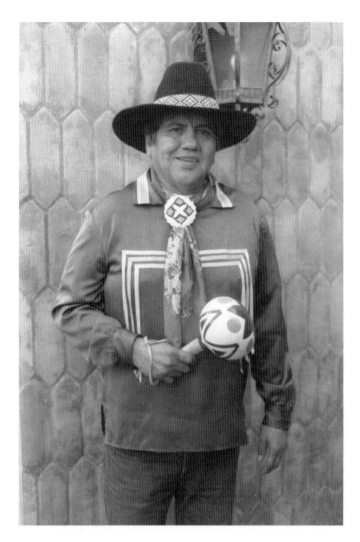

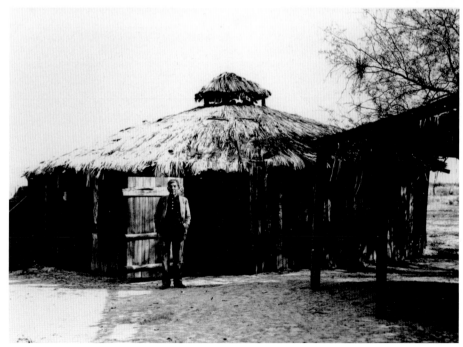

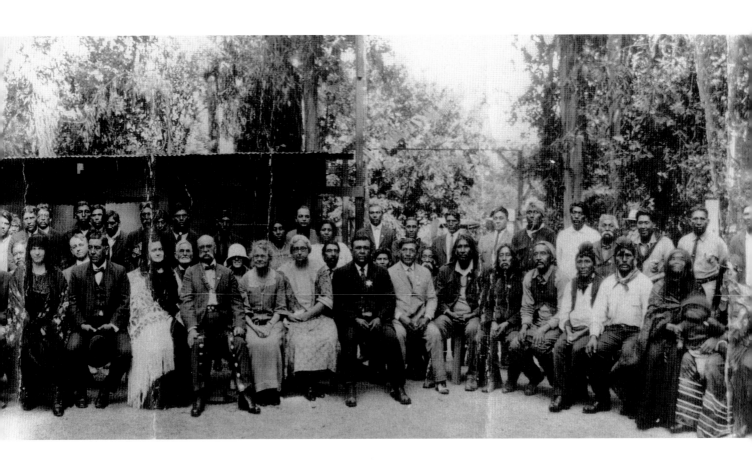

If you listen to what our leaders say all the time, they're always educating our congressmen, our senators, because that's where laws are made. And that's where they can say [that] either we exist today or we don't exist today—by paper. And unfortunately, today, paper is how we are recognized.
—Paul Cuero Jr. (Campo Kumeyaay)

IN NATIVE CALIFORNIA, THE LAND OF NUMEROUS DISTINCT AND WELL-STOCKED microenvironments, large political entities were unnecessary. An estimated three hundred thousand people were living in California when the Spanish arrived, speaking over three hundred dialects of about a hundred separate languages. In most parts of the state, "tribes" were made up of a few villages at most, their territory often limited to a single watershed. Today, there are still about a hundred and fifty organized tribes in California (some two-thirds of them recognized by the U.S. government).

Despite this tradition of diversity, California's native people have sometimes found it expedient to organize into intertribal groups. In southern California, two influential groups formed in the past century that gained visibility and more equitable treatment for their members, and hence for native people throughout the state and indeed throughout the nation.

From 1919 until 1965, the spirited and at times controversial Mission Indian Federation functioned as a grassroots political organization that represented the concerns of southern California Indians. The main goal of the federation was to protect sovereignty—the fact that Native Americans, though U.S. citizens since 1924, retain the status of independent nations that have (or deserve) government-to-government relations with the United States. For much of its existence, the Mission Indian Federation opposed the Bureau of Indian Affairs and its policies, particularly those pertaining to land issues and the governing of reservations. They fought long and hard against the abuses of government agents and against such practices as having U.S. officials appoint tribal headmen and policemen.

The head of the federation for many years was Adam Castillo (Cahuilla), a serious and thoughtful man, judging from pictures of the time, and a man whose actions inspired the federation to new heights, opposing allotment of reservation lands, joining in land-claims struggles, and encouraging tribal governments to elect women leaders. Over the years, the organization had frequent run-ins with federally appointed tribal police. In 1922, for example, the BIA cracked down on a meeting of the Mission Indian Federation. The U.S. Board of Indian Commissioners recorded that:

> At the federation meetings expressions of ill will or hostility to the government were occasionally heard. Grievances were aired and complaints, both legitimate and trivial, were uttered. As a result and under orders of the Department of Justice, some 57 Indians were placed under arrest on the charge of conspiracy against the government. Upon arraignment they were dismissed without bail.[5]

OPPOSITE *Mission Indian Federation convention, Riverside, October 9, 1924.* COURTESY OF FRAN YORBA.

Charges were dropped when Indians were awarded citizenship in 1924.

The Mission Indian Federation was not universally accepted within Indian circles. Most of its members and supporters came from a generation whose primary concerns were holding onto tribal land and living without interference of any kind from the government. Some younger Indians, however, saw citizenship as the key to advancement, believing that participation in the legal and political structure of the dominant society would bring about the recognition and equality that they sought. Bitter rivalries and factions broke out, and several splinter groups were formed, although none ever gained the success or prominence that the federation did.

A decade after the Mission Indian Federation formally disbanded, a new organization appeared. The Southern California Tribal Chairmen's Association (www.sctdv.net) was established in 1972 as a consortium of nineteen southern California tribes focusing on "the health, welfare, safety, education, culture, economic, and employment opportunities [of] its tribal members." Active to this day, the association sponsors day-care services, law enforcement, Tribal Temporary Assistance to Needy Families, career development centers, and vocational training. Additionally, they have been spearheading the Tribal Digital Village program, organized under a five-million-dollar grant from Hewlett-Packard, to build a high-speed Internet access network and supply equipment and technical assistance to participating reservations. While this may seem a long way from the days when the Mission Indian Federation called for the dismantling of the BIA, in another light it is clear that safeguarding culture and community is and always has been the common concern. As Edward Castillo notes, "All of these pan-tribal concerns among native California peoples have a single important purpose. That is to improve the quality of life for native people, as Indians themselves define a better life. That better life is not only for the individual but depends on the cultural survival of the band and tribe as well.[6]

OPPOSITE TOP *Agua Caliente men in front of the tribal trading post, early 1900s. Standing, left to right: John Segundo, Robert Saubel, Chris Saubel, Albert Patencio, Clem Segundo, Roman Manuel, Frank Largo. Sitting: Miguel Welmas, Austin Cruz. Sitting, bottom: Tony Toro, Lilly Mike, Ray Lugo.* COURTESY OF THE AGUA CALIENTE CULTURAL MUSEUM.

BOTTOM *Cahuilla police deputies at a Fourth of July celebration, early 1900s.* COURTESY OF THE AGUA CALIENTE CULTURAL MUSEUM.

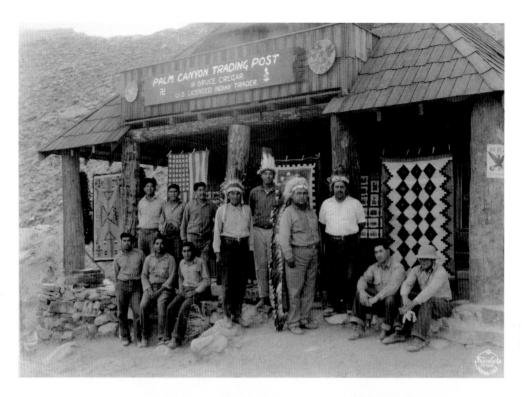

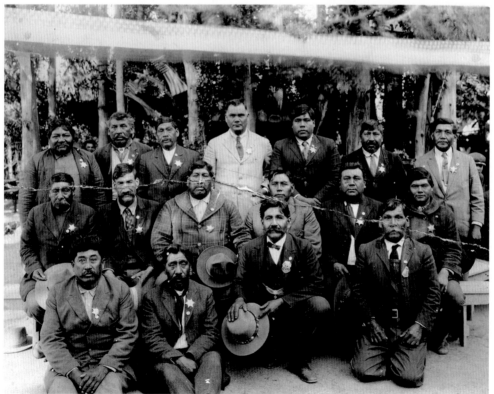

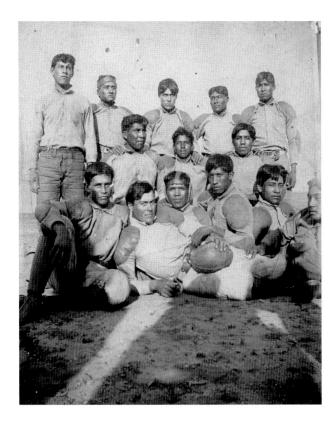

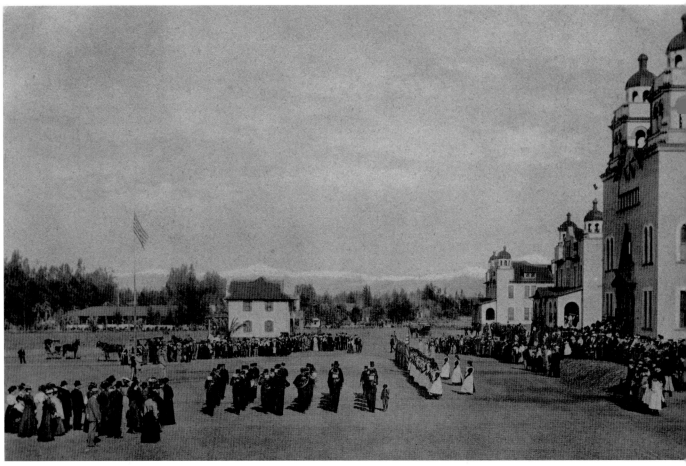

Let all that is Indian within you die!...You cannot become truly American citizens, industrious, intelligent, cultured, civilized, until the Indian *within you is* dead.

—*Rev. A. J. Lippincott*[7]

IN THE LATE 1800S, HAVING ISOLATED THE MAJORITY OF NATIVE AMERICANS ON reservations, the federal government reversed its approach and adopted new policies aimed at assimilating native people into mainstream society. One of the mainstays of this plan was education: Indian children would be removed from their homes, placed in special all-Indian schools, and taught to be English-speaking Christians. An excerpt from a speech by Richard H. Pratt, founder of the Carlisle Indian Industrial School in Pennsylvania, encapsulates the attitude of the era:

> It is a great mistake to think that the Indian is born an inevitable savage...Transfer the infant white to the savage surroundings, he will grow to possess a savage language, superstition, and habit. Transfer the savage-born infant to the surroundings of civilization, and he will grow to possess a civilized language and habit.[8]

Through the Bureau of Indian Affairs, in conjunction with various churches and supplemented by reservation day schools, the U.S. government established boarding schools around the country to accomplish this goal. Sherman Institute was opened in the fall of 1902, in Riverside, California, to serve the native people of California and the Southwest. By 1926 it offered both elementary and secondary classes as well as a cosmetology course, and it had one thousand enrolled students. Eugene Jamison, from northern California's Round Valley Reservation, recalled traveling from Ukiah to Riverside in 1926 as a seventh-grader. A train took him and other students to Sausalito. They took the ferry to San Francisco, where they were joined by a trainload of students coming from Eureka.

> [A] single person...had to see that all of these youngsters were fed, and there were probably about close to one hundred of them, and he did a very good job. A few of them in San Francisco went visiting or looking around and got lost, and that slowed us up a little bit, but anyway around midnight...we left the Ferry Building in San Francisco and crossed the bay again to a train waiting in Oakland.

Traveling all night and into the next day, they arrived in Los Angeles and from there were transported to Riverside, reaching Sherman around ten or eleven o'clock at night.

> They took us up to the mess hall, which was a large establishment. My first experience eating hominy was at that time, and it was kind

OPPOSITE TOP *The 1900 Sherman Indian High School football team: Don Magee, Mariano Blacktooth, Steven Alvarez, John Majel, Silvas Lubo, George Magee, Alex Tortez, John Pugh, Joe Scholder, Faustino Lubo, Willie Gabriel, John Ward.*
COURTESY OF THE SHERMAN INDIAN MUSEUM.

OPPOSITE BOTTOM *Early postcard of Sherman Indian High School.*
COURTESY OF THE SHERMAN INDIAN MUSEUM.

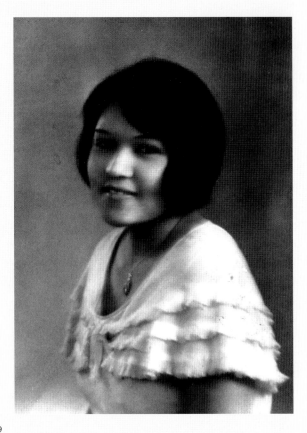

of real nice. We all sat down and had our meal, and then the boys were taken over to the boys' side, and the girls were taken over to the girls' side. That was really the last time I saw the girls. I didn't see any girls, except at a distance, for all those years I was down there. Yeah, once a month or something like that they would have a social night in which the boys and girls would gather.[9]

In addition to a basic education, boarding school students received vocational training. Girls were taught cooking, sewing, or basic home nursing skills. Boys were trained in subjects such as carpentry, painting, cabinet making, blacksmithing, wagon making, shoe and harness work, printing, or agriculture. Students ran the Sherman Farm, which provided food for the school. Few students were encouraged to think about higher education. Only English could be spoken, and children were punished for speaking their native languages.

During holidays, students were sent to work for local white families; many did not see their own families for years. Homesick and disliking the strange food, strange practices, and strict discipline, many children ran away. Judith Lowry (Mountain Maidu/Hamowi Pit River) has illustrated a children's book (written by Chiori Santiago) called *Home to Medicine Mountain* that tells the story of her grandfather's and great-uncle's experiences at Sherman:

At the school, Benny Len and Stanley were given uniforms and stiff, new shoes. Benny Len's feet no longer touched the earth. His uniform was scratchy, not soft like his old overalls. He no longer heard the sounds of Susanville—the music of the birds in the pines and wind in the branches. The boarding school was a world of sharp edges, shiny surfaces and shouting bells.

Stan Lowry and Benny Len in the end ran away, returning on a long, epic journey to their homeland and the teachings of their grandmother.

Loren Bommelyn (Tolowa/Karuk) tells a family story about his aunt escaping from Sherman. The staff at Sherman carefully rationed food at each meal to make sure that no one could hoard it for an escape. Nevertheless, Loren Bommelyn's aunt and four other girls from various parts of California stashed clothing and whatever else they could manage:

> She said they took the sheets off the bed and cut the screen open...
> and took off. They hid during the day because the [authorities] were
> looking for them, they had a patrol after them...they would sleep all
> day and they would walk all night in the moonlight.

When they eventually reached the home territory of one of the girls, Santa Rosa Rancheria in the southern San Joaquin Valley, the girl's family took them in, took care of them, and fed them. They then proceeded to the next family and to Pomo territory.

> And finally she somehow got a letter or message to my grandma,
> and that's when cars were starting to be a kind of item in American
> culture, as far as just general people being able to have them; and
> my uncle Alfred or somebody had bought one and didn't know
> how to shift, didn't realize you had to put gas in it...anyway, [my
> grandmother] got a message from her and so she hired somebody
> to drive her to Ukiah, and then they picked up my aunt and she got
> home. So that last leg she didn't have to walk...My grandmother put
> up a big gate [and when the government men would come looking
> for school-age kids, she] would say she didn't have kids. My mom was
> safe, because my grandma learned the hard way.

By 1969 Sherman Institute had changed dramatically. It was now governed by an all-Indian board of directors, and children were no longer forcibly removed from their homes and taken to boarding schools. Sherman, like Indian schools nationwide, today focuses more on reinforcing native cultures than on abolishing them.

But the legacy of the past is inescapable. Harsh policies of the past contributed to much of the loss of language and culture that marked the late nineteenth and early twentieth centuries. Recalling the punishments and beatings they had suffered, students who could still remember their languages after leaving school often chose not to teach them to their own children. The break in cultural continuity has in many ways caused deep damage to the fabric of Indian life.

As it turned out, however, Indian boarding schools did have a few positive effects for native people, some of whom came from broken homes and communities whose populations had been decimated by disease, poverty, and violence. Students from

OPPOSITE *Fayth Mardale Barrackman (Mojave) at the Sherman Institute in 1931. Fayth was the first Mojave to graduate from college, receiving her R.N. degree in 1936 from the College of Nursing, Ganado Mission, Ganado, Arizona.*
COURTESY OF DARKMOON CLIFFDWELLER.

159

Students from Sherman Indian High School's Native Traditions class on a field trip to Mockingbird Canyon, 1999.

different regions and cultures found common ground, strength in numbers, long-lasting friendships, and even romance. Sometimes a student from northern California would meet and fall in love with someone from the southern part of the state, so that today it is not uncommon to meet people with rich and complex family connections all over California.

Sherman Institute is still operating, renamed Sherman Indian High School and given new direction in recent decades. Today it has approximately 185 teachers and support staff and 550 students. In addition to basic and remedial education, Sherman now includes a focus on higher education and has created partnerships with the University of California to encourage students to pursue college degrees. Classes on a variety of cultural topics are also offered, such as tribal government, museum operation, basketry, and the Navajo language. All but one of the original buildings were torn down in the 1970s and rebuilt to conform to earthquake standards. The remaining original structure—the administration building—now houses the Sherman Indian Museum, curated by Lorene Sisquoc (Ft. Sill Apache/Mountain Cahuilla), a fine resource for the history of both the school and area.[10]

Beverly Lyon Chihuahua (Desert
Cahuilla), the 2003 Torres-
Martinez Princess.

Donna Largo (Cahuilla), 1990.

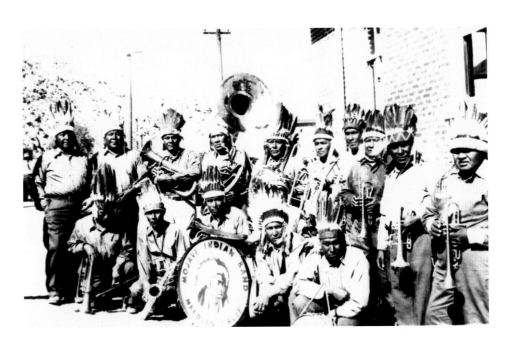

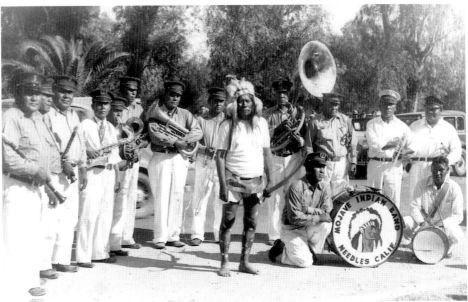

Old Fort Mojave Band, undated.
Courtesy of Darkmoon Cliffdweller.

Fort Mojave Indian Band, undated.
Courtesy of Darkmoon Cliffdweller.

Elda Butler: I don't think there's anybody on the council who understands or speaks Mojave but one person. We have Mexicans on there, we have other tribes on there. Course you have to be one-quarter Mojave to be a member…my great-grandchildren now, cannot be members.

L. Frank: And what do you think of that system?

Elda Butler: I don't know. We talk about that again and again. Because we're so close, even that far down, when it's less than a fourth. I mean, my great-grandson is nothing but Indian, you know?

FROM THE CENTRAL VALLEY: *We live down there, off the reservation…And everybody thinks that just because we're Indians, we're rich! Because these casinos are making whole bunches of money and stuff, and they think that we've got it made…We want recognition for the education of our children, and for the health care. We've built into our kids that they are proud to be Indian. But they can't take advantage of it because they're not federally recognized…*

We went through the process. For about nine years my uncle dedicated his life to this. And nothing ever came of it. It's just such a long process. It's just not worth it. It split up the family.

—Jennifer Malone, Wukchumni

What gives people the right to put a blood quantum on us? We're the only human beings on this earth that have a blood quantum. We're judged by that. Why? That is one of the saddest things in our life—because we're human. I had a white person ask me, about six months ago, as I was getting out of my car…"Oh, are you a full-blooded Indian?" My answer to him was "Are you a full-blooded white? If you are a full-blooded white, then ask me if I am a full-blooded Indian." He even told me, "Well, do you understand that you are getting out of a $42,000 car?" So I said, "What's the difference if you're driving it or I'm driving it?"

—Adelina Alva-Padilla (Santa Ynez Chumash)

To me, if you're Chumash—this is the way I look at it—we're all one. Who cares if you've got a casino or a reservation, we're still one group and we should be treated as one group. Not that I'm better than you or she's better than you, no, we're one family. That's the way we were taught, you know, don't get political.

—Mike Phillips (Chumash)

INDIAN GAMING HAS BEEN IN THE NEWS ALMOST CONSTANTLY FOR THE PAST TWO decades. The issues range from economic development to problem gambling, from traffic congestion and environmental impact to fighting poverty and paying taxes.

Suffused with emotion and seasoned with thousands of legal technicalities, much of the controversy revolves around the concept of sovereignty. The law recognizes that at the time of conquest tribes were autonomous, sovereign nations; and although conquered they still retain parts of that original sovereignty.

The modern age of Indian casinos began with a landmark 1987 case, *California* v. *Cabazon Band of Mission Indians*, in which the Supreme Court ruled that California could not regulate bingo games on tribal territory. Bingo was legal in California—the mainstay of church groups and others—therefore, the tribes had the right, as sovereign governments, to open bingo parlors on their lands and to regulate them according to tribal laws. The era of high-stakes bingo was ushered in.

The *Cabazon* decision led Congress to pass, in 1988, the Indian Gaming Regulatory Act (IGRA), which created three classes of gaming: Class I games are social and traditional games and are not regulated; Class II includes low-stakes games like bingo that are allowed elsewhere in the state and on Indian lands. Class III is everything else, a huge category that includes high-stakes games like slot machines and craps. Under the IGRA, tribes have the right to operate Class III games, but to do so they must follow certain rules and must negotiate compacts with their state governments under the supervision of the U.S. Department of Interior.

The subsequent history of gaming in California becomes hugely complex, a legalistic swirl of court cases, compacts between tribes and the state, disputes within the Indian community, and propositions on the state ballot. The result, though, is that in 2006 there are fifty-six casinos in California employing more than fifty thousand people and generating more than a hundred million dollars annually in personal and corporate state income taxes, sales and use taxes, and payments in lieu of taxes.[11]

Indian gaming has many critics (both Indian and non-Indian) who say that it brings crime and other ills to communities. Some think the casinos are eyesores and morally reprehensible. Some fear that the last traces of the old ways will be lost. Others believe that gaming has brought prosperity, success, and visibility to communities who have long been poor and marginalized: a literally golden opportunity for people who have been shoved onto tiny fragments of their former homelands. A woman from Pechanga Reservation said, "In the old days, when an Indian went to town, we were treated like trash. We'd be seated at the back of restaurants and had to sit for a long time before anyone would wait on us....Today we're the largest employer in the county, and when I come to a restaurant or a shop the staff jumps to attention. That's what the casino has meant to me."

While it might be said that sudden wealth has caused problems in many communities, it is also true that casino money has brought health care, education, and housing to impoverished reservations.

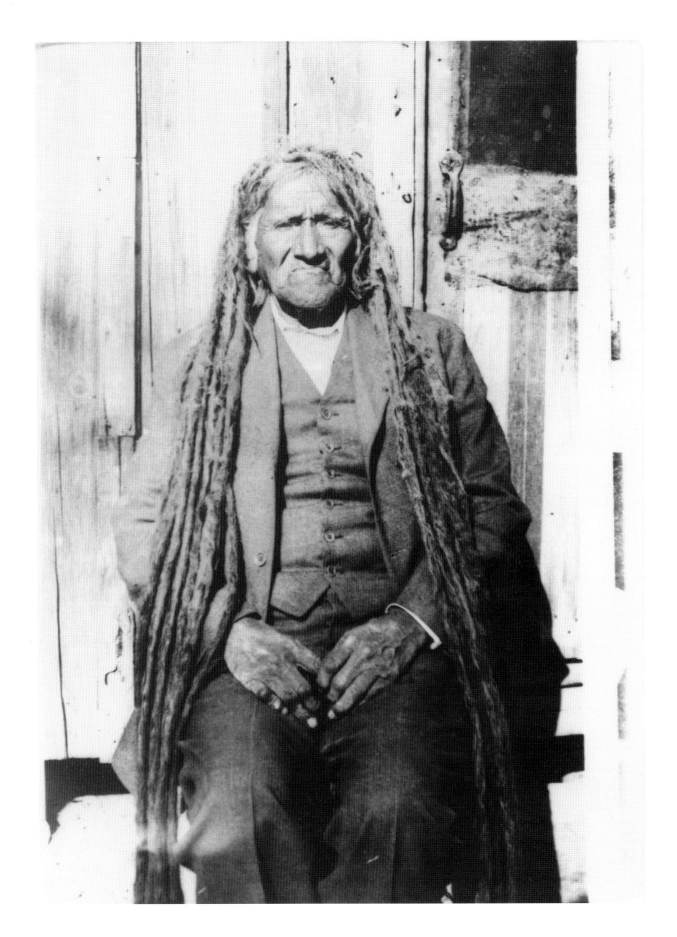

NATIVE CALIFORNIA TRIBES GENERALLY LACKED THE HIGHLY DEVELOPED WARRIOR culture that the tribes of the Great Plains had. Most had no war chief or centralized authority. Their value systems de-emphasized rather than exalted warriors, and their only weapons were hunting tools.

The people of the Colorado River were an exception, and the Quechan (referred to in older texts as the Yuma), along with the neighboring Mojave, were widely known and feared as fierce warriors. Quechan warriors were quite frequently tall—over six feet—with long, mudded hair. They carried war clubs, spears, and bows and took such pride in hand-to-hand combat that they scorned other tribes who, after the arrival of Europeans, adopted horses for raiding and fighting. Quechan and Mojave war parties were known to have battled the Maricopas and Pimas of the Gila River area 160 miles to the east and were thought to have made incursions to the coast as well.

With a strong central organization and a warrior tradition, the Quechan were able to offer successful armed resistance to early European invaders. And resist they did. In the eighteenth century, Spain began the search for an overland route from northern Mexico to Alta California, in order to better supply their fledgling colonies on the Pacific coast. They established several settlements, including two missions, near Yuma, and Spanish citizens began moving into the area around 1779. Until then, Quechan relations with Spaniards who were crossing the desert had been fairly congenial, but once official settlement began and the priests and soldiers tried to impose Spanish religion and law, problems arose. The Spanish pushed the Quechan off the best agricultural land, stole their crops, grazed livestock on other agricultural fields, and raided what stored food the natives still had. Several Quechan—including the son of a chief—were publicly beaten.

In July 1781 the Quechan struck the missions, burning churches and houses. They battled directly with the Spanish military detachment, killing the captain (who was also the lieutenant governor of California) and about fifty other Spaniards, mostly soldiers. Some colonists escaped, others were imprisoned and later freed in a ransom agreement. For two more years, the Spanish tried to retake the settlement, but they were unsuccessful. The overland route between Mexico and California was cut off and supplies to Alta California were disrupted. The Quechan effectively controlled the lower portion of the Colorado River until the Anglo-American era.

Despite this early and sustained success, the Quechan were not able to hold onto their homelands forever. Throughout much of the mid-nineteenth century they confronted growing waves of Anglo travelers and settlers. The outsiders would eventually win out by virtue of their overwhelming numbers, and the Quechan were settled on the Fort Yuma Reservation in 1884. Today there are about twenty-five hundred enrolled members of the tribe. On the 45,000-acre reservation, massive irrigation systems water fields that feed the nation. Most of the agricultural operations have been leased to private farmers, the proceeds going to the tribe.

OPPOSITE *Martin Aquinas (Quechan) displaying his traditional mudded hair at Fort Yuma, 1909.*
COURTESY OF THE JEFFERSON FAMILY.

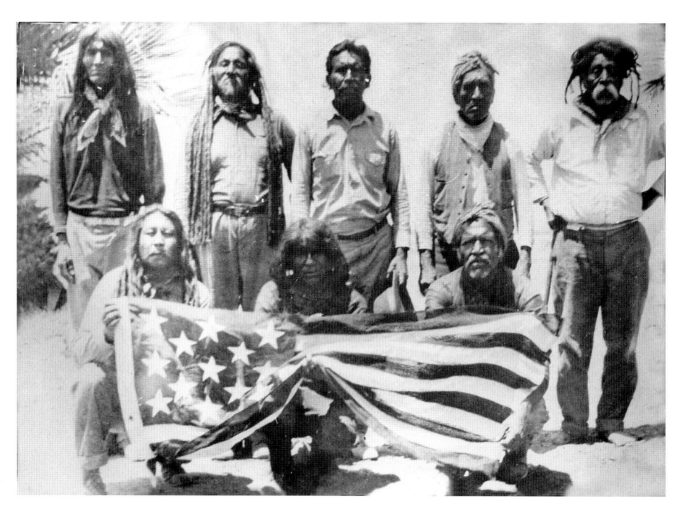

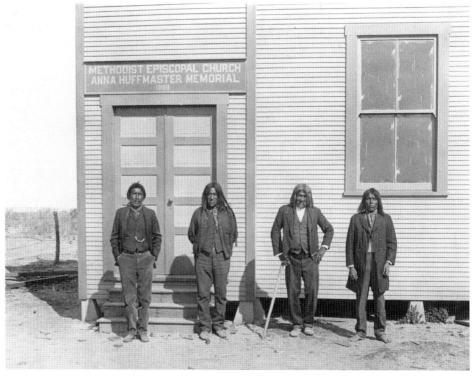

Unidentified men holding a U.S. flag, probably at Fort Yuma, early 1900s.
COURTESY OF THE JEFFERSON FAMILY.

Four Quechan Indians standing in front of the church at Fort Yuma, 1909.
COURTESY OF THE JEFFERSON FAMILY.

Preston Arrowweed: Men would cut their hair in mourning, which is possibly why these men have shorter hair, or they could have done it because of changing styles or pressure in school.

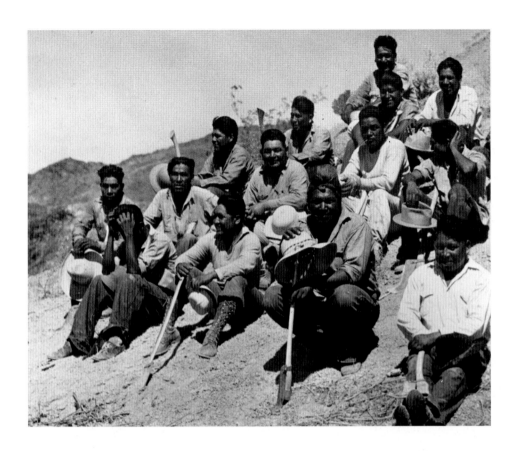

Some years back we went to Ward Valley...They said, "Maybe we should run up there"—that's what the kids do...I asked the kids I've been teaching, and they said sure. So a whole bunch of kids ran, all the way out to Ward Valley...We went because we wanted to stop the people from putting the radiation up there...To us it's a monster.

How did we stop monsters in the old days? We had to go by a legend that says they called on the ocean. The ocean has the power. So [in the old days] we called on the ocean, [and the] ocean sent either a squid or an octopus, one of them, upriver...and [it] destroyed that monster and brought him downriver and everybody stood on the banks and watched as he dragged him and took him to the ocean and got rid of him. So...we're going to take that power from the ocean and take it up north with us...And only when we got there did we realize that giant that we were trying to take with us was us when we are all together...

But a boy was the one who told that to me. We're up at one sacred mountain, on the way down, and I'm sitting there. He said, "You know, Preston, when the sun was going down I was sitting there and I saw this thing there and it got bigger and bigger and bigger, and it was really my shadow got bigger, when the sun moved. It got big as a giant and that giant was me!" I said, "That's right. All together, we're a giant, and we're going up there."

—*Preston Arrowweed (Quechan/Kumeyaay)*

(Note: In 1999 a coalition of five tribes and many environmentalist organizations and individuals succeeded in their struggle against the nuclear waste dump proposed for this sacred area, when, after a historic 113-day occupation, the Department of Interior put an end to the project.)

Quechan men working on the construction of the All American Canal near Laguna Dam, 1920s.

Courtesy of Victor Curran Jr.

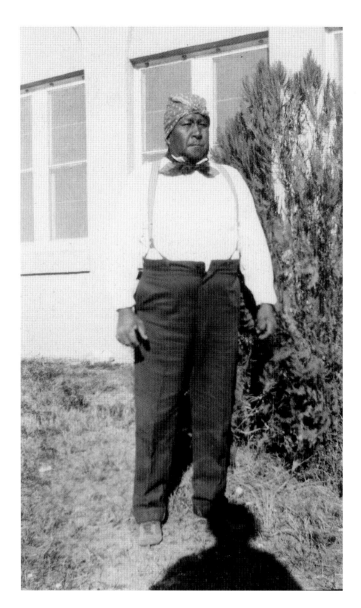

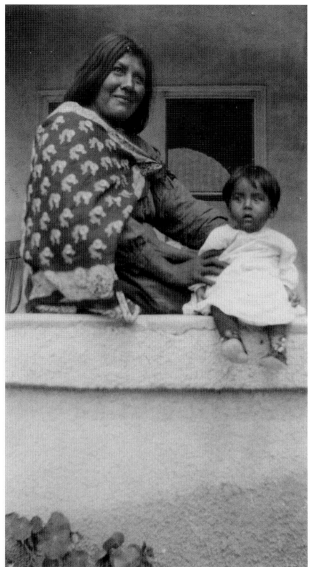

Mike Jefferson (Quechan) with his long
hair wrapped up turban-style, Fort
Yuma, 1920s.
Courtesy of Ila M. Dunzweiler.

Mrs. Harry Escalante (Quechan) with
her son Oliver, Fort Yuma, 1920s.
Courtesy of Ila M. Dunzweiler.

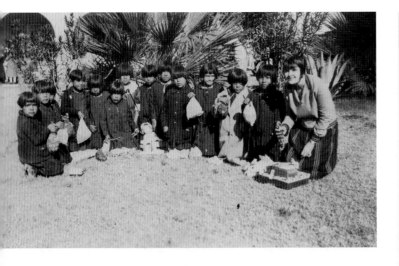

Ruth Schlapbach with students of the Methodist Church School at Fort Yuma, 1929.
COURTESY OF ILA M. DUNZWEILER.

Mabel Brown, Fort Yuma, 1996.
COURTESY OF BARBARA LEVY.

Quechan elder Mabel Brown was seventy-five when this photo was taken. Some of her stories have been recorded and some also appear in *Spirit of the Mountain* by Leanne Hinton. She worked for the tribe's senior nutrition program for thirty years.

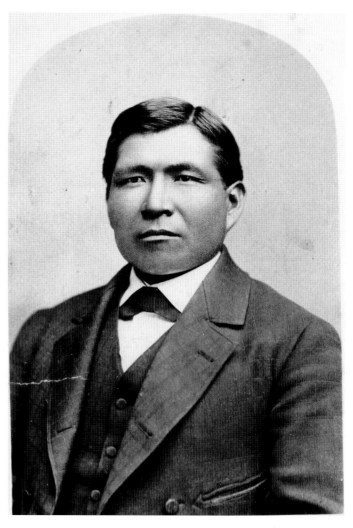

Captain John Morongo (Cahuilla), late 1800s. The last leader of the Morongo Band and a respected liaison between the tribe and the government, he spoke English, Serrano, and Cahuilla.

Captain John Morongo's daughters, Nancy and Annie (Cahuilla), Morongo, early 1920s.

Sarah Morongo (Cahuilla) at Morongo, early 1920s.

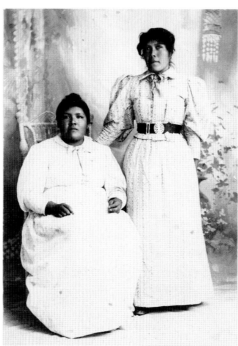

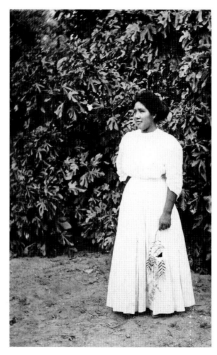

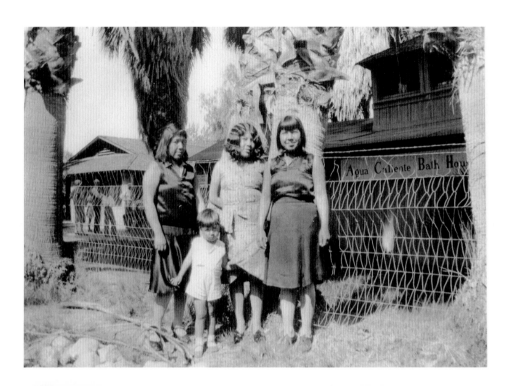

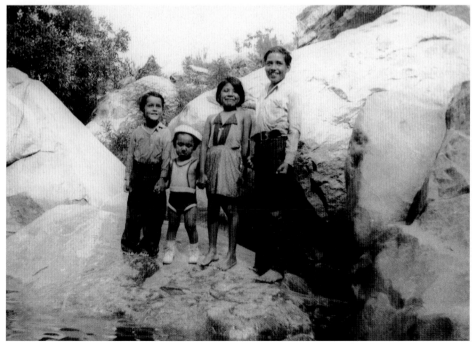

*Dorothy Ramon (Serrano/Cahuilla)
with Julia, Harry Jr., and Katherine,
Palm Springs train station, c. 1930.*
COURTESY OF ARLENE SIVA CRAFT.

*Gordon Horseman, Ernest Siva
(Pima/Serrano/Cahuilla), Arlene Siva
(Pima/Serrano/Cahuilla), and Harry
Horseman, Morongo area, 1940.*
COURTESY OF ARLENE SIVA CRAFT.

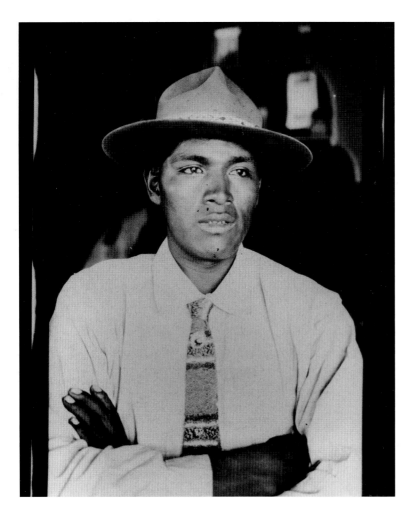

Clemente Segundo (Cahuilla).

People have been going to the Palm Springs area for the healing waters seemingly forever, but Clemente Segundo managed the first bathhouse, in the late 1930s. The fee for bathing in the 104° water was then twenty-five cents, towel not included. The Agua Caliente tribe's Palm Springs Spa Hotel (now the Spa Resort Casino), which opened in the mid-sixties, is on the site of the original bathhouse.

Flora Patencio (Cahuilla) with Mojave guests at the opening of the first Spa Hotel, Palm Springs, 1963.

Clemente Segundo, Chairman Willie
Marcus, Lena Welmas, and Joe Patencio
(Cahuilla) on the porch of the tribally
owned hot springs and bath house in
Palm Springs, 1930s.
Courtesy of the Agua Caliente Cultural
Museum.

Agua Caliente tribal chairman Richard
Milanovich with his sister Virginia,
1950s.
Courtesy of the Agua Caliente Cultural
Museum.

Tonita Largo Glover (Mountain Cahuilla/Fort Sill Apache) with her father, Joseph Anthony Largo, in Phoenix, 1930s.
COURTESY OF LORENE SISQUOC.

Blossom Maciel (Mountain Cahuilla/ Fort Sill Apache) with Skylar at the Cahuilla Reservation, 2002.
COURTESY OF LORENE SISQUOC.

Lori Sisquoc (Mountain Cahuilla/Fort Sill Apache) and Marian Walkingstick (Ajachmem) gathering juncus on the Cahuilla Reservation, 1997.

Photo by Blossom Maciel. Courtesy of Lorene Sisquoc.

Michelle Sisquoc (Mountain Cahuilla/ Fort Sill Apache) weaving at Nex'wetem gathering, Riverside, October 2002.

Courtesy of Tonita Amua Largo.

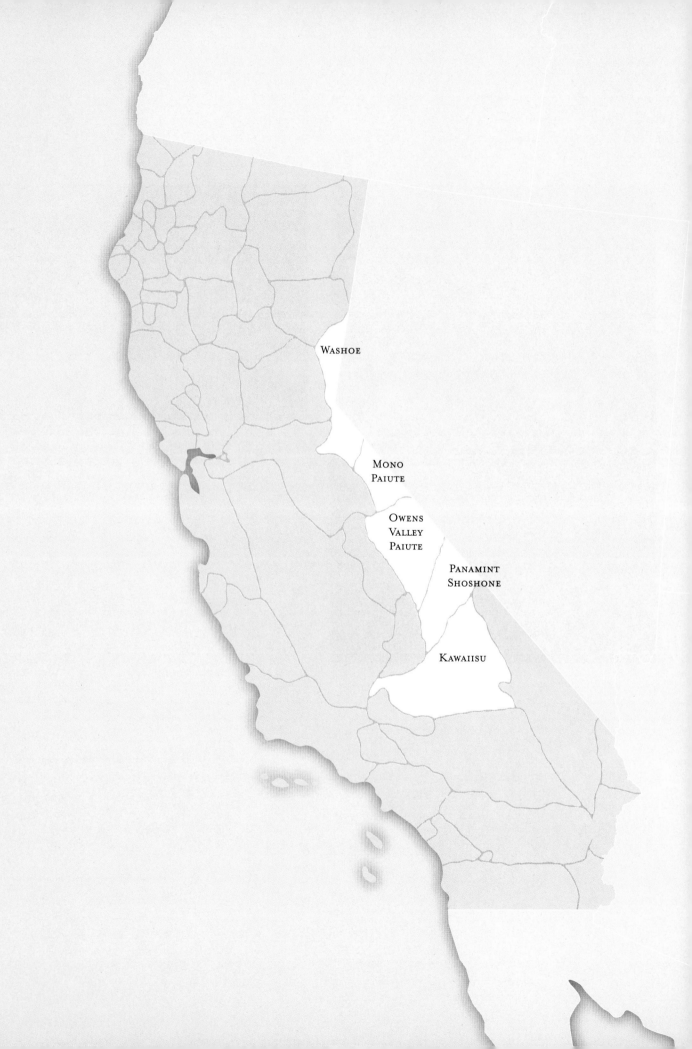

Washoe

Mono
Paiute

Owens
Valley
Paiute

Panamint
Shoshone

Kawaiisu

Five

GREAT BASIN

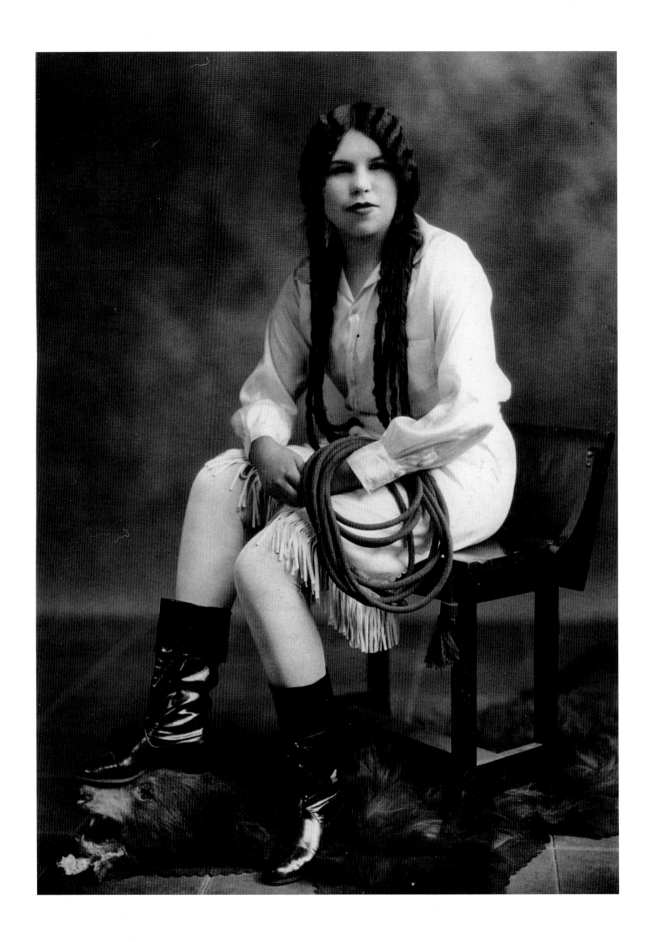

If state lines followed topography, the crest of the Sierra Nevada might have been California's eastern boundary. Instead, the constitutional convention of 1849 set the

state line somewhat to the east, and California includes a good portion of the Great Basin. So named because it exists like a large bowl between the Sierra Nevada on the west and the Rocky Mountains on the east, the Great Basin covers over two hundred thousand square miles in five states—California, Nevada, Utah, Idaho, and Colorado.

Displaying the characteristics of the Sierra Nevada, the Great Basin, and the Mojave Desert, the land just east of the Sierra is one of contrasts: at 282 feet below sea level, Death Valley's Bad Water is the lowest point in the continental United States; not far away, Mount Whitney soars to the highest point, 14,494 feet. Arid desert zones are overlooked by snowy mountains.

The roughness of the terrain discouraged Anglo settlements until relatively late, and therefore there are still many Indian communities scattered throughout the eastern slopes of the Sierra and the adjoining flatlands. Intact Indian communities can be found in the Lake Tahoe basin, near Carson City, Bishop, and Lone Pine, in Death Valley, and elsewhere.

Like the lines on maps, distinctions between tribes are often less clear in reality than they are on paper. Anthropologists and archaeologists call the natives of the eastern Sierra—Washoe, Paiute, and Shoshone—Great Basin peoples, and it's certain they are, but they also live in a frontier zone, a crossroads where cultural blending occurs.

The Washoe region around Lake Tahoe is more lush and diverse than most of the rest of the Great Basin. The native language here is in the Hokan family—a language family that includes the Quechan, Karuk, and Pomo languages—while most Great Basin tribes speak Numic languages, shared with the Comanche, Shoshone, and Northern and Southern Paiutes.

Despite the daunting Sierra Nevada, people from the eastern and western sides of the mountain range visited each other regularly. Centuries before American and European immigrants attempted to cross the Sierra in wagon trains, Native Americans had created a network of three main trails and a series of interconnected smaller trails that formed a massive trade system. During favorable seasons, Paiutes from the east and Miwuk and Mono people from the west would follow these paths to visit friends and family, attend dances and festivals, trade their own regional goods for others, and enjoy the beauty of the High Sierra.[1]

From the east came salt, red paint, pine nuts, seeds, obsidian, fur blankets, and tobacco. The west offered salmon, trout, acorns, berries and other food, shell and bead money, and basketry materials such as redbud and bracken fern. Both sides

OPPOSITE *Alice Williams McKenzie (Paiute) in her cowgirl costume, Bakersfield, 1926. Alice's brother-in-law, Texas Tommy, was a performer and she appeared in his California shows.* COURTESY OF JAMES R. PRICE.

traded their characteristic finely woven baskets. Paiutes from Mono Lake carried on regular trade with the Miwuk of Yosemite Valley, sometimes even spending the winter there in lean years. Intermarriage between the two groups was common. Treks across the mountains continued to take place well into the twentieth century.

Although some traditional trails were destroyed by the introduction of horses, wagons, and cars, the cross-mountain interaction continues. In 1990, the Southern Sierra Miwuk of Mariposa County instituted the Yosemite Walk, retracing the original trail over Mono Pass to Mono Lake. Dorothy Andrews, a Paiute from Lee Vining, then seventy-four, led the forty-six mile trip. Jay Johnson (Miwuk/Paiute) explained that the walk, revived after sixty years, was an expression of unity for Native American people from the area, who are seeking federal acknowledgment. "While we never expect to get our land back, we would at least like to have our tribal identity."[2]

Members of the Mono Nation started their own annual event in 1999, the Mono Nation Traditional Walk. Together with members of various Owens Valley Paiute communities, they hike from Bishop, in Inyo County, over to Mono Hot Springs, in Fresno County. As in the old days, the Mono Nation event is a family affair, with children and elders alike walking through the same ruggedly beautiful landscape that their ancestors have passed through for generations.

Despite the fact that humans have lived there successfully for at least ten thousand years, the Great Basin was one of the last areas of North America to be colonized by Europeans. To the pioneers who crossed it on their way to the California goldfields or the farmlands of Oregon, the land was barren, desolate, outright hostile, more often than not compared to hell—a forbidding land to be gotten through and left behind as quickly as possible. Mostly flat and covered in sagebrush, the region is short on water. Even today, Salt Lake City and Las Vegas notwithstanding, this area is not heavily populated. Like the interior of southern California, though, it has been a site of environmental contention in recent years—sometimes because of its apparent barrenness, sometimes for its splendor, often for its battles over precious water.

Native stewardship over land, practiced for thousands of years, is generally disregarded by the dominant culture. Ironically, although indigenous people know their homelands down to the most minute detail, programs designed to preserve the wonders of public lands have often excluded and sometimes even victimized native people. The Shoshone, the Paiute, and the Washoe all have recent stories of land-use struggles to tell.

In 1933, when Death Valley National Monument was created, no mention was made of the Timbisha Shoshone, who had lived there for centuries. A forty-acre "Indian Village" was created near Furnace Creek in 1938 as a home for the Shoshones, a home that they could occupy but not own. By the 1970s, tribe members were living without electricity in falling-down adobes in the shadow of a luxury "ranch" hotel, complete with swimming pool and golf course, built for the visitors to their land. Although they were acknowledged as a tribe in 1981, in part on the merit of

their living language, their troubles did not end. Subsequent disputes between the Timbisha Shoshone and the National Park Service (NPS) came to a head in the 1990s when the California Desert Protection Act of 1994 required NPS to find them a suitable reservation. NPS officials suggested a site in Nevada, to the east of the park, but the tribe was adamant about living inside the valley. Finally, in December 2000, the Timbisha Shoshone Homeland Act created a reservation located partially inside the park.

The land on which the Owens Valley Paiute live was a fertile oasis in the days before Owens Lake was drained. In fact an early name for the area was Owens Lake Valley. But city officials from Los Angeles, looking for outside water sources for their growing metropolis, focused on Bishop Creek, Owens River, and Owens Lake.[3] By 1905 the city had acquired enough land and water rights, and by 1913 an aqueduct had been built to carry the new water supply down to the San Fernando Valley. Residents of Owens Valley—Indian and white alike—saw their water being drained away to Los Angeles while their own ranches and farms withered in the desert heat. Groups of outraged citizens would repeatedly dynamite the aqueduct throughout the 1920s.

Faced with the loss of their livelihoods, many people left the valley. The U.S. shuffled Paiutes around to various pieces of land, mostly useless except for the water rights that went along with those parcels. Eventually, the Los Angeles Department of Water and Power "acquired" most of these water rights, too. The Bishop Reservation, however, managed to retain some of theirs, and recently the Owens Valley Indian Water Commission has, through the courts, made significant headway toward gaining more control over their water.

The Washoe world is centered to the north, at Lake Tahoe, both physically and spiritually. Sadly, outsiders did not always feel the same reverence for the lake. Beginning around 1860, commercial mining, logging, and fishing depleted wildlife in and around the lake, polluted what was left, and seriously degraded the lake's famed clarity and beauty. Tourism—ski slopes, golf courses, hotels, resorts, casinos, and huge numbers of people—continued the process. "We still believe we're some of the luckiest people on earth to call this home," said Brian Walker, chair of the Washoe Tribe. "But it's hurtful to see the congestion."[4]

The Tahoe Regional Planning Agency, formed in 1968 to bring environmental responsibility to development efforts in the Tahoe Basin, has received mixed reviews for its efforts. But during the last ten years, the U.S. Forest Service has acquired some thirty thousand acres (about 67 percent of the Lake Tahoe basin is now in public ownership). Washoe people have been lobbying for years to have at least part of their homelands returned to them, and they have been active in several groups that seek to protect Lake Tahoe and manage it properly. In 2003 legislation was enacted to convey a small portion of the Washoe homeland—twenty-four acres—to the Interior Department to hold in trust for the Washoe Tribe of Nevada and California. Recognizing that the tribe "historically gathered along the shore of Lake Tahoe for activities such as

spiritual renewal, land stewardship, traditional learning, and reunification of tribal and family bonds," the law precludes commercial use and is intended to promote traditional and cultural activities on the land. In 1997 the tribe won an agreement from the Forest Service to manage the 350-acre Meeks Bay meadows to grow native plants, as well as another 90 acres for a cultural center and tribal access to the lapping waters of the great lake for the first time in a century. For a glimpse into traditional and ongoing Indian culture, visit Wa She Shu It Deh, the Washoe Cultural Arts Festival held each summer at the Tahoe Tallac Historic Site (www.washoetribe.us).

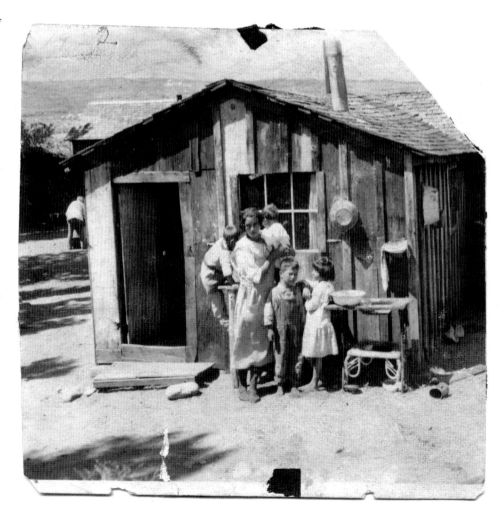

Richard Stewart's grandmother Ida Stewart (Paiute), with Kelly, Aileen, and Harvey Stewart and an unidentified child in front of the family's home in Big Pine, 1920s.
COURTESY OF RICHARD STEWART.

Richard Stewart: One of the things that is kind of interesting is that my grandfather [Louie Stewart] had a camera in 1919, and he took pictures—that's where a lot of these come from. And...when the first little compact recorders came out...he bought one, and taped himself before he died...I have probably twenty hours of tape that he did of language and stories—you know, just conversation. He carried it on with himself because there was no one else around. And he kind of like fell in love with the machine...So you're kind of moving with the time and staying with it, which he did. And the interesting thing was, when he died is when I found out he couldn't read or write.

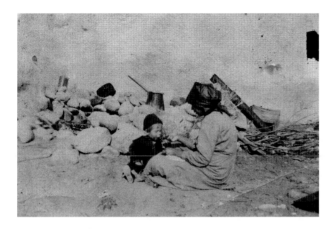

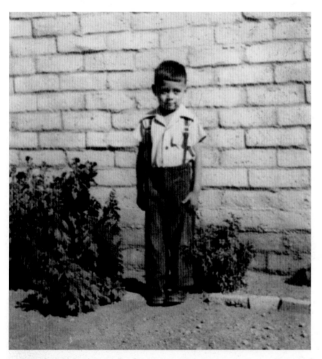

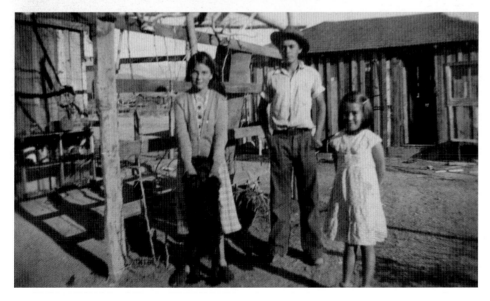

Nettie Stewart (Paiute) feeding baby Kelly Stewart in Big Pine, 1919.
Courtesy of Richard Stewart.

Siblings Aileen, Kelly, and Dorothy Stewart (Paiute), Indian Camp at Big Pine, 1936.
Courtesy of Richard Stewart.

Richard Stewart explained that Indian Camp was five acres owned by Indians. The house in the background still stands— it's his garage and looks much the same. The girls in the picture (his father's sisters) look very much like Richard's own daughters.

Richard Stewart (Paiute/Pima) at age three, standing in front of a government building in Big Pine, 1947.
Courtesy of Richard Stewart.

Richard Stewart recalled that this picture was taken when the family first moved down to the reservation. There were only seven families on the reservation at the time, and the children went to public schools. His grandfather Louie Stewart had been sent to boarding school in Phoenix and ran away and returned to Owens Valley on foot. His mother's father, Nat Cyrus (Pima), was sent to Sherman Indian School in the seventh grade and didn't go home until graduation, but he retained the language.

185

North America, during the Ice Age, was dominated by mastodons, horses, camels, bison, sloths, saber-toothed tigers, and other large mammals—the so-called megafauna of the Pleistocene Age. About twelve thousand years ago, the glaciers that covered much of the continent receded and the climate changed. Early humans—always adaptable—were able to find new foods and create new living patterns, but the large mammals couldn't. Eventually, with some pressure from humans as well as climate change, they would become extinct. It wasn't until the arrival of Europeans in the Americas that horses would be seen here again.

In eastern California and along the edges of the Great Basin, people lived along the shores of the lakes created by the melting glaciers: Owens Lake, which frequently overflowed into China Lake and Searles Lake; Lake Manley, which is now Death Valley; and Lake Lahontan, which was the precursor to Pyramid Lake and covered a good portion of Nevada. Over the next several thousand years, the climate would continue to change, becoming progressively warmer and more arid; the lakes would dry up, leading to the formations we know today; and people would adapt themselves to a desert environment.

Humans have lived for centuries in the Great Basin. Recently archaeologists working at Searles Lake in the Christmas Canyon area have found evidence that would date human habitation of the area to eleven thousand years ago, placing it on a par with other well-known early sites, including the famed site at Clovis, New Mexico.

Recent work with rock art, however, suggests the possibility that many sites in eastern California were inhabited long before previous estimates. There are two main types of rock art: pictographs, or paintings on rock, and petroglyphs, which are chipped into the outer surface of rock with a stone tool. The rock art that survives in the Great Basin is primarily petroglyphs. Common images found here include geometric patterns, people, and bighorn sheep and other animals.

While no one is absolutely certain of the meaning behind the images, the prevailing theory is that they were ritually created by shamans and related to hunting. One of the largest collections of extant rock carvings is at China Lake, in the Coso Range of eastern California. Some scholars believe that the first petroglyphs were made here sixteen thousand years ago, and that use of the area continued through historic times. Based on this, there are some who believe that the style of rock art found throughout the Great Basin and the Southwest may have originated in the Coso Range.

Today, China Lake is part of a Naval Air Weapons Station. While there are petroglyphs in canyons throughout the base, the highest concentration are in Little Petroglyph Canyon, which is open to the public on a limited basis. The public affairs office at the weapons station allows public and private tours, and the Maturango Museum in China Lake offers guided tours for a fee. There are over six thousand images to be seen. As the museum's website says of Little Petroglyph Canyon, "It is the canyon which is little, not the petroglyphs."

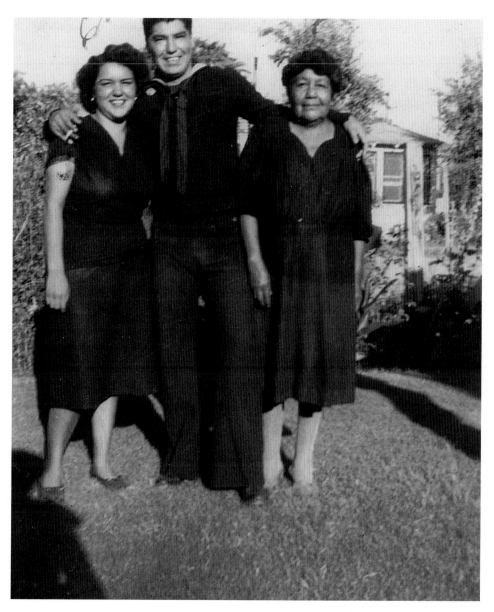

Evelyn Bevers (Owens Valley Paiute),
Bud Tungate (Tubatulabal–Koso), and
Legora Miranda (Tubatulabal–Koso),
1946.

Steve Gonzales (Tubatulabal–Koso–
Yokuts–Kumeyaay) with his grandmother
Clara Chico Apalatea (Tubatulabal) and
cousin Melissa Comacho (Tubatulabal–
Koso Yokuts), 1990.

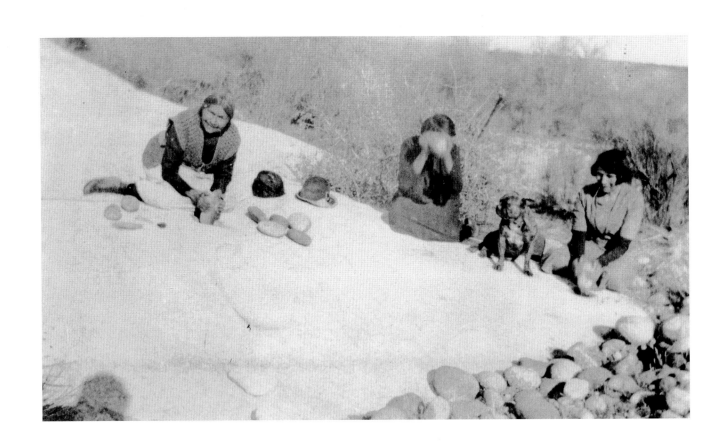

*Refugia Williams (Paiute) pounding
acorns with her daughters Eliza Williams
Coughran and Mary Williams Esponda,
Isabella, 1920s.*

Courtesy of James R. Price.

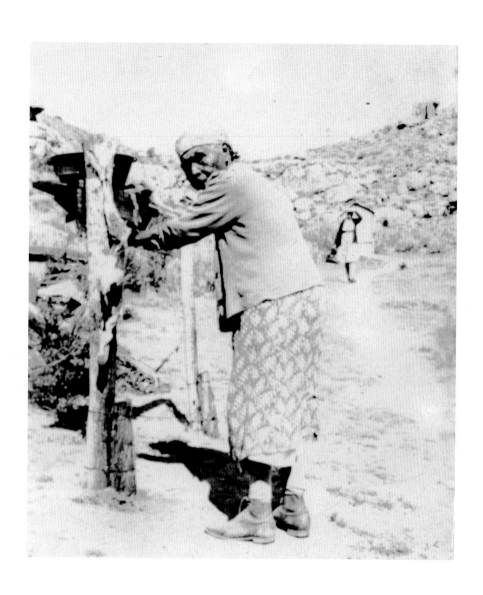

Refugia Williams (Paiute) at Kelso Valley in the 1950s. She lived to be 101 years old.

COURTESY OF JAMES R. PRICE.

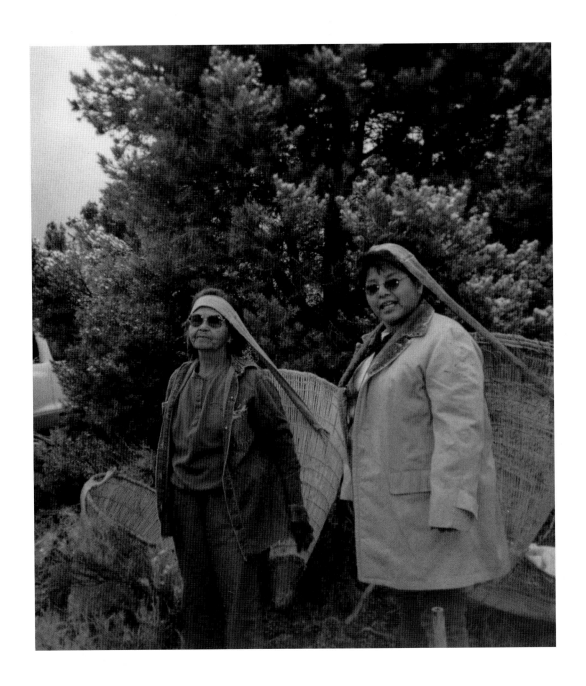

IN THE GREAT, SAGEBRUSH-STUDDED PLAINS AND SLOPES OF EASTERN CALIFORNIA, a person must sometimes range a long way to find food, and it is foolish to pass up any opportunity for sustenance. Thus ants, bees, wasps, crickets, cicadas, grasshoppers, and locusts, either as adults or in their larval and pupal (cocoon) stages, were once an important part of the diet of this region. Nearly all of these insects can be roasted or dried, used whole or ground into powder for soup, and stored for the winter.

In addition to these more or less dependable insects, certain delicacies are available from time to time. After feeding, caterpillars of the pandora moth descend from the trees to begin their pupal stage in the ground, at which point they can be collected and roasted. And in the salty lakes of the Great Basin, where few fish live but insects breed enthusiastically, the shore fly was considered a delicacy. Around September the pupae of these flies move toward shore and wash up in droves. Women would gather, dry, thresh, and winnow them. The flies could be eaten fresh or stored and then roasted, mixed with berries, or boiled into a soup. They were so highly regarded that they were a popular trade item with tribes on the west side of the Sierra. Amazed at the two-foot-high pile of shore fly pupae that ringed Mono Lake when he visited there in 1865, J. Ross Browne noted that he'd been told the dried pupae, acorn, and fruit mixture "is very nutritious and not at all unpalatable."[6]

In addition to these tiny but plentiful protein sources, rabbits, antelope, mountain sheep, and other mammals were hunted. This was generally done in communal drives: rabbits were herded into long nets and then clubbed, antelope and sheep were driven into brush corrals or box canyons. Besides food, these animals were a source of bone to be used for jewelry, tools, and weaponry, and their skins brought warmth in the winter.

Hunting skills were highly developed with a large spiritual component. In 1939, Robert Lowie wrote about the role of the shaman in traditional antelope hunting:

> The antelope shaman would first try to locate some game through his
> dreams. Then he would go and observe them, talk softly to them, and
> let them get used to him. Then he would organize the construction
> of a sagebrush corral. Finally, with the shaman using his magic to
> keep the antelopes calm, the hunters would drive the game into the
> corral and kill them.[7]

The oak trees that sustained much of native California are rare in the arid basin, but nature offered the people of eastern California another plentiful and nutritious staple: the nuts of the piñon pine. At 3.8 grams of protein, 15.3 grams of carbohydrates, and a whopping 35.4 grams of fat per 100 grams, pine nuts are well worth the effort it takes to gather them.[8]

Piñon harvesting began in the early fall—late August in lower elevations, through September and October in the higher mountains—when the cones were mature

OPPOSITE *Melba Beecher (left, Western Mono) and Weylena Jeff (Washoe) gathering piñon nuts near Carson City in 2002.*
COURTESY OF MELBA BEECHER.

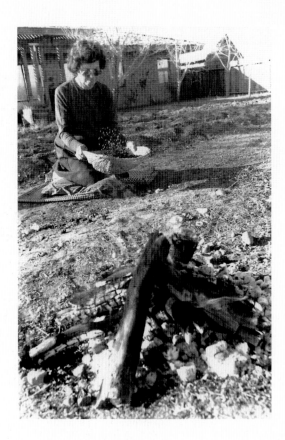

but still slightly green and closed, retaining their nuts. Each tribe had a different approach. The Washoe gathered in small family groups. Among the Paiute, people of different regions had rights to specific groves. The Shoshone gathered communally.

People plucked the cones from low branches and used long poles, sometimes with hooks attached, to knock cones from high branches. They could open ripe cones by hitting them on the broad end with a sturdy stick or a rock, and they split other cones open by drying them in the sun or building a large bonfire on top of them and roasting them. The people would shell and winnow the nuts, and then roast them or boil them, to be eaten whole or pounded into flour that could be made into soup. The piñon harvest would last only a few weeks, but in that short time a family could gather enough to last through winter. By the time they ran out, spring would have arrived, bringing with it new plants and other foods.

Remembering times spent with Goldie Bryan, a Washoe elder who passed on in 1995, Laura Fillmore recalled a pine nut camp where:

> The wind whipped through the sagebrush fire as people circled it slowly, poking the burning sagebrush with long sticks, folding the fire back on the pile of pine nuts. A distance away, children sat encircling adults as we cleaned *tá gim* "pine nuts" from the cones that had been opened by the sun—tap, tap, tap, tap, as we struck dried piñon sticks on the broad ends of the cones, and then the rainfall sound of the nuts hitting the tarps below us.[9]

A sweet melody and sweet memories, from the dry side of the Sierra.

Theresa Jackson (Washoe) winnowing pine nuts.

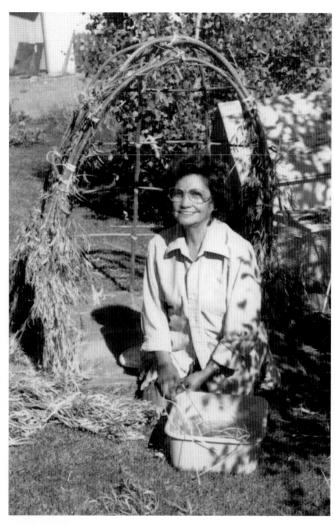

Theresa Smokey Jackson (Washoe)
building a willow shelter.

Qwina West, Ray Stone, and others
building a traditional Paiute toni *for*
the Owens Valley Career Development
Center, Bishop, 2002.

Jessie Keith (Paiute) near Bishop,
1940s.

Courtesy of Dolly Manuelito.

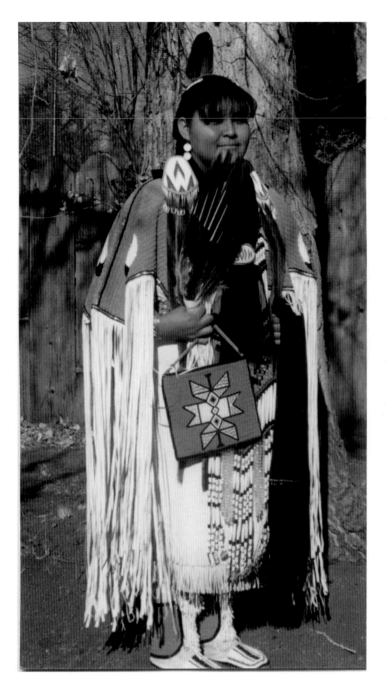

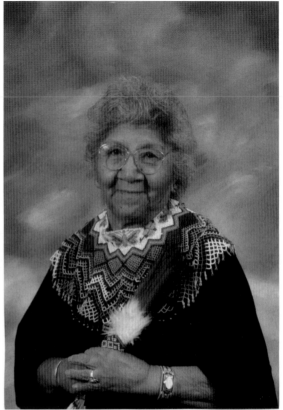

Tara Lynn Frank (Paiute/Navajo/Sho-shone) wearing regalia that incorporates family designs, Bishop, 2000.
Courtesy of Dolly Manuelito.

Jessie Keith Manuelito (Paiute) wearing her traditional shawl and carrying a traditional feather fan, 1999.
Courtesy of Dolly Manuelito.

Dolly Manuelito recalled that her mother had this picture taken the year that she died. She gave copies to her kids on Mother's Day. The photographer helped her with her regalia. She did lovely beadwork, finer than what others do now.

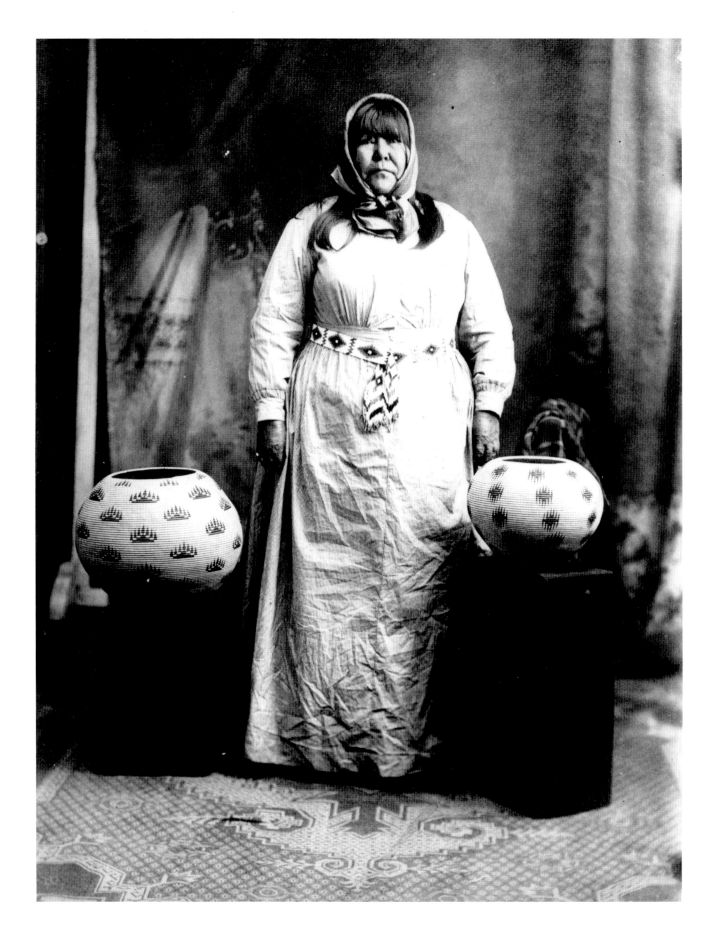

AROUND THE TURN OF THE TWENTIETH CENTURY, AS ART COLLECTORS FOUND A new appreciation for applied arts in general and the arts of Native America in particular, a market for indigenous basketry developed. Native traditions had been declining, and by this time Indian women often had to take menial jobs to help support their families. With metal pans, glass dishes, and canvas bags readily available, there was little practical incentive to weave, and many gave up basketry entirely. Once art collectors identified baskets as a collectible and saleable commodity, however, basket weaving became a way to make a living while doing something traditionally Indian and artistically gratifying, and some weavers did a brisk business with art dealers and collectors. Hundreds of baskets from this time still exist, mostly in museums and private collections. Unfortunately, their weavers' names are seldom known, and the baskets are often identified only by tribal designation, a rough date, and perhaps the location of the sale.

There are a handful of weavers, however, who not only escaped anonymity, but in fact acquired a certain celebrity. One is Datsolalee, a Washoe woman who was one of the most famous weavers in California and Nevada. She was born sometime between 1830 and 1850, near the mining town of Sheridan in the Carson Valley, and given the name Debuda. Working as a laundress and cook, she traveled throughout the mining districts in and around the Carson Valley. In 1888 she married her third husband, a part-Washoe man named Charlie Keyser, and took the name Louisa.

In 1895, Louisa Keyser went into the Emporium Company in Carson City to sell some baskets she had made. The Emporium was owned by Abe Cohn, whose father Louisa Keyser had worked for some twenty years before. Abe and his wife, Amy, were so taken by her talent that they offered her a deal: in exchange for her baskets, they would support her and Charlie. The Keysers began to spend their winters at the Emporium and their summers in Tahoe City, where the Cohns had a curio shop.

The Cohns managed every aspect of Louisa Keyser's career carefully and created a mythic past to increase the value of her work. The name Datsolalee may have been invented by the Cohns, although there are at least two other viable theories about its origin. Regardless of how she got the name, Datsolalee is what the Cohns called her, and it is the name by which she is most widely known.

Datsolalee traveled widely with the Cohns to fairs and exhibitions. By the early 1900s she had perfected basketry styles and innovations that she would become famous for—notably intricate stitching, ample and complex patterns, and shapes, especially the globular *degikup,* that were aesthetically pleasing to the market she was selling to. Emphasizing the sophistication of her artistry, Larry Dalrymple writes:

> Keyser's success at discovering various types of designs that complement the *degikup* shape turned her craft into an art. She frequently created compositions with columns, running from top to bottom of the basket and situated intermittently around the

OPPOSITE *Datsolalee (Washoe) with two of her baskets.*
COURTESY OF THE NEVADA HISTORICAL SOCIETY.

piece. In addition, she used diagonal bands that angled from the bottom to the top of the basket. A third design type she developed was called a scatter pattern because the design was repeated in different positions on the surface, giving a feeling of motion. All three configurations emphasized the shape of the *degikup*, while the combined use of redbud (red) and bracken fern (black) produced a three-dimensional quality.[10]

Toward the end of her life, some of Datsolalee's pieces commanded huge prices: a new, exquisitely stitched "Beacon Lights"–patterned basket sold for $4,000 in 1914, which would be more like $25,000 today.[11] She died in 1925 and was buried at the Stewart Indian Colony at Carson City. In the thirty years that she lived with the Cohns, she had made at least one hundred and twenty baskets and possibly as many as three hundred. Many of them are in museums today.

Datsolalee was not the only Washoe basket maker to craft and sell fine baskets. Among those who are almost as well known are Lena Dick, Lillie James, Maggie Mayo James, Sarah Jim Mayo, Lizzie Peters, Jennie Bryant Shaw, and Tillie Snooks. Although Washoe basketry—like Indian basketry everywhere else—faced a sharp decline in the mid-twentieth century, it has come back in recent years. Many Washoe weavers can be found in both the California Indian Basketweavers Association and the Great Basin Native Basketweavers Association.

Although the Cohns are gone and the market for new, well-made baskets has diminished, modern practitioners find other values in pursuing the art. Contemporary Washoe basketweaver Amy Barber explains that weaving is more than a physical skill: traditional weaving necessitates clearing your mind of worries. "They used to say, the basket's here. It knows your feelings. I used to think that was silly, but when I got older I understood."[12]

OPPOSITE TOP *Pete Sport (Paiute) of Warm Springs and his wife, Big Min, selling baskets near Big Pine in the 1920s.* COURTESY OF RICHARD STEWART.

OPPOSITE BOTTOM *Washoe basketweavers Joann Martinez, Florine Conway, and Theresa Jackson.* COURTESY OF SUE COLEMAN.

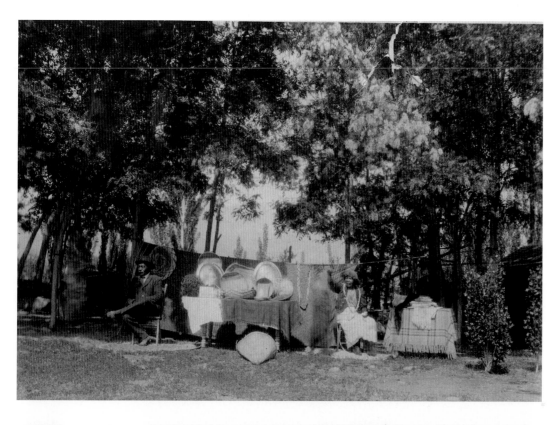

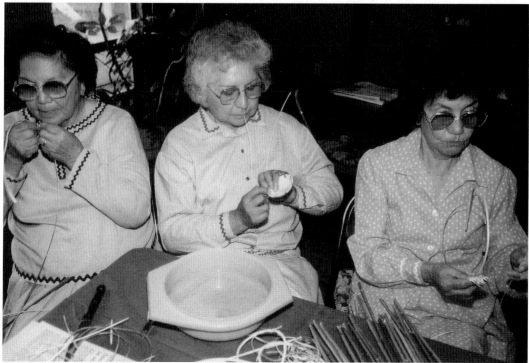

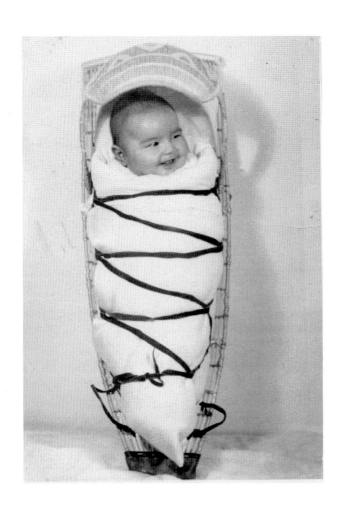

*Sue Coleman (Washoe) in a baby basket
made by her mother, Theresa Smokey
Jackson, c. 1950.*

OPPOSITE *Washoe baskets from the
Smokey family collection.*

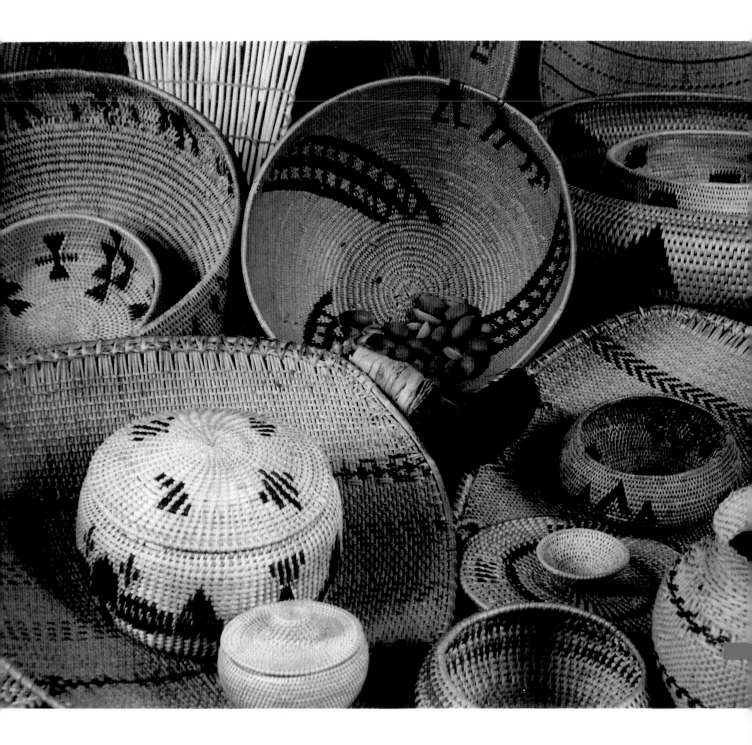

REGARDING THE FIFTY CALIFORNIA INDIAN LANGUAGES THAT WERE STILL BEING spoken in 1994, linguist Leanne Hinton wrote:

> [They] are indeed in the ultimate crisis in a life-and-death struggle. After decades of social change and attempts by authorities to eradicate native language use, Native California languages are rarely spoken at home, so children do not learn them. Most languages are spoken only by a few elders. Some languages have only one fluent speaker left and, as has already happened to so many, some have none. We may see 90 percent of these languages, or perhaps all of them, disappear in our lifetimes.[13]

Since that time, programs to save endangered languages have been gathering strength worldwide, with mixed results. One of the strongest in California is on the eastern side of the Sierra, the Owens Valley Career Development Center's Nüümü Yadoha program. The center was founded in 1977 to provide vocational services to the native people of Inyo County; but through the years it grew beyond Inyo and it expanded to offer other services as well, including, in 1988, the language program. The Nüümü Yadoha name—bestowed by elder Norma Nelson (Bishop Paiute)—means "the Indian people's language."

Nüümü Yadoha participants believe that a revitalized language can help restore traditional cultural practices and values, to the benefit of the entire community. To this end, the program does not just happen in language classes, but through the involvement of community members in cultural activities.

Since it was started, Nüümü Yadoha has grown to include five counties east of the Sierra, in the foothills, and in the Central Valley, and six languages: Paiute, Yowlumni, Kawaiisu, Western Mono, Wukchumni, and Pakanapul. Participants work in teams, under the supervision of one or more fluent elders, to increase their knowledge of the language with the eventual aim of becoming teachers themselves. Together, teams analyze the needs of their communities, plan activities, and develop a curriculum. During the first year of training, they emphasize documenting and recording fluent speakers and increasing the fluency of others. After that first year, teams teach beginning language classes to others in their community, and they also organize cultural activities.

With support from the Advocates for Indigenous California Language Survival and the American Indian Language Development Institute, Nüümü Yadoha trains team members in administration, the use of recording equipment, archiving, and teaching skills, and provides funds for equipment, training, facilities, and transportation. With the recent addition of a research librarian and a specialist in second language acquisition, the program has become a model for other tribal language programs.

OPPOSITE *Norma Nelson (Paiute) at a Nüümü Yadoha training workshop presented by the Advocates for California Indigenous Language Survival (AICLS) in 2004.*
COURTESY OF OWENS VALLEY CAREER DEVELOPMENT CENTER.

Photos from a Nüümü Yadoha training workshop presented by the Advocates for California Indigenous Language Survival (AICLS) in 2004.

Courtesy of Owens Valley Career Development Center.

TOP *Mary Davis (Paiute) teaching*

BOTTOM *Lucille Hicks (Kawaiisu) teaching*

OPPOSITE TOP *Margaret Valdez (Yowlumni) teaching*

OPPOSITE BOTTOM *The Pakanapul crew*

As Paul Chavez of the Owens Valley Career Development Center explains, language survival is key to cultural survival:

> As far as the Owens Valley Career Development Center and serving our communities is concerned, everything is based around nation building and we do that by building strong families....You know there are a lot of problems in the Indian community. As we all know there's alcoholism, sickness, diabetes, there's all that. Some of the spiritual leaders say it is because we're out of balance. It's about bringing back into balance what once was...with the culture, tradition, language, education...Language is a big part of that. That's a real fundamental building block of a healthy community.

Margaret Valdez: I enjoy what we do. I'm so glad that they know to find us, that they wanted someone to work with Indian languages...A lot of my Indian words came back to me. And we have fun, we have our classes from nine to twelve, then we have a real nice little lunch afterwards, and it's really been interesting, it really has. And we have gone on trips....I thought we were the only people that spoke Indian until we went to Berkeley. That was my first conference of all the Indian languages that they could speak, you know.

At home when we were growing up, Grandma spoke Indian. And my mom. My dad was Mexican, so we already knew how to speak Spanish and Indian before we started school. And they told us not to speak our language. And it's funny—it's come back, now everybody wants to be an Indian. Everybody wants to learn to speak Indian.

There is a school here... I think they have thirty little students. So that's my plan—go there and teach those little kids Indian language. And they don't forget the words. Once they hear it, they don't forget it.

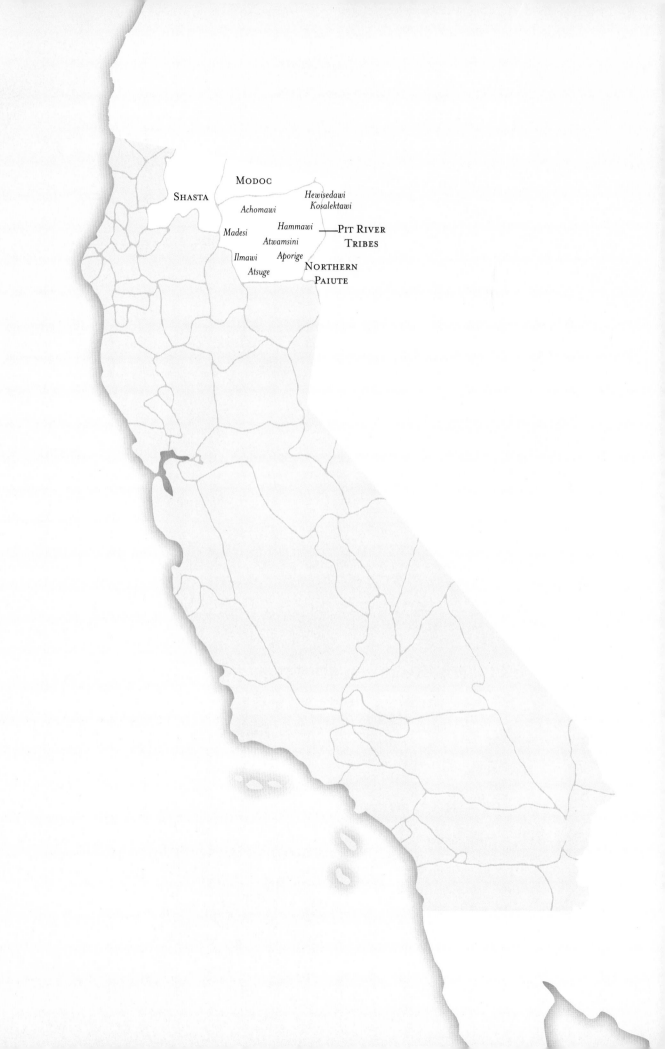

SHASTA

MODOC

Achomawi

Hewisedawi
Kosalektawi

Hammawi —— PIT RIVER
Madesi TRIBES
Atwamsini
Ilmawi *Aporige*
Atsuge NORTHERN
PAIUTE

Six

Northeastern California

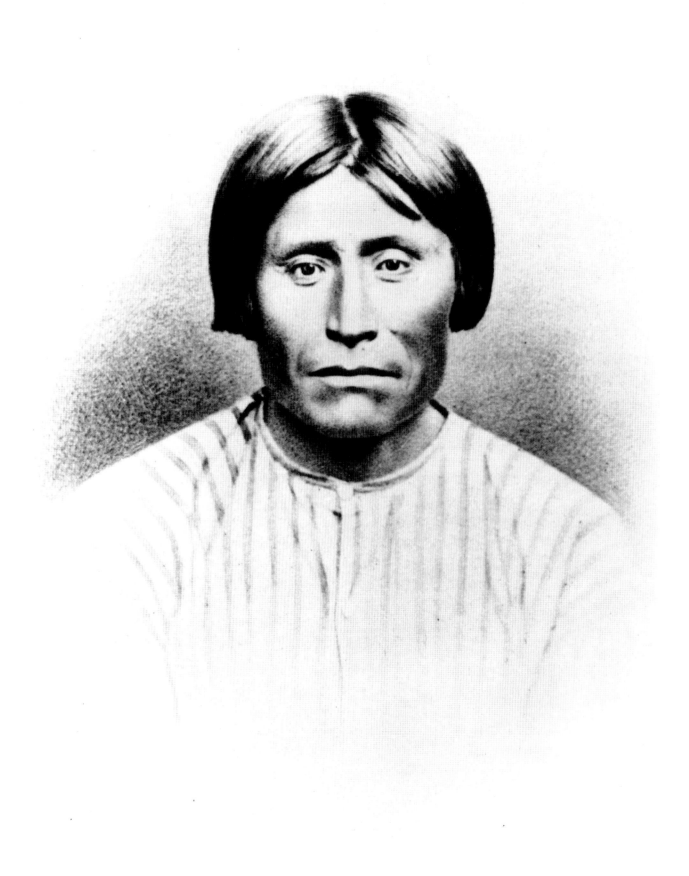

Just beyond the northern end of the Central Valley and the Sierra Nevada, the Cascade Range dips into California in the form of two striking volcanic peaks,

Mount Shasta and Mount Lassen. They herald the change to extreme temperatures and rugged terrain, a change that distinguishes the native cultures of this region from those of the rest of California.

There are five tribes in this northeastern corner of California: the Shasta, Modoc, Pit River (primarily Achomawi and Atsuge),[1] Northern Paiute, and Yana. But the physical environment changes so rapidly here that most of these groups developed distinct and autonomous subcultures, making the word "tribe" something of a misnomer—as it is in most of California. Food, medicine, hunting and fishing methods, dialects, and languages are all likely to differ as one moves from, say, a wetlands environment to a forest or to a high plateau.

The Shasta are an example of this. Their homeland moves clockwise from the southwestern side of Mount Shasta, which receives about seventy inches of precipitation annually, to the northern side, which receives less than fifteen inches.[2] The people sometimes lumped together as the Pit Rivers live in natural environments that range from dry, volcanic patches to swamps, from pine forests and rivers with pounding waterfalls to sagebrush flats; they speak two distinct languages, Achumawi and Atsugewi, and are politically divided into eleven bands whose cultures differ considerably. The Modoc land includes desolate lava beds, mysterious caves, high peaks, river marshes, and the remarkable Tule Lake, with its thousands of waterfowl and wintering bald eagles. The Modoc, whose territory lies at the ecological crossroads of the wet and the dry, were great traders with a tendency toward independence and adaptability compatible with this skill. Along the eastern edge of the state dwell the Northern Paiute, a Great Basin culture. The Northern Paiute traveled throughout their high desert homelands, which are covered with grasses with delectable seeds and roots, and which are full of caves and rocks rich with petroglyphs and pictographs. South of the Pit River peoples, the Yana occupied lands next to Mount Lassen and extending southwest to the upper Sacramento Valley and the adjacent rolling eastern foothills.[3]

Like other tribes in remote northern California, the native people of this area had little contact with Americans and Europeans until the mid-nineteenth century. In 1848 Peter Lassen, hoping to lure overland immigrants to his trading post near what is now Red Bluff by offering them a way around the northern end of the Sierra Nevada, pioneered the Lassen trail. His route passed over the Warner Mountains, followed the Pit River toward the area now covered by Lake Almanor, and then went

Captain Jack (Kintpuash), 1873.
COURTESY OF THE SMITHSONIAN INSTITUTION.

along Deer Creek and into the upper Sacramento Valley. Though Lassen's trail was no shortcut, a steady stream of prospectors and settlers began to arrive in northeastern California and continued throughout the 1850s.

The interaction between Indians and whites was particularly brutal here, marked by kidnapping, murder, massacre, and revenge. Tribal people tried a number of tactics for dealing with the invaders, including negotiation, harassment, and warfare. Examples from Shasta, Yana, and Modoc history illustrate the level of violence that affected all peoples of northeastern California.

In 1851, when President Millard Fillmore's representatives were negotiating treaties with the Indians of California, several bands of the Shasta took part and were promised a reservation. The memory of this event has been passed down through the generations: at the feast the Shastas held to celebrate the treaty, local vigilantes poisoned the food and then went on to burn whatever villages they could. Only five couples and twenty-eight single women survived that night. In the 1930s, some eighty years after the massacre, their descendants had organized a reservation. Today, some Shasta people share federal trust land at Quartz Valley Rancheria with Karuk and Upper Klamath people, and at least one other Shasta group is still seeking to be recognized by the United States.

Perhaps because Americans arrived so late that their reputation preceded them, the Yana—and in particular their southernmost division, the Yahi—did all they could to prevent encroachment on their lands. Independent-minded and belligerent, the Yana kept up a constant stream of harassment. As they lost access to more of their land and resources became scarcer, they stole cattle and raided cabins for food. They were responsible for several murders. Failing to distinguish between individual Indians or even tribes, immigrants retaliated against whoever was handy. In 1863 the Southern Yana were removed to the Round Valley Reservation, their presence erased from their homeland. In 1864, two white women were killed in the northern part of Yana territory, and the backlash nearly destroyed the Northern Yana band. Today there are Yana descendants living with Wintu and Pit River people on the Redding Rancheria.

The Yahi were also victims of massacres, and the few who survived were driven into the backcountry where they remained hidden for forty years. Ishi, the last Yahi, emerged in Oroville in 1911 and died in 1916.

In 1864, after an already bloody series of encounters between Indians and settlers, the U.S. government removed a group of Modocs in the Tule Lake area of northern California to the Klamath Reservation, in Oregon.[4] The Klamath Indians and the Modoc were traditional enemies. As tensions rose between the two tribes, a Modoc leader—called Captain Jack by the Americans and Kintpuash by his own people—asked for help from the government's Indian agent, only to have his concerns brushed off. Jack and his followers decided to leave the Oregon reservation and return to their homes in California. Although they were talked into returning, conditions did not improve, and in 1870 they left again. This time, they would not go back voluntarily.

The United States Army was sent out after Captain Jack's people with orders to bring them back to the reservation, peaceably if possible, forcibly if necessary. On the morning of November 29, 1872, soldiers woke the sleeping Modocs where they had camped on Lost River, on the northwest shore of Tule Lake. Accounts differ as to who fired first and why, but in the ensuing melee, an Army soldier and two Modocs were killed. The majority of the Modocs escaped over the lake in boats to the lava beds on the south shore, a traditional hiding place that they knew well. Meanwhile, a small group led by a man called Hooker Jim (Hakar) went around the lake shore and killed fourteen settlers in retribution for the attack earlier that morning. Jim then joined Captain Jack in the caves and asked for his protection. In these lava beds—a dangerous, disorienting series of caves, cracks, cones, ridges, and irregular pathways—a drama began to unfold that would capture headlines and rivet the entire world.

After the attack by Jim's men, the Army was more interested in arresting him and trying him for murder than in returning the Modocs to their reservation. This was the true beginning of the Modoc War. For the next four months, 53 warriors and 102 women, children, and elders would hold off the Army from inside the caves now known as Captain Jack's Stronghold, inflicting 143 casualties and losing only 5 people. Throughout a series of talks with American peace commissioners, Jack consistently asked for a reservation in the Modoc homeland, either along Lost River or in the lava beds.

Negotiations stalled time and time again over the fate of Hooker Jim's band; having granted his protection to them, and believing that the white man's law would not deal with them fairly, Jack refused to turn them over to the Army. At the same time, the Modoc warriors were growing weary. Watching the American forces grow, many believed that they would have to kill the American leaders in order to prevail. Captain Jack did not believe this would work. When he opposed the idea, the warriors he had been protecting called him a coward and a woman. Under pressure from his people, Jack agreed to kill General E. R. S. Canby at the next peace talk if he did not agree to Modoc demands.

On April 11, 1873, Captain Jack and five of his men met with the Americans. As he had before, Jack requested a reservation for his people on the Lost River, and he was once again denied. He then shot General Canby in the face, killing him. Reverend Eleazar Thomas was also killed that day. Colonel A. B. Meacham was saved through the intervention of the Modoc interpreter Tobey Riddle (Winema).

It turned out that Captain Jack was right about the consequences of the Modoc actions. The Army did not go away, and in fact they now had greater reason to fight. They led another charge on the stronghold and although they were once again repulsed, they came close enough to worry the Modocs. The people split into factions, argued among themselves, and abandoned the caves to go their separate ways.

The Army captured Hooker Jim and his band first and offered amnesty to Jim and three others—Scar-faced Charley (Chik-chack-am Lul-al-kuel-atko), Bogus

Charley, and Shaknasty Jim (Ski-et-tete-ko)—if they would track Captain Jack's group. In June, Captain Jack's band was captured and transported to Fort Klamath, in Oregon. Captain Jack, subchief John Schonchin (Skoncnes), Black Jim (Te-te-tea-us), and Boston Charley (Bostin-Ah-gar) were tried and found guilty of murder.

"You white people have driven me from mountain to mountain, from valley to valley, like we do the wounded deer,"[5] Captain Jack said at the end of the trial. His closing remarks, translated by Frank Riddle, summed up not only his own situation but eloquently described what prevailed throughout all California:

> You people can shoot any of us Indians anytime you want to, whether we are in war or in peace. Can any of you tell me where, ever, any man has been punished in the past for killing a Modoc in cold blood?...Think about Ben Wright.[6] What did he do? He killed nearly fifty of my people. Among the killed was my father. He was holding a peace council with them. Was he or any of his men punished? No, not one. Mind you, Ben Wright and his men were civilized white people. The other civilized white people at Yreka, California, made a big hero of him, gave him a fine dinner and a big dance in his honor for murdering innocent Indians. He was praised for his crime.
>
> Now here I am. Killed one man, after I had been fooled by him many times—and forced to do the act by my own warriors. The law says, "Hang him. He is nothing but an Indian, anyhow. We can kill them anytime for nothing, but this one has done something, so hang him." Why did not the white man's law say that about Ben Wright?

Captain Jack and his codefendants were hanged on October 3, 1873.

The other survivors of the war were sent to the Quapaw Agency in Oklahoma. The transition to a new and foreign environment far from everything they'd known was difficult, and many of the Modocs did not survive. Over the years, some came back to California, or to the Klamath Reservation in Oregon, where many Modocs who had not been a part of the war still lived. To this day, some two hundred Modocs live in Oklahoma.

As years passed the Lava Beds would become a National Monument under the management of the National Park Service. In 1990 the Park Service helped sponsor an event both dramatic and emotional: the first Return to the Stronghold gathering was held, involving Modoc people from California, Oregon, and Oklahoma. For the first time since 1873, a dance was held in the stronghold's dance circle. Gatherings have been held every summer since then in remembrance of the past and in celebration of the present and future of the Modoc people.

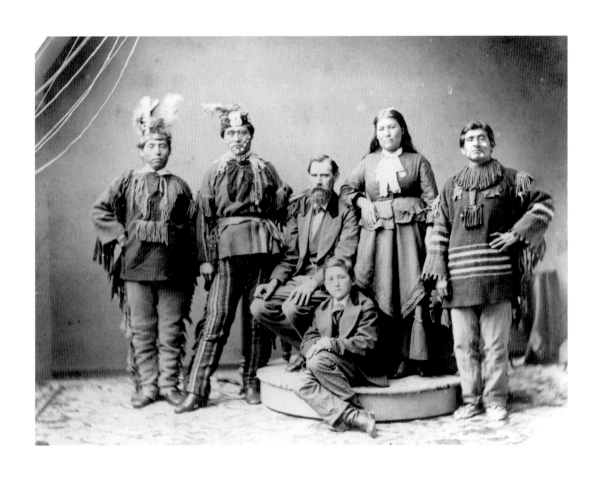

Several people involved in the Modoc War later traveled the U.S. as part of A.B. Meacham's medicine show, a traveling Wild West entertainment. From left: Shacknasty Jim, Steamboat Frank, Frank Riddle, Jeff Riddle (on floor), Winema, and Scarface Charlie.

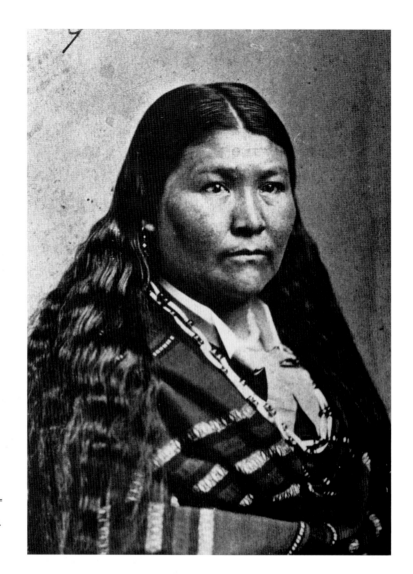

Winema, Washington, D.C., late 1800s.
<small>COURTESY OF DEBRA RIDDLE HERRERA.</small>

Debra Herrera: They went on a tour after the war, like a chautauqua. They toured all the states back east and they talked about the Modoc War and the things that led up to it. And he [Meacham] gave her a stage name, Winema. It's a Cherokee name—a lot of people think that it's a Modoc name, but it's not. And she met President Grant, and they interviewed her here after she went to D.C. and had dinner with him, and they said, "Well, what do you think of the president?" And I've seen the original field notes down there at the museum, and it says she told everybody that if she'd wanted to see a bullfrog she could have just stayed home!

When the government came in they forced them—they wanted to relocate them [the Modocs] to Oregon, and so at first they came peacefully. And then they put them on a reservation at Modoc Point and that didn't work so well. So they ran away, and they went back to the lava beds again, in that area, and that's where the Modoc War was fought.

So after the war was fought—I'm leaving a lot of stuff out—they shipped back to Oklahoma all the Indians that fought and resisted, and the Modocs that didn't resist were the ones that went over here to Yainax, which was like a subagency...They couldn't get along at Modoc Point, where they'd first put them, because that was near the Klamath agency, because the Modocs and the Klamaths didn't get along. The Klamath were taking things that were given to the Modocs, so that's what some of the arguments were about.

So some of [my] family went back to Oklahoma, on my dad's side, and then on my mother's side, all stayed here...And Winema, my great-great-grandmother, and my great-great-grandfather Frank...were there during the Modoc War too, but they were interpreters for the government. She was Captain Jack's first cousin—their dads were brothers. So she tried to talk to him, and she was the go-between. So that's the side of the family that stayed. And they were relocated to Yainax, and they also lived in Yreka and out here by Bonanza, another Modoc town where a lot of Modocs stayed.

—*Debra Riddle Herrera (Modoc)*

<small>214 NORTHEASTERN CALIFORNIA</small>

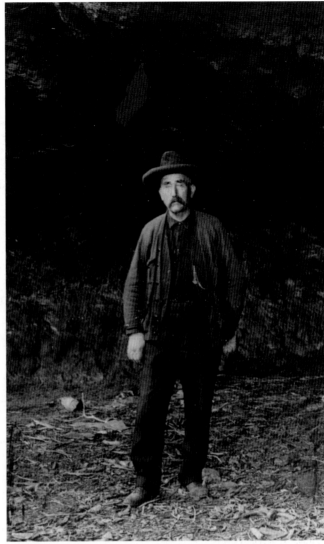

Jeff Riddle (Modoc) standing in front of his mother's summer cave near Tulelake in the late 1930s.
COURTESY OF DEBRA RIDDLE HERRERA.

Jeff Riddle's parents were Winema and Frank Riddle. His version of the events, *The Indian History of the Modoc War, and the Causes That Led to It*, was printed in 1914.

Roselind, Christine, and Warren Riddle (Modoc) in front of the family car in Beatty, Oregon, 1935.
COURTESY OF DEBRA RIDDLE HERRERA.

Conrad Herrera (Modoc/Paiute), 1988.
COURTESY OF DEBRA RIDDLE HERRERA.

Debra Herrera: My son, Conrad Herrera…He's been riding calves since he was eight years old, and he won a buckle that year. That's his horse Spud. He got the buckle from the Flying A Rodeo in Beatty. I have all his buckles he won.

Native doctoring was a bridge between the physical world and the spiritual. While anyone might know how to cure minor illnesses and injuries with herbal remedies, serious problems required a specialist—a man or woman often called "shaman" for lack of a better word. A shaman might be called to cure illness, but this was only one of the many functions he or she performed. Those who felt themselves bewitched might call upon a shaman to seek out the cause and prescribe a cure; people might deal with their enemies by hiring a shaman to harm or kill them; others might hire a shaman for something as innocuous as finding a lost object. A shaman had great social prominence, and in some societies was on equal footing with the headman. There were liabilities as well: shamans could easily be accused of malpractice, and they were sometimes killed if they failed to cure or if they were believed to have evil intent.

Key to understanding native doctoring among the northeastern California tribes is the almost universal belief in spirit aids, or as they are sometimes called, "allies," "helpers," or "familiars." Among the Shasta these varied in power and were found in rocks, mountains, the sun, the moon, stars, and a variety of animals. The greater the power of this aid, the greater the power of the shaman who controlled it. Similar spirits abounded in the Achomawi and Atsugewi worlds, spirits who possessed supernatural power and brought people good luck in hunting, gambling, war, and doctoring. While nearly everyone had some kind of nature spirit, only shamans controlled the ones that were more powerful and more directly connected to medicine and doctoring. In 1953, Bill McClennan (Apwaruge) told anthropologist Thomas Garth the story of how an average man enlisted a spirit aid.

> An old Dixie man gambled and lost everything he had to the Big Valley Indians. He felt badly about it and decided to go to the mountains for luck. He went to a lake high on a mountaintop and dove in. He fell through the roof of a sweathouse in the water. Here a beaver and some flies were gambling. They gambled with him and he won some of their things. The beaver gave him some playing sticks and some beans (counters) and told him to put a basket of water near where he was playing. Then he was kicked out on the shore of the lake. He went home. Soon the Big Valley people came over again to play. The old man's people bet everything they had left. He put a basket of water under his playing mat. This was for the use of the beaver power. He began winning till the Big Valley people had nothing.[7]

Shamans were not only healers, but also poisoners. Illnesses and injuries, it was felt, were very often caused by powerful practitioners—malevolent doctors who used their spiritual powers for poisoning. They would shoot "pains"—physical manifestations of sickness—into people. A pain had a life of its own. Bill McClennan explained:

opposite *Shasta doctor Jenny Pickle in 1911.*

Photo by Grace Nicholson. Courtesy of the Grace Hudson Museum.

A pain wants to eat people, but a good doctor would say no. The pain would keep arguing with him. If the pain wanted to eat five people, the doctor would tell them to pound up a certain quantity of *epos* roots and give it to him. This satisfied the pain. If only four of the people gave roots, the pain would eat the person who did not give any.[8]

Once the pain had been shot into someone, a powerful doctor was needed to suck it out. Sucking doctors were able to literally suck the pain or poison from someone by way of the mouth, usually spitting out a retrieved object—perhaps a piece of bone or a feather or an animal hair. Once outside the patient's body, the pain was plunged into a bucket of water or sometimes flung in a direction indicated by the shaman's spiritual guide.

Men or women could be doctors, but the prevalence of one or the other depended on the tribe. Shasta doctors were primarily women, and half of the Achomawi and Atsugewi doctors were women as well, while Yana doctors were primarily men. Dreams, sought or otherwise, were usually the first indication of a person's innate doctoring ability. Dreams were also the means of acquiring power. In dreams and trances, spirits and pains would come to the novice shaman, revealing their songs and powers. Anthropologist Francis Riddell recorded that, for the Northern Paiute, on a mountain about five miles north of Eagle Peak in Modoc County, "There was a place to swim in a pool under the rimrock. [Ike Northrup's] father, Nunu' kai, went there to swim and to the rimrock to sleep in order to get a dream 'to learn something, to be a doctor, to keep bullets from hitting you.'"[9] Both Northern Paiute and Yana shamans relied on dreams to diagnose illness and cure their patients.

From the time that a person embarked on a shaman's path, it could take years before he or she was ready to practice. The Northern Paiute tested their dreams before practicing medicine on patients. Doctoring was a hereditary position among the Shasta, and a shaman could not actively practice while her shaman parent was still alive; meanwhile, she had to gather the large amounts of paraphernalia required for her craft. Atsugewi shamans had to obtain and master the songs of each pain, a process that might take five years.

Becoming a doctor was not undertaken lightly. The Achomawi understood the danger of the profession and expected that doctors would be high-strung and prone to anxiety attacks. Doctors were even expected to have nervous crises. However, while it was dangerous to be a doctor, it was equally dangerous to ignore the calling. A continued refusal to accept the training and position could lead to illness and even death.

Although today there are health clinics and college-trained doctors in many Indian communities, traditional healing is still respected and, in some places, practiced. Floyd Buckskin (Achomawi) reminds us that, whether one believes in the traditional ways or not, the old ways and the old power spots remain extremely potent.

He writes:

Doctors had their own springs, their own springs where they would go. None of the ordinary people would go to these places. One of the elders of the tribe who had studied to be a doctor and later on went down the Christian road, his wife went to a doctors' spring. She got into the spring and she began to swim around because it was hot. She had been told by the elders to stay away from there, but she thought that because she had the power of God and Jesus that nothing could harm her. She broke out into a horrible rash, which she had for a couple of months. It almost killed her.

Finally, this old doctor came along and told her what she had done and where she had gone. She said, "Yes, that's what I did. I don't believe in those doctor ways, but I'm so desperate now I'll try anything." So he cured her, he took away this horrible rash that was all over her body and causing such great suffering. So that goes to show, you know, that whether you believe it or not, it's there.[10]

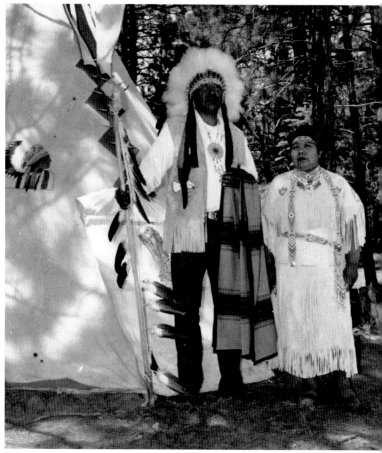

*Viola Lowry (Maidu/Pit River) wearing
Plains Indian regalia in Susanville,
1920s.*
Courtesy of Virginia Aguilar.

*Clyde Northrup (Paiute) and Gladys
Mankin at the Janesville Bear Dance,
1950s.*
Courtesy of Ramona Evans.

Debra Herrera (Modoc/Paiute) at the Klamath Falls Memorial Day Parade, 1969.
COURTESY OF DEBRA RIDDLE HERRERA.

Christine Allen (Modoc) at the Beatty Powwow and Parade, Oregon, 1930s.
COURTESY OF DEBRA RIDDLE HERRERA.

FAMOUS IN AMERICAN INDIAN HISTORY BECAUSE ITS PRACTICE AND SUBSEQUENT suppression led, in part, to the massacre at Wounded Knee, South Dakota, in 1890, the Ghost Dance movement actually originated some twenty years before. Wodziwob, a Paiute prophet from Walker River, Nevada, had preached a message with great appeal to people whose world seemed to have been destroyed. He prophesied an end to the current world and a time when white people would be destroyed and the Indians restored, their dead come back to life. The movement swept through Nevada, Oregon, and California, and though it has mostly been overlooked on a national level, the Ghost Dance of 1870 is of great importance in California Indian history.

Spreading north among the Modoc and Klamath peoples to Oregon and northern California, and south through the Mono to the Yokuts and others in central California, the Ghost Dance promised a return to the old ways, attracting large numbers of native people. The way to bring the prophesied change about was twofold: first, to believe; second, to dance continuously. The primary dance was a simple round dance, performed by both sexes and continued until exhaustion won out and the participants could no longer go on. Participants sometimes fell into trances during the dances or dreamed of the "advent," although most of the dreaming was done by just a few people.

By 1872 the promised end had not come, and many people became disillusioned. The Ghost Dance lost its appeal and died out, but not before it left a lasting influence on several other northern California religious movements.

The Yana were the first to practice what came to be known among anthropologists as the Earth Lodge Cult. The Earth Lodge Cult then spread west to the Wintun people, and beyond; north to the Shasta and on to Oregon; and southwest, into Pomo country. People who adhered to this variation of the Ghost Dance religion believed they would survive the coming apocalypse in deep underground dance buildings. It was also melded to traditional ceremonial healing practices. Several large earth lodges were built throughout the region as the religion spread. As with the Ghost Dance, there was a period of intense participation followed by a period of disillusionment when the world failed to change, and the religion faded.

By far the most long-lasting effects of the Ghost Dance were felt in the development of the Bole-Maru religion. The name comes from the Hill Patwin word *bole* and the Eastern Pomo word *maru*, both of which are words for the dreamer who leads the ceremonies as well as the myth or dream at the center of the ceremony. Two dreamers, Homaldo (Nomlaki) and Lame Bill (Hill Patwin), were the first to begin the Bole-Maru, circa 1872, and they carried their visions around the region, from the Wintu and the Chico Maidu all the way out to Pomo country on the coast. Susie Lewis (Hill Patwin of Cache Creek) described how:

> Lame Bill...said the world was to end and he called all the people
> together. Water was to come up and cover the earth. The Indians were

all to be caught in a big fish trap but the whites were to be washed away. The whites weren't going to heaven when the world ended. That year there was a big storm and lightning danced on the ground. It looked as though the world were cracking up (i.e. coming to an end). The ground smelled like blasting powder. Lame Bill got all the people together into the deep sweathouse he had built there at Lolsel. He went up on top of the house and sang, but all the others stayed in the house. When he came in he told all the people to dance naked. The people at Sulphur Bank (Southeastern Pomo) were doing the same thing. There was a storm there too.[11]

While the Bole-Maru religion did not include all of the apocalyptic overtones of the Ghost Dance, it leaned heavily on the idea of a dreamer who spoke to the spirit world. The dreamer was solely responsible for dictating all details of a ceremonial dance: when to hold it, what songs and dances to perform, what regalia to use. All of this information came through dreams. A flag and a flagpole representing the center of the earth were central to the ceremony, and the symbols incorporated into the flag would also come from a dream. During the dances, the dreamer would tell his or her dream and preach on various moral and ethical topics, generally against drinking, fighting, and other forms of inappropriate behavior. The dreamer became central to the community and also assumed many of the functions that doctors—shamans—of previous generations would have performed.

The Bole-Maru ceremonies integrated older local native traditions but altered them to suit the changing times. Where ceremonies in the past had involved secret societies that strictly forbade the participation of women, the new ceremonies were open to everyone. Many people were distressed to see these changes in their traditional practices, but others welcomed adaptations that would help their traditions survive; if a religion were to survive among the small and fragmented native populations of the day, it would have to include all possible members of society.

Both the Bole-Maru and its offshoot, the Big Head religion (so called because of the headdresses worn by the dancers), are still practiced. A sense of the Big Head dances is powerfully expressed by Marvin Brown (Pomo):

The Black Head was the most powerful and nothing to fool around with. (The Big Heads are usually white, yellow, red, and black.) I remember the last time the Black Head was at the Elem Indian Colony. We had just received electricity the prior year on the reservation and were still living in our old houses in early 1969. I was dancing the leader part of the two-man dance ceremony and a cousin of mine, Ron, was dancing the Black Head. I was real sore and tired and I had just come home from working in the brick plant nearby. My dad,

Jim Brown II, who was our cultural leader at the time, asked me to dance with the Black Head after my first dance even that same night. I wasn't afraid, so I agreed.

It felt real good dancing. I could have gone on all night. The Black Head was a good spirit and I've heard that the guys under the Head would become that spirit and somehow they had all that fire and spirit and would really go. I tried to keep up with the Black Head and succeeded.

It was said that if you didn't do something right while dancing you would have to pay dearly with your health immediately, like by falling into the fire or getting cramps in both legs. Your heart had to be right and your hate must be gone. Your future was at stake. Dancing with the fire was not as easy as it looked.

Finally it was over. No blisters on my feet, didn't step on a sharp or hot rock, no cramps in my legs, didn't feel dizzy or sick, no marks on my forehead from the headgear being too tight, no feathers dropped into the fire, and none of my family had gotten ill. Great, I thought, must have done good with the Black Head, and I didn't feel tired anymore and was ready for another night of dancing.[12]

In considering the impact of the Ghost Dance it is important to note, as anthropologist Cora DuBois did in the 1930s, that the format of a single dreamer sharing teachings laid the groundwork for the Christian preacher. Indian churches, for example the Indian Shaker Church and the Indian Full Gospel Assemblies in northwestern California, are an important legacy of the Ghost Dance.

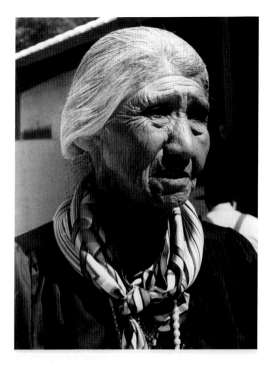

Ramona Evans related that her mother, Grace, was an orphan. She was apparently a little unruly, so she was sent to Stewart Indian School by Carson City. Then she went to Oakland as a maid. She later returned to Susanville, where she married. In 1926 she was a spokesman for the rancheria. A hard worker, she died at age eighty-three of cancer.

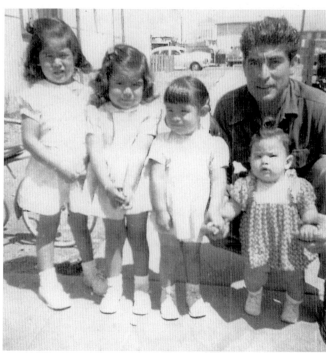

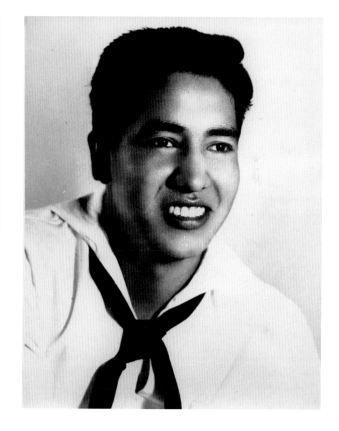

The Martinez sisters (Pit River/Apache) with their father, Frank John Martinez (Spanish/Apache), Oakland, 1951. Left to right: Diane Martinez-Dierking, Loretta Martinez, Kathy Martinez-Quent, and Jessie Martinez-Riddle.

Leo Gutierrez (Paiute) in the U.S. Navy, 1946.

Mount Shasta is a massive snow-covered volcano that rises fourteen thousand feet into the air to dominate the northern California landscape. According to geologists, it erupts on average once every six hundred years; the last eruption was in 1786. Isolated, conveying grandeur, drama, and mystery by its very presence, it is sometimes visible from as far away as Mount Diablo in the San Francisco Bay Area. Tribes over a vast area of northern California hold it sacred, essential to their religious belief and practice. The Shasta, for whom the mountain is named, believe it is the first place their creator stopped when making the world. The Wintu and others believe that after death their spirits climb Mount Shasta, and from its summit they step onto the Flower Trail (Milky Way), the pathway to the other world. Darryl Babe Wilson (Achomawi/Atsugewi) has written about how for his people the mountain contains a cosmic power, Mis Misa, which balances the earth with the universe. Along the slopes of the mountain are springs and meadows where native people continue to hold important ceremonies, and even tribes who live a considerable distance from the mountain view it with reverence and recognize its spiritual significance.

In the 1980s, the sanctity of the mountain came under assault as developers attempted to open a major ski resort on the site of a smaller resort that had been closed after an avalanche some years earlier. Alarmed at the destruction the new resort could wreak on the mountain and on traditional cultural practices, tribal groups, in alliance with environmentalists, succeeded in having the entire mountain designated a historic site in 1994. Gaining protection for a place deemed sacred by its nature and use, not by what was constructed by humans, was a major legal triumph. Nonetheless, pro-development forces—claiming that this designation would undermine the local economy and give "unfair" usage rights to the tribes over other groups—challenged the designation, and that same year, the ruling was reversed. The permit for the ski resort was granted, but this decision in turn was revoked in 1998 on the basis of the environmental and cultural significance of the mountain. For now, Shasta remains intact, but the only areas under legal protection are a ceremonial site called Panther Meadows (forty acres) and an area named the Native American Cosmological District (nineteen thousand acres), which is above the tree line.

Forty-five miles northeast of Mount Shasta another debate over sacred sites and native usage rights has been underway for several years. The Medicine Lake volcano's 150-mile base circumference makes it the largest volcano in California. About a hundred thousand years ago, a huge eruption caused the center of the mountain to collapse, forming the basin in which Medicine Lake now sits. The Pit River people believe the creator and his son bathed in the waters of the lake. Vernon Johnson (Pit River), who heads the California Council of Tribal Governments in Redding, says, "It's a sacred place and we don't want anybody drilling on or near it. There's been proof of people going in the lake, bathing, praying and getting cured."[14]

The area around the lake, called the Medicine Lake Highlands and part of the Klamath National Forest, is, however, the site of geothermal activity—underground

steam—and this has attracted the attention of the energy industry, which wants to convert the energy into electricity. In 1997 two corporations, Calpine and CalEnergy, proposed to develop geothermal plants in the highlands. A coalition of environmental groups, homeowners, and Pit River, Modoc, and Shasta tribes opposes any development, on the grounds that it would cause irreparable damage to the physical features and rare wildlife of the region, as well as the spiritual health of the native people who use the highlands ceremonially. Calpine's own Environmental Impact Statement affirmed this view, stating that the project's two geothermal plants, miles of roads, pipelines, and transmission lines would have a significant impact on the environment and traditional cultural resources, but they pushed forward with the project anyway.

In 1999, Medicine Lake was placed on the National Register of Historic Places, but in 2002, under the Bush administration's National Energy Policy, both projects were granted go-aheads. As of this writing, test drilling in the lake has commenced, but the coalition has not rested; appeals and lawsuits have been filed.

The people are killing themselves by killing the elements in that water...Your turtles and all that stuff that used to be out there in the water, you used to be able to go out and see them all over. You don't see them anymore. If you want a turtle now, you have to go down and buy them from the people from Taiwan or something. And them desert guys, the desert tortoises, they've had so many of them damn atomic tests out there, there ain't none of them no more...The pine weevil, he had his purpose out there in the woods. And they said they're going to kill him off. So the next thing you know, you go out there and you look and you see them trees out there, just one after the other dying. The pine weevil's not there to kill off the other bugs that come in and kill 'em. You ever go up to Lake Tahoe and look out there? [It looks] like a mangy animal out there, with the trees dying.

—Robert Burns (Nor-el-muk Wintu)

Edna Evans Lowry (Pit River) in
Susanville as a young woman, 1890s.
Courtesy of Virginia Aguilar.

Members of the Mission Indian School
baseball team, Greenville, 1890s. From
left: unidentified, Wyatt Lowry (Maidu),
and Robert Lowry (Maidu).
Courtesy of Virginia Aguilar.

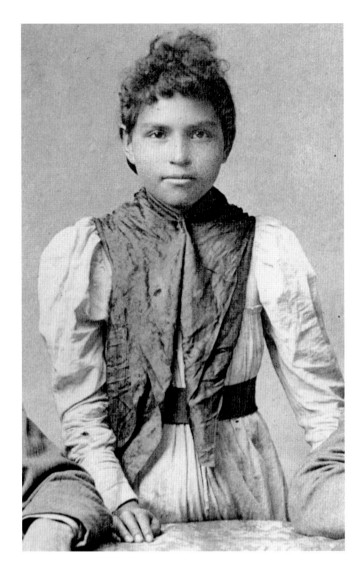

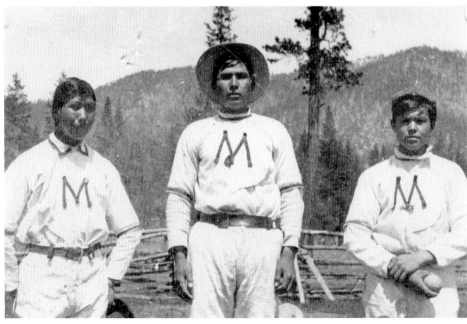

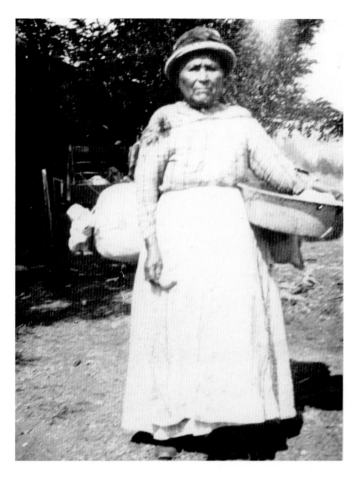

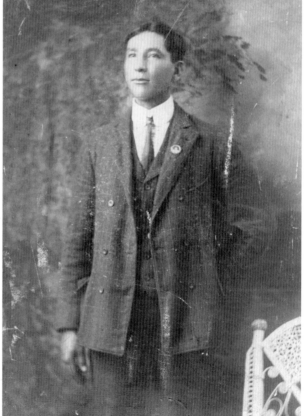

Susie Evans (Pit River) in Susanville, 1930s.
Courtesy of Virginia Aguilar.

Robert Lowry (Maidu) in Seattle as a young man, early 1900s.
Courtesy of Virginia Aguilar.

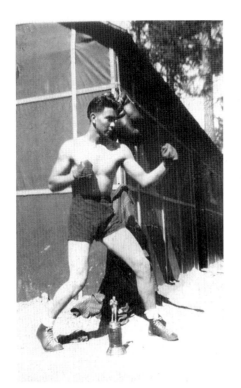

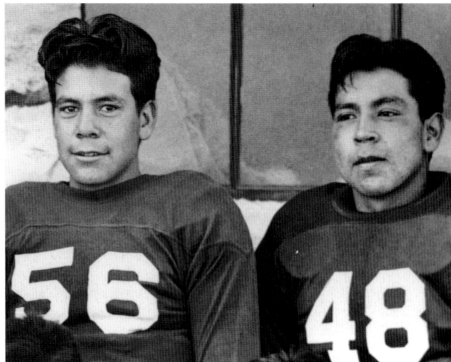

Leonard Aguilar (Maidu/Paiute) boxing at the Civilian Conservation Corps camp in Oregon during the Great Depression.
COURTESY OF VIRGINIA AGUILAR.

Brothers Slim and Robert Aguilar (Maidu/Paiute) playing football at Stewart Indian School in Nevada, 1940s.
COURTESY OF VIRGINIA AGUILAR.

OPPOSITE *Edna Evans Lowry (Pit River) with three of her children and their dog Trixie, Susanville, 1910. Left to right: Leo, Jess (Dugan), and Viola.* COURTESY OF VIRGINIA AGUILAR.

Virginia Lowry (Maidu/Pit River) and Robert Aguilar (Paiute/Maidu) on their wedding day in Reno. COURTESY OF DUGAN AGUILAR.

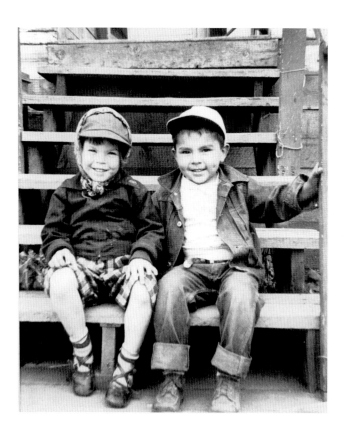

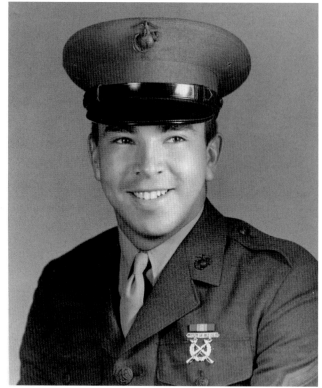

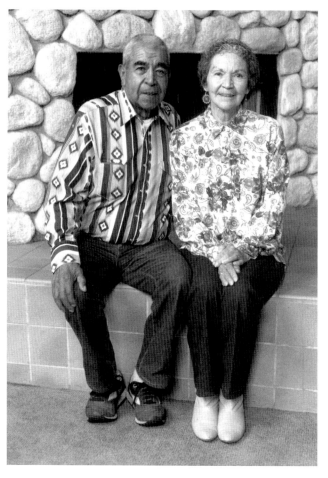

Cousins Judith Lowry (Maidu/Pit River) and Dugan Aguilar (Pit River/Maidu/ Paiute) on the steps of their grandparents' home in Susanville, c. 1950.
Courtesy of Dugan Aguilar.

Dugan Aguilar's first memories include his grandmother sitting under the lilac bush in their front yard, and his grandfather feeding him oatmeal mush or pancakes in the morning around the cookstove in the kitchen.

Dugan Aguilar (Pit River/Maidu/ Paiute) after graduation from Marine Corps boot camp in 1968.
Courtesy of Dugan Aguilar.

Virginia and Robert Aguilar at the All Indian Schools Reunion in Sacramento, 1990.
Courtesy of Virginia Aguilar.

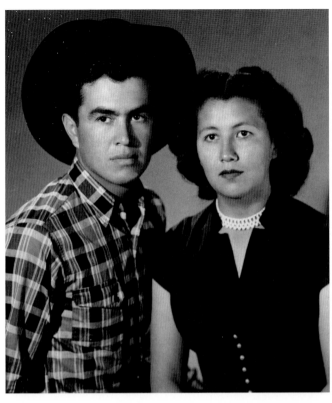

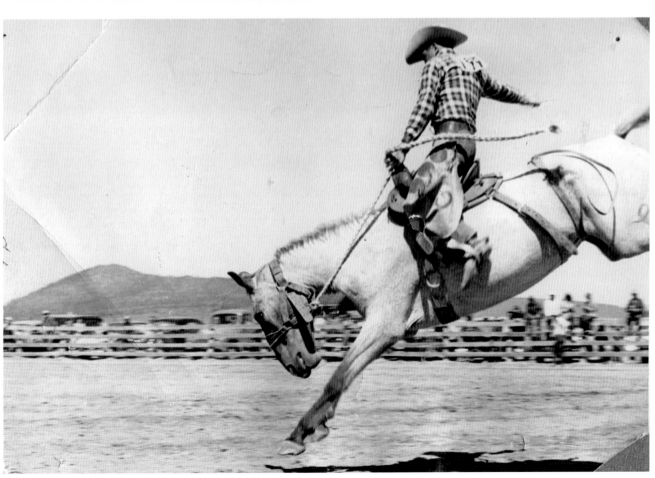

Bill and Rachel Tupper (Modoc),
Klamath Falls, 1954.
Courtesy of Bill Tupper.

Bill Tupper (Modoc) during his bronc-
riding days, Beatty Rodeo grounds,
1956.
Courtesy of Bill Tupper.

NORTHEASTERN CALIFORNIA

ISHI, CERTAINLY THE MOST FAMOUS OF ALL CALIFORNIA INDIANS, WAS FROM THE Yahi band of Yana Indians, who lived along Deer Creek and Mill Creek, east of the Sacramento River near Mount Lassen. In the 1850s, as the number of white settlers in the Yana homelands increased, tensions arose between the Yana and the Americans; violence escalated as people on both sides were killed and others sought revenge. By the 1870s, most of the Yahi people had been massacred by vigilantes. The survivors had abandoned their villages and faded into the backcountry, surviving by hunting and gathering on tiny remnants of their lands and by raiding cabins. For more than three decades, they managed to stay successfully hidden. Their existence was rumored but never confirmed.

Around 1908, a survey party happened across some of the remaining Yahi: a man who would later be named Ishi, an old woman who may have been his mother, an old man, and a younger woman. The group scattered; Ishi never saw the old man or the young woman again, and the old woman died soon after. Ishi lived alone in the wilderness for two or three more years, until in 1911—starving, lonely, and desperate—he wandered into an Oroville slaughterhouse, where his presence was betrayed by barking dogs. Workers there found him huddled and emaciated, dressed in a tattered canvas cloak and with close-singed hair, a traditional sign of mourning. He may have been en route to the Feather River Rancheria (Konkow Maidu), which was known to offer sanctuary to the Yahi.

The slaughterhouse workers called the sheriff, and Ishi was locked in the Oroville jail until T. T. Waterman, an anthropologist at the University of California, arrived by train to speak with him. Waterman brought with him a northern Yana word list. Although the vocabulary differed from Ishi's dialect, it was close enough for Ishi to understand many of the words, and he was understandably delighted. And, perhaps also to his surprise, instead of being locked up permanently or killed, after moving with Waterman to San Francisco, he was celebrated as an instant sensation, an engaging, fascinating "wild man," as the journalists first called him.

For the next five years, Ishi lived at the University of California's anthropology museum, then located in San Francisco. In accordance with Yahi custom, he never revealed his true name. It was at the university that he was given the name by which he would become known: anthropologist Alfred Kroeber called him "Ishi," the Yahi word for man.

Ishi worked at the museum as a janitor. Although no one will ever know his inner thoughts, he seemed—at least to the outside world—happy to be gainfully employed. He also worked with numerous anthropologists and linguists, as well as the general public, sharing his knowledge of flint knapping, hunting, and other traditional skills. He particularly enjoyed telling long stories in the Yahi language for linguists and anthropologists who recorded them on wax cylinders. And he drew thousands to meet him on Saturdays at the museum, giving public demonstrations

OPPOSITE *Ishi, c. 1912.*
COURTESY OF THE OAKLAND MUSEUM OF CALIFORNIA.

of traditional Yahi skills with astonishing grace, warmth, and playfulness. Many have memories that echo those of Fred H. Zumwalt Jr., who wrote in 1962 that:

> As a very small boy Ishi was not only something of a hero to me but also a delightful playmate. He made a small bow and arrows with which he taught me to shoot lizards, a willow seine for catching minnows and soft rabbit-skin moccasins with the fur on the inside...To me, he will never be gone completely as long as I can still remember his great kindness, patience and understanding to me.[13]

Countless children and adults were moved by their experience of meeting Ishi in San Francisco, and many carried that memory with them into old age. Yet in 1916, just five years after he had come out of the wilderness, Ishi became ill with tuberculosis and died after several months of decline. His friends mourned him deeply. Ishi had told Kroeber that he did not want to be autopsied after his death—in adherence to Yahi custom and religious belief, he wanted his remains to be cremated intact—and Kroeber supported this. He wrote to another University of California anthropologist, E. W. Gifford, from New York that "if there is any talk about the interests of science, say for me that science can go to hell. We propose to stand by our friends." His letter was not received until after Ishi's death, and although Gifford protested the autopsy, he was overruled. He and Waterman did ensure that after the autopsy Ishi was cremated, and his remains were placed at Olivet Memorial Park Cemetery, near San Francisco.

Yet the complete story of Ishi's autopsy was not uncovered until the late 1990s, when the Butte County Native American Cultural Committee petitioned Governor Pete Wilson for an investigation so that Ishi's remains could be repatriated to his homeland. Art Angle of Redding Rancheria says that he had "always known"—it was part of his family lore—that Ishi's remains had been desecrated: in particular, Angle believed that Ishi's brain had been removed from his skull during the autopsy. Angle was driven to find out the truth and have Ishi's brain repatriated and reunited with the rest of his body. He enlisted Orin Starn, an anthropologist at Duke University, who unearthed Kroeber's correspondence regarding Ishi's remains. And, indeed, Starn was able to track the brain to the Smithsonian Institution, where Kroeber had sent it to be part of a larger collection under the charge of Ales Hrdlicka, curator of the anthropology department there. After consulting with several native groups, the Smithsonian recommended that Ishi's brain be turned over to the Pit River tribe and the Redding Rancheria, where a number of Yana people still live today. In 1999, eighty-three years after his death, Ishi's brain came home to California. His ashes were exhumed and his reunited remains have been reburied in an undisclosed location, so as to protect a man who refused to reveal his name but shared his life and good humor so generously.

Sam Batwi (Northern Yana, left) and Ishi (Yahi), 1911.

Photo by A. L. Kroeber. Courtesy of the Phoebe A. Hearst Museum of Anthropology, University of California, Berkeley.

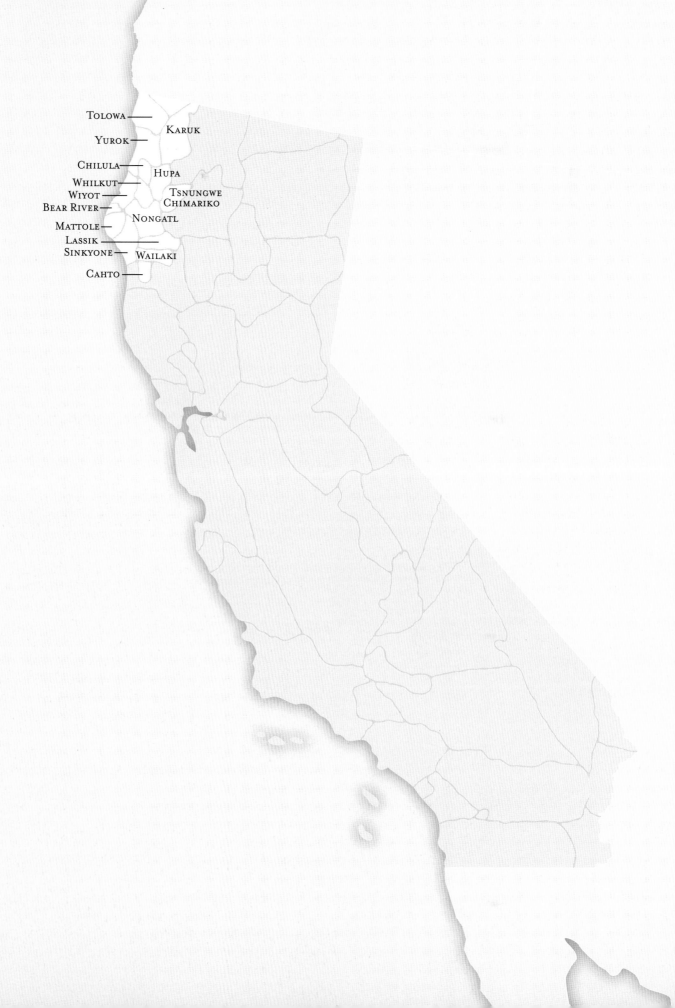

TOLOWA

KARUK

YUROK

CHILULA

HUPA

WHILKUT

WIYOT

TSNUNGWE

BEAR RIVER

CHIMARIKO

NONGATL

MATTOLE

LASSIK

SINKYONE

WAILAKI

CAHTO

Seven

Northwestern California

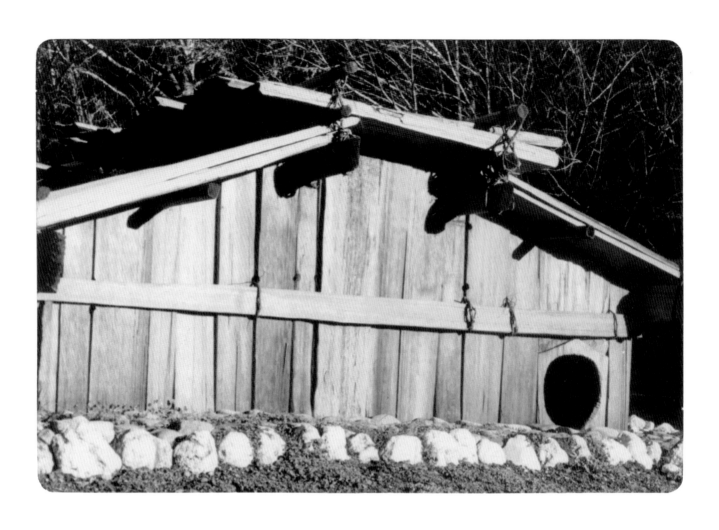

Following the Klamath River some two hundred and fifty miles from its source in Oregon's Upper Klamath Lake, past steep mountainsides covered with pines and

redwoods, alongside deep ravines, through oak-dotted meadows, and past the deep sands at its mouth—seeing it when a run of magnificent king salmon are surging upstream and filling the channels—it is easy to understand that the cultures of northwestern California are defined by its various waterways. The Klamath is home to the Yurok and Karuk people. The Trinity (a tributary of the Klamath) is home to the Hupa, the Smith River is home to the Tolowa. Smaller tribes of the area are likewise defined by the waters along which they have lived—the Wiyot at Humboldt Bay, the Tsnungwe on the South Fork of the Trinity, the Chimariko and the Chilula along Redwood Creek and Mad River. Several other tribes call the area south of Humboldt Bay their homeland—the Bear River, Sinkyone, and Mattole along the coast, the Nongatl, Lassik, and Wailaki just inland. At the southern edge of the region—though the tribal lines of California were never hard and fast boundaries—are the Coast Yuki. The Yuki and the Huchnom are inland, culturally as related to central California as they are to the northwest.

The people of the lush and eternally damp northern region plied the waterways in dugout canoes made from redwood logs, sturdy and blunt-ended to enable paddlers to make a close approach to an island or a rock. Their houses, designed to keep warmth in and rain out, were made of redwood or cedar planks with pitched roofs and round doorways. Crawling through the round entranceway, one would usually find at ground level a "shelf" perhaps two or three feet across used for storing household articles, baskets of food, fishing nets, and items of wealth. One reached the dwelling area, generally about ten feet on each side, with a fire pit and an earthen floor hardened almost to stone by generations of use, by ladder:

> Going down into the basement they take a log about one foot through and cut the right length, cut notches in it for footsteps, and set it in place, and the little Indian children can go up and down this like squirrels with less accidents than the white have on their stairs. The whole family eats in the basement, and all the cooking is done there, and at night things are cleared away, and all the women and girls sleep in this basement, while the men and boys all go to the sweathouses to sleep.[1]

These wooden houses had stature, history, and permanence: the most prestigious had names, and according to archaeologists, some of them were continuously occupied

OPPOSITE *Traditional Yurok plank house built at Margaret Keating School in Klamath, 2000.*
PHOTO BY SANDRA LOWRY. COURTESY OF SANDRA LOWRY.

Sandra Lowry: A traditional home would have been semi-subterranean—the picture shows the top half of the house. The household would have been multi-generational and probably multi-family. The round hole is down low to the ground as a reminder of humility. The low doorway also represented a protective factor, as it was a disadvantage for people who meant harm to the family inside or who were carrying bad feelings, because they had to bend way down to get in.

for at least two thousand years. The doors usually faced the river, and within a village the houses were arranged according to hierarchies of wealth, the more prosperous families living in houses farther upslope from the river.

Though they speak entirely different languages, the tribes of northwestern California share something of a common culture: besides similarities in design and construction of traditional houses and boats, they have in common foods, medicines, basketry design and materials, hunting and fishing methods, doctoring techniques, ceremonial regalia, and social structure. In particular, they share religious practices—daily acts to be sure, but most noticeably the seasonal dances and feasts devoted to world renewal—the huge responsibility, given by the creators of the world to human beings, of restoring balance to the earth and safeguarding the universe.

Throughout the region, society was highly structured, with distinct "classes" and hierarchies. And though warfare and bloodshed were not unknown, a complex legal system was in place aimed at settling disputes, resolving conflict, and—if there was outright violence—assessing penalty. Negotiation, overseen by professional mediators, rather than fighting, was the preferred means of dealing with disagreements, within and between tribes. If negotiation failed and open warfare ensued, the winning family was expected to pay reparations for the dead and injured. Accumulated wealth was thus an indication of virtue: the more wealth one had, the greater the evidence of a blameless life.

Beginning in 1775, ships from Spain, Russia, England, and elsewhere began to anchor at Trinidad Bay, Humboldt Bay, and Point St. George to take on supplies, trade with Indians, and trap for furs; but during this early period the Europeans and Americans didn't settle permanently or venture more than a few miles inland from the shore. Later, during the 1820s, beaver trappers began to come through the area on overland trails and were surprised to encounter tribes skilled in business negotiations. Jedediah Smith, the famed explorer, trader, and "mountain man," said of the Tolowa he encountered in the 1820s that "they were great speculators and never sold their things without dividing them into several small parcels, asking more of each than the whole was worth."[2] No settlements were established in this period, and there was little conflict between trappers and Indians until the gold rush.

During the 1850s and 1860s, miners flooded the area, followed quickly by ranchers, farmers, loggers, and merchants. Competition for land and resources was fierce, with the Indians generally being pushed from their land and barred from traditional hunting and fishing grounds. By the mid-1850s, major outbreaks of violence had taken place. Thomas J. Henley, the superintendent for Indian Affairs for California, prevailed on the U.S. Army to send soldiers; an underling had suggested that because Indians were defending their land it might become necessary to "surrender this whole mining country to the Indians, which would be unthinkable."[3] By 1855 the United States was attempting to deal with the "Indian problem" by establishing reservations in the area, beginning with the Klamath River Reservation, a strip of land extending

approximately twenty miles inland from the Pacific Ocean along the Klamath River. In 1858, Fort Gaston was founded in the Hoopa Valley and became a sort of refugee camp as the military rounded up Indians, some from other nearby tribes, and took them to the valley. The Hoopa Valley Reservation was officially established by treaty in 1864 and confirmed by executive order in 1876.[4]

Meanwhile, on Humboldt Bay, Eureka had become one of the busier ports on the West Coast. Merchants in the city believed that the Indian villages around the bay were a threat to shipping, the fishing trade, and other commerce. After the U.S. Army failed to comply with civilian requests to deal with this issue to their liking, merchants and ranchers from Eureka formed a vigilante militia of forty-five local men under the leadership of James Seaman. They called themselves the California Battalion of Mountaineers.

In February 1860, Wiyots were hosting a weeklong ceremonial gathering—a world renewal ceremony—on Indian Island (which they called Tulawat), in Humboldt Bay. People from the Mattole, Yurok, Hupa, and Chilula tribes, among others, attended as well. On February 25 Seaman's militia members began a multi-pronged massacre of Indian people all around the bay, from the south shore of the Eel River to villages in Ferndale, Rio Dell, and Table Bluff, and then went on to Indian Island. Here the exhausted dancers and onlookers were sleeping. Many of the men had paddled to the mainland to refresh supplies, leaving behind mainly women, children, and elders. The vigilantes, who used knives and clubs, purposely leaving their guns behind so as not to draw attention from Eureka, murdered almost everyone left at the gathering and then moved on to villages at Bayside, Freshwater Creek, Mad River, and Widow White's Creek. The *Northern Californian* reported:

> The spectacle they left behind them was horrible. Blood stood in pools on all sides; the walls of the huts were stained and the grass colored red. Lying around were dead bodies of both sexes and all ages from the old man to the infant at the breast...Some had their heads split in twain by axes, other beaten into jelly with clubs, other pierced or cut to pieces with bowie knives. Some struck down as they mired; other had almost reached the water when overtaken and butchered.[5]

The Indian Island massacre was not unique to California or even the northwest coast. The Sinkyone, the Chimariko , and the Tolowa are just three of the northwestern tribes that suffered similar human-made disasters: five hundred Tolowa died at Yontocket, followed by two more attacks within three years, at Echulet and Howonquet. The murder of Wiyots at Indian Island is infamous not only for its sheer horror but because Bret Harte wrote about it. He reported on the massacre for an Arcata paper and also wrote an editorial condemning it, and was run out of town for his

efforts. The massacre became nationally known when San Francisco readers learned of it by way of anonymous letters to a newspaper there, believed to have been written by Harte. Eureka was called "Murderville" in New York and San Francisco papers.

The few surviving Wiyots were taken to Fort Humboldt, supposedly for their protection, and later were moved around the region to a succession of reservations. The descendants of one child who survived the night on Indian Island, Jerry James, are tribal leaders today at Table Bluff Rancheria, just south of Eureka, and have organized a yearly vigil in remembrance. In 2004 the city of Eureka returned a portion of Indian Island to the tribe. In an area where Anglo citizens have routinely denied the atrocities of the past, atrocities in which prominent ancestors and "founding fathers" participated, this was a unique occurrence. At the celebration of the event, Cheryl Seidner, tribal chair of Table Bluff Rancheria, said, "We are coming home to our island. In 1860 people did not see fit for us to live. But this city council, they beg to differ. They said, 'Come, let us be together.' And the Wiyot said, 'This is what we want.'" Later, she prayed in Wiyot and in English: "We thank you for our differences and our different ways. We thank you for the Wiyot people, who are coming back, who are coming back to life...It's been a long day coming."[6]

The Wiyots are now endeavoring to restore language, ceremony, and other distinctive knowledge and traditions. This type of effort has been underway among the tribes of northwest California for some time. Like indigenous people everywhere, they have adapted to a new way of life in order to survive, but perhaps because outsiders arrived late and because so much of the land here is remote, some of the old ceremonies have been held regularly without much interruption, and others are being revived from living memory. Throughout the region, families gather to craft ceremonial clothing—elaborate constructions of abalone, dentalia, pine nuts, woodpecker scalps, deer hide, and other materials. The Hupa, Tolowa, Karuk, and Yurok

Cheryl Seidner (Wiyot) touring Indian Island in Humboldt Bay, April 2000. Photo by Malcolm Margolin.

Table Bluff Rancheria had just purchased one and a half acres on the island.

languages all have living speakers and are taught at several high schools. People still fish in their traditional spots, despite recent fish kills, environmental disasters, and years of dispute with government agencies and the commercial and sport fishing industries. Basketweavers gather maidenhair fern, bear grass, hazel sticks, and woodwardia and weave them into intricate designs. Craftsmen have retained the knowledge of how to make dugout canoes, elkhorn purses, sinew-backed bows, and other traditional objects. Families attend annual fish camps, preserving not only food but knowledge and a sense of family and community.

White Deerskin Dances and Jump Dances are still performed—day in and day out for a week or more, the community focuses on cleansing the world of its ills. These grand dances still draw people together, nourishing participants, audience, and the world at large with their embedded wisdom and truth. In a 2003 interview, Clarence Hostler (Hupa), active in the ceremonial life of the area, describes the effects of the White Deerskin Dance this way:

> The purpose of the dance is to take a deeper look at ourselves, so that when we're going out to make our world new, that we take care of ourselves first and then we help all those people who come there in prayer. And we help them take a deeper look at themselves. And then the white deer are so sacred that they come down and eat up all that stuff that us humans—us physicals—carry around to contaminate our world. So we get rid of it. The main character, the main spirit, in the dance is actually the obsidian blade. We don't use obsidian to take a life with, it's so sacred. The obsidian blade in this dance is held by the rock carrier, and the pattern in their dance, in their solo, shows how we are symbolically cutting open our world as individuals to take a deeper look; and when all that is exposed, then those white deer come down and graze on it. And then we raise those white deer up and let the creator deal with all that wrongdoing. So we get rid of it. Get rid of it so we don't take it into our family and we don't take it into our most sacred dance.

Although many dances are performed—brush dances for the healing of the sick, flower dances to celebrate a girl's coming of age, and still others—the World Renewal Dances or Jump Dances hold central importance. Done not for Indians alone, but for the world, they fulfill an ancient compact. It was ordained that deer give themselves over to people to be eaten, that fish struggle to return to the streams of their birth, that oaks bear bounteous crops of acorns. Humans benefit from the largesse of the world, and among the many responsibilities humans have, the greatest is to hold the dances that "fix the world." Throughout the region, people still gather to fulfill that ancient and most sacred compact.

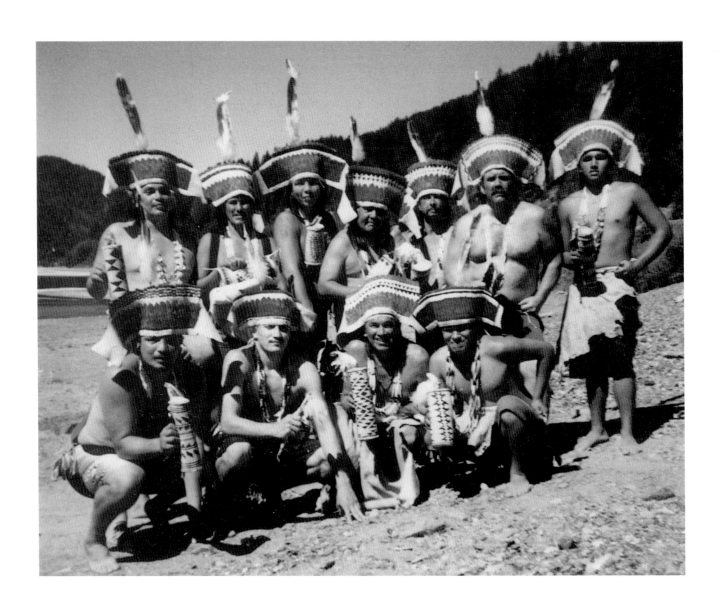

TRADITIONAL INDIAN LIFE IN NORTHWEST CALIFORNIA IS GOVERNED BY COMPLEX and interwoven systems of law, ownership rights, spiritual responsibility, and a hierarchical social structure. In mainstream American culture, the economic, political, familial, and spiritual aspects of life tend to be fragmented: a person might be engaged economically from nine to five on weekdays, be with family evenings and weekends, be part of a spiritual community for a few hours on Sunday morning, and be part of a political community during biannual election campaigns. In traditional Indian life, these aspects to which the English language has given separate names were far more integrated, suffused with spiritual significance.

Helping to regulate this complex orchestration of human behavior was a carefully defined system of what we call currency, or money. But since "money" in mainstream culture is relegated to narrowly defined economic spheres, the word is misleading if taken literally. One basic unit of currency was dentalia: tubular, tusk-shaped shells, often scrimshawed or intricately wrapped in black and red snakeskin and a fleck of scarlet woodpecker scalp. Dentalia shells come in different sizes, the smaller ones being common, the very largest being rare and consequently worth much more. Dentalia of the same size were strung in lines of uniform length (precisely, the length from an average-sized man's shoulder to the thumb of his outstretched hand). A dentalium of two and a half inches made for eleven shells per string; dentalia one and seven-eighths inches for fifteen per string. A string with large dentalia, though there were less of them, was worth dramatically more than one with small dentalia. Alfred Kroeber wrote in 1925 that a string of eleven dentalia was worth fifty dollars, a string of twelve was worth twenty dollars, and so on; an increase in shell length that would reduce the number of shells per string by one roughly doubled the string's worth.

Abalone shells, white deerskins, and large and unflawed pieces of obsidian, red woodpecker scalp feathers, and other items associated with ceremonies also have extraordinary value and are the basis for exchange. Along with dentalia, they are seen not as lifeless and abstract markers, but as beings of divine origin, spirit beings who established the ways of the world and who left their knowledge for human delight and instruction. Money, in other words, has force, spiritual power, presence, and a long and intimate history of being involved with humans. As Julian Lang (Karuk) has explained:

> The story of Pithváva, Big Dentalium (the largest of the dentalia shells, approximately six inches long), reveals how the Karuk People are descended from money. Pithváva was born alone in a lake. When he grew up he contemplated the future of the First People to come. "What will they have as money?" Ahh! His children, the smaller dentalia. He then created the whole range of "Indians treasure" to be used by the future First People. He created the way dentalia-money would look, how it would be stored, and what it would mean to the

OPPOSITE *Jump dancers at Pecwan, 2000.*

PHOTO BY DEBORAH BRUCE. COURTESY OF CLARENCE HOSTLER.

First People. He went on to create other forms of wealth, and then, from his hair he created the First People as well! Pithváva's story reveals the basis of the affinity between northwestern California Indian people and the objects of wealth—the *fúrax* [red woodpecker scalps], obsidian, white deerskins, and dentalia. They are us.[7]

A common theme in the stories of this region is the wealth quest. A man, often in order to prove himself to his beloved's family, devotes himself to accumulating dentalia, red woodpecker scalps, white deerskins, and other forms of wealth. He does so by leading an exemplary life, by fasting, by abstinence, by collecting wood in a ritual manner, by proving himself worthy so that wealth, in the form of dance regalia, might come to him. The amount and quality of such regalia that a person owned lent not only special prestige but a sense of divine blessing, an honorable connection to powers beyond the ordinary. This kind of wealth was meant to be shared and used and displayed at the great world renewal dances for all to see and admire: hoarding it or hiding it away would dissipate its inherent power. Wealth in these communities was not only a blessing, it was a sign of great personal virtue. A person who did not live right would see his wealth depleted, not only because the spirits would pull away from him but, more practically, because under the legal systems of the area he would be "sued" for infractions and lose wealth in that manner.

The people of many northwest California tribes were simply passionate in their desire for wealth, as Julian Lang points out:

> In story after story, the central character is compulsively meditating,
> if not obsessing, about wealth. A good life, the stories seem to say,
> depends in large part on one's ability to own and publicly display
> one's regalia at the grand annual ceremonies to fix the world.[8]

The idea that wealth and its accumulation must be used to fix the world rather than destroy it surely has much to offer the modern world.

OPPOSITE *Leona Wilkinson (Wiyot) with her granddaughter Hilaena, Eureka, 2002.*

PHOTO BY CHERYL A. SEIDNER. COURTESY OF CHERYL A. SEIDNER.

Clamshells, abalone shells, all those things are symbols of God. The more you have, the harder you've worked to attain them. The hard-working person is most happy—which is true with most tribes.
—Kimberly Stevenot (Northern Sierra Miwuk)

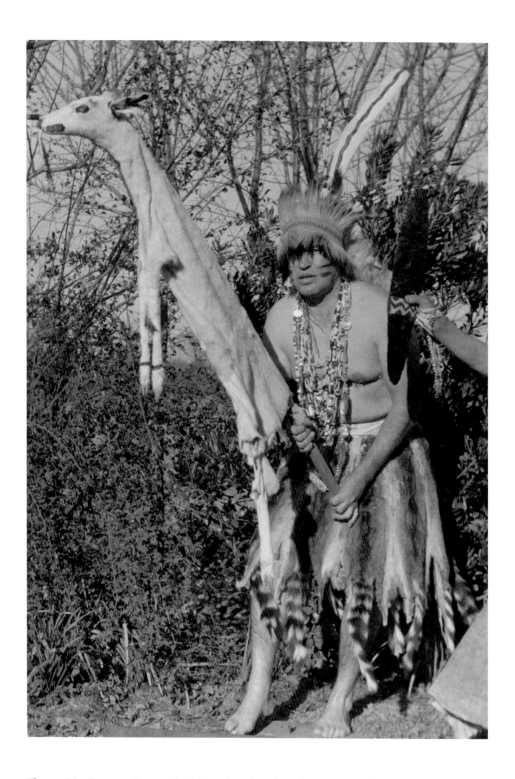

The wealth of our people is our health, and so when the girls or men wear the dentalia shells, especially the old money, they are protecting our people. And that's more valuable than having a dollar or five million dollars in your hand. So when our girls wear this stuff—like the ceremonial caps—they signify healing our people and keeping us here forever. And that's a very powerful way of looking at wealth that the mainstream doesn't look at. For Indian people, the concept of wealth is different, it's in our regalia.

—Sandra Lowry (Yurok)

David Risling (Karuk/Yurok/Hoopa) in
Deerskin Dance regalia at the California
State Fair in Sacramento, 1960.

Frank Gist Sr. (Yurok) in regalia for a dance presentation at Cal Expo in Sacramento, 1980.

COURTESY OF FRANK GIST JR.

Anthony (left) and David Risling (Karuk/Yurok/Hoopa) in brush dance regalia at the California Indian Conference in Sacramento, 2001.

PHOTO BY BEVERLY R. ORTIZ. COURTESY OF BEVERLY R. ORTIZ.

NORTHWESTERN CALIFORNIA

TATTOOING, AN ANCIENT ART PRACTICED AROUND THE WORLD, IS COMMON IN northwest California as well, particularly among women. Different tribes had different patterns and tattooed different parts of the body, but the women of every tribe in this region bore chin tattoos. Even into the early years of the twentieth century, chin tattoos were a common sight—usually "111s" ("one-elevens"), so called because they consisted of three vertical bars: two extending from the corners of the mouth and one from the center of the lower lip down to the curve of the chin. The stripes could be wide or narrow. Hupa women sometimes added curved marks around the mouth. Wiyot women also had small lines that extended upward from the corners of their mouths. The Mattole bore a series of small dots from the corners of their mouths to the lower edges of their ears.

For men, arm tattoos were the primary mark, received in adulthood and usually in the form of equally spaced short lines, used like a ruler for measuring the length, and hence the value, of dentalia-shell money. Men of some tribes also had tattoos on their arms or shoulders, "for looks" it is said. Among the smaller tribes along the Bear River, men were also tattooed on their foreheads; other tribes purportedly reserved forehead tattooing to mark criminals.

Among the Hupa, girls were tattooed early in life with light, delicate lines that were added to as they grew. The Tolowa gave small children light, dotted tattoos on their shoulders "to pull them up as they grew." Among the Bear River people, children—especially from the mid-nineteenth century on—were tattooed for identification in case they got lost or were taken from the tribe. In an era when the state and federal governments either ignored or sanctioned the kidnapping of Indian children, the importance of this practice is clear.

Tattooing was done by an expert, a woman in some tribes (such as the Eel River groups), a man in others (such as the Yurok). For small marks, the procedure was much like the modern one: the tattooist would use a sharp flint or bone to make small pricks along the skin, filling them with soot. Wider bars generally involved deeper cuts, which were then filled with soot and covered with pitch or bear grease until they had healed.

Traditional tattoos all but disappeared in the middle years of the twentieth century; older generations had died, and younger people had little interest in continuing the tradition. Because of this interruption, there is much debate today about what tattoos signified. Most agree that there was little religious symbolism involved. Women were generally tattooed around puberty, and thus the tattoos were a sign of maturity. A woman with chin tattoos was thought to have a complete and beautiful face; it was also understood that she could withstand a certain amount of pain, and the tattoo indicated that her family had sufficient wealth to hire a tattooist.

In 1990, Bertha Peters Mitchell and Beverly Nix Walsh became the first Yurok women in over a century to have their chins tattooed. When Bertha Peters was criticized by someone who told her, "You can't bring back the old ways," she had a

OPPOSITE *Sandbar Jenny (Karuk).*
COURTESY OF THE STATE OF CALIFORNIA
DEPARTMENT OF PARKS AND RECREATION.

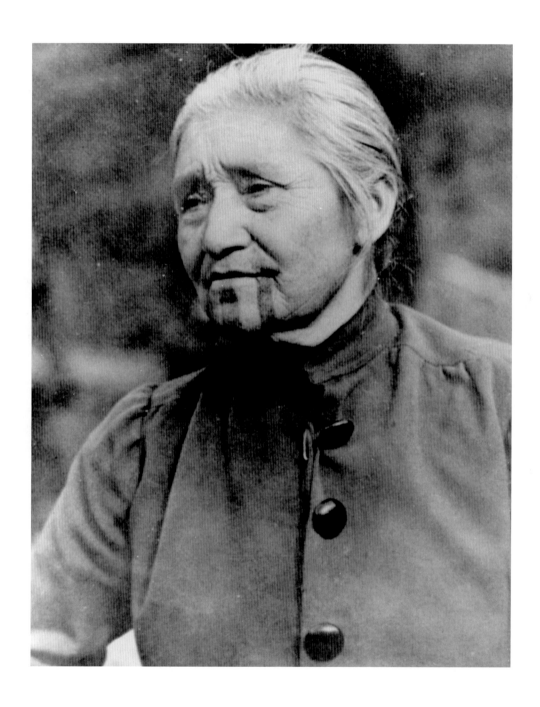

response: "I'm not bringing back the old ways. I'm continuing them." Since then, other women have taken up the tradition, and chin tattoos are becoming a familiar sight at native gatherings.

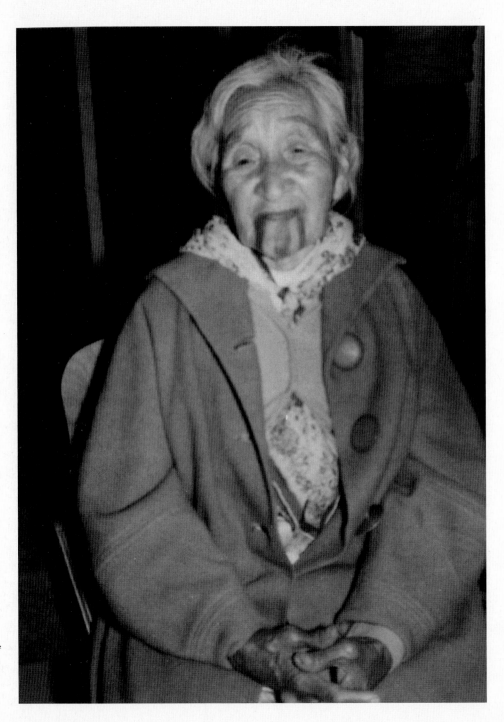

Maggie Jones Pilgrim (Yurok), Klamath, 1940s.

THERE IS NO OVERSTATING THE IMPORTANCE OF FISH IN THE LIFE OF THE
northwestern California tribes. The Yurok word for Chinook salmon is *nepu*, which
literally translates to "that which is eaten," or simply "food." All along the Klam-
ath, Smith, Salmon, Trinity, Mad, and Eel Rivers and the other waterways that wind
toward the Pacific, salmon run in yearly cycles that have fed the bodies and given form
to the cultures of native people for generations.

Other fish as well as salmon hold an important place in diet and in culture as well.
As Sandra Lowry (Yurok) so passionately says:

> One of our traditional foods we're very concerned about is the green
> sturgeon. It may be put on the endangered species list because of
> the lack of water. And that's a big issue right now on the Klamath
> River; we had a salmon kill last year and now we're worried about
> our lamprey eel and green sturgeon. If they don't have enough water
> to get upriver to spawn, then in four or five years our people won't
> have fish. And our people are fish eaters. We are the salmon. We
> are the sturgeon. We are the eel. And if that goes, that's going to be
> devastating for our people.

The people here fished from established spots on the banks and from redwood
canoes. They waded into roiling rivers with long hooks to pull out eels and into the
crashing surf of the ocean to gather smelt in surf nets at annual fish camps. Salmon
thrashing their way upstream were caught in nets and in fish weirs—long porous dams
that spanned the river but were constructed to allow some fish through, ensuring they
could spawn. Strong hands wove eel traps from sticks, rolled fibers from the leaves of
native iris into huge nets, and carved harpoons, fishhooks, knives, and other tools.
In the old days, before dams, agriculture, logging, and commercial fishing damaged
river quality and depleted fish stocks, a person would barely be able to ford a river
against the wild surge of salmon running at their peak. Technology, ceremony, ritual,
and traditional rules sustained the salmon and ensured that the entire community
would be fed.

Families still head out each year to beaches where their ancestors had fish camps,
and they still catch salmon from traditional family fishing places along the rivers. One
can hardly attend an Indian event in northwestern California without being served a
generous helping of salmon cooked the way it has always been cooked here, skewered
on redwood sticks and grilled around an open pit fire.

This continuity of tradition has not been easy; the people, the fish, and the rivers
have faced one challenge after another over the past century and a half. Most recently,
native fishermen were threatened, physically and legally, in the so-called Salmon Wars
of the 1970s and 1980s as they struggled to protect native fishing rights. And then,
in 2002, the Bureau of Reclamation and the Department of Interior diverted water

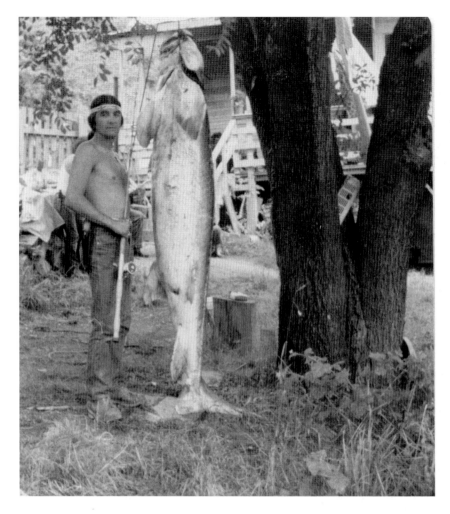

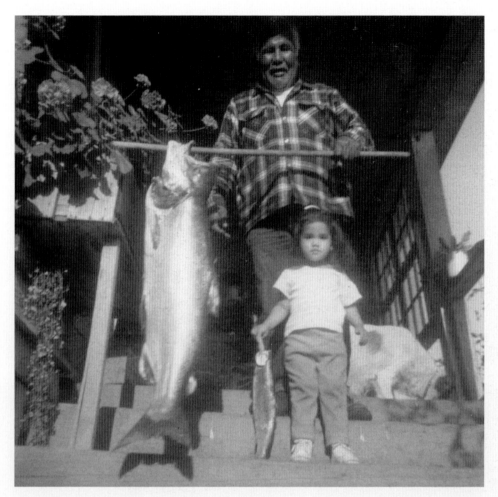

from the lower Klamath River in order to provide more water for upriver farmers. Water levels shrank on the Klamath and the Trinity, and an estimated thirty thousand salmon died in what has been described as the worst fish kill in U.S. history. Barry Wayne McCovey Jr., a Yurok fishery worker, described his reaction:

> The carnage I've seen over the past week and a half is so utterly grotesque that I cannot sleep at night. I close my eyes and the images of dead, rotting fish envelop me...I can't eat, because food, no matter what it is, reminds me of the smell. Perhaps it's because the rotting fish represent so much of my people's food gone to waste.[1]

Already pushed to low (even endangered) levels by commercial fishing, and with their spawning grounds damaged by logging along the rivers, northwest California salmon are now at the brink of extinction. All the Klamath River tribes have been affected by this disaster and are doing what they can—lobbying public officials, introducing legislation, instigating legal action. In a promising alliance, commercial and sport fishermen have joined the affected tribes and environmental activists in lawsuits. Meanwhile, on the river, tribal fisheries are tagging endangered salmon in order to monitor their spawning habits, and doing what they can to clean up the watershed. In this broken ecosystem, native stewardship is not a romantic notion, but a vital necessity.

OPPOSITE TOP *Merk Oliver (Yurok) posing with a rod and reel next to a 300-pound sturgeon that got tangled in a gill net, Requa, 1970s.* COURTESY OF MERK OLIVER.

Merk Oliver: Oh this—I faked it out with this rod and reel, right? [laughter] I don't think that rod and reel could have held that fish—there was a sturgeon that weighed three hundred pounds. Big white sturgeon. And somehow that thing got its tail wrapped up in a net, and that's how we got him—or her, it was a female. Had five gallons of eggs in it... a lot of eggs, caviar.

OPPOSITE BOTTOM *John Donahue (Yurok) repairing a net, Requa, 1985.* COURTESY OF MERK OLIVER.

ABOVE *Johnny Peters (Yurok) with Cassie and a forty-pound salmon on the porch of the Oliver home in Requa, 1968.* COURTESY OF MERK OLIVER.

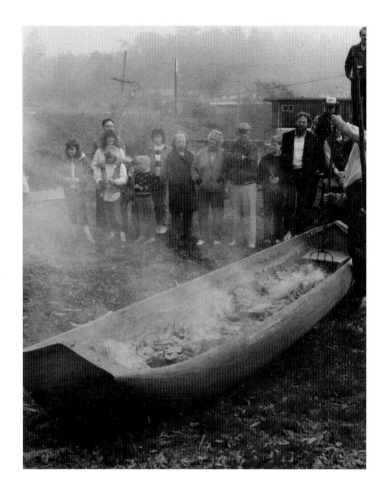

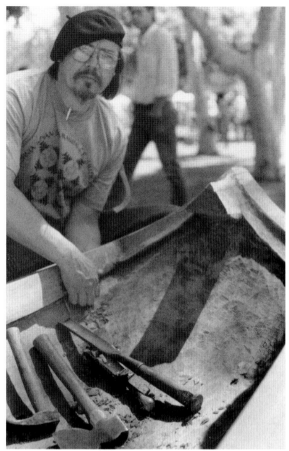

A redwood canoe built by Axel Lindgren (Yurok), with chips burning to seal the inside. Trinidad, 1990s.

George Blake (Hupa/Yurok) working on a redwood canoe, 1990.

THE PEOPLE OF NORTHWESTERN CALIFORNIA, INHABITANTS OF RIVERS AND THE coast, are known for their canoes. Each fine vessel is carved from a single redwood tree and suitable for travel and fishing on river and ocean. Though they are heavy, these canoes are constructed to move lightly on the water and to maneuver easily. One end is blunted to protect the boat from being damaged when paddled close to rocks. Because of the canoes' rounded hulls and the way they sit low in the water, a freshly killed seal can be easily loaded in by rocking one side down to the water line and rolling the seal aboard.

Though diminished, canoe building is still a living art. To those who carve them, canoes are living spirits, sharing some major features with humans and other beings: eyes, nose, ribs, heart, kidneys. Individual carvers sometimes build identifiers into their canoes that make them unique. For example, the late master carver Axel Lindgren Jr. (Yurok) carved two grooves into the heart of one of his canoes to signify the double bypass operation he'd undergone shortly before.

Before a canoe can set off on its maiden voyage, it must be sealed against both nature and evil. Chips and shavings left over from the carving are piled in and around the canoe and set afire; the flames and heat will burn away splinters and seal the wood while the smoke purifies the craft. Watching one of his boats take float for the first time, Lindgren was heard to say, "You can catch a song by listening to the sound of water rushing past the bow of the canoe as it cuts through the water. You can. I've done so myself."[9]

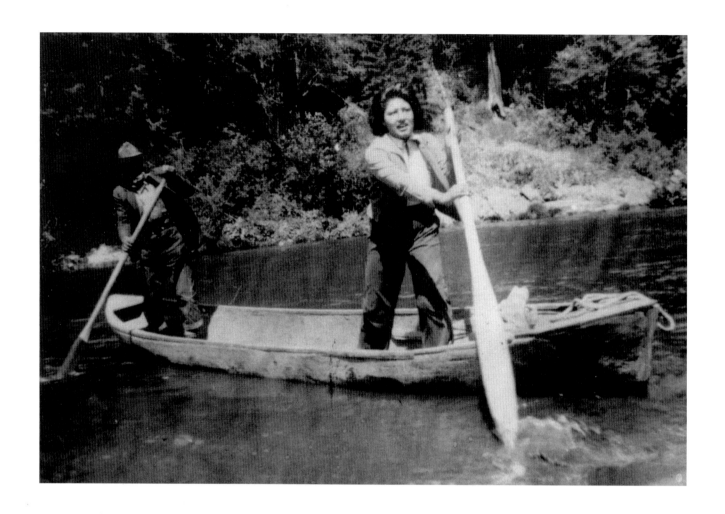

This last jump dance, last August or September...When it started the women were supposed to take baths, because they handle the food. When we got there I was the first one out of the car, and I walked down to the creek, and I was going to wash my hands and my face, and there was no water. And I remember looking up to God and [saying] "You're going to have to send the water, because the women have to bathe."...Everyone was shocked...there wasn't that much water...What the women did was, they went up to the creeks further up and they took the first bath up there...And what do you know, after a while, the next day, it started raining, and it rained all over us. We didn't mean for it to rain all over us....The funny part is, we got our water and the creek lasted until the final day of the dance. We stayed an extra day because we had to do clean-up in the camp. And the next day the water was gone again.

—Christina Ipina (Yurok)

Barbara McQuillen (Yurok/ Tolowa): The Yurok people are fishing people, and we came from a family of women that fished. And there are a lot of people who say Yurok women didn't fish, but we know that's not true. My great-grand-mother Ida James, she fished. She set an eel basket. She set a net at a time when it was prohibited to do here, and she says she could paddle a boat where it wouldn't be making a sound going through the water, because they were hiding from the game wardens at that time. I know that the women fished, because sometimes we had to.

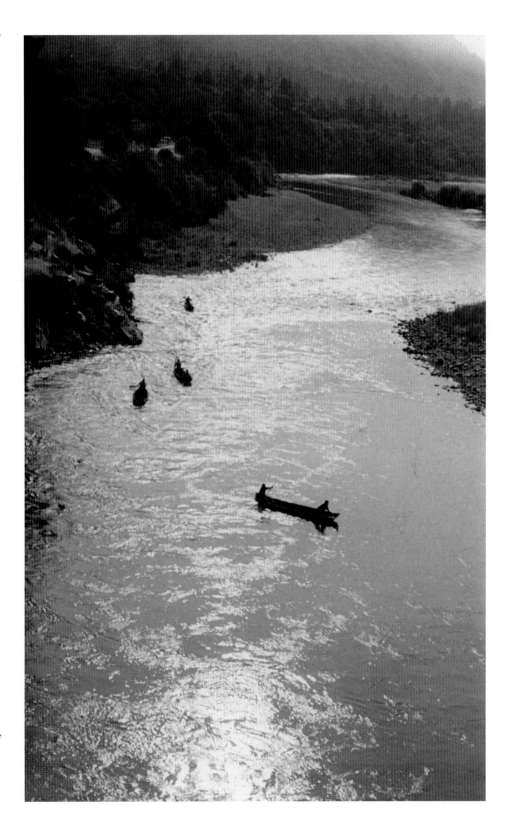

Plank canoes moving downriver on the Klamath, 2001.

WELL-SETTLED VILLAGES LINED THE KLAMATH RIVER AT EVERY FLAT AND SPREAD along the coast. The larger the flat, the more houses, often organized in concentric rings. Houses of redwood or cedar planks had either double- or single-pitched roofs and raised flagstone patios in front. Remains of some of the oldest houses can still be seen. The village site at Takimildin in Hoopa Valley still has three well-preserved houses, and when not in ceremonial use they can be visited by appointment with the Hupa Tribal Museum.

The idea of reconstructing a traditional Yurok village in northwest California began circulating in the 1920s, but nothing came of it until the mid-1980s, when a site at Patrick's Point State Park was set aside and state funds were allocated for the project. The goal of the village is to educate the public about local culture, and also to provide a community and ceremonial space for the Yurok. Since the Patrick's Point area had long been important to the tribe—several significant beings lived there in mythological times—it seemed an ideal site for the village, and indeed California State Parks had been encouraging Yuroks to use the park for ceremonies for years. An advisory board of Yurok tribal members worked with State Parks archaeologists to build three family houses, two sweathouses (one public and one specifically reserved for ceremonies), and a dance pit. All construction was done in the traditional manner, using old-growth redwoods uprooted during a flood on the Eel River. Builders hand-split the logs and then bound them with hazel and grapevine. They built patios with water-worn cobbles gathered on the beach, and they gave the village the name "Sumeg"—the Yurok name for Patrick's Point.

The care that was taken in constructing the village is illustrated in this anecdote by Breck Parkman, an archaeologist with the State Department of Parks and Recreation:

> The Yurok builders were not satisfied until everything was just right...One building had to be redone because of the photo I had given the builders of a house on the Klamath River. Walt [Lara] and the others built a Sumeg house just like it, but were troubled by its appearance when done...No one could decide what was wrong with it. ...Walt found the same photo from the 1950s that I had found there, but he also located an earlier photo of the same house, and it showed a slightly different roof arrangement. Apparently, my photo had depicted an improperly repaired roof. With the new photo in hand, Walt returned to Sumeg, and the correction was soon underway.[10]

They finished the job in 1990, and a four-day celebration was held to dedicate the village. Since then it has served not just as a museum of the past, but as a living cultural center, the site of many seasonal ceremonies for the Yurok and members of other tribes who join them.

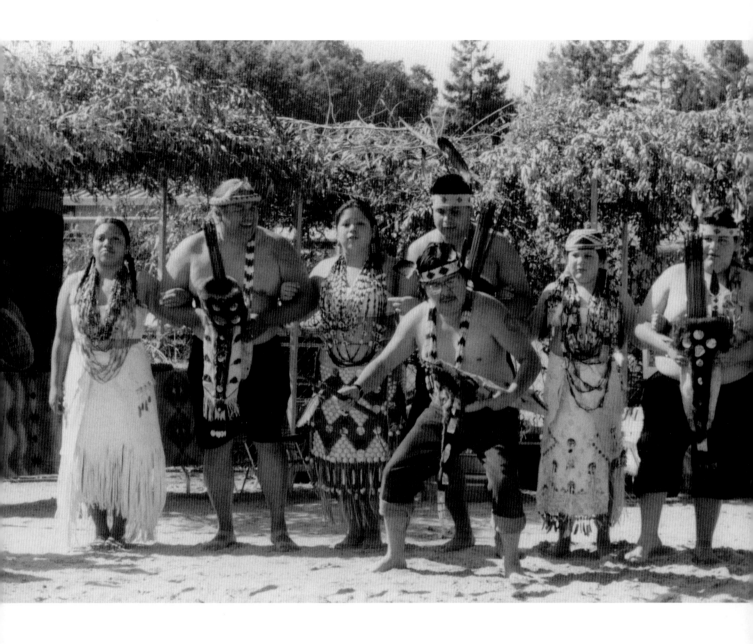

Tribalism didn't exist amongst us—tribalism came in when the Euro-Americans wanted to classify us for whatever reason, and that's starting to show up now. But I was always taught that it's what village you come from…It's my responsibility to pass that on to my kids and my grandchildren.

—*Clarence Hostler (Hupa)*

Frank Gist Jr. with extended family at a Family Day presentation, Nimbus Fish Hatchery, 2002.

COURTESY OF FRANK GIST JR.

Violet Super (Karuk) playing cards with Luke Supahan and teaching him the Karuk language, Orleans, 1994.

Courtesy of Terry Supahan.

Clarence Hostler (Hupa) with his grandson Lance at Katamiin, 2002.

Photo by Deborah Bruce. Courtesy of Clarence Hostler.

Clarence Hostler: Little Lance is in his baby basket...[It's] a real superior design as far as safety, because our people traveled on the rivers a lot. That baby basket is designed to, when it hits the water it'll float upright, so that the baby's head will be up out of the water. And then, across the top, where the string of beads goes across, is a life line...there's a whole other lesson about the life line and what you do with that, once a baby is grown up, and then they take that with them when they head back to the spirit world.

He taught me a Brush Dance song. See, what Grandma always taught us was, when you're holding that baby, and you watch that baby, when you think they're crying, what they're doing is singing. Because the babies are the freshest ones, that come from the spirit world. And then you learn from them. So when little Lance was a little guy in his baby basket...I'd pick him up and I'd look at him, and he'd start in. It was like he was crying, but he'd look right deep into me, and then he'd start in.

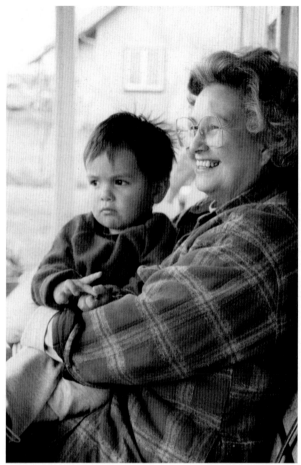

Tripp and O'Rourke girls posing on the pier at Ameekiiyareem, on the Klamath River, 2001.

COURTESY OF TERRY SUPAHAN.

Geraldina Rubra (Wiyot) with her grandson Lio Lopez, Table Bluff Rancheria, 2001.

PHOTO BY CHERYL SEIDNER. COURTESY OF CHERYL SEIDNER.

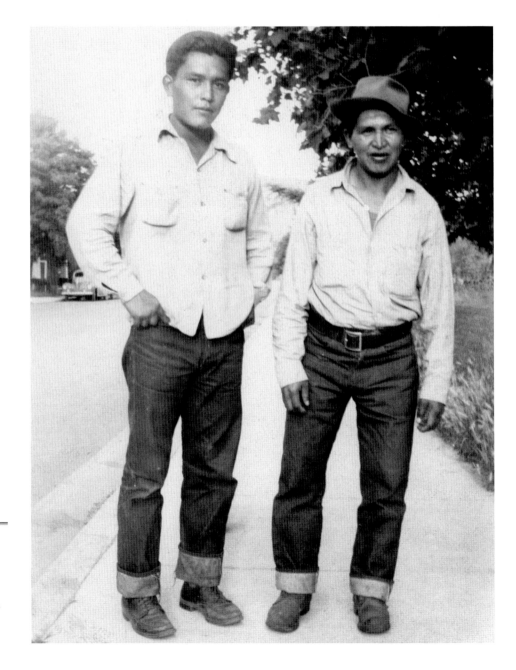

Al McLaughlin and Dave Johnny (Karuk) at Somes Bar, early 1940s.
Courtesy of Terry Supahan.

Dave Johnny was in World War II and ended up traveling all over the world.

Front to back, left to right: cousins Christine Hill, Pauline Caldwell, Geraldine Slife, Sherry Caldwell, Pauline Reed, and Julie Hubbel (Yurok), Eureka, 1976.
Courtesy of Christina Ipina.

Pete Super (Karuk) with his sons Tass and Trevor, Yreka, 1998.
Courtesy of Arch Super.

John Ammon (Tsnungwe, right) tutoring algebra at the San Jose Indian Education Program, 2002.
Photo by Gloria Ammon. Courtesy of John Ammon.

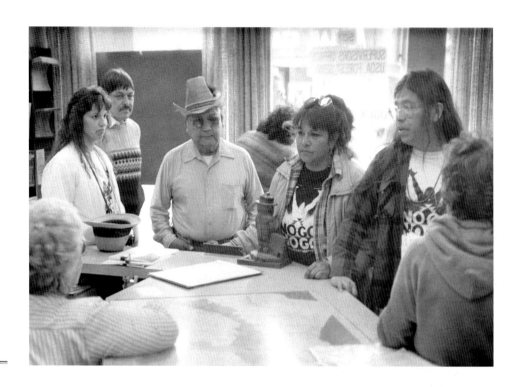

G–O Road protestors at the Six Rivers National Forest headquarters in 1988: Lyn Risling (Karuk/Yurok/Hupa), Byron Nelson (Hupa), Jimmie James (Karuk), Junie Mattice (Tolowa), and Julian Lang (Karuk/Wiyot).

Northwest California Indians were protesting Forest Service plans to build a road from Gasquet to Orleans (the G–O Road) through the "high country," still a center of spiritual activity. The issue went to the U.S. Supreme Court in a religious freedom case, *Lyng v. Northwest Indian Cemetery Protective Association.*

Walter Lara Sr. (Yurok), founder of the Northwest Indian Cemetery Protective Association, with daughter, Klamath, 1960s.

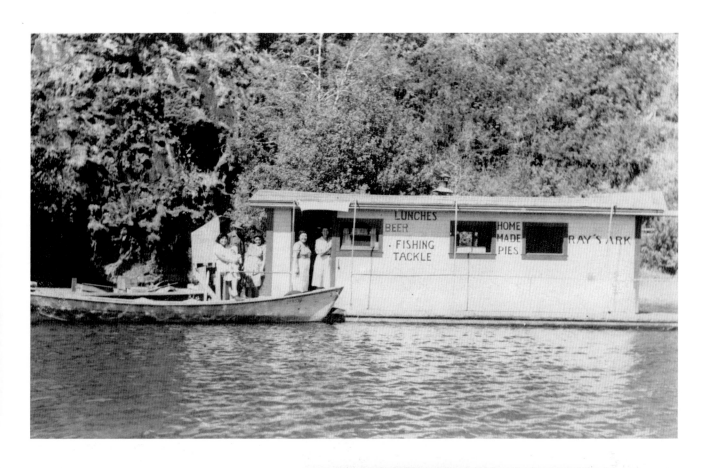

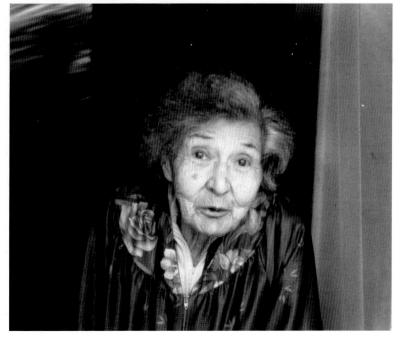

OPPOSITE *Florence Shaughnessy's floating restaurant, filling station, and bait shop at the mouth of the Klamath River, 1943.*
COURTESY OF MERK OLIVER.

Merk Oliver: "Puh-lik-la" is our own language. See, this here ["Yurok"] comes from Karuks. Because evidently that's where the white man started from, up there, and they got to the Karuks, they asked those people up there, "Is there somebody else down there?" Well that ["Yurok"] means "downriver."

Florence Shaughnessy (Yurok), 1980s.
COURTESY OF JEAN PERRY.

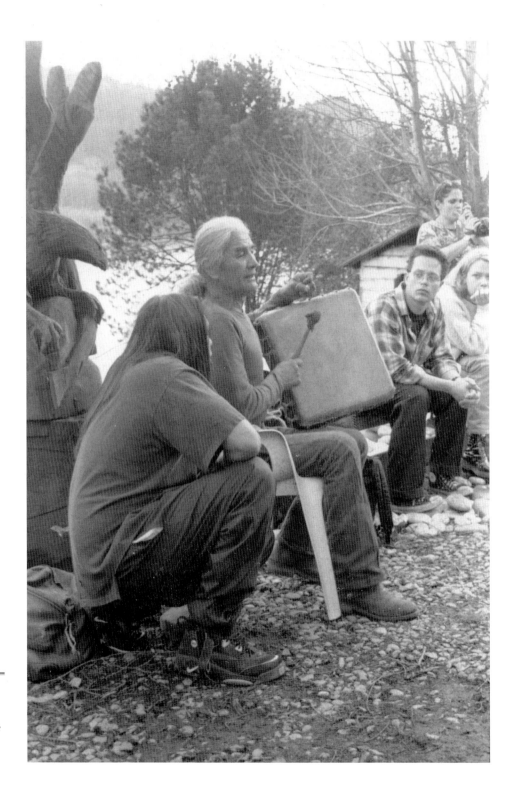

*Levi Tripp (left) and Merk Oliver
(Yurok) singing gambling songs for
Julian Lang's San Francisco Art Institute
class, Requa, 1999.*

COURTESY OF JULIAN LANG.

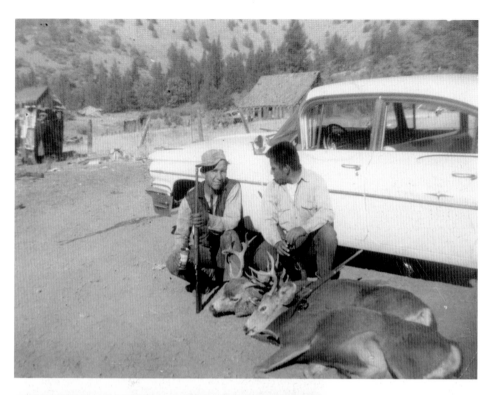

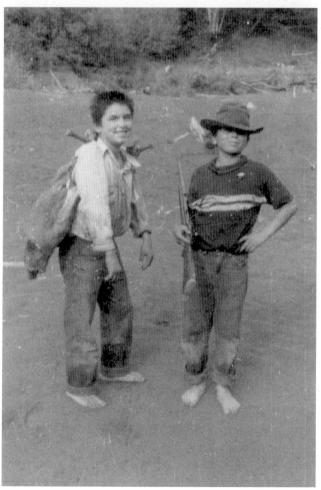

*Brothers Peter and Ray Super (Karuk)
hunting deer at Moffitt Creek, 1965.*
COURTESY OF ARCH SUPER.

*Brothers Mickey and Dennis O'Rourke
(Yurok) hunting deer at Moreck, 1950s.*
COURTESY OF CAROLE LEWIS.

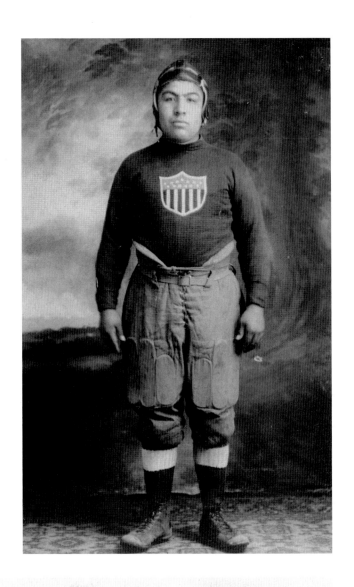

Kirby Peters (Yurok) playing football for the military, early 1900s.
COURTESY OF MERK OLIVER.

Cousins Danny Ipina and Dennis O'Rourke (Yurok) boxing on the Klamath River, 1963.
COURTESY OF CHRISTINA IPINA.

David Super (Karuk) with basketball trophy, Grenada, 1976.
COURTESY OF ARCH SUPER.

Arch Super: I think that's probably basketball. He was always very good in basketball. Even now, he's still good at basketball...He's good at most of the sports he plays. Actually, all the sports he plays.

Maida Maunaolana Hubbell (Yurok) and two teammates from the Elsie Allen High School softball team, Santa Rosa, 2000.
COURTESY OF CHRISTINA IPINA.

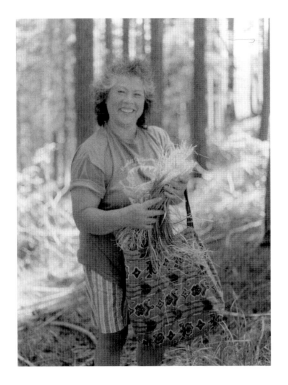

ABOVE LEFT *Leona Wilkinson (Wiyot)*
gathering bear grass after a burn near
Orleans, 1995. Photo by Lorraine Taggert.
COURTESY OF CHERYL A. SEIDNER.

ABOVE RIGHT *Vivien Hailstone (Yurok/*
Hoopa/Karuk) displaying her baskets at the
California State Library, Sacramento, 1989.
PHOTO BY HEATHER HAFLEIGH. COURTESY OF
HEATHER HAFLEIGH.

RIGHT *David and Theresa Ipina (Yurok)*
cutting their wedding cake, which was
decorated with traditional basketry designs.
Arcata, 1976.
COURTESY OF CHRISTINA IPINA.

Christina Ipina: My mother was
so proud. We have two Yurok
languages. One is the upper-class
and one is the normal one every-
one uses. When she got home she
started talking and we couldn't
understand a word she said. And
I said, "What are you saying, Mom?"
"I'm thanking God for the fact that
I am so proud of my grandson's
wedding." When you have an
Indian wedding, everyone mixes in.

Sean Johnny (Karuk), a firefighter in
Medford, Oregon, 2001.

Photo by Nisha Supahan. Courtesy of
Nisha Supahan.

*Phil Albers and Elaina Supahan in
Ashland, Oregon, 2003.*

FOREWORD

1. Peter H. Burnett, "Governor's Annual Message to the Legislature, January 7, 1851," in *Journals of the Senate and Assembly of the State of California, at the Second Session of the Legislature, 1851–1852* (San Francisco: G. K. Fitch & Co., and V. E. Geiger & Co., State Printers, 1852).

CHAPTER 1
CENTRAL VALLEY AND WESTERN SIERRA NEVADA

1. James J. Rawls, *Indians of California: The Changing Image.*
2. Sim Moak, *The Last of the Mill Creeks, and Early Life in California.*
3. Rawls, *Indians of California.*
4. Ibid.
5. Thomas Jefferson Mayfield, *Indian Summer: Traditional Life among the Choinumne Indians of California's San Joaquin Valley.*
6. Brian Bibby, *Deeper Than Gold.*
7. For full accounts of traditional acorn processing, see Beverly Ortiz and Julia Parker's *It Will Live Forever*, Richard Simpson's *Ooti: A Maidu Legacy*, and ethnographic accounts by E. W. Gifford, C. Hart Merriam, and others.
8. B. Pavlik et al., *Oaks of California.*
9. Unless otherwise stated, this and all subsequent excerpts in this chapter are from 2003 interviews by L. Frank and Marina Drummer done in conjunction with this book.
10. Sara Greensfelder, *News from Native California* 6(1).
11. For more information on the California Indian Basketweavers Association or to become a member, visit their website at www.ciba.org.
12. Jennifer Bates, *News from Native California* 13(1).
13. Frank LaPena is a founding member of the Maidu Dancers and Traditionalists. This quotation is from his book *Dream Songs and Ceremony.*
14. Brian Bibby, *News from Native California* 7(1).
15. Brian Bibby, *News from Native California* 7(3).
16. Frank Latta quoted in Clifford Trafzer's *American Indians as Cowboys.*

17. Lizzie Enos (Nisenan), quoted in Richard Simpson's *Ooti: A Maidu Legacy.*
18. Brian Bibby, *News from Native California* 7(3).
19. George H. Phillips, *"Bringing Them under Subjection": California's Tejon Reservation and Beyond, 1852–1864.*
20. For a few months in 1859 and 1860, Fort Tejon also housed a herd of camels: Beale had urged the U.S. military to use camels for travel in the deserts of the American Southwest, but it didn't work out, and the camels were on their way to Benicia to be auctioned off.

CHAPTER 2
CENTRAL COASTAL CALIFORNIA

1. Miguel Costansó, *The Discovery of San Francisco Bay.*
2. Mission San Carlos Borromeo was moved to Carmel in 1771.
3. Kent Lightfoot, *Indians, Missionaries, and Merchants.*
4. Greg Sarris, *News from Native California* 14(3).
5. Rose Marie Beebe and Robert M. Senkewicz, *Lands of Promise and Despair.*
6. Jean François de la Pérouse, *Life in a California Mission.*
7. Kathleen Smith, *News from Native California* 5(1).
8. Kathleen Smith, *News from Native California* 5(2).
9. From Kashaya Pomo leader Essie Parrish's oration at the 1972 Strawberry Festival at the Kashaya Reservation.
10. For more on the Bole-Maru religion, see "The Ghost Dance," chapter 6.
11. Marsha Ann McGill, *News from Native California* 4(3).
12. Suzanne Abel-Vidor et al., *Remember Your Relations.*
13. Meyo Blue Cloud, *News from Native California* 12(1).

CHAPTER 3
COASTAL SOUTHERN CALIFORNIA

1. Rose Marie Beebe and Robert M. Senkewicz, *Lands of Promise and Despair.*
2. Jean François de la Pérouse, *Life in a California Mission.*

3. Rupert Costo and Jeanette Henry Costo, *The Missions of California.*
4. Helen Hunt Jackson, *A Century of Dishonor.*
5. Allan J. Ryan, *News from Native California* 14(2).
6. Travis Hudson, et al., *Tomol: Chumash Watercrafts as Described in the Ethnographic Notes of John P. Harrington.*
7. "Life and Times," KCET-TV, July 2, 2004.
8. Julie Cordero, *HopeDance* 25(4).
9. Scott O'Dell published a fictionalized account of her life—the main character is a girl, and the missing child is her brother—in *Island of the Blue Dolphins*, in 1960. It was made into a movie in 1964.
10. Beebe and Senkewicz, *Lands of Promise and Despair.*
11. Richard Carrico, www.kumeyaay.com.
12. Leanne Hinton, *Flutes of Fire.*
13. Ibid.

CHAPTER 4
INLAND SOUTHERN CALIFORNIA

1. JoMay Modesto, in Deborah Dozier, *The Heart Is Fire.*
2. Dozier, *The Heart Is Fire.*
3. Ibid.
4. Bev Ortiz, *News from Native California* 5(4).
5. Edward D. Castillo, "Twentieth-Century Secular Movements."
6. Ibid.
7. Lippincott's commencement address at Carlisle Indian School, in David Wallace Adams, *Education for Extinction.*
8. Official Report of the Nineteenth Annual Conference of Charities and Correction (1892), in Francis Paul Prucha, *Americanizing the American Indians.*
9. Victoria Patterson et al., eds., *The Singing Feather.*
10. For more information: see the museum's website at www.shermanindianmuseum.org. Museum hours are by appointment only: (951) 276-6719.
11. Darrell Moorehead, "Paying Our Fair Share."

CHAPTER 5

GREAT BASIN

1. Several thousand years ago, Paiutes crossed the mountains and established villages in the western foothills of the Sierra. They are now known as the Western Mono.

2. Laughing Coyote, *News from Native California* 15(3).

3. In 1880 Los Angeles had a population of 11,000; by 1900 it had grown to 100,000, and by 1920 it had swelled to 600,000 (Samuel G. Houghton, *A Trace of Desert Waters*).

4. Jon Christensen, *High Country News*, August 18, 1997.

5. Frank LaPena, *News from Native California* 6(2).

6. J. Ross Browne, "Washoe Revisited."

7. John A. Price, "The Washo Indians."

8. Robert F. Heizer and Albert B. Elsasser, *The Natural World of the California Indians*.

9. Laura Fillmore, *News from Native California* 9(2).

10. Larry Dalrymple, *Indian Basketmakaers of California and the Great Basin*.

11. Craig D. Bates and Martha J. Lee, *Tradition and Innovation*.

12. Beverly R. Ortiz, *News from Native California* 8(1).

13. Leanne Hinton, *Flutes of Fire*.

CHAPTER 6

NORTHEASTERN CALIFORNIA

1. There is some disagreement as to how these groups are configured, but the eleven bands of Pit River Indians are generally considered to be the Achomawi, Apwaruge, Astariwawi, Atsuge, Atwamsini, Hanhawi, Hewisedawi, Ilmawi, Itsatawi, Kosalextawi, and Madesi. Their languages are Achumawi and Atsugewi.

2. The four similar but culturally distinct Shasta groups are the Shasta, the Okwanuchu, the New River Shasta, and the Konomihu.

3. Anthropologists recognize four subdivisions of the Yana people: Northern, Central, and Southern Yana, and the Yahi.

4. The Klamath of southern Oregon are a separate tribe, not to be confused with the tribes (primarily Karuk and Yurok) that live along the Klamath River in northern California.

5. Jeff C. Riddle, *The Indian History of the Modoc War*.

6. Wright perpetrated the 1852 massacre of Modoc men, women, and children.

7. Thomas R. Garth, *Atsugewi Ethnography*.

8. Ibid.

9. Francis Riddell, "Honey Lake Paiute Ethnography."

10. Floyd Buckskin, "Ajumawi Doctoring: Conflicts in New Age/Traditional Shamanism."

11. Cora Du Bois, "The 1870 Ghost Dance."

12. Marvin Brown, *News from Native California* 6(3).

13. Karl Kroeber and Clifton Kroeber, eds., *Ishi in Three Centuries*.

14. Scott Winokur and Christian Berthelsen, *San Francisco Chronicle*.

CHAPTER 7

NORTHWESTERN CALIFORNIA

1. Lucy Thompson, *To the American Indian*.

2. Maurice S. Sullivan, ed., *The Travels of Jedediah Smith*.

3. Rosborough to Henley, Feb. 22, 1855, National Archives, RG75, Ltrs. Recd., OIA, Calif. Supt.

4. Later, the Hupa Extension Reservation along the Klamath River would be established. Combined with the Klamath River Reservation, this is now part of the Yurok Reservation. Other reservations in the area include Quartz Valley, Resighini, Big Lagoon, Trinidad, Table Bluff, Blue Lake, Rohnerville, and Round Valley.

5. *Northern Californian*, February 29, 1860, quoted in "Remembering Indian Island" by Auriana Koutnik, *News from Native California* 9(2).

6. Bill Kowinski, *News from Native California* 18(1).

7. Julian Lang, *Ararapíkva*.

8. Julian Lang, *News from Native California* 7(4).

9. Conger Beasley Jr., *News from Native California* 2(4).

10. Breck Parkman, *News from Native California* 5(2).

Abel-Vidor, Suzanne, Dot Brovarney, and Susan Billy. *Remember Your Relations: The Elsie Allen Baskets, Family & Friends.* Berkeley, Cal.: Heyday Books, 1996.

Adams, David Wallace. *Education for Extinction: American Indians and the Boarding School Experience 1875–1928.* Lawrence, Kan.: University Press of Kansas, 1995.

Allen, Elsie. *Pomo Basketmaking: A Supreme Art for the Weaver.* Healdsburg, Cal.: Naturegraph Publishers, 1972.

Archuleta, Margaret L., Brenda S. Child, and K. Tsianina Lomawaima, eds. *Away from Home: American Indian Boarding School Experiences.* Phoenix, Ariz.: Heard Museum, 2000.

Barna, Mark. "Unearthing New Perspective." *Bakersfield Californian,* 2 February 2004, page A1.

Bates, Craig D., and Martha J. Lee. *Tradition and Innovation: A Basket History of the Indians of the Yosemite–Mono Lake Area.* Yosemite National Park: Yosemite Association, 1990.

Bates, Jennifer. Introduction, "Special Report: Western Regional Indigenous Basketweavers Gathering." *News from Native California* 13(1).

Bean, Lowell John. *Mukat's People: The Cahuilla Indians of Southern California.* Berkeley and Los Angeles: University of California Press, 1972.

—— and Katherine Siva Saubel. *Temalpakh (From the Earth): Cahuilla Indian Knowledge and Usage of Plants.* Banning, Cal.: Malki Museum Press, 1972.

Beard, Yolanda S. *The Wappo: A Report.* Banning, Cal.: Malki Museum Press, 1979.

Beasley Jr., Conger. "The Yurok Redwood Canoe." *News from Native California* 2(4).

Beebe, Rose Marie and Robert M. Senkewicz, eds. *Lands of Promise and Despair: Chronicles of Early California, 1535–1846.* Santa Clara and Berkeley: Santa Clara University and Heyday Books, 2001.

Bibby, Brian. *The Fine Art of California Indian Basketry.* Sacramento: Crocker Art Museum, 1996.

——. "A Purpose for Everything." *News from Native California* 7(1).

——. "Still Going: Bill Franklin and the Revival of Miwuk Traditions." *News from Native California* 7(3).

—— and Dugan Aguilar. *Deeper Than Gold: A Guide to Indian Life in the Sierra Region.* Berkeley, Cal.: Heyday Books, 2004.

Blue Cloud, Meyo. "The Strawberry Festival: A California Tradition" in *News from Native California* 12(1).

Brown, Marvin. "The Big Head Religion Today" in *News from Native California* 6(3).

Browne, J. Ross. "Washoe Revisited" in *Harper's Monthly Magazine,* May–July 1865. Reprint Oakland, Calif.: Biobooks, 1957.

Buckley, Thomas. *Standing Ground: Yurok Indian Spirituality, 1850–1990.* Berkeley & Los Angeles: University of California Press, 2002.

Buckskin, Floyd. "Ajumawi Doctoring: Conflicts in New Age/Traditional Shamanism." In *California Indian Shamanism,* ed. Lowell John Bean. Menlo Park: Ballena Press Anthropological Papers No. 39, 1992.

Campbell, Paul D. *Survival Skills of Native California.* Salt Lake City: Gibbs Smith Publisher, 1999.

Carrico, Richard. "We Did No Harm to You: Two Hundred Years of Native Voices" (1902 Hearing on the Purchase of Land for the Cupeño Indians, Warner's Hot Springs), www.kumeyaay.com (October 2, 2006).

Castillo, Edward D. "Twentieth-Century Secular Movements," in *The Handbook of North American Indians,* vol. 8, "California," ed. Robert F. Heizer. Washington, D.C.: Smithsonian Institute, 1978.

——, ed. *Native American Perspectives on the Historic Colonization of Alta California.* New York & London: Garland Publishing, Inc., 1991.

Chatterjee, Pratap. *Gold, Greed and Genocide: Unmasking the Myth of the 49ers.* Berkeley, Cal.: Project Underground, 1998.

Christensen, Jon. "At Tahoe Forum, a Tribe Wins a Deal." *High Country News,* August 18, 1987.

Cleland, Robert Glass. *The Cattle on a Thousand Hills.* Berkeley: University of California Press, 1990.

Clifford, Frank. "Ruling Apparently Kills Ward Valley Nuclear Dump Plan." *Los Angeles Times,* 3 April 1999, part A.

Cook, S. F. *Colonial Expeditions to the Interior of California: Central Valley, 1800–1820.* University of California Anthropological Records, vol. 16, no. 6. Berkeley & Los Angeles: University of California Press, 1960.

——. *Colonial Expeditions to the Interior of California: Central Valley, 1820–1840.* University of California Anthropological Records, vol. 20, no. 5. Berkeley & Los Angeles: University of California Press, 1962.

Cordero, Julie. "Tomols and Healthy Watersheds." *HopeDance* 25(4).

Costansó, Miguel. *The Discovery of San Francisco Bay: The Portolá Expedition of 1769–1770.* Lafayette, Calif.: Great West Books, 1992.

Costo, Rupert, and Jeanette Henry Costo. *The Missions of California.* San Francisco: The Indian Historian Press, 1987.

Cox, Vic. "Re-creating the Tomol." *Alolkoy* 7, no. 4 (1995): 12.

Coyle, Courtney Ann. "Defending Quechan Indian Pass—Again." *Indian Country Today,* 10 November 2003.

Crum, Steven J. *The Road on Which We Came: A History of the Western Shoshone.* Salt Lake City: University of Utah Press, 1996.

Dalrymple, Larry. *Indian Basketmakers of California and the Great Basin.* Santa Fe: Museum of New Mexico Press, 2000.

Darling, Dylan. "Tribe Hopes Technology Will Help Save Salmon." *Klamath Falls Herald and News,* 7 November 2003.

Dixon, Roland B. *The Huntington California Expedition: The Shasta.* Bulletin of the American Museum of Natural History, vol. 17, no. 5. New York: American Museum of Natural History, 1907.

Downs, James F. *The Two Worlds of the Washoe: An Indian Tribe of California and Nevada.* New York: Holt, Rinehart and Winston, 1966.

Dozier, Deborah. *The Heart Is Fire: The World of the Cahuilla Indians of Southern California.* Berkeley, Cal.: Heyday Books, 1998.

Drucker, Philip. *The Tolowa and Their South-west Oregon Kin.* University of California Publications in American Archaeology and Ethnology, vol. 36, no. 4. Berkeley: University of California Press, 1937.

Du Bois, Cora. *The 1870 Ghost Dance.* University of California Anthropological Records 3(1). Berkeley & Los Angeles: University of California Press, 1939.

Eargle, Jr., Dolan H. *Native California Guide: Weaving the Past & Present.* San Francisco: Trees Press, 2000.

Fillmore, Laura. "Washoe Pinenut Camp, 1991." *News from Native California* 9(2).

Forbes, Jack. *Native Americans of California and Nevada.* Happy Camp, Cal.: Naturegraph Publishers, Inc., 1982.

Garth, Thomas R. *Atsugewi Ethnography.* University of California Anthropological Records 14(2). Berkeley & Los Angeles: University of California Press, 1953.

Gendar, Jeannine. *Grass Games and Moon Races: California Indian Games and Toys.* Berkeley, Cal.: Heyday Books, 1995.

Goddard, Pliny Earle. *Life and Culture of the Hupa.* University of California Publications in American Archaeology and Ethnology, vol. 1, no. 1. Berkeley: University of California Press, 1903.

Goldschmidt, Walter. *Nomlaki Ethnography.* University of California Publications in American Archaeology and Ethnology, vol. 42, no. 4. Berkeley & Los Angeles: University of California Press, 1951.

Gooch, Sara, ed. *The Journal of the Modoc County Historical Society* 12 (1990).

Grant, Campbell. *Rock Drawings of the Coso Range, Inyo County, California.* China Lake, Cal.: Maturango Museum, 1969.

Greensfelder, Sara. Introduction, "Special Report on California Indian Basketweavers Gathering. *News from Native California* 6(1).

Gutierrez, Ramon A. and Richard J. Orsi, eds. *Contested Eden: California Before the Gold Rush.* Berkeley & Los Angeles: University of California Press, 1998.

Hackel, Steven W. *Children of Coyote, Missionaries of Saint Francis: Indian-Spanish Relations in Colonial California, 1769–1850.* Chapel Hill: University of North Carolina Press, 2005.

Heizer, Robert F., ed. *The Handbook of North American Indians,* vol. 8, "California." Washington, D.C.: Smithsonian Institute, 1978.

———, ed. *The Destruction of the California Indians.* Santa Barbara & Salt Lake City: Peregrine Smith, Inc., 1974.

———, and Alan J. Almquist. *The Other Californians: Prejudice and Discrimination under Spain, Mexico, and the United States to 1920.* Berkeley & Los Angeles: University of California Press, 1971.

———, and Martin A. Baumhoff. *Prehistoric Rock Art of Nevada and Eastern California.* Berkeley and Los Angeles: University of California Press, 1962.

———, and Albert B. Elsasser, *The Natural World of the California Indian.* Berkeley: University of California Press, 1980.

Hinton, Leanne. *Flutes of Fire: Essays on California Indian Languages.* Berkeley: Heyday Books, 1994.

———. *Spirit Mountain: An Anthology of Yuman Story and Song.* Tucson: University of Arizona Press, 1984.

Holt, Catharine. *Shasta Ethnography.* University of California Anthropological Records, vol. 3, no. 4. Berkeley & Los Angeles: University of California Press, 1946.

Houghton, Samuel G. *A Trace of Desert Waters: The Great Basin Story.* Glendale, Calif.: The Arthur H. Clark Company, 1976.

Hudson, Travis, Janice Timbrook, and Melissa Rampe, eds. *Tomol: Chumash Watercrafts as Described in the Ethnographic Notes of John P. Harrington.* Santa Barbara, Cal.: Ballena Press, 1978.

Jackson, Helen Hunt. *Ramona: A Story.* New York: Signet Classics, 2002 [1884].

———. *A Century of Dishonor: A Sketch of the United States Government's Dealings with Some of the Indian Tribes.* Minneapolis: Ross & Haines, 1964 [1885].

Jackson, Robert H. and Edward Castillo. *Indians, Franciscans, and Spanish Colonization: The Impact of the Mission System on California Indians.* Albuquerque: University of New Mexico Press, 1995.

KCET-TV. "Life and Times," July 2, 2004

Kelly, Isabel T. *Ethnography of the Surprise Valley Paiute.* University of California Publications in American Archaeology and Ethnology, vol. 31, no. 3. Berkeley: University of California Press, 1932.

Kilpatrick, Jacquelyn. *Celluloid Indians: Native Americans and Film.* Lincoln: University of Nebraska Press, 1999.

Kowinski, Bill. "Home at Last." *News from Native California* 18(1).

Kroeber, A. L. *Handbook of the Indians of California.* New York: Dover Publications, Inc., 1976 [1925].

Kroeber, Karl, and Clifton Kroeber, eds. *Ishi in Three Centuries.* Lincoln: University of Nebraska Press, 2003.

la Pérouse, Jean François de. *Life in a California Mission: The Journals of Jean François de la Pérouse.* Berkeley: Heyday Books, 1989.

Lang, Julian. *Ararapíkva.* Berkeley: Heyday Books, 1994.

———. "Wealth and "Spirit." *News from Native California* 7(4).

LaPena, Frank. *Dream Songs and Ceremony.* Berkeley: Heyday Books, 2004.

———. "Rights and Symbols." *News from Native California* 6(2).

Latta, Frank F. *Handbook of Yokuts Indians.* Santa Cruz, Cal.: Bear State Books, 1977 [1949].

Laughing Coyote. "Walking for the Ancestors." *News from Native California* 15(3).

Lawton, Harry. *Willie Boy: A Desert Manhunt.* Banning, Cal.: Malki Museum Press, 1976.

Lightfoot, Kent. *Indians, Missionaries, and Merchants: The Legacy of Colonial Encounters on the California Frontiers.* Berkeley: University of California Press, 2005.

Lönnenberg, Allan. "The Native Peoples of Santa Cruz County." *Santa Cruz County Historical Journal* 1 (1994): 9-20.

Luthin, Herb, ed. *Surviving Through the Days: Translations of Native California Stories and Songs, A California Indian Reader.* Berkeley and Los Angeles: University of California Press, 2002.

Margolin, Malcolm. *The Ohlone Way: Indian Life in the San Francisco–Monterey Bay Area.* Berkeley, Cal.: Heyday Books, 2003 [1978].

——. *Preserving the Layers of History: Fort Hunter Liggett Military Installation.* Berkeley, Cal.: Heyday Books, 1997.

——, ed. *The Way We Lived: California Indian Stories, Songs, and Reminiscences.* 2nd ed. Berkeley, Cal.: Heyday Books, 1993.

May, James. "Klamath Tribes Believe a River Should Run through It: Part Three." *Indian Country Today*, 4 November 2003.

Mayfield, Thomas Jefferson. *Indian Summer.* Berkeley: Heyday Books, 1993.

McGill, Marsha Ann. "The Pomo Women's Club" in *News from Native California* 4(3).

Milliken, Randall. *A Time of Little Choice: The Disintegration of Tribal Culture in the San Francisco Bay Area, 1769–1810.* Menlo Park, Cal.: Ballena Press, 1995.

Moak, Sim. *The Last of the Mill Creeks, and Early Life in California,* at the Library of Congress website, http://lcweb2.loc.gov

Moorehead, Darrell. "Paying Our Fair Share," in "Indian Gaming, March 1, 2006, www.indiangaming.com (October 5, 2006).

Mullis, Angela and David Kamper, eds. *Indian Gaming: Who Wins?* Los Angeles: UCLA American Indian Studies Center, 2000.

Native Americans on the Central Coast: A Photo Essay. Ventura, Cal.: Black Gold Cooperative Library System, 1997.

Nelson, Jr., Byron. *Our Home Forever: A Hupa Tribal History.* Hoopa, Cal.: Hupa Tribe, 1978.

Nomland, Gladys Ayer. *Bear River Ethnography.* University of California Anthropological Records, vol. 2., no. 2. Berkeley: University of California Press, 1938.

——. *Sinkyone Notes.* University of California Publications in American Archaeology and Ethnology, vol. 36, no. 2. Berkeley: University of California Press, 1935.

Oandasen, William, *Round Valley Songs,* Minneapolis: West End Press, 1984.

Ortiz, Beverly R. "Washo Baskets and Foods." *News from Native California* 8(1).

——. "A Bird Dance at the Andreas Ranch." *News from Native California* 5(4).

——, and Julia Parker. *It Will Live Forever.* Berkeley: Heyday Books, 1991.

Parkman, Breck. "Dedicating Sumeg." *News from Native California* 5(2).

Patterson, Victoria, Deanna Barney, Les Lincoln, Skip Willits, eds. *The Singing Feather: Tribal Remembrances from Round Valley.* Ukiah, Cal.: Mendocino County Library, 1990.

Pavlik, B. and P. Muick, S. Johnson, M. Popper. *Oaks of California.* Los Olivos, Calif.: Cachuma Press, 1991.

Phillips, George H. *"Bringing Them under Subjection": California's Tejon Reservation and Beyond, 1852–1864.* Lincoln: University of Nebraska Press, 2004.

——. *The Enduring Struggle: Indians in California History.* San Francisco: Boyd & Fraser Publishing Company, 1981.

——. *Indians and Indian Agents: The Origins of the Reservation System in California, 1849–1852.* Norman: University of Oklahoma Press, 1997.

Price, John A. "The Washo Indians: History, Life Cycle, Religion, Technology, Economy, and Modern Life." Nevada State Museum Occasional Papers No. 4, 1980.

Prucha, Francis Paul. *Americanizing the American Indians: Writings by the "Friends of the Indian" 1880–1900.* Cambridge, Mass.: Harvard University Press, 1973.

Ramon, Dorothy and Eric Elliot. *Wayta' Yawa': Always Believe.* Banning, Calif.: Malki Museum Press, 2000.

Raphael, Ray. *Little White Father.* Eureka, Calif.: Humboldt County Historical Society, 1993.

Rawls, James R. *Indians of California: The Changing Images.* Norman: University of Oklahoma Press, 1984.

Ray, Verne F. *Primitive Pragmatists: The Modoc Indians of Northern California.* Seattle: University of Washington Press, 1963.

"Return to Indian Island." *North Coast Journal Weekly,* 21 September 2000.

Riddell, Francis. "Honey Lake Paiute Ethnography." Nevada State Museum Occasional Papers no. 3, part 1, 1978.

Riddle, Jeff C. *The Indian History of the Modoc War.* San Jose, Cal.: Urion Press, 1974 [1914].

Ryan, Allan J. "Acorn Soup: Drawings and Commentary by L. Frank." *News from Native California* 14(2).

Sandos, James A. *Converting California: Indians and Franciscans in the Missions.* New Haven: Yale University Press, 2004.

Santa Barbara Museum of Natural History Education Center. *California's Chumash Indians.* San Luis Obispo, Cal.: EZ Nature Books, 1986.

Santiago, Chiori. *Home to Medicine Mountain* (illustrated by Judith Lowry). San Francisco: Children's Book Press, 1999.

Sapir, Edward and Leslie Spier. *Notes on the Culture of the Yana.* University of California Anthropological Records, vol. 3, no. 3. Berkeley & Los Angeles: University of California Press, 1943.

Sarris, Greg. "First Thoughts on Restoration." *News from Native California* 14(3).

——. *Grand Avenue.* New York: Hyperion, 1994.

Shepherd, Alice. *In My Own Words: Stories, Songs, and Memories of Grace McKibbin, Wintu.* Berkeley, Cal.: Heyday Books, 1997.

Sherer, Lorraine M. *Bitterness Road, The Mojave: 1604–1860.* Menlo Park, Cal.: Ballena Press, 1994.

Shipek, Florence Connolly. *Delfina Cuero: Her Autobiography, An Account of Her Last Years, and Her Ethnobotanic Contributions.* Menlo Park, Cal.: Ballena Press, 1991.

——. *Pushed into the Rocks: Southern California Indian Land Tenure, 1769–1986.* Lincoln: University of Nebraska Press, 1988.

Simpson, Richard. *Ooti: A Maidu Legacy.* Millbrae, Calif.: Celestial Arts, 1977.

Smith, Genny, ed. *Sierra East: Edge of the Great Basin.* Berkeley and Los Angeles: University of California Press, 2000.

Smith, Kathleen, ed. *We Are Still Here: A Coast Miwok Exhibit.* Bolinas, Cal.: Bolinas Museum, 1993.

——. "The Bitter and the Sweet" in *News from Native California* 5(1).

——. "More Than Food Alone: Crab Louis and the Jitterbug." *News from Native California* 5(2).

Steward, Julian H. *Ethnography of the Owens Valley Paiute.* University of California Publications in American Archaeology and Ethnology, vol. 33, no. 3. Berkeley: University of California Press, 1933.

Sullivan, Maurice S. *The Travels of Jedediah Smith.* Santa Ana, Calif.: Fine Arts Press, 1934.

Thompson, Lucy (Che-Na-Wah Weitch-Ah-Wah). *To the American Indian: Reminiscences of a Yurok Woman.* Berkeley, Cal.: Heyday Books, 1991 [1916].

Trafzer, Clifford E. *American Indians as Cowboys.* Sacramento: Sierra Oaks Publishing, 1992.

———*Yuma: Frontier Crossing of the Far Southwest.* Wichita, Kan.: Western Heritage Books, Inc., 1980.

———, Luke Madrigal, and Anthony Madrigal. *Chemehuevi People of the Coachella Valley.* Coachella, Cal.: The Chemehuevi Press, 1997.

Wallace, W. J. "Southern Valley Yokuts," in *The Handbook of North American Indians*, vol. 8, "California," ed. Robert F. Heizer. Washington, D.C.: Smithsonian Institute, 1978.

Waterman, T. T. *The Yana Indians.* University of California Publications in American Archaeology and Ethnology, vol. 13, no. 2. Berkeley: University of California Press, 1918.

Whitley, David. *The Art of the Shaman: Rock Art of California.* Salt Lake City: University of Utah Press, 2000.

Winokur Scott, and Christian Berthelsen. "Calpine's Quest for Power" in *San Francisco Chronicle* March 5, 2001.

Yamane, Linda, ed. *A Gathering of Voices: The Native Peoples of the Central California Coast.* Santa Cruz, Cal.: Santa Cruz Museum of Art and History, 2002.

Ygnacio-DeSoto, Ernestine. "Last Chumash Speakers: The Ygancio Family." *Alolkoy* 7, no. 4 (1995): 8.

L. Frank (Ajachmem/Tongva) is an artist and "decolonizationist" who has exhibited in numerous shows and published a collection of her drawings, *Acorn Soup.* A cultural activist, she is one of the founding board members of the Advocates for Indigenous California Language Survival. She lives in Santa Rosa.

Kim Hogeland has a B.A. in history and Native American studies from the University of California, Berkeley. She worked at Heyday Books and *News from Native California* in numerous capacities for four years and is now working on a Ph.D. in history at the University of California, Davis.

HEYDAY INSTITUTE

SINCE ITS FOUNDING IN 1974, HEYDAY BOOKS HAS OCCUPIED A UNIQUE NICHE IN the publishing world, specializing in books that foster an understanding of the history, literature, art, environment, social issues, and culture of California and the West. We are a 501(c)(3) nonprofit organization based in Berkeley, California, serving a wide range of people and audiences.

We thank the following for their help in launching and supporting Heyday's California Indian Publishing Program:

Anthony Andreas, Jr.; Barona Band of Mission Indians; Fred & Jean Berensmeier; Black Oak Casino; Buena Vista Rancheria; Candelaria Fund; Columbia Foundation; Colusa Indian Community Council; Lawrence E. Crooks; Judith & Brad Croul, in memory of Harry Fonseca; Patricia A. Dixon; Elk Valley Rancheria; Marion E. Greene; Hopland Band of Pomo Indians; LEF Foundation; Morongo Band of Mission Indians; National Endowment for the Arts; San Francisco Foundation; Sandy Cold Shapero; Ernest & June Siva in honor of the Dorothy Ramon Learning Center; Thendara Foundation; Tomioka Family (In memory of Taeko Tomioka); Tom White; Harold and Alma White Memorial Fund

For more information about Heyday Institute, our publications and programs, please visit our website at www.heydaybooks.com.

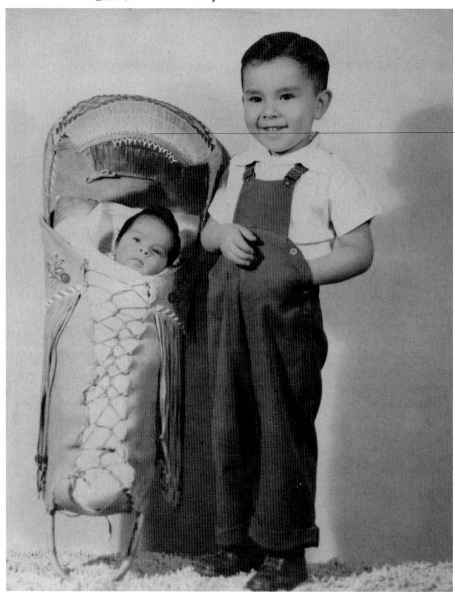

*Joleen Aguilar in cradleboard with her
brother Dugan Aguilar (Paiute, Pit
River, Maidu), Susanville, 1950*

COURTESY OF VIRGINIA AGUILAR.